THE LUSTRON HOME

THE HISTORY OF A POSTWAR PREFABRICATED HOUSING EXPERIMENT

by Thomas T. Fetters

Vincent Kohler, Contributing Author

McFarland & Company, Inc., Publishers
Jefferson, North Carolina, and London

The present work is a reprint of the illustrated case bound edition of The Lustron Home: The History of a Postwar Prefabricated Housing Experiment, *first published in 2002 by McFarland.*

LIBRARY OF CONGRESS CATALOGUING-IN-PUBLICATION DATA

Fetters, Thomas T.
 The Lustron home : the history of a postwar prefabricated housing experiment / by Thomas T. Fetters ; Vincent Kohler, contributing author.
 p. cm.
 Includes bibliographical references and index.

 ISBN-13: 978-0-7864-2655-3
 softcover : 50# alkaline paper ∞

 1. Prefabricated houses—United States—History. 2. Lustron Corporation—History. I. Title.

TH4819.P7 F48 2006
338.7'6432—dc21 2001052113

British Library cataloguing data are available

On the cover: Top: The special Fruehauf trailer used to haul the house assemblies to the final site. *Bottom:* The "Newport" house that was built in the front parking lot of the Columbus plant. (*Both photographs are from the Clyde Foraker Files, Dan Foraker Collection.*)

Manufactured in the United States of America

McFarland & Company, Inc., Publishers
 Box 611, Jefferson, North Carolina 28640
 www.mcfarlandpub.com

To Gloria,
who remembered the Lustrons being built,

and to Jean Conner,
who started the whole project for high school

Contents

Contents

Acknowledgments

Some of the information in this book resulted from a cooperative effort between Lustron Research and a number of historical societies, both interested in determining the number of Lustron houses in the geographical area of interest. Some of the statewide surveys proved to be particularly interesting. I would like to acknowledge the contribution of all the following groups:

Chicago Architecture Foundation, October 21, 1994, Chicago, IL
Chicago Art Deco Society Magazine, Summer, 1996, Chicago, IL
Des Plaines Historical Society, Des Plaines, IL
Dickinson County Historical Society and Museum, 1993, Abilene, KS
Du Page County Historical Museum, January 16, 1993, Wheaton, IL
Du Page County Historical Museum, March 13, 2000; Program, T. Fetters
Elmhurst Historical Society, Elmhurst, IL
Hinsdale Historical Society, Hinsdale, IL
Historic Preservation Commission of South Bend & St. Joseph Co., IN, August 21, 1992
Historic Preservation Planning Bulletin, Oct.-Dec. 1996, NJ Dept. of Env. Protection
Historic Preservation Services, Kansas City, MO
Historic Wilmington Foundation, Inc., Wilmington, NC
Homewood Historical Society, July 1986, Homewood, IL
Illinois Department of Highways, Dixon, IL

Illinois Historic Preservation Agency, October 7, 1993
Indiana Preservationist, November, 1986
Indiana Preservationist, July-August, 1994
Kansas Preservationist, vol. XVII #6, Sept.-October, 1995
KSUI-WSUI Public Radio, Iowa City, IA
Landmarks Preservation Council of Illinois, vol. 26 #1, May 1997
Library of Congress, Folklife Center, Washington, DC
Lombard Historical Museum, April 8, 2000; Lustron Housewalk & Program, T. Fetters
Lombard Historical Society, Lombard, IL
McHenry County Historical Society Tracer, Winter, 1995, McHenry Co., IL
McHenry County Historical Society, April 1, 1996; Program, T. Fetters
Ohio Historic Preservation, Columbus, OH
Ohio Historical Society, Columbus, OH
The Preservation & Conservation Association, Champaign, IL
State Historical Society of Iowa, Des Moines, IA
State Historical Society of North Dakota, Bismarck, ND
State Historical Society of Wisconsin, August 21, 1992, Madison, WI
State University of New York College at Fredonia, September, 1992
United States Department of the Interior, National Park Service, Indiana Dunes
West Virginia Division of Culture & History, Wheeling, WV
West Virginia Division of Culture & History, December 1, 1992

Libraries, too, were an ever-helpful source of information. The local Helen Plum Library of Lombard, Illinois, working together with the Suburban Library System, decided to get behind the Lustron project in a big way. A huge permanent file of newspaper clippings was gathered as reference material for all patrons enquiring about the Lustrons in Lombard, DuPage County, Illinois, and in the USA. A huge thank you is directed to the staff of both facilities for their help over and above the norm.

Columbus, OH, Public Library
Dallas, TX, Public Library
Helen Plum Library, Lombard, IL (Donna Slyfield)
Suburban Library System (Chicago Suburbs) (Linda Ameling)

The newspapers of the Midwest began publishing historical articles on Lustron homes in the mid–1980s as the fiftieth anniversary of the Lustron Corporation drew near. The story was interesting to feature writers, and each staff writer took his or her own slant on the available facts. Many of the stories were very valuable in finding Lustron houses. I would like to thank those authors and their newspapers for their attention to the subject. The newspapers, with the article dates, are listed in this book's bibliography.

The discovery of so many extant houses in so many states would have been impossible without a network of friends and correspondents who volunteered to hunt down the elusive Lustron in its habitat, and to provide addresses and, in some cases, photos of the units. They interviewed the owners and occupants and often obtained the serial number to establish an exact identity.

Many Lustron owners proved to be excellent sources of directions to other units in their immediate area.

The people listed here deserve recognition and certainly have earned my thanks for helping to locate so many of these units. There are some who did not get listed and who deserve equal recognition, and I extend my thanks to them as well.

Without the help of the following searchers, owners and contributors the listing of units in this book would have been pitifully small.

But first, thanks to Gloria Fetters, who sparked the initial interest, and to Jean Fetters Conner, who wrote the initial report.

Abbatiello, Douglass, Sharon, PA
Abbott, S. Ardis, Vernon, CT
Addkison, H. M., Jr., Jackson, MS
Agnello, Ellen, Crown Point, IN
Allen, Mrs. Bernard, Belvidere, IL
Allen, David E., New Bern, NC
Allen, George, Algona, IA; KLGA radio
Allen, Linda B., Huntsville, AL
Arronson, Tod E., Gibsonia, PA
Austin, Phil, Indianapolis, IN
Baatenburg, René, Jenison, MI
Baker, Mark, Crest Hill, IL
Bakersmith, Thomas, St. Louis, MO; St. Louis area houses
Balzano, Lynn, Wilton, CT
Banich, John, Chicago, IL
Barrow, Jim, Naperville, IL; photos of the Top of the Mark Motel
Begley, Doug, Palatine, IL
Bettenhausen, Brad, Tinley Park, IL
Bishop, Craig, Battle Creek, MI
Blair, Clarke, Fonda, NY
Blewett, Dale, Cincinnati, OH
Blunier, Gayle, Wadesville, IN
Bondo, Mrs. Doris, Dedham, MA; Boston houses
Braybrooks, Kenneth, Paw Paw, MI
Brodt, Philip, Bloomington, IN
Brown, F. O., Chillicothe, OH
Bruder, Anne, Maryland houses
Brush, Diane, Parma, MI
Buckley, Paul, Chesterton, IN
Buntz, Janet, Clark Summit, PA

Burgener, Ray, Parkersburg, IL
Burkett, Mary, Paw Paw, MI
Burns, John A., AIA, Washington, DC
Busby, Lynne, Gnadenhutten, OH
Cameron, Hugh, Front Royal, VA
Camp, Marian, Evansville, IN
Candor, Elva, Schaller, IA
Canterbury, Mr. & Mrs. Paul, South Williamson, KY
Carrington, Linda, East Grand Rapids, MI
Carver, Martha, Nashville, TN
Cash, Stan, Oakland, IL
Caville, Turisa, Scotia, NY
Clark, Beverly, Lincoln, NE
Cloud, Dana, Kansas City, MO
Collin, Terrance, Madison, WI
Coultas, Mrs. Erin, Moweaqua, IL
Craw, Joan, Belleville, IL
Culver, Mary, Ann Arbor, MI
Cunningham, J., Schaumburg, IL
Cyburt, Deborah, Elk Grove Village, IL
Dasho, Charles & Maria, St. Louis, MO
Davidson, William, Trenton, NJ
Dick, Christopher, Black Rock, CT
Dobson, Eric N., Arlington, VA
Domke, Ginny, Lombard & St. Charles, IL
Dorn, Carol, Chicago, IL
Drew, Bernard A., South Barrington, MA
Dudones, Janet Worthington, Saranac Lake, NY
Dycus, Herma, Olney, IL
Elmer, David, Milwaukee, WI
Erickson, Gene, Los Angeles, CA
Ezratty, Lee, Liberty, NY
Featherstone, R. M., Jr., Indianapolis, IN; Indiana houses
Fell, Andrew, AIA, Urbana, IL
Fetters, Robert, Chillicothe, OH
Finney, Mrs. Marvin, Wheeling, WV
Foraker, Dan, OH; grandson of Clyde Foraker; archival material
Ford, Gene A., Tuscaloosa, AL; Alabama houses
Ford, John, Benicia, CA
Fowler, Dave, Norfolk, VA
Framer, Mary Susan, Jacksonville, IL
Frantz, Ronald, Jr., Oklahoma City, OK
Freese, Kathy, Byron, IL
Fye, Mrs. John, Olney, IL
Gassman, Henry, Olney, IL
Gatza, Mary Beth, Charlotte, NC

Gauliapp, Janie, Monroe, WI
Goldi, Carol, Philadelphia, PA
Graves, John K., Webster Groves, MO
Gray, Tom, Little Rock, AR
Griffis, Joan, Danville, IL
Haberfield, Mark, Elgin, IL
Hadley, Witt, Jr., Elk Grove Village, IL
Hague, Elizabeth, Indianapolis, IN
Hansen, Dick, Des Moines, IA
Harrod, Steven, Hartford, CT
Hartig, Mikki, Sarasota, FL
Hatt, Mary J., Milford, CT
Hebert, Joy, Evanston, IL
Hellard, Keith, Kentucky houses
Henderliten, Lucy, Champaign, IL
Herderick, Terry & Anne, Gahanna, OH; copies of Bob Runyan's archives
Herman, Howell S., Mount Morris, IL
Hill, Dick, Fort Collins, CO
Hill, Doug, Chapel Hill, NC
Hill, Lawrence, Dixon, IL
Holtcamp, Christy, Centralia, IL
Honnert, Theresa, Chicago, IL
Howe, Dennis, Des Moines, IA
Huffman, Wylda, Harvard, IL
Hunt, Aileen, Hamilton, OH
Hunter, Rebecca, Elgin, IL; Sears houses
James, Alex, Columbus, OH; Lustron Employee; Lustron Convention 2000
Janda, Don and Sheila, Cedar Rapids, IA
Janisch, Joe, Chicago, IL
Jesperson, Kathy, Westover, WV
Johnson, Dave, Carmi, IL
Johnson, Mary V., New Orleans, LA
Johnson, Willis G., Downers Grove, IL
Johnston, James A., AIA, Springfield, IL
Jones, Brian W., Miller, SD
Jones, Richard N., Greenwich, CT
Kane, A., Newton, MA
Kane, Ellie, Toledo, OH
Kehe, Al, Elmhurst, IL
Kelley, Ken, St. Louis, MO
Kelly, Joe, Mundeline, IL
Kendzior, Joann, Lombard, IL; organized first Lombard Lustron House walk
Kennedy, Mrs. Paul, Milan, IN
Kenner, Kristin, Devils Lake, ND
Kester, Walter, Olney, IL
Keys, Jerry Lee, Louisville, KY
Kilker, Glennes, Mount Morris, IL
Kotch, Thomas, Allentown, PA

Kreitzer, Andy, Evansville, IN
Kron, Carolyn, Olean, NY
Kruper, Jacqueline, Lebanon, PA
Kummer, Karen, Champaign, IL
Laird, James, Waupun, WI
Landness, S., Atlantic, IA
Leggit, Joellyn, Ohio
Leininger, Michael, Cambridge, MA
Leonard, Steve, Springfield, IL
Levere, Frank, Lombard, IL
Lewis, Roger K., AIA, University of Maryland
Lighthiser, Peggy, Largo, FL
Logan, Jack, Los Alamos, NM
Luce, Ray, Columbus, OH
Luso, Donald, Mount Morris, IL
MacCarl, Juanita, Niagara Falls, NY
Magnus, James, St. Louis, MO
Manning, Cindy, Villa Park, IL
Marcus, Gwen, San Francisco, CA
Martin, Ellen, Horseheads, NY
Martin, John, Syracuse, NY
Mason, Jill, Angola, IN
Maye, Mona, Greenville, NC
Mayes, Alan, Anderson, IN
McAtee, Twyla, Grinnell, IA
McCabe, Charlotte, Villa Park, IL
McKay, Frank, Needham, MA
McKnight, Colin D., Castleton on Hudson, NY
Mehler, Ralph C., Sharpsville, PA
Melchiorre, David, Wilmette, IL
Miller, Mrs. Charles, Danville, IN
Miller, Emilie, Elk Grove Village, IL
Mills, Doris, Webster Groves, MO
Millspaugh, Abbott, Baltimore, MD
Mitchell, Pat, Hutchinson, KS
Mitchell, Robert A., AIA, Bismarck, ND; Alaska
Motz, Velma, McCook, NB
Moxon, Margaret, Huron, SD
Muller, Gayle, Dalton, PA
Murphey, John, NM
Nash, Jan, Iowa City, IA
Nelson, James, Rockford, IL
Nemec, Ray, Naperville, IL
Newhart, Donald, Naperville, IL
Newkirk, Genevieve, Mount Carmel, IL
Nordby, Gene, Chicago, IL
Norfleet, Nancy, Albany, NY
O'Connor, Mary, Seattle, WA

Ondovcsik, Maryann, Brooklyn, NY
Palombo, Timothy N., Wildwood, NJ
Parsons, Gerry, Washington, DC
Perrine, Lois, Bloomington, IL
Peterson, Douglas, Canton, IL
Peterson, Rev. John E., Ord, NB
Phipps, Helen, Champaign, IL
Pieper, Rachel, Mount Morris, IL
Pollack, Jim, Des Moines, IA
Price, Susan, Wheaton, IL
Prigmore, Kathryn, AIA, Alexandria, VA
Pritchett, Clara, Grayville, IN
Protzek, William, Milan, OH
Randall, Ruth, Evansville, IN
Ransbottom, Mrs. Alfred, Roseville, OH
Reckling, Mel, N. Royalton, OH; Cleveland houses
Reed, Phyllis, Rotterdam Junction, NY
Reep, Joan, Larned, KS
Reese, Ginger & Tim, Elgin, IL
Reiff, Daniel, Fredonia, NY
Reiter, Jennifer, Muncie, IN; Lustron thesis, Ball State University, 1992
Renschler, Thomas, Hamilton, OH
Robertson, Dennis E., Monona, WI
Robertson, Joy, Henderson, KY
Ross, Robert S., Northfield, OH
Runyan, Irene, Dayton, OH; many articles from her husband's files
Ruppre, Howard, Mount Vernon, IA
Sandborg, Ron, Eau Claire, WI (Carl Strandlund's nephew)
Sanders, Cyndi, Mount Vernon, IN
Scheible, Pat, Mebane, NC
Schlosser, William, Bryan, OH
Schmidt, Eugene F., AIA, Atlanta, GA
Schroeder, Connie, Miller, SD
Searight, Barbara, Perkasie, PA
Shantz, Josie, Redfield, SD
Shapiro, Ron, Albany, NY
Shehigian, Judy, Kalamazoo, MI
Sherman, R. G., Columbus, OH
Simonds, Bob, Pittsburgh, PA
Skvir, Gayle, Copperas Cave, TX
Slattery, Christina; Lustron thesis, Ball State University, 1992
Smith, Arlene F., Stillwater, OK
Smith, Dana R., Granville, OH
Snedeker, Paula, Meriden, CT
Speer, Hal, Sea Cliff, NY
Spitler, Carol, Downers Grove, IL

Stone, Bert, Northfield, OH
Stoner, Floyd, Baileys Harbor, WI
Storm, Edward, Sioux City, IA
Strayer, Colin, Toronto, Canada
Streater, Jack, Chagrin Falls, OH
Swanson, Irene, Ames, IA
Szwedo, Ron, Bollingbrook, IL
Tabor, Jim, Champaign, IL
Terry, Jack, Palos Verdes, CA
Thiedel, Mr. & Mrs. Elmer, Hinsdale, IL; the first occupants of a Lustron
Thoreson, Renee, Rochester, MN
Todd, Gary, Columbus, OH
Trunda, Vince, Cicero, IL; former employee who shared archival material
Tucker, Joe, Valparaiso, IN; former employee who shared information
Ultzen, Richard, Webster Groves, MO
Vairo, Stacey, Savannah, GA; Savannah College of Art, thesis
Valek, Mrs. Peter, Joliet, IL
Varney, W. D., Kittery Point, ME
Wagner, Rena, Quincy, IL

Wallfisch, Charles, New Orleans, LA
Walters, Deleen, Caldwell, OH
Warner, Tom, Edinboro, PA
Wasserman, Adelaide F., Homewood, IL
Watt, Mr. & Mrs. Darwin, Mexico, MO
Watts, Gerry, Lombard, IL
Webster, Maureen, Mentor, OH
Weinhoeft, John, Springfield, IL
Weiss, David, Burlington, IA
Weitzel, Susan, Tampa, FL
Werner, John F., Evansville, IN
White, Carl, Columbus, OH
Williams, Bill, Kansas City, MO
Wilson, Richard Christian, Ann Arbor, MI
Wineberg, Susan, Ann Arbor, MI
Woodruf, Sarah F., Webster Groves, MO
Worthington, Ed, Saranac Lake, NY
Yantis, Terry, Canal Winchester, OH

The authors also wish to thank the University of Pittsburgh at Bradford for generous support from the Faculty Research Fund.

Preface

The Lustron home was an enameled-steel prefabricated house that was immensely popular and highly promoted during a two-year period in United States history, 1948 to 1950. This book is a history of the Lustron Corporation, from the first concept to the final bankruptcy. I have interviewed a number of former employees and have searched in depth through the literature of the time—including company documents, newspaper and popular magazine articles, and articles in trade journals—to get a good perspective on the company. Abundant information on the houses themselves is also provided, from detailed descriptions of the six available models to an account of how the house could be assembled in as little as two days. The text is illustrated with period photographs, technical drawings from company documents, advertisements, and photographs of some of the homes as they look today.

This book is part of a larger project in which I have been heavily involved for a number of years. I have searched for the remaining Lustron homes and have documented the location, model, color and details of about 2000 of the 2500 homes that were built, from eastern Massachusetts west to Los Alamos; from North Dakota to Fort Lauderdale, Florida; and from Alaska even to Venezuela. Still, however, there is much documentation left to be done. Not all the units have been found, photographed, recorded and listed with color, model and serial number. Your help is needed to complete the task of locating all the remaining units.

If you know of a Lustron unit, or find one as a result of reading this book, record the address, the model, the color of the wall tiles and roof, inquire about the serial number, and photograph the house. Send this information to Lustron Research, 545 S. Elizabeth Drive, Lombard IL 60148, where it will be added to the known units listed in the directory found in this book. This is your opportunity to become a contributor to this research project.

While unorganized, there is a loose association of the owners of Lustron homes. Every owner seems aware of where other Lustron units are located. Owners have an immediate mutual interest when they meet, sharing stories of the quirks and pitfalls they have discovered and overcome. Some informal meetings have been held in Iowa, and it does not take much foresight to imagine that eventually a formal organization of Lustron owners may emerge.

The Lustron project began when my daughter, Jean, was still riding in a car seat. Because many Lustron homes were built in Illinois, especially in our area, my wife and I could point out the "tile houses" to keep Jean occupied. When Jean was in high school, the "tile houses" became a history fair project in which I helped a bit. Then I dug in, and soon I was traveling around the country and asking

friends to help in the search for more of the Lustron homes. With perseverance, and the help of the local library, I soon had more information than anyone, and I began working with state historical societies to document Lustron houses around the country.

Alan K. Lathrop, Professor and Curator, Northwest Architectural Archives at the University Libraries, University of Minnesota, contacted me on November 10, 1987, asking for help with an article he was writing about Lustron Houses. We shared information on construction drawings and some of the Minnesota Lustron locations. He also recommended that I contact Professor of English Vince Kohler at the University of Pittsburgh at Bradford who was working on a book about the social and cultural significance of the Lustron Houses. Kohler was well along on a rigid academic work and had interviewed Carl Koch, a consulting designer of the proposed second generation Lustron.

The three of us arranged to meet at a Popular Culture Convention in St. Louis, and after giving a well received lecture on the steel Lustrons, we decided to merge the three independent lines of interest into a single book which would probably be easier to publish.

Kohler sent out a prospectus for the proposed book in September of 1988 to a midwestern university, but it was rejected for several reasons. I rewrote the material in January of 1990 into a different format and this version was accepted by Preservation Press, a publishing arm of the National Trust for Historic Preservation, in May of 1992. During a phase of editing, most of Lathrop's material was removed as it concentrated on predecessor pre-fab houses and constructions more than the Press desired.

However, Preservation Press fell victim to budget cuts, and the manuscript, which had gone through a vigorous critique that removed even more material, was returned.

After a half dozen new rejections, the manuscript was once again revised and I began to add the personal recollections of Lustron employees, both labor and management, from sources not originally available. In addition, numerous newspaper and magazine articles on Lustron that I supported with factual material fed back more responses from readers with strong ties to the former company. The lecture trail and the preparation of a video documentary on the Lustron Houses of Lombard, Illinois, which ran on the local access channel for two months, led to still more vital sources of information.

This book is vastly different from the early 1990 version that never saw print. However, a sincere thanks goes to both Alan Lathrop and Vince Kohler who have left their own flavor in the text. Some of the sources on early pre-fabs were provided by Lathrop, and some of the interviews with Koch were summarized by Kohler. I believe both still plan to release their own viewpoints on the Lustron story in the future.

From such a little acorn, a mighty project has grown.

1

The Promise

"Lustron."

This sibilant name, derived from "luster on steel," leapt into the public eye and conscience in postwar 1948. Subliminally, it projected some hint of "lust," to which the marketing group had no objection so long as it led to a populist movement for buying the all-steel, porcelain-covered housing units that the company was manufacturing. The Lustron brochures, slickly produced for the time, promised a step into the postwar future for prospective home buyers who were accustomed to only being offered traditional wooden frame structures, sturdy brick bungalows or larger homes that utilized both building materials.

Certainly there were some homes being built that used decorative stone or basic concrete blocks as a variation, but for all practical purposes, steel was unknown as a material for conventional home building. Indeed, the supply of steel was, at this time, still under government control with the available tonnage allocated under still existing wartime boards.

It was the war, World War II, which led directly to the formation of the new Lustron Corporation. Rather, it was the termination of hostilities and the return of the young veterans to America, with their hope of forgetting their earlier quest to free Europe and the Far East from the evil fascist Axis powers and reuniting with the sweethearts waiting under the apple tree. It was this migration home that precipitated the need for rapid construction of new houses.

These new fecund families, burgeoning in the great baby boom, put a massive demand on a housing industry just awakening from the hibernation of the war years. In some cases, the demand was directed to the government to provide huge numbers of new homes across the country. While traditional builders responded by hiring large numbers of carpenters and tradesmen, and increasing their production many fold, the traditional construction methods were far too slow to supply housing fast enough. There was a demanding consumer movement of men not content to live at home with the in-laws.

Aware of this growing consumer need, Carl Strandlund, engineer and inventor, strode into the Washington office of Wilson Wyatt of the Veterans Emergency Housing Program on a cool fall day in 1946, just over a year after the war had come to an end. Wyatt wore two hats, also serving as the government's Expediter of the National Housing Agency. Strandlund had come to Washington to ask Wyatt for a release of some of the government's hoarded steel supply so that his company could begin again to produce a line of gleaming white, enameled steel service stations and similar hamburger stands.

Porcelain-enameled steel had been introduced originally in the 1930s by Chicago Vitreous Enamel Products Company. "Chicago Vit" had developed a production line for manufacturing the gleaming white porcelain-coated steel panels that were used to quickly enclose a framework of wood studs and framing to provide attractive and maintenance-free structures for commercial purposes. White Castle, Standard Oil of Indiana, Socony Mobil and many other companies had dozens of examples of these structures across the Midwest and Northeast with a number of other structures built here and there in other parts of the country.

When the early war effort in 1941 had abruptly eliminated the steel supply for their manufacturing line, Chicago Vit turned to producing other steel products vital to the war effort and made its valuable contribution to eliminating the Axis powers.

With the war ended, Chicago Vitreous had turned again to thoughts of supplying a product that was unique to this company. Confident that he could present its case in a logical fashion, the company sent Carl Strandlund to Washington to obtain the steel it needed to get the lines running again.

Wilson W. Wyatt was new to Washington himself. A lawyer, he had been elected and served two terms as mayor of Louisville, Kentucky, during World War II. As his term neared an end, he had looked forward to returning to his practice. However, President Truman, through intermediaries, had asked him to come to Washington to discuss a few things. Wyatt had turned down the requests. Then Truman called him directly and "said he needed to see me."

Wilson took the next train east, although he was determined not to accept Truman's offer. But when the President said, "This is an extension of the war problem. I need you to come help me do this," there was only one answer to be made: "Yes," he agreed. "I'll do it!"

Truman's problem was what to do with several million people coming out of the service when there was very little available housing since the industry had been nearly shut down for close to five years. The War Production Board had made a Herculean effort at starting up a war industry, and now the President saw the need for a similar large-scale quick start-up of the housing industry. Truman told Wyatt: "Make no little plans. It has no power to stir men's blood."

Wyatt proceeded to develop a major plan to meet the challenge. It called for 1,200,000 new homes for the year 1946, a figure six times greater than the housing production in 1944. The spokesman for the construction industry, F. W. Dodge, told Wyatt the goal was unrealistic, and that the most to be hoped for was 300,000 units.

Nonetheless, the National Housing Administration, together with the Federal Housing Administration, National Public Housing, and the Federal Home Loan Bank, led the program to 1,003,600 units by the end of 1946. It was not quite the goal, but it was more than three times the industry's estimate.

The houses were on the small side, about 600 square feet, and cost the veteran $6,000 to buy, or if they were rental units, $50 a month. While conventional housing was the standard, Wyatt was certainly open to any proposal for prefabricated housing.

Wyatt's plan was drawn up before April 1946 and passed by Congress in May—considered very fast even then, although Congress and the President were Democratic. The plan was prepared while the country was still under tight government control in regard to the allocation

of strategic materials.* So, Wilson Wyatt was primed to redirect Strandlund's proposal from gas stations to prefabricated housing as the great man strode in the door of Wyatt's office with a cigar stub clenched in his teeth.

One can imagine the swiftly changing looks that crossed Strandlund's visage as he was told that there was no steel available for gas stations, but that an unlimited supply was available for the housing market. The first words must have dashed his hopes for re-instituting the small manufacturing line, yet the alternative offered him was so broad an opportunity, it might well have caused another less imaginative man not to grasp this golden opportunity. It is easy to see Strandlund pausing to control his jubilation, perhaps drawing a deep lungful of cigar smoke, then standing up to accept the offer with the words, "I just happen to have the Lustron designs on me!"

*In November of 1948, the presidential midterm elections teetered between Truman and Dewey, and both houses of Congress changed from Democratic to Republican. As a result, Truman ended many of the controls and allocations that the Wyatt plan had been formulated upon. With that, Consolidated-Vultee Company (aircraft), Curtiss-Wright (aircraft) and Kaiser Frazer (liberty ships and other war production) all lost their initial interest in the housing program and backed away. With no guaranteed market, and no channeling of materials to assure availability, the former war plants "were unwilling to take the risk of a totally new business."

Pioneer Prefabricated Homes

For many modern Americans, life must be lived on the suburban fringe of busy towns and cities. It is for these middle-class people that planners and architects such as Frederick Law Olmstead, Frank Lloyd Wright, Irving Gill, Richard Neutra, Walter Gropius, Konrad Wachsmann and Carl Koch have wrestled with the problem of appropriate housing. From Wright's Usonian houses to the Packaged House designed by Wachsmann and Gropius, architects have addressed the problem of making the American dream of a detached single-family house a reality.

Traditionally, the single-family house would be cut and assembled on-site. However, the concept of partially or completely prefabricating housing units and other structures dates back at least to the late 18th and early 19th centuries.

Prefabricated structures were often seen as temporary expedients in the 19th century. Some structures were of wood and canvas; others of cast or corrugated iron. Prefabricated iron churches offered sturdy and secure places of worship that could be erected fairly quickly. But the notion persisted that prefabrication was a "temporary" solution to housing, and this notion haunts the proponents of prefabricated housing to this day.

The first significant market for prefabricated housing in the United States was the California Gold Rush of 1848. Housing in the camps in the Sierra valleys and in the nearby cities was scarce and the price of building materials, a fledgling market on the Pacific Coast at the time, was exceptionally high. Charles Peterson described the situation in his "Prefabs in the California Gold Rush, 1849": "Small buildings, roughly built, let from twelve to fifteen thousand dollars a year. Tents were popular, and in more sturdy structures, cloth partitions were commonplace. Many lived on ships abandoned in the harbor, even though it cost two dollars to be rowed ashore. Lumber at times sold as high as a dollar a square foot and bricks at a dollar apiece. The ready-made building was a logical answer to the emergency. Prefabricated structures were brought to San Francisco from all around the world. Houses were shipped in from as far away as New Zealand, China and Tasmania."[1]

However, the Gold Rush was, after all, an exceptional affair. The real test of prefabricated housing would be its adoption under less extraordinary conditions.

Thomas Edison was attracted to the concept of prefabricated housing after the turn of the last century. His support for a concrete house, built with prefabricated iron forms, received attention in the national press and the great inventor obtained patents for his idea in 1915 and 1917. But the Edison Cement Corporation, which he formed, was never a success. The biggest problem was that the initial cost of the Edison iron forms to

the contractor-builder was a whopping $30,000.

The precut, mail-order house was an important development in the history of prefabricated housing in the United States. Entire precut houses were first marketed in 1889 by George F. Barber of Knoxville, Tennessee. However, it was the Aladdin Company of Bay City, Michigan, that in 1904 began to mass-manufacture and mass-market a complete home which could be assembled by an unskilled prospective homeowner.

Bay City was also the home of International Mill & Timber Company's Sterling Homes operation. This company offered as many as 57 different mail-order kits for single-family houses and three summer cottages as early as 1920. By this time, Sears, Roebuck & Company had been in the precut housing business for a dozen years, but had effective competition from Montgomery Ward Company's Wardway Homes.

It was shortly before World War I that a curious housing form, "the Bungalow," was developed for urban outskirts. Although built of various materials and embracing several styles, the ideal bungalow was in stark contrast to the Victorian house that had predominated in the market. This low-profile house was the immediate predecessor of the single-story "ranch" houses that became popular after World War II.

As early as the 1920s, there were some experiments with steel as a housing material in Europe by Walter Gropius and his Bauhaus colleagues at Dessau in Germany. A steel house was built there to coincide with the erection of a new Bauhaus building in 1926. Karl Kastner and Company of Leipzig produced a steel model house in the same year. Germany had been faced with a shortage of 800,000 houses during the mid–'20s and this led to serious consideration by many architects of mass-producing steel housing units.

While prefabricated or prebuilt buildings were made almost exclusively of wood throughout the 19th and early 20th centuries, some developers had also been using iron and steel in such construction. Manufacturers were becoming more interested in the employment of steel by the 1920s as a prime structural component. The initial use seems to have been for small commercial buildings and storage sheds. L. W. Ray succeeded in designing and patenting a portable unit that became the standard for the White Castle Hamburger System in 1928. White Castle Hamburger stands not only utilized a steel frame, but also porcelain-enameled steel panels that fastened to the frame to form interior and exterior walls.[2]

Porcelain enamel is a sand and glass mixture that is baked onto steel sheets to give them an enduring finish. It has been widely used as a durable coating for exterior signs and for home appliances such as washing machines, refrigerators and bathroom fixtures including sinks and tubs. Its chief advantage is that it will not crack or appreciably fade over time.

Much of the impetus for introducing porcelain-enameled steel into architecture came from both the steel and porcelain industries, rather than as a result of the demands of architects or builders. *Better Enameling*, the trade publication of the Chicago Vitreous Enamel Products Company, one of the largest producers of porcelain enamel, published several articles in the early thirties urging the wider use of this product in the building industry. The story "Porcelain Enamel Will Make the All-Steel House Practical" by Guy Irwin was published in March of 1931. Irwin wrote that "the surge toward a widespread use of steel for the carrying out of modern designs in architecture [is so definite] that it is only reasonable to

suppose that the time is not far off when houses will be built entirely or principally of steel. This means that not only frames and interior and exterior walls will be of steel, but the window sash and frames, doors and door frames, mantels, shelves, cabinets and other trim will also be steel."[3]

Irwin's article featured five house designs that utilized steel in the construction of the frame and walls, but criticized them for not employing porcelain enamel as a wall finish. "The practical solution of this problem of using steel adequately for interior and exterior wall surfaces and for partitions," he said, "would seem to lie in the use of porcelain enamel."[4]

It was the Century of Progress Exposition in 1933 that raised the real possibility of acceptance of prefabricated metal housing in America. Altogether, 11 different model houses were constructed for the exposition with three fabricated primarily of steel.

They were the General Houses House; the Armco-Ferro Enamel House, which was jointly developed and manufactured by the American Rolling Mill Company (ARMCO) of Middletown, Ohio, and the Ferro Enamel Corporation of Cleveland; and the Strand-Steel House. A fourth, the House of Tomorrow, had a light steel frame covered on the ground floor by a molded plastic veneer.[5]

Metal houses were not to be exclusively found at the exposition in Chicago. Four companies—Armco, Ferro, and two others—experimented with this type of construction during the early years of the Great Depression in other areas of the country.

Armco built a house in Cleveland that boasted of an all-steel frame and porcelain-enamel siding. The interior walls were of traditional plastered insulating board and the work to complete the house was apparently quite substantial. Even so, the *Better Enameling* magazine

issues of September and October 1932 described the project with approval.[6]

The same year, Ferro Enamel Corporation of Cleveland built a house there using a traditional wood frame covered with porcelain enamel shingles as both siding and roofing. Some of the metal components were used in the frame, and they were welded together on the site. (It should be noted that the Lustron house improved on this Ferro house by using an easily erected steel frame to which the interior and exterior panels were attached. To avoid damaging the panels, the Lustron metal framework had channel grooves to accept the screws used to assemble the Lustron walls. By using power screwdrivers, instead of the hammers used on the Ferro House, Lustron was able to reduce the chipping of the enameled parts to a minimum.)[7]

Still another house was built as a demonstration project in Solon, Ohio, just outside Cleveland, by the Ferro Enamel Corporation and ARMCO. This house had no frame. Instead, the walls consisted of factory-assembled panel sections of 20-gauge steel stamped into a corrugated shape with channels two inches deep and six inches wide. The panels were welded together at the site to form the walls of the house. Insulation board and "porcelain enameled shingles" were fastened on the exterior surface. The shingles were rectangular pieces of steel coated with porcelain enamel. The floors were 18-gauge steel covered with linoleum and laminated hardwood. The house also included a porcelain-enameled metal sink and shower cabinet. This house was dedicated on October 12, 1932, and, although there was much fanfare, the concept did not catch on.

There was little public enthusiasm for these initial enterprises. An *Architectural Forum* article in 1933 offered the opinion that the American public was probably not ready for prefabricated metal housing at

that time. The article listed six promising experiments in metal housing, but suggested that there would be stiff competition from conventional prefabricated units distributed by companies like Sears.

The advancements in the design of automobiles, ships, aircraft and household appliances had prepared both manufacturers and the American public for the Lustron house. The 1930s had created a new, streamlined aesthetic look which sprang from the design boards of Normal Bel Geddes and Raymond Loewy, who had created striking forms for steam locomotives and ocean liners. Buckminster Fuller, in addition to his innovative house designs, had designed and built the futuristic Dymaxion cars that radiated sleekness. Even General Electric had redesigned their refrigerators to fit the times following the lead of Loewy's streamlined Coldspot refrigerator introduced by Sears in 1935. The lessons of all this activity, especially the streamlining of home appliances, was not lost on the designers and engineers at Chicago Vitreous Enamel Products Company.

During the early part of World War II, much of the productive energy of the American industrial system was converted to military needs and the earlier advances in prefabricated housing came from wartime necessities. For example, the sectional housing developed by the Tennessee Valley Authority (TVA) architects in the 1930s and first manufactured in 1940 was further refined for emergency wartime housing needs. During the war, several thousand of these TVA-designed units were constructed to house those working on the atomic bomb projects at Oak Ridge, Tennessee. At Portsmouth, Virginia, the Homasote Company built 5,000 prefabricated wallboard houses for the navy base there. Here again, the use of prefabricated structures was tied to emergency conditions, as had been the case during the Gold Rush of 1849.

As the Allied effort turned toward victory, it was not surprising that the idea of the assembly-line production of a prefabricated metal house for peacetime use would come from the porcelain enamel industry. The traditional American belief in the irreversible tide of progress was fully supported by the appliance makers whose products filled the pages of *Better Enameling* magazine. Throughout the 1930s, industry created more and more labor-saving devices for the American household and the use of porcelain enamel in such products was widespread. Domestic appliances, outdoor commercial veneers, indoor walls of commercial structures, marquees of theaters, the lining of roadway tunnels, and even roofing for single-family homes were made of porcelain enamel baked on steel at high temperatures. The industry was a logical place for the ambitious idea of a durable factory-made single-family house to take root.

The development of the Lustron house in the fall of 1946 by Carl Strandlund and his team of Chicago Vit designers was not a revolutionary act, but the result of changes in industrial designs which were already well-developed by the time World War II had broken out. While it is true that Chicago Vit would have preferred to continue to make porcelain enamel gas stations, which the company had made before the war, it took only a few months for the company's engineers to come up with a house design in 1946 when the government denied any allocations of steel for gas stations. The application of advanced industrial design to a metal factory-made house, like the Lustron, was evolutionary and quite logical.

It didn't hurt that the influx of returning veterans was remarkably like the surge of gold miners to the Gold Rush and caused nearly the same demand for a quick resolution of housing needs.

Strandlund's Great Idea

When Carl Strandlund reached for his briefcase in Wilson Wyatt's office after announcing that he had some plans there, he concealed a grin as he began to pull out the sketches of the Lustron house from the rear file. Strandlund knew that he was holding a strong hand in this game he had come to play in Washington, and Wyatt had just passed him an ideal opening. Strandlund had more than a little experience in getting people to see things through his eyes, and he was certain that he could sell this new idea too.

Carl Gunnard Strandlund was born in Sweden in 1888. He was the great-grandson of the man who had originated the water sluice for transporting cut logs from the forest to the nearest river, lake or mill. The system used the power of the streams and gravity to move the logs quickly and with little damage. This development, only 100 miles below the Arctic Circle, had changed the face of the countryside as timber, once considered too far from the mill to be economically moved with teams, now slid freely down the flumes. Carl's grandfather was one of Sweden's outstanding engineers, and his father, Carl G. Strandlund, Sr., was cut from the same timber, so to speak. Carl Senior decided to go to America and left Sweden in 1892 with his family, including the four-year-old Carl Jr. Once he was settled in the Midwest, Carl Sr. worked for John Deere at Moline, Illinois, and soon had applied for and been granted some 300 U.S. patents on farm implements and improvements.

The young Carl graduated from Moline High School and took correspondence courses to eventually become a graduate engineer. He worked for a number of local farm implement companies like John Deere, Minneapolis Moline, and the Oliver Farm Machinery Company. Carl, like his father, saw ways to make improvements and soon had some 150 patents of his own. He found a way to lighten a combine to reduce the harvest time per acre from five hours to one hour. He put tractors on rubber tires for the first time. He improved the rigid tractor seat that had been a notorious backbreaker for farmers across the prairies. Carl also lightened the tractor to utilize more of the available energy for the job at hand. Some sources have even credited Strandlund with pioneering air conditioning in a movie theater.

Strandlund became the director of engineering and development for Oliver Farm Equipment and later was promoted to the manager and works coordinator for the four manufacturing plants at Springfield, Ohio; Battle Creek, Michigan; South Bend, Indiana; and at Charles City, Iowa. He directed the improvement of the plants' organization, developed better coordination among the various activities and processes, and created more economical methods of production. His dream was to eliminate piece-by-piece

assembly by creating a less wasteful and less costly procedure known as unit assembly. Under his direction, the company changed from being a $20 million operation to a $120 million concern.

Strandlund left Oliver and worked as a consulting engineer for Chicago Steel Foundry Company and then worked for B.F. Goodrich in Akron, Ohio. It was here that he developed an improved tank tread that gave him some initial government recognition.

In April of 1942, shortly after the United States had been thrust into World War II, Strandlund joined Chicago Vitreous Enamel Products Company as a works manager at their Cicero, Illinois, plant.

Chicago Vitreous had been formed in 1919 by a former star track runner at the University of Chicago, William Hogenson, and his brother, Emanuel Hogenson. The company produced steel enamelware for companies that manufactured refrigerators, stoves, washing machines and other household enameled appliances. Later the company developed a high-grade steel enamel which was used for architectural panels for store fronts, interior walls and other similar uses. This production was developed under the name of the Porcelain Products Company. Porcelain Products was formed in 1932 to

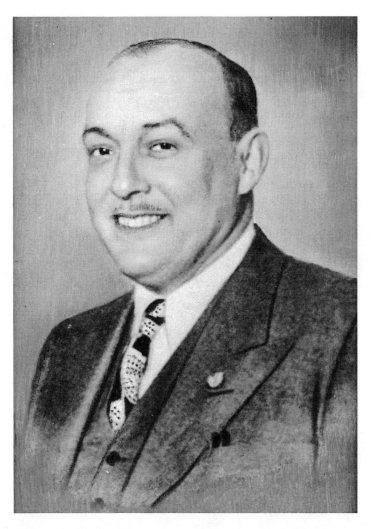

Carl G. Strandlund, 1888–1974. (Collection of Ron Sandborg.)

develop and market porcelain-enamel steel panels as a practical cosmetic wall finish for store fronts, theaters and gasoline stations. The name "Lustron" was trade-marked (#353,109) by Porcelain Products Company of Cicero on October 19, 1937, but the company had been using the term as early as August 24, 1936.[8]

Toward the end of the Depression, the Standard Oil Company of Indiana contracted with Porcelain Products to produce enameled steel gas stations in several modern sleek designs that were all built in sanitary white enamel and re-

quired very little maintenance. Some 600 stations had been put up in the Midwest before Pearl Harbor suddenly ended the steel supply for nonessential uses.

Strandlund was suddenly promoted to vice president and general manager of the firm on September 10, 1943, after he developed a means of making a better tank armor in a remarkably short time. Backed with $700,000 of government war money, he managed to cut the manufacturing time from 14 hours to six minutes.[9]

Armor plate is normally heated to 1,600 degrees Fahrenheit and then quenched with cold water to make it tough. The quenching causes the plate to warp or distort as it tries to relieve internal stresses. The manufacturing plants were forced to use big presses to hammer the warped sections back to the original flat plate. Strandlund changed this by quickly removing the plate from the annealing furnaces and moving it on transfer railcars to the large presses. The presses were fitted with huge waffle iron dies with 7,200 holes for injecting the quenching water. The presses would grip the red-hot armor plate in the dies and a rapid flow of cold water would quench the plate while under 2,500 tons of pressure that prevented any warping or distortion. The armor plate would emerge from the dies flat and ready to use. One Strandlund-modified press could do the work of 25 cold-hammering presses. The Cicero Chicago Vit plant saved one million man-hours and 500,000 machine hours in 1943 producing armor plate. This was equivalent to nine cents a pound in savings, which was extraordinary.

For this startling development, Strandlund won the *Chicago Tribune*'s War Workers Award—a gold, diamond studded, V for Victory pin. The *Tribune* gave these pins for outstanding developments by Chicago area war-plant employees. In a highly publicized event, the pin

was awarded to Carl Strandlund by Major S. C. Massari of the Chicago Ordnance District in a ceremony broadcast over WGN Radio on April 26, 1944.[10]

Strandlund had been intrigued by the Porcelain Products architectural panels when he joined Chicago Vit. They were fabricated mostly in a two-foot by two-foot square panel that could be used as a veneer over brick, wood, or concrete block buildings to improve the appearance of the structure. These were hung on the building and offered no structural support of their own. Work on the porcelain enamel production had ended as the war began and Chicago Vit had turned to the production of armor plate in its place.

Strandlund began to realize that his idea of unit assembly could be applied to the manufacture of buildings and houses and that these could be made of porcelain enamel steel panels. He voiced his ideas before the industry in 1945 in a speech to the Eastern Enamelers Club in Philadelphia. He sharply assailed builders and the manufacturers of prefabricated buildings for their unimaginative approach to the problem of design and fabrication of houses. He pointed out that all of them were still using the antiquated technique of building homes "nail by nail, piece by piece, brick by brick." Those who had tried to develop prefabricated metal homes had gone only so far as to plan them to be erected with steel studs "so designed that you can nail into them—again showing that they like to lean on the present art of the carpenter, and drift so far away from prefabricating that again this program is defeated."

The thinking of prefabricated housing manufacturers, according to Strandlund, was "that [these] houses must of necessity be very cheap—so cheap that they have defeated a real conversion to desirable steel homes, the general result being Quonset huts, implement sheds and

emergency shelters. I cannot find," he concluded, "a single one with a determination and an idea that they are going to design or build something finer in quality than our present homes."[11]

This speech was reprinted in *Better Enameling* magazine, the trade journal produced by Chicago Vit, in its January 1946 issue. Strandlund mentioned that as many as 3,500,000 new homes were needed and that only 460,000 could be built with all the available carpenters. He mentioned one shortcoming of the porcelain panels that needed to be resolved. In the past, they had been used to dress up a building, but for them to be used as the actual structural wall of a house or building, a weather tight permanent packing was needed.

Strandlund told of a visit by Secretary of Commerce Henry A. Wallace and John Blanford of the National Housing Administration who had been shown "a colored portrayal of a porcelain enameled bungalow" which could be prefabricated from the porcelain-enameled steel panels. "They became immensely enthused and interested from the standpoint of quality," he stated.

He had told the Eastern Enameler's Club that "There is no reason in the world why we cannot use these panels directly on studs to form an integral part of a wall. With its noncorrosive feature, high reluctance, its ability to withstand the elements, and its beauty of color—porcelain enamel is a 'natural.'" Steel, he went on, "lends itself to beautiful shapes. [Let's] take the beauty and color and permanence of porcelain and mold the two together. Let's produce something far more distinctive than we have done in the past—something that will outclass in convenience and beauty the present plodding wood constructed homes. I am sure that prefabricated porcelain coated metal homes will become a reality in a very short time."

This was not an attempt by Chicago Vit to enter the housing market, but to become part of a new industry as a "frit manufacturer," referring to the ceramic material used to make the porcelain. They wanted an additional outlet for their enameled panels without the risk of entering an entirely new business.

Strandlund modified the existing panel design by providing edges based on a slots-and-tabs pattern and applied for a patent on September 9, 1945. This critical and essential design change was granted to Carl Strandlund as Patent #2,416,240 on February 18, 1947, but assigned to Chicago Vitreous Enamel Products Company.

The patent only referred to the invention of an architectural porcelain-enamel-coated panel. To quote from the application itself, the patent disclosed a "novel and improved construction and an arrangement of interlocking and sealing adjacent enamel panels, units or adjoining parts of the exterior or interior walls of a building or structure of any type or design."

The novelty of Strandlund's invention lay in the method in which the panels interlocked. One edge was shaped somewhat like a "5," with the matching edge more like a "7." The straight edge of the latter was designed to fit into the open slot of the former with the metal-to-metal contact restricted by a plastic gasket material.

Rather than being attached to the frame of the building with metal clips, the panels were interconnected by means of these special flanges on their outer edges, thus forming continuous walls of porcelain-enameled steel. The whole assembly could then be fastened by bolts or screws to metal studs. The fact that the panels were connected to each other meant that there was less of a problem with expansion of the joints and this, in turn, reduced the

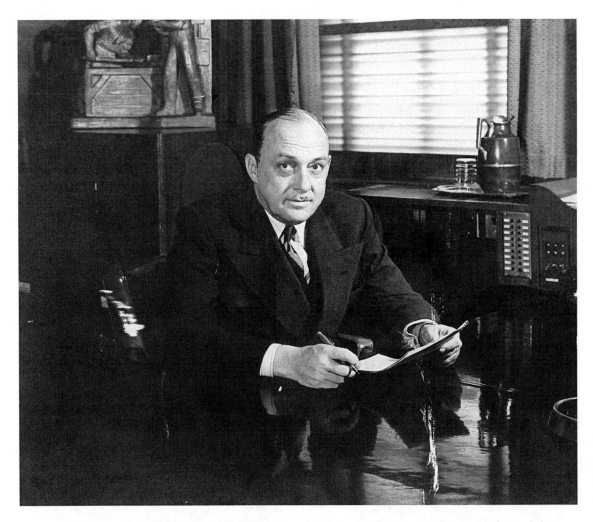

Carl Strandlund basks in the glow of success as the Lustron Corporation begins to place exhibit homes in the major U.S. cities. This photograph, taken circa fall 1948, found Strandlund at the peak of his career. (Collection of Ron Sandborg.)

need for expensive and less efficient caulking. Strandlund emphasized in his patent application that his method provided the "means for permanently sealing" the joints "so that expansion or contraction will not break or disrupt the seal."

Another advantage of this mode of construction was that the seals themselves would, according to Strandlund, provide an insulating effect by means of the interlocking assembly that would make possible tighter seals between the panels. Strandlund pointed out that "a further

object of the invention" was to provide a means of assembly that "will not require the services of a skilled artisan to install."

Strandlund had originally planned on using the panels as architectural trim for existing buildings. The panels would be screwed to strips of wood, which would then be mounted on the façade of the building. At lunch with an old friend, Carl Rolen of Canton, Ohio, in Chicago just after the war had ended, Strandlund described how the company planned to resume building enameled service stations

for Standard Oil of Indiana. Rolen, not one to hide his lamp under a bushel, suggested that Strandlund should consider steel nailing strips developed by his Macomber Steel Company in Canton. Strandlund, although interested, told Rolen that the panels would not hold up to a blow from a hammer.[12]

After some thought, Rolen suggested that a sheet metal screw in the nailing slot might work, and Strandlund asked him to send a sample to the Chicago Vit plant.

The next day in Canton, Rolen took a box of assorted sheet metal screws to his office. There he found that the screws would cut their own threads in the nailing slot and actually hold better than nails or a screw in a wooden strip.

When Strandlund and Chicago Vit saw the strip, they sent a design for the service station to Rolen and asked Macomber Steel to fabricate and erect a station in Chicago. Macomber first put the station up in the Macomber Steel plant yard and used some of the panels that Strandlund had sent to them. Chicago Vit then dismantled the whole of its paneled service station and shipped it to Chicago, where it was erected by the Macomber Steel crew.

In the end, however, Chicago Vit decided not to proceed with the collaboration with Macomber because of possible unfavorable public opinion over this use of steel which remained under war-assets control.

After V-J Day signaled the end of World War II, orders began to come into Chicago Vit from companies that wanted to aggressively re-enter the commercial marketplace with an impact that the Lustron panels could provide. Standard Oil of Indiana wanted to put up 500 new gas stations, and the Kraft Cheese Company visualized erecting some 52 cheese outlets to sell their product. By the end of 1945, Strandlund had lined up some $20 mil-lion worth of new business, but the company could not obtain steel in sufficient quantities to meet the orders since this material was still subject to wartime allocations.

The government in Washington had effectively prohibited construction of any such commercial or industrial buildings since *all* structural work, outside of essential construction, was prohibited. All efforts were to be directed to providing homes for veterans. From today's point of view this restriction may seem extreme, but in late 1945 the government was facing the return of thousands of young men who had married shortly before leaving or were to marry quickly upon their return, all of whom were looking forward to a house of their own for their families.

Strandlund set out to seek permission from the federal government to obtain the steel necessary to allow his company to manufacture the all-steel commercial buildings. His argument was that these structures did not use conventional building materials and would not retard the veterans' housing program. In August 1946, he traveled to Washington to meet with officials of the Civilian Production Agency (CPA), the body that was handling the conversion of industry from wartime to civilian production. They pointed out that such things as gas stations and commercial buildings were not on the list of critical needs for steel as set forth by Wilson Wyatt, who had been appointed by President Truman in January of 1946 to be the Housing Expediter, and as such was the head of the National Housing Administration (NHA).

When Strandlund told the CPA officials that his company's porcelain enameled steel panels could also be used to create houses, which *did* rank as a critical need, the CPA encouraged him to visit the NHA itself. He lost no time in getting an appointment there.

He met first with the staff of the engineering division and then with members of the NHA's materials and equipment division on August 10. Strandlund was shown into Harold Denton's office at the National Housing Administration with his architectural renderings of the Lustron house in hand.

Harold Denton was to become an important member of the Lustron development and, to understand his motivation, his background is of more than casual interest. Denton had completed his undergraduate work in economics at Kansas University and then moved on to study law at Yale. While in law school, he took a senior seminar and selected the newly created Tennessee Valley Authority (TVA) as his subject. His research in the fall of 1933 got him thoroughly involved with the idea of the new agency as a promising concept in broad regional planning. On his Easter break, in the spring of 1934, Denton went to Washington, where he called the TVA office and arranged for an appointment with TVA chairman Arthur Morgan.

Morgan had apparently already heard of Denton's interest in the TVA agency and offered him a job on the spot as his special assistant. Denton accepted with little hesitation and returned to New Haven to finish law school. He then returned to Washington to work for Morgan.

Denton was sent to the Knoxville, Tennessee, TVA headquarters to study the feasibility of individuals building houses with their own labor. His duties brought him to the great Norris Dam TVA project east of Knoxville where he witnessed the building of a permanent town at the site (Norris, Tennessee). Denton recalls seeing metal houses in Norris at this time which were erected by the Tennessee Coal & Iron Company (TC&I) of Birmingham, Alabama. Gov-

ernment documents claim that Norris was an early experiment in the establishment of a national housing policy, but Denton recalls no such policy initiative.

Denton's first project at the TVA was to determine the number of man-hours involved in building one's own house. Two years of study led him to the conclusion that when all costs, including community services, were taken into consideration, it would take the average worker half a lifetime to produce a house. These facts certainly contradicted Thoreau's famous cost analysis of his cabin in Walden, and they led Denton to a lifelong commitment to increasing productivity in the commercial housing industry. They were to eventually lead him to his work for the highly mechanized Lustron housing operation.

In 1936, Denton went back to Washington and worked in various capacities for the Department of Labor. He had arrived at the same conclusion as prefabricated advocate Albert Farwell Bemis that, while production of other goods had been modernized, "the house is almost outside the influence of modern mass production methods." Denton continued his work on housing as a market analyst for the Home Loan Bank Board in the late 1930s and collaborated on an important study of housing conditions in 1941 for the Temporary National Economic Committee.

Denton then directed his concerns to the global conflict just beginning. In his "Investigation of Concentration of Economic Power," he argued that the federal government should provide funds to effect "reductions in [housing] costs resulting from increased efficiency through technological development."

During a personal interview, Denton referred to himself as a housing "crusader" and it is clear that he became a housing reformer concerned with the improvement

of productivity through the industrial production of prefabricated houses. During the interview, Denton presented a consumer bulletin printed in 1944 by the National Housing Administration as a solid and helpful study. The concluding remarks of that World War II booklet are prophetic in relation to Denton's own career. "The residential building industry offers great potentialities as an active post-war industry if the large pent-up demand for new houses can be effectively tapped by lower costs. The modernization of the building industry to permit more efficient operation is a challenge to the industry, and should be taken aggressively by it."

So it was not an unprepared young man who greeted Strandlund that August afternoon, but one of the most knowledgeable housing experts in the country. He listened carefully as Strandlund proposed to produce a steel-frame house covered with porcelain enamel on both the exterior and interior walls. The roof was also to be covered with porcelain-enamel shingles.

Strandlund, of course, was enthusiastic. After Denton excused himself to leave the office for a meeting in nearby Baltimore, he returned several hours later to find Strandlund still holding forth about the practicability of the porcelain-enamel house and showing the renderings to his staff members.

The NHA engineers found the Lustron designs to be "extremely attractive" and expressed enthusiasm for the idea of utilizing steel to meet the anticipated postwar housing crunch. Especially appealing were the production methods Strandlund outlined in his report: "The rapidity and efficiency with which the basic material can be rolled, formed, welded, shaped and finished lends itself to mass production," it noted. Furthermore, they were impressed with the "experienced organization" that Strandlund appeared to have supporting him. Of additional interest was Strandlund's indication that Chicago Vit was also positioned to manufacture "package bathrooms" which would include all necessary fixtures.

Denton was easily swayed by Strandlund's enthusiasm there in the office as it mirrored his own thoughts. Both men knew that the time was right for a well-designed industrial house, as thousands of returning veterans would provide a robust market and, in addition, general consumer demands set aside by the war promised a booming economy. Denton invited Strandlund to return for further talks.

A month later he did return, late in September, and met with Wilson Wyatt in his office. Wyatt pressed him on whether Chicago Vit could make houses with Lustron panels. As Strandlund pulled the sketches from his briefcase, he could barely suppress a grin.

4

The Hinsdale "Esquire" Model

When Strandlund reached Chicago the next morning on the Baltimore & Ohio's "Capitol Limited," he still had his head in the clouds as a result of the presentation in Denton's office. He left Grand Central Station near the post office and caught a cab back to Chicago Vit in Cicero. With no time to waste, he made plans to begin the design of the house as soon as possible. A few days later, he and seven other men sat down in a small garage on South Kimball Avenue near the Chicago Vit plant and planned, designed and created the first Lustron house based on the existing tooling that the company had retained from before the war. This house, the "Esquire," was designed by Roy Blass and M. H. Beckman (Blass and Beckman) of Wilmette, Illinois, on the North Shore.

Roy Blass landed the job. Blass had done some work for Chicago Vit on the remodeling of several Chicago area movie theaters with porcelain-enamel components and had met Carl Strandlund on these projects. Beckman drew up the plans for the Lustron prototype, and the structural drawings and panel drawings for the model.

Beckman had never worked with porcelain-enamel components before and never did afterwards once this Lustron project had been completed. He remembered that Strandlund saw the house as a durable variation of an established housing type—the bungalow—and erected the model in order to get government help in the production of sorely needed commercial housing by securing scarce stocks of steel for Chicago Vit. The two architects were merely designing a streamlined metal house using existing components.

With the design in hand, Strandlund turned again to Carl Rolen and Macomber Steel in Canton, Ohio, to design and frame out the house following the Blass and Beckman design. He took the train to Canton to help with the designwork. Then the framework was shipped to the nursery in South Hinsdale.

Chicago Vit's engineers had not been idle in the meantime. They had applied themselves to finding a gasket material that was the last link in the construction. After a large number of tests, they settled on polyvinyl chloride which formed a "specially developed resilient" plastic gasket that was watertight, weather-tight, long-lasting, termite-proof, and fireproof. This same type of material is used commercially today in bottle cap gaskets for babyfood, pickles, jelly and other food products.

The "Esquire" was assembled at 7210 South Madison Street in unincorporated Hinsdale on the grounds of the Hinsdale Nursery, a large commercial supplier of trees, shrubs and plants for private and commercial use. They had a large formal garden near the entrance, and the Lustron unit was built in the middle of it. The house featured porcelain-enameled steel

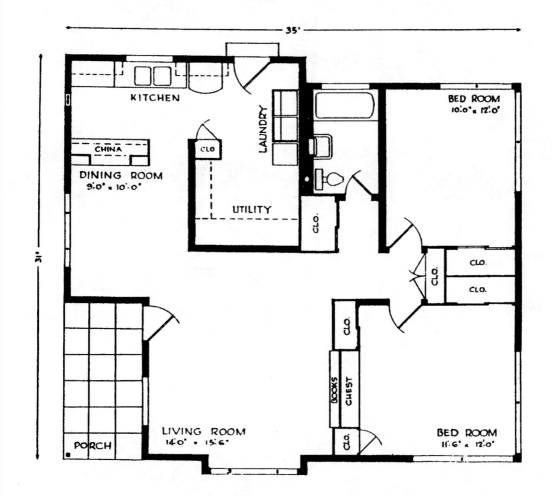

FLOOR PLAN OF
LUSTRON MODEL HOUSE

Manufactured By

LUSTRON CORPORATION
CICERO 50, ILLINOIS

Promotional brochure of Lustron model house distributed at Hinsdale. The offset in the rear was eliminated in subsequent models. Architect Morris Beckman picked up several copies of the brochure at the opening, where he was just "a face in the crowd." (Collection of Mr. Morris Beckman.)

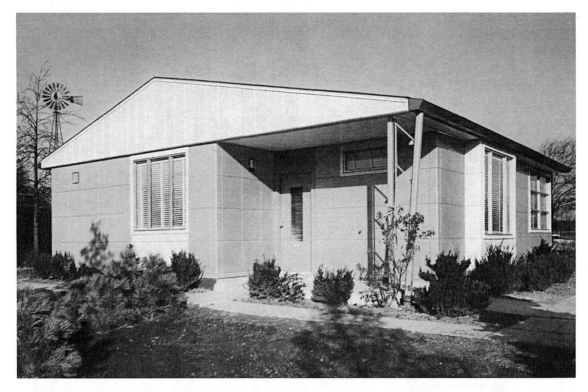

Lustron's "Esquire"model. (Courtesy Vince Trunda.)

on the outside including the walls, roof, gutters and downspouts, although the window casements were aluminum. Some of the interior walls and the ceilings were made of porcelain-coated steel, but wood and plywood were used to construct several interior partitions and then painted to replicate what eventually was also planned to be porcelain-enameled steel in the production house. The formal garden was selected to show off the house to its best advantage.

The house measured 31 by 35 feet and contained a living room, a dinette with a built-in china cabinet forming the room divider, kitchen, master bedroom, guest or children's bedroom, bathroom and a utility room. Altogether, it comprised approximately 990 square feet of floor space. So, following the Blass and Beckman design, the parts that had originally been designed for service stations

and hamburger stands came together in a new assembly to form a small two-bedroom ranch house.

Blass and Beckman's design for the two-bedroom house was built with a few minor changes in construction. The front door, which was originally to face the street in the broad front elevation was moved to the sidewall of the front porch. The two-foot offset in the rear wall of the original plan was built, but was eliminated in subsequent models, making the "Westchester" and other models a rectangular form. In the model at Hinsdale, the closet located at the front entrance was eliminated, and a built-in china cabinet was moved eight feet toward the rear of the house to divide the dining room from the kitchen.

A promotional brochure was given to the visitors to the Hinsdale house that contained the floor plan of the model as

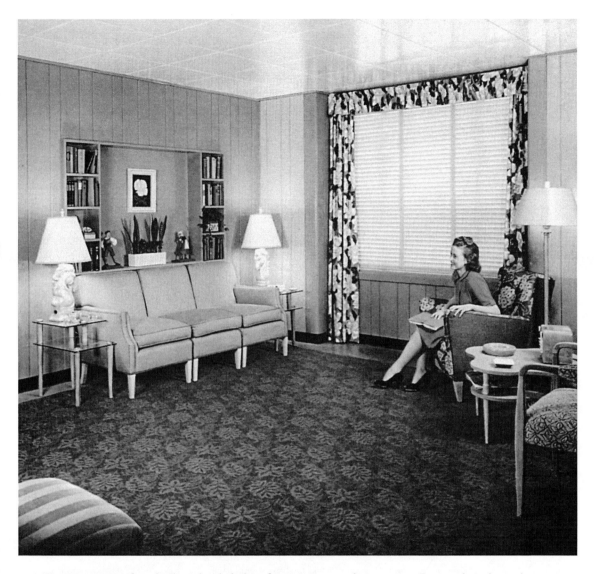

"Big picture window, built-in bookshelves feature spacious living room. Basic colors through-out the house hormonize with your own decorating 'scheme.' You get the beauty of porcelain combined with the strength and permanence of steel." Caption from Lustron brochure. (Courtesy Vince Trunda.)

built. The house was designed to be built on a concrete slab, had unitized structural steel support members that formed the wall sections, steel trusses supporting the roof, 1½ inches of fiberglass insulation behind the exterior wall panels, and four inches of the same material above the false ceiling over the ceiling panels. Radiant heat was supplied to the structure through the ceiling panels from a Williams Oil-O-Matic furnace, although coal or natural gas furnaces could be installed depending on the owner's preference and local availability.

The Thiedel family that owned Hinsdale Nursery included young 21-year-old Elmer, a returned war veteran soon to be married to Jeanette McCollum of

Close-up of Structural Details

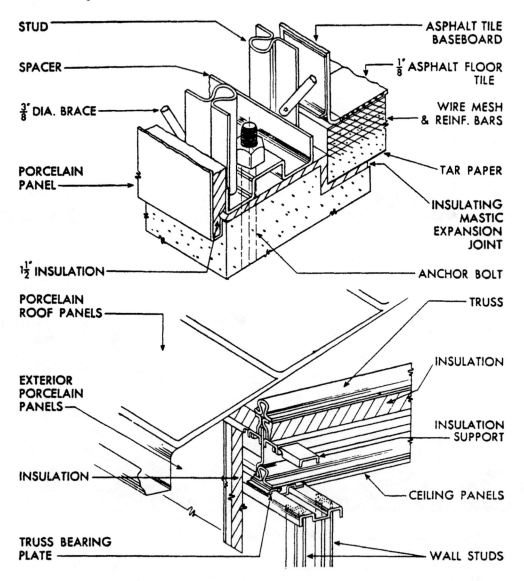

STUD

SPACER

$\frac{3}{8}$" DIA. BRACE

PORCELAIN PANEL

$1\frac{1}{2}$" INSULATION

ASPHALT TILE BASEBOARD

$\frac{1}{8}$" ASPHALT FLOOR TILE

WIRE MESH & REINF. BARS

TAR PAPER

INSULATING MASTIC EXPANSION JOINT

ANCHOR BOLT

PORCELAIN ROOF PANELS

EXTERIOR PORCELAIN PANELS

INSULATION

TRUSS BEARING PLATE

TRUSS

INSULATION

INSULATION SUPPORT

CEILING PANELS

WALL STUDS

Part of a Lustron promotional brochure distributed at dealer-built model houses. (Collection of Mr. R. Harold Denton.)

nearby Downers Grove. Strandlund had the young engaged couple pose for publicity photos and agreed to sell them the Esquire prototype model after about six months of public promotion as a demonstrator unit. Elmer and Jeanette appear in all of the early interior photos for newspaper advertisements and in the Lustron brochures.

So it was on September 11, 1946, after he had shown Wyatt the renderings of the Lustron house in Wyatt's office in Wash-

ington, that Strandlund requested the housing expediter to help him obtain a government loan, allocate the Dodge-Chrysler automobile plant in Chicago for Lustron's manufacturing plant, and release a substantial supply of the critical steel. Wyatt demurred, as he needed something more than a few pretty pictures to sway his resolution.

For the second time, Strandlund had scored. Taking another deep drag on his stogie, he walked back to his chair, sat down and looked Wyatt in the eyes. He then asked if Wyatt would like to fly to Chicago to see one of the Lustron houses.

Wyatt slightly choked as his mind raced. How could the company so quickly have assembled a house, he wondered. "Yes," he replied, "I would like to see it!"

In October, Strandlund completed the arrangements for Wyatt's flight to Midway on Chicago's southwest side. He picked Wyatt up in a limousine, and they drove west on 55th Street to Archer and out to Route 83 before turning north to Hinsdale. There they drove into the nursery and Wyatt saw the new Lustron house built by Chicago Vit as an example of what mass production could provide the returning veteran.

When Wyatt was driven up to the house, situated among the trees and late blooming mums, he was "very impressed" with Lustron's plans to manufacture the enameled-steel dwelling. He called it a "sensationally good" idea.

Strandlund assured him that with a government loan of $52 million, the surplus war plant to convert into a factory for production of the house, and an allotment of steel, he could produce 400 houses a day and would produce 30,000 houses in 1947. Wyatt's mouth must have dropped at this announcement. Here was the answer to his problem, wrapped up neatly and the proof stood before him there in

the midst of a beautiful garden set in the western prairie beyond Chicago. (Is it any wonder that he fell hard for the presentation, since it was custom-designed to sell him exclusively on the whole concept?)

Wyatt hoped to see 2,700,000 homes built by the end of 1947. Part of his program hinged on the provision of loans from the Reconstruction Finance Corporation (RFC), a federal agency, to the fledgling manufacturers of factory-made houses, such as Lustron. The only factor holding up the production of housing in the volume which Wyatt anticipated was the critical shortage of materials, including steel, caused by a series of crippling strikes that had occurred in the steel, railroad, and coal industries between the end of the war and the beginning of 1947. Faced with increasing pressure from veterans who were desperate for housing, Wyatt had ordered the earlier ban on most "non-essential" construction, which included schools, hospitals and factories, so that the scarce building material could be diverted into home building. Wyatt was particularly anxious to have steel and aluminum made available to the prefabrication industry. This industry held the most promise, in his opinion, of expeditiously resolving the housing crisis and attaining the goal of nearly three million homes within two years.

For Chicago Vit, Lustron and Carl Strandlund, things were off to a good start. A porcelain-enameled house designed by an architect unfamiliar with the building material and conceived by an engineer who had virtually no background in the housing business looked extraordinarily practical to Wyatt.

Strandlund was not one to drop a ball in play. On November 22, 1946, using the stationery of the Lustron Corporation, Better Homes Division, Strandlund wrote to Senator Ferguson of the Senate National Defense Investigating Committee

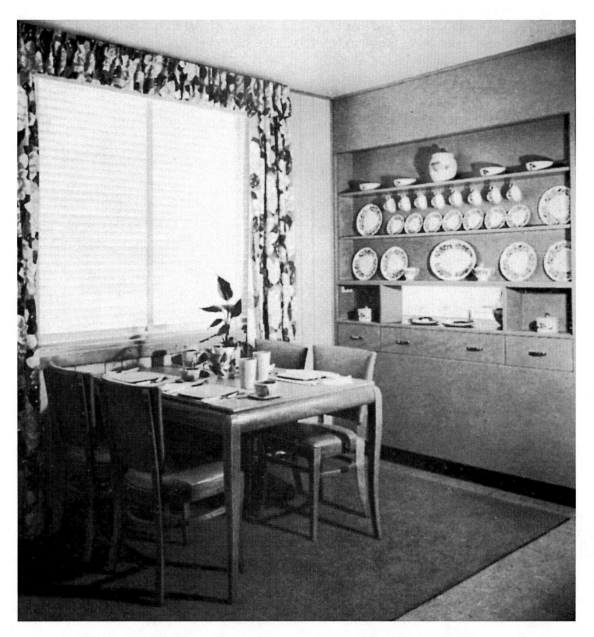

"Built-in cabinet in dining space gives display for your best china, ample linen storage, and 'passthrough' counter space from kitchen. Drawers for silver are under the counter." Caption from Lustron brochure. (Courtesy Vince Trunda.)

to invite him to come and see the house erected in Hinsdale. He mentioned that it had been visited by National Commander Starr of the VFW, Mr. Marcos of the American Legion National Housing Committee, and Mr. Roy Sawyer, Chairman of the Amvet National Housing Committee.

He was able to give the following breakdown of the charges to develop the program since the Senate had questioned the $52 million loan request to the RFC.

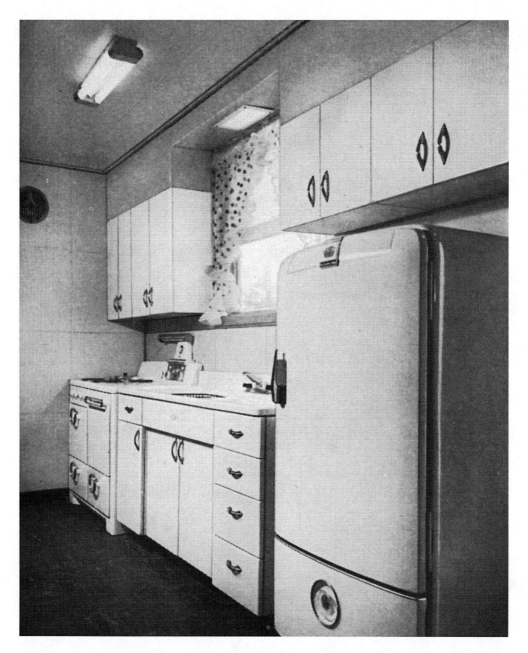

"New dishwasher-clotheswasher, kitchen cabinets, exhaust fan, lighting fixtures are among features included. Stove and refrigerator are not included, but standard makes fit floor space." Caption from a Lustron brochure. (Courtesy Vince Trunda.)

1. Engineering of materials for mass production:
 400 men for seven months $ 1.5 million
2. Engineering of equipment, fixtures and dies $ 2.0 million
3. Pilot production units: 200 houses built at loss of $8,000 each $ 1.6 million
4. Organization of the plant: 1500 men for seven months; 500 officers $ 4.8 million
5. Machinery and equipment $22.0 million
6. Working capital $20.0 million

"Automatic water heater and fully automatic heating unit are included with home. Note location of furnace at ceiling of utility room for greater usable floor area ... ideal home workshop." Caption from Lustron brochure. (Courtesy Vince Trunda.)

all the Lustron features, although some of the interior features of their home had been simulated in wood to duplicate the later metal production units. Some of these differences can be seen in the photos: for example, the living room bookcase is atypical.

The June 1947 issue of *Architectural Forum* featured a cover photograph and feature story on the new Lustron house in Hinsdale. It also contained a review of Paul and Percival Goodman's "Communitas: Means of Livelihood and Ways of Life." This treatise on urban planning and the goals of modern life presented the concept of neofunctional critique. The Goodmans proposed to judge the uses and forms of modern technology in a broad and comprehensive fashion. "We ... propose a different line of interpretation altogether: form follows function, but let us subject the function itself to formal critique. Is the function good? Bona fide? Is it worthwhile?"

Strandlund also mentioned that Chicago Vitreous Enamel had already spent over $500,000 in a year and a half of development and $200,000 in pilot dies and tools. This would set Chicago Vit's interest in developing a house back to August of 1945, well before Strandlund made his trip to Washington to obtain an allocation of steel. All in all, this was probably window dressing on Strandlund's part and not entirely factual.

The Esquire was opened for public inspection on November 20, 1946. Elmer and Jeanette did marry, and they became the first veteran couple to enjoy

Thus, the very issue of the *Forum*, which introduced the new Lustron metal house to its readers, also presented a creative new idea with which to consider the notion of living in a house which was made entirely of cold rolled steel with a baked enamel surface. Didn't the exterior and interior lack character and associative value? As if in answer, the Goodmans wrote that "An [ancient] Athenian's house was very simple; it was not an asylum for his personality." Rejecting the overly ornate Victorian house of the past, the

Goodmans opted for simplicity and pointed specifically to a dwelling in Tokyo which was open, unadorned and uncluttered.

There can be little doubt that the unadorned Lustron with its straightforward design and space-saving efficiency would have earned the approval of the authors of "Communitas."

No doubt the space-saving, built-in furniture and the honest use of materials would have received favorable comments. Metal was used as metal in the Lustron and there was no attempt to disguise it as wood, brick or any other building material. The embossing of the interior wall panels was totally functional and gave them added strength.

The *Consumer Reports* for June of 1948 rated the new Lustron house against a prefabricated *Look* magazine house manufactured by Adirondack Homes from wood and conventional materials. They found the *Look* house poor by comparison. The comments about the Lustron are particularly interesting from the contemporary viewpoint; they are based on the Hinsdale Esquire model, since manufacturing at Columbus only began later that month.

"The Lustron house is made almost entirely of metal; the floors are asphalt ... and only the built-in shelving and cabinets are wood. The house is being manufactured by the Lustron Corporation of Columbus, Ohio, will be distributed nationally and is tentatively priced at about $8000."

"Second bedroom features privacy, ample wall space, and large double closet with sliding doors." Caption from Lustron brochure. (Courtesy Vince Trunda.)

"Steel construction makes expansion practically impossible." "Very well designed. About 1000 square feet. Living room serves as passage; dinette accommodates six; twin beds could be fitted in either bedroom. Washing machine comes with kitchen and there is space for ironing in utility room." "Sliding door closet 6 × 2 ft in each bedroom." "Choice of six pastel colors for interior. [This choice was for the kitchen and bathroom only, however.] Porcelain enamel finish, advertised as 'dull' is highly reflective. Can be cleaned with soap and water; chips can be retouched with paintbrush. May need repainting after 10 or 15 years. [The reviewer wasn't convinced that the porcelain color was permanent.] Plenty of electric outlets, wall switches, etc. Hardware

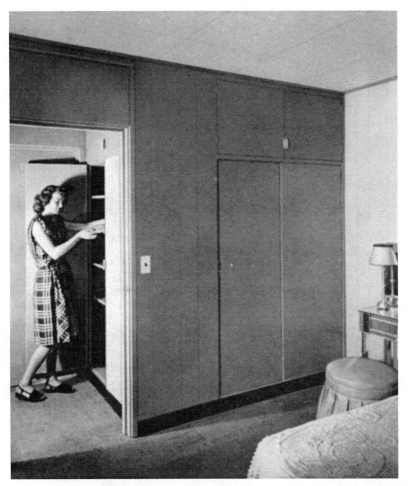

"Plenty of room for linens is supplied by hall linen closet. Note sliding doors on the big bedroom closet—all the floor space in the house is *living* space. Note also the overhead cabinets." Caption from Lustron brochure. (Courtesy Vince Trunda.)

cially in the bedrooms. It has a superior heating system, and the steel construction with its porcelain enamel finish needs little in the way of maintenance or repair. The house is rust-proof, and, insofar as any house containing furnishings can be, it is fireproof."

"The *Look* house costs $7,500; buying a lot and doing some grading, etc., would bring the cost up close to $10,000; the Lustron would cost even more. Getting a *Look* or Lustron house might mean going dangerously overboard unless the family income approximates at least $100 a week. According to 1946 Federal Reserve Board statistics, only 6 million families in the entire nation at that time had incomes of $5000 or more per year."

The last sentence is particularly revealing, as the Lustron house was pegged at twice or more the annual salary of the majority of the population.

superior to that in *Look* house. [Homeowners by 2000 found the Lustron barely adequate in electrical outlets, but the number of appliances and electronic entertainment devices has swelled since 1946.]

"Of the two, the Lustron house is the better buy. The materials and construction are excellent mechanically; the added floor space—it contains 1000 square feet as against 762 square feet for the *Look* house—makes for greater flexibility in furniture arrangement, espe-

The Esquire made its mark in the housing industry, but, in itself, was not seen as an entirely serious threat to the other prefab manufacturers, as there was no support structure organized behind it. That was to come.

A photo story illustrating all the features of the new house was printed in the December 1946 issue of *Better Enameling* magazine and portions of this story

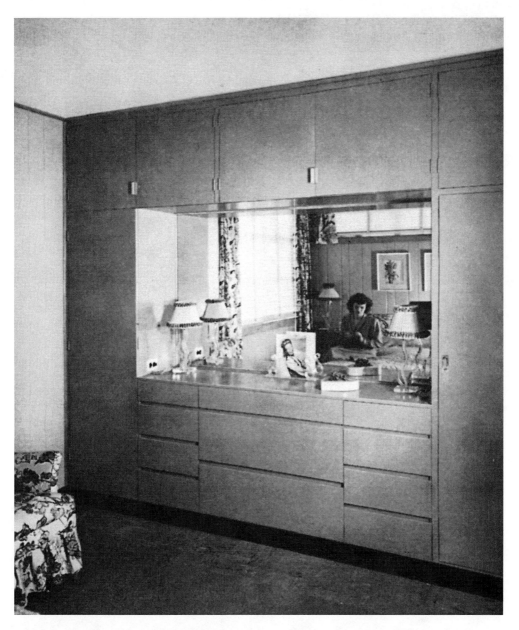

"Built-in dressing table in master bedroom comes complete with mirror. Drawers are built in below the table, closets on either side, cupboards above. You don't even need a chest of drawers." Caption from Lustron brochure. (Courtesy Vince Trunda.)

became the new sales brochure for the company.

Many years later, the Thiedels built a brick ranch-style house further back on the nursery property and moved out of the Lustron Esquire. However, they rented the unit to student nurses in training at Hinsdale Sanitarium Hospital for many years to follow. The front porch was enclosed in these later years and a porch addition of conventional material was built against the dining room wall. The roof

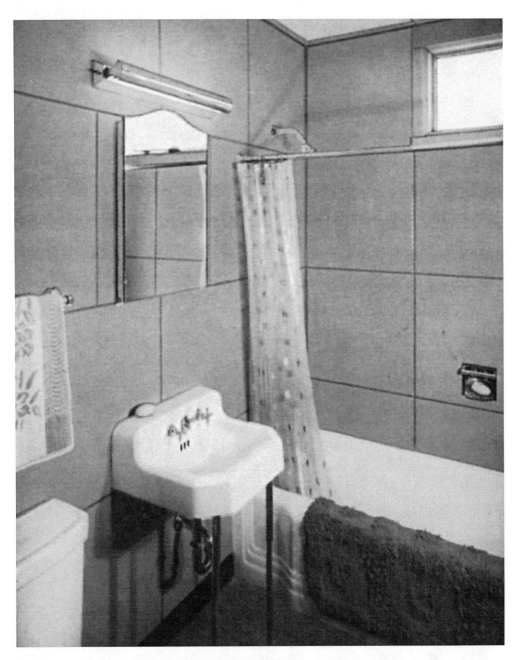

"Colorful bathroom comes complete with all fixtures. All hot and cold water plumbing pipes are copper." Caption from Lustron brochure. (Courtesy Vince Trunda.)

finally had to be replaced and a conventional asphalt shingle roof was used in place of the porcelain tiles.

The Esquire was finally demolished in 1989 after 43 years of service. This was a remarkable life span for a handmade prototype model that lacked many of the refinements of the production units that followed. At the end, though, its loss was mourned by very few.

Wyatt Takes the Ball

When Wilson Wyatt returned to his Washington office, he smiled and relaxed as he settled into his chair. Some of the weight of his assignment seemed to have been lifted by his Chicago trip. The little steel house sitting south of Hinsdale was remarkably convenient and seemed to be perfect for the veterans whom he was committed to helping. But time was still a premium and he sat forward to use the phone.

Wyatt put in a call to the War Assets Administration (WAA) and directed it to transfer the Dodge-Chrysler automobile plant in Chicago, which had been converted under government authority into an aircraft engine plant, into the hands of the Lustron Corporation. This was a $17 million plant covering 840 acres under one roof. But there was a glitch. The WAA had already agreed in September to a ten-year lease of the Dodge plant to Preston Tucker's Tucker Corporation and regarded its commitment "as a contract." When the WAA approached Tucker about releasing the plant, he held the WAA to its agreement, since his intention was to produce a 100 mile per hour, $1,000 hydraulic-drive car to be known as the "Torpedo."

Wyatt next wrote two letters to the Reconstruction Finance Corporation (RFC) on October 21 and 22 requesting "prompt and careful consideration" for his request that RFC provide some $54 million for prefabricated housing. This was not all for Lustron, although Wyatt

earmarked $32 million for them, as he also hoped to fund Andrew J. Higgins of New Orleans ($11 million), a company that had been mass-producing boats on an assembly basis; Clements Corporation of Southport, Connecticut ($3 million); Western Gypsum Company of Sigurd, Utah ($800,000); Laminated Wood Products Company of Chicago ($1,700,000); General Homes, Inc., of Columbus, Ohio ($2 million); Knox Corporation of Thomaston, Georgia ($1 million); General Panel Corporation of Los Angeles ($1,500,000); Crawford & Company of Baton Rouge, Louisiana ($850,000); Interlocking Walls Corporation of Los Angeles ($100,000); and Vacuum Concrete Company of Philadelphia ($500,000).

RFC chairman of the board Charles B. Henderson wrote on October 31: "As you know, the Lustron application provided that, in relation to total borrowings of $52 million, the owners of the business would contribute only $36,000 or 7/100 of one percent. Thus if the enterprise were unsuccessful, the profit to the owners would be enormous and out of all relationship to their investment or risk." He calculated that Lustron could get a return of $5 million on its $36,000 invested.

Then two days later, on November 2, 1946, the RFC officially turned down Wyatt's request for Lustron's $32 million since the "rejected companies, including Lustron, were not putting enough of their own capital into the financial plans."

Wyatt was "angered at the turndown" and began to make plans to serve a directive on the agency to compel its compliance.

The RFC was actually run by George R. Allen, the director, who considered the $52 million as a "bad business loan." It wasn't long before Wyatt and Allen took the matter as a personal challenge of authority and many of their arguments became public.

Wyatt called Strandlund and had him fly back to Washington to talk to Allen. The next day, Wyatt and Strandlund went to Allen's office at the RFC and presented the case to him personally. He listened impassively without smiling and, when the men had finished, asked one question: "Where are the assets?" There was no answer for there were none. Allen, known in Washington circles as the "White House Jester," was on firm ground in denying the loan and the two visitors in his office knew it. Allen then offered a ray of hope. He told Strandlund that if he could raise $3,600,000, he could have the loan.

Strandlund returned to Chicago that night, and the next day told Chicago Vit of the RFC's alternative. Although dismayed, the company decided to float a stock issue to raise capital. The company hired Hornblower & Weeks of Chicago to sell stock in the new Lustron Corporation, a Chicago Vit subsidiary, as soon as possible. They managed to sell $840,000 in nonvoting stock to 20 Midwesterners. Strandlund, himself, put up $1,000 of his own money to obtain all 86,000 shares of the voting stock. Although this was a far cry from matching Allen's demand, Strandlund returned to Washington by train with four handtrucks loaded with drawings of the house, applications for funding, a request for the surplus war plant on South Cicero Avenue that had been assigned to Tucker, and a request for allocations of building steel. He settled into a suite at the prestigious Mayflower Hotel in downtown Washington and used this as his "war-room" for obtaining the authority to proceed.

Meanwhile, Strandlund applied other means of pressure. A story appeared in *Better Enameling* that described the Hinsdale house, but which also raised the housing problem in the first paragraph: "For many months the Government and hundreds of other agencies have sought a solution to the national housing problem. The solution now appears to be the Lustron home—a factory pre-built, modernly designed, low cost, mass produced home for veterans—a development which offers the porcelain enamel industry the greatest opportunity it has ever had for expanding the use of its product. The National Housing Agency, under the direction of Wilson Wyatt, has acknowledged Lustron's conviction that, to produce a large number of low-cost homes, it is absolutely essential that mass production techniques and methods be applied in the manufacture of these homes, and that materials which lend themselves to mass production be used."[13]

Wyatt continued to pester the WAA about the Dodge Plant in Chicago and finally offered to find a way for Lustron and Tucker to share the huge factory. Strandlund agreed to consider joint occupancy of the plant with the Tucker Automobile Company, but Preston Tucker, the volatile president and inventor of the highly innovative car that bore his name, would not hear of the arrangement. (Some idea of Tucker's personality can be gained by viewing the movie *Tucker*.)

Wyatt went on record as favoring Lustron over Tucker because, in his words, "The relative importance to the American people of houses over automobiles is too obvious to bear comment." The housing expediter then issued a directive

on November 4 ordering the WAA to relinquish the plant to Lustron, citing authority given under the Veterans Emergency Housing Act of 1946. The WAA refused to bend to the pressure and Wyatt took his battle directly to President Truman.

Truman was a vigorous supporter of housing reform. His New Deal background, his familiarity with the problems faced by veterans of World War I, and his involvement with defense housing issues while serving in the Senate, all made him a supporter of new housing initiatives. The 11th point of his September 1945 Message of Reconversion asked Congress to pass a housing bill which would work toward the goal of providing decent housing for the families of America. Housing and employment legislation had followed. Housing expediter Wilson Wyatt had convinced the President to put a $10,000 price ceiling on new houses and to allocate half of the available construction materials for the housing industry. Housing was a high priority and Wyatt had become its most visible proponent. The government had even encouraged the housing industry by agreeing to buy any unsold housing units at cost from producers unable to dispose of them.

Truman was struggling with the dilemma of either continuing or abolishing the price controls on building materials and other commodities that had been imposed during World War II. Wyatt believed that such controls were vital to his dream of guaranteeing mass-produced, low-cost, housing for the returning hoards of veterans. However, early in November before Wyatt and Allen could meet with Truman, the President lifted the ceiling on the prices of building materials. The relative scarcity of these items caused them to skyrocket in price and thereby doomed Wyatt's program. It also meant that the makers of prefabricated houses could not

obtain much-needed materials—in the case of Lustron, this meant steel—at lower prices.

Wyatt and Allen walked into Truman's office at the White House with some trepidation. They both felt sure of their position, but they both knew the stories of Truman's wrath when provoked, and this was a provocative subject. Truman listened patiently to the two sides of the story told by Wyatt and then by Allen. He then decided that Allen was right to be cautious about the unsecured loan. On December 6, Truman got back to Wyatt and told him that as President, he could not support the liberal loan policy advocated by the housing expediter and that he had decided to side with the RFC in the matter of denying the Lustron loan.

Stunned with the rejection, Wyatt immediately resigned his post in a huff. Lustron lost its most effective voice in Washington that day.

The same day that Wyatt resigned, Strandlund issued a press release noting Wyatt's resignation and that "Preston Tucker would keep the Chicago Dodge plant." Strandlund continued that, "We know that mass production of quality-built homes patterned after automobile production line methods is the real and sincere approach to the solution of the desperate and tragic housing shortage for veterans and others. Whether we are permitted to utilize the Dodge plant, which is ideally suited for this vast undertaking, or whether we proceed in some smaller plant, we are going ahead and [will] mass-produce quality homes in the best plant we can obtain.... After thousands viewed the model home at Hinsdale, Illinois, public approval of the house has been so strong as to leave no doubt of its universal acceptance as permanent housing."

To allay the doubts about the loan he had been negotiating with the RFC, Strandlund said, "There have been many

misleading statements about the amount of equity that Lustron is itself investing in the enterprise. We have already spent almost a million dollars in development work, engineering, and pilot equipment. This is a cash outlay in pioneering this fine home for the GI and represents our good faith in the enterprise. We are not seeking a subsidy but a loan to be repaid with interest, resulting in a profit to the taxpayer. We are anxious to cooperate on any basis which will make possible the production of Lustron homes."

Wyatt continued to encourage Strandlund to seek government support for Lustron and suggested that a separate company, a subsidiary of Chicago Vitreous, formally apply for the loan. The company designated was Porcelain Products Company, which held the "Lustron" trademark. On January 17, 1947, Porcelain Products filed an application for a loan of $12.5 million with the RFC. The amount of the loan had been significantly scaled down from the original $52 million in order to improve the chances of obtaining it. The RFC called Strandlund to testify in "quite a lot of hearings," he later remembered, and engaged the consulting engineers Stone & Webster to investigate the Lustron technology and the engineering of the production line which was planned for mass-producing the houses. Strandlund was also told informally at that time that Congressional support would be required to influence the acceptance of the loan by the RFC.

A new housing expediter, Frank R. Creedon, took Wyatt's place and began to look for other ways to skin a cat. He worked with the WAA and was able to offer Strandlund his choice of two Curtiss-Wright war plants in Ohio at either Columbus or Cincinnati. Strandlund decided in favor of the Columbus plant and Lustron signed a lease for $428,000 a year. The first hurdle had been overcome.

The Curtiss-Wright plant was huge by any standard. It had been used to produce two significant warplanes during World War II: 7,500 of the navy's Helldivers, an SB2 C-1 divebomber used in the Pacific Theater to take the islands, and a smaller number of the navy scout bombers, the SOC-3 C-2. Lustron won the western half of the building while the eastern half went to North American Aviation. North American brought in management teams from its California operation that did not sit well with the Ohio workers. One California-based foreman told Al James, a Curtiss-Wright employee, that since they were from California, "they *knew* how to build airplanes, and North American was going to teach them the *right* way to build them!" North American Aviation, for its part, wanted the entire building and began agitation in Washington to force Lustron out.

George Allen, having never made a bad investment for the government, resigned a few weeks after Wyatt. Following this, on January 31, 1947, the RFC approved conditionally the $12,500,000 two-year loan at 4 percent, but added a number of provisions that Chicago Vit decided to study before accepting. (These concerned placing liability for the loan on the parent company.) It seems clear that Allen knew of the loan approval and decided to get out with his record untarnished.[14]

Strandlund raised his estimates of what could be produced at the Columbus factory. He predicted that it could produce 100 houses a day for $7,000 per house and that he could be producing these units in nine months.

Shortly after this, the Department of Commerce allocated 59,000 tons of steel to be used for housing. Although not specifically for Lustron, there was no doubt in anyone's mind where this steel would be going. The second hurdle had been overcome.

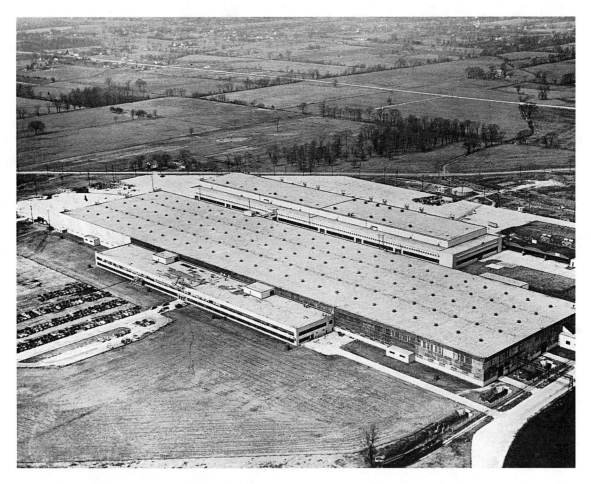

A view of the Lustron Corporation plant in Columbus, Ohio, looking to the north where the present Port Columbus Airport is today. Note the large "Lustron" sign over the center main entrance. (From the Clyde Foraker Files, Dan Foraker Collection.)

Nonetheless, the RFC loan was absolutely essential to Lustron's startup plans and the RFC seemed to be in no mood to change the loan provisions regarding Chicago Vit's liability, despite some inquiries along those lines by Lustron.

In May 1947, Carl Strandlund felt that he had done all that could be done, and he began to pack his bags in his suite at the Mayflower Hotel. As he picked up his pajamas to toss them into the suitcase, the phone began to ring. On the other end was Lewis E. Starr, national commander of the Veterans of Foreign Wars, who begged him to stay and see just one more man: Senator Ralph Flanders of Vermont. Strandlund hesitated, took a drag on his stogie, and Starr persisted. Then Strandlund agreed that he would stay. It was one of the best decisions he ever made.

Strandlund later recalled that he had "no friends or acquaintances in either house [of Congress], and it looked like quite a task to do such a Herculean job. But with the advice of some Veteran officials [*sic*] who knew some, and made appointments for me, I think one of the first Senators that I got an audience with was Senator Flanders, a Senator who

himself is an engineer, he said, and who told me to bring all my prints and all the details. He gave me a very constructive hearing."

The Congressional connection paid off. Flanders became one of Strandlund's most enthusiastic supporters, remarking, "If Lustron doesn't work, let us forever quit talking about the mass-produced house." The senator, a member of the Senate Banking Committee, supported the Lustron loan, and sponsored the Lustron inventor in making an appearance before a joint gathering of the Senate and House banking committees. He also assisted Strandlund in obtaining a substantial startup loan.

Strandlund was fired up and sent a telegram to Senator Homer Ferguson, chairman of the Senate National Defense Investigating Committee (and the man most likely to have used his considerable power to sink the Tucker Automobile Company),[15] extending an invitation to visit the prototype Lustron in Hinsdale. In the telegram, he responded to the committee's concern about the size of the loan request, specifically the preproduction cost estimates, by submitting a detailed breakdown of the expenses connected with preproduction, including engineering of equipment, design and manufacturing of 200 pilot units "at a loss of between 7 and 8 thousand dollars each," and plant organization. The total was estimated at $10 million. Strandlund noted that "Chicago Vitreous, the parent company, has spent over $500,000 in a year and a half in development on his house and $200,000 in pilot dies and tools." He concluded by urging the committee to visit Chicago to see the model house, then he added "... but if the committee desires, I will be happy to come to Washington to testify before it."

Meanwhile, the Stone & Webster report was issued to the RFC not too much later. It was quite favorable in its conclusion about the design of both the house and the manufacturing plan.

Things began to move rapidly now. The Emergency Housing Act was to expire at midnight on June 30, 1947. Congress acted to authorize the RFC to loan up to $50 million for prefabricated housing. On June 30, John D. Goodloe, the chairman of the board of the RFC, received a note from John R. Steelman, the presidential assistant. It said, "I have discussed this matter with the President and he has authorized me to state that the views here expressed meet with his approval." Not one to ignore a direct suggestion of this magnitude, the RFC passed a loan of $15,500,000 only 15 minutes before the midnight deadline!

There were several other players that had pushed this program to a head. Representative Frank Sundstrom of New Jersey certainly lent the new company his influence. When he lost his run for re-election, he turned up as a Lustron executive vice president in charge of sales for a salary of $25,000 a year. "Sunny" did not work out well in this position and Strandlund realized that as a partner in a New York brokerage house, "All he knew was how to call friends on the telephone!" He was later fired.

In August 1947, Carl Rolen of Canton, Ohio, was back in Chicago and met with Carl Strandlund and Merl Young "of the RFC who was introduced to me as a cousin of President Truman. Here I was offered the job as Sales manager. I was en route to Phoenix as a guest of Del Webb Construction to go lion hunting. At this meeting, I learned that Webb had ground at Tucson for 10,000 houses, at Phoenix for 2,000 and at San Diego for 10,000. I returned, took the job and gave notice to Macomber [Steel] at Canton. I took over as Sales manager of Lustron on November 17, 1947."

Merl Young had helped Strandlund get through some of the mire in Washington and his connection to both the RFC and to Truman helped. Young was married to a White House secretary who also provided some access to the inner circle. Strandlund hired Young from his $6,500 a year job and made him a Lustron "Representative" in Washington at $18,000 a year.

When Strandlund offered Harold Denton a position as director of marketing development, Denton leapt at the opportunity to join the new firm. Denton, as we shall see, really was sold on the new company's potential, and worked hard for it.

With the three hurdles overcome, Carl Strandlund returned to Chicago triumphant and ready to begin the development of the new Lustron Corporation. He was filled with anticipation and knew that the company would prove to be much more than even he had prophesied.

However, Chicago Vit viewed the provisions of the loan to Porcelain Products, which gave limited liability for the loan directly to Chicago Vit itself, as too risky. Porcelain Products became inactive at this point and Chicago Vit declined the loan, not wanting to accept any liability. This cleared the way for a totally new "Lustron Corporation" which Strandlund formally set up on October 31, 1947, to receive the government loan. As he stated in an interview in 1949, "I'm an endorser on all notes. If there is any failure in Lustron, you can meet Carl on the breadline."

On the same day, October 31, Strandlund resigned from Chicago Vitreous Enamel Products and at the same time purchased the "Lustron" trademark, the

machinery required to produce the pilot homes, and all interests that the company had in the Lustron house, using his substantial holding of Chicago Vit stock in a trade.

Chicago Vit, which had proudly offered the readers of *Better Enameling* magazine a "Picture Tour Through a Lustron House" in the December 1946 issue, had publicly withdrawn from the project by November 1947 when the magazine reported "Chicago Vit Sells House Interests."[16]

According to Harold Denton, who had resigned from the NHA after accepting Strandlund's offer, what actually happened was that the two Hogenson brothers, who with Strandlund owned the majority stock in Chicago Vit, refused to use their stock as collateral for the RFC loans. The loans were necessary for the expensive tooling up of the Curtiss-Wright aircraft plant in Columbus which Strandlund had finally obtained for Lustron production. It appears that although William Hogenson was bullish on the possibilities of porcelain enamel in his January 1947 *Better Enameling* article on the project, he was not willing to risk the ownership of Chicago Vit, which he shared with his brother and Strandlund, on the fortunes of the Lustron venture. The Hogensons were even more right than they had suspected.

Denton has also pointed out that while Strandlund put up $1,000 in cash for the 86,000 shares of voting stock, his purchase of the Lustron trademark, his patent for the panel design and the machinery from Chicago Vit were all purchased with his own Chicago Vit stock. The stock "was worth at least half a million dollars!"

The Dream Bears Fruit

Strandlund's new Lustron Corporation met its initial financial requirements in October 1947 and was capitalized at $16,340,000. The financing, which had been directed by Hornblower & Weeks, had raised $840,000 which was combined with the $15,500,000 RFC loan to get the new grand total. The RFC loan was conditionally for seven years at 4 percent interest and was convertible into common stock after four years at ten shares per every $100 of loan value.

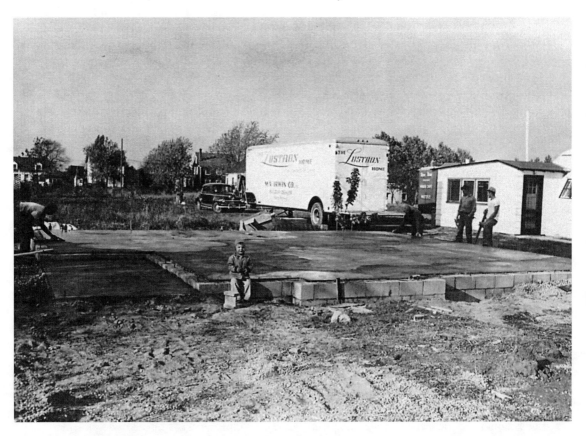

Fall 1948: Young Master Graves poses for his dad by sitting next to the wet concrete that is being smoothed by the M. V. Irwin Company crew of Erie, Pennsylvania. The family lived in the Quonset hut next door to the right, and the Lustron would really provide a change in their lifestyle. (Photograph by Richard Graves. Courtesy Dennis and Kim Teed.)

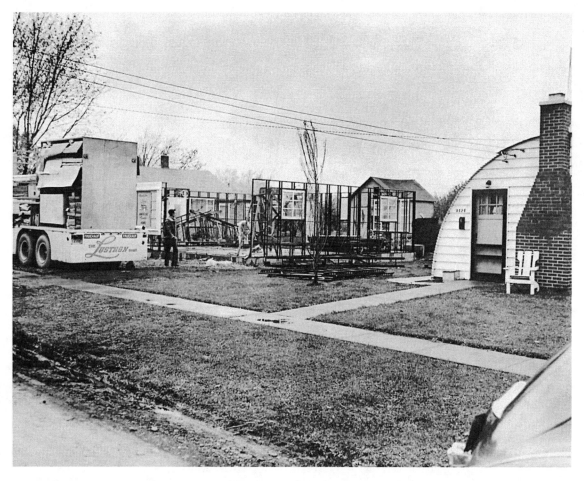

With the channels bolted down to the concrete, the side wall frames with the integral windows have been quickly installed. We see the bedroom end wall here with the Fruehauf trailer providing inventoried items as they are needed. (Photograph by Richard Graves. Courtesy Dennis and Kim Teed.)

At the organizational meeting on October 31, the company established a seven-member board of directors. It was composed of Joseph E. Nolen, a partner in Bell, Boyd & Marshall; Raymond Hurley, vice president of the Thor Corporation that was to provide the kitchen washer appliance; Louis Learone, president of the Automatic Canteen Company of America; Howard E. Buhse, a partner in Hornblower & Weeks; George Delp, president of the New Holland Machine Company; Paul O. Buckley, director of the Federal Machine & Welder Company

that provided many of the presses and electrical resistance welding units; and Raymond Hayes, a partner in the Wellington Company.

Two weeks later, Lustron completed negotiations with the craft unions and signed a two-year agreement with three American Federation of Labor (AFL) building trade unions: the Plumbers & Pipefitters Union signed by Martin Durkin; the Electrical Workers signed by Daniel Tracy; and the Carpenters & Joiners signed by the international president, Walter Hutcheson. They mutually agreed

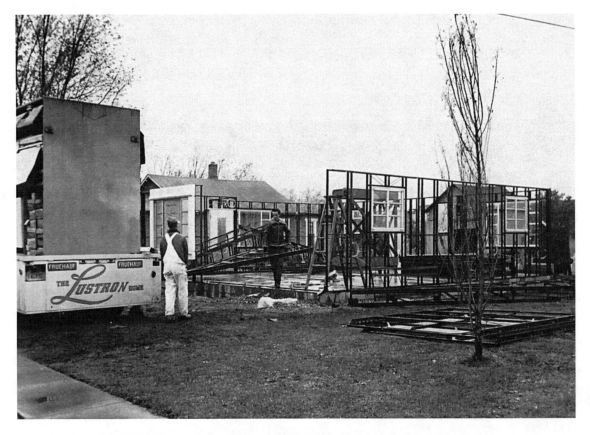

Two of the M. V. Irwin Company crew carry another roof truss over to the dining room area before the bedroom wall frame is installed. Note that none of the interior, nonload-bearing walls have been installed at this point. (Photograph by Richard Graves. Courtesy Dennis and Kim Teed.)

to uninterrupted production of the houses at the Columbus factory and the efficient erection of the houses at sites in the U.S. and Canada; to a reduction of the craft unions from the dozen or more that might have been involved to the three named; and finally to the international union officers enforcing the contracts with the involved locals if necessary. Strandlund had thus assured a steady relationship with only three crafts instead of the tangled web woven by having a dozen unions represented, and he had the additional assurance of the leaders that there would be no interruptions at either the factory or the housing sites. It was a well-thought-out contingency plan.

Early in December, a Senate banking subcommittee began to investigate the RFC loan and why it had been granted. John D. Goodloe, chairman of the RFC, testified that only $3 million of the $15,500,000 had been disbursed to Lustron as of December 11. Senator Homer E. Capehart of Indiana asked, "Where did pressure come from to make you grant the loan?" Goodloe replied that there had not been any pressure. But the subcommittee's chairman, C. Douglas Buck of Delaware, then told the committee of a letter from John Steelman urging the RFC to make the loan. Goodloe could only tell the senators that "I don't know whether the loan is going to pay out, but the Govern-

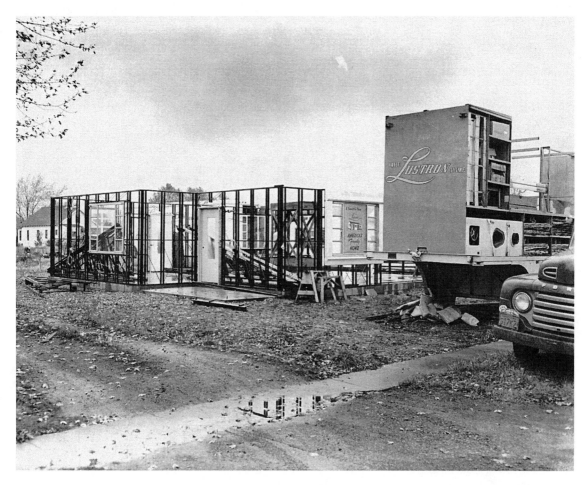

From the left we can see the dining room window, the kitchen door, the living room door, the rear bedroom window and the living room bay window. Not to miss a beat, the Irwin company has put a poster for America's Family Home in the front window. (Photograph by Richard Graves. Courtesy Dennis and Kim Teed.)

ment was justified in making it." He then pointed out that the loan had been made to a new Lustron Corporation after the old company (Lustron Corporation of Chicago Vit) had decided it did not want the loan under the RFC terms. This apparently satisfied the subcommittee's curiosity and the investigation was dropped.

A backlog of nearly 6,000 orders for Lustron Homes had been generated by mid–January by the energetic sales force of 30 people. Full production, about 3,700 houses a month, was to be realized,

according to the staff, at the end of 1948. Ultimately, retooling the former aircraft factory took 19 months and the company consumed six more loans from the RFC totaling $37.5 million.

The company developed a newsletter for communication to the Columbus employees as the new plant began to be organized. Vol. 1, No. 1, was released on January 23, 1948, as a single typewritten page concerned with local transportation, parking and cafeteria problems. "Newsletter" 5 on February 19 was written by Russell G. Davis, executive vice president, who

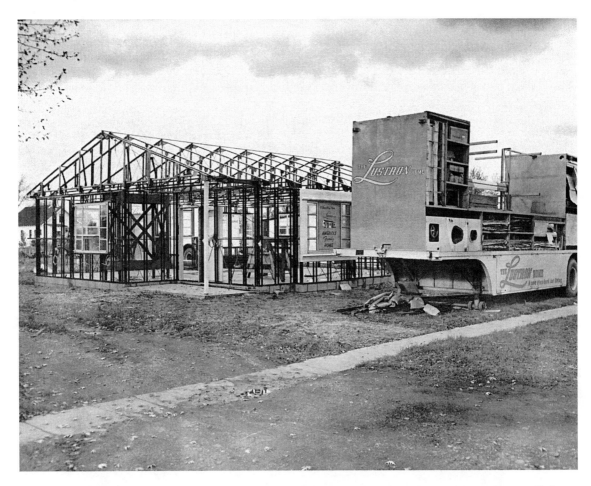

The roof trusses have been installed and tied together and the porch support has been installed at the front. A careful observation will reveal the supports for the upper and lower panels for the radiant heat ceiling. (Photograph by Richard Graves. Courtesy Dennis and Kim Teed.)

mentioned that "Lustron now has 336 employees, the great majority hired within the last six week period." Davis was confident that "we will produce 17,000 homes this year and more than 40,000 in 1949."

Beginning early in 1948, officials from the RFC began asking hard questions of Strandlund and the entire Lustron venture. From evidence given by Strandlund and officials of the RFC during a series of congressional hearings in 1950 and 1951 into the operations of the Reconstruction Finance Corporation, it seems that the RFC had second thoughts about the soundness of the loans and

began considering desperate and drastic steps to rectify the situation through the exertion of more managerial control over Lustron. Strandlund was suspicious of their motives.

"I was forced to the conclusion that a group of persons, including some of the officials of the RFC, were engaged in a deliberate conspiracy to acquire control of Lustron Housing Corporation for their personal gain," he disclosed later.

When RFC officials and Strandlund met at the latter's office in Chicago in the spring of 1948, he was requested to employ two men from the RFC, including Merl

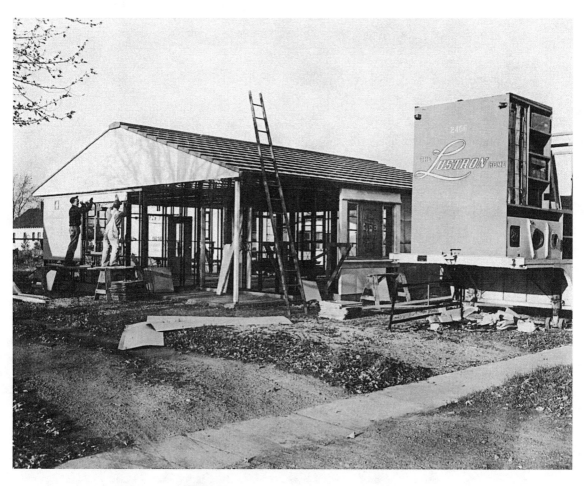

The roof tiles have been installed first and the end gables are already in place. Wall paneling has started at the kitchen and dining room wall and at the living room bay window, and is moving toward the bedroom. (Photograph by Richard Graves. Courtesy Dennis and Kim Teed.)

Young, who was then hired by Lustron as an assistant secretary (as we have seen). In the fall, the chairman of the RFC "suggested" that Young now be promoted to vice president and Strandlund was forced to accept the promotion. The following February (1949), Young requested that Lustron accept the appointment of Walter Dunham to the board of directors of the company, and Strandlund again acceded. Dunham expressed his full support for the management and the entire Lustron operation when he first met Strandlund, but this new wind was to blow ill for Lustron.

The "Newsletter" of March 6 reported that the company's new factory had been the object of interest of a number of real estate editors; they had been to the home builders convention in Chicago and routed their return through Columbus as they returned east. The *Army Times* had featured the Lustron in its veterans' edition and the sales office had seen letter inquiries double the following week. Bell Telephone was "exploring the possibilities of building several hundred Lustron Homes at a new plant in Summit, New Jersey." The big news, though, was that "Lustron's No. 1 home will go on display

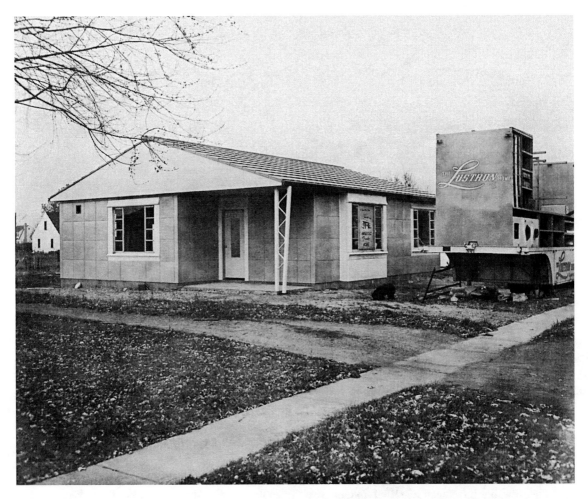

The exterior has been completed in less than a week. The interior lacks only a few details for the house to be ready for occupancy. (Photograph by Richard Graves. Courtesy Dennis and Kim Teed.)

in New York City next month in cooperative promotion with the Society of Illustrators. The home will be given away at the Artists and Models Ball, April 30, in the Waldorf-Astoria."

Carl Strandlund wrote the entire March 12 "Newsletter" (issue 8). He said: "Because our organization is growing so fast and so much work is being accomplished, I realize more and more that it is difficult to reach you all in person. That's why I welcome an occasional chance to speak to you through the Newsletter.... I have tried to stick to one sound rule. And

that is 'Everybody works for everybody else.' From that one rule I have witnessed the growth and prosperity of many corporations and other enterprises.... Our personal successes will come in direct ratio to the overall success of Lustron Corporation. I remember that every minute."

Richard Reedy, the traffic manager for the Curtiss-Wright plant, was only 28 when the war ended and the factory closed in late 1945. Filled with enthusiasm over the peacetime opportunities, he had started his own one-plane airline out of Columbus. Soon he was hauling every-

thing from machine parts to baby chicks as well as a number of overexuberant football fans who took a toll on his small plane. Often he carried drunken fans that the other Columbus airlines had turned away. The counter agent would flag him over, and he'd ask them where they wanted to go. Nonetheless, business was not that good and he found himself forced to sell the airline.

On the day of the sale, the unemployed Reedy drove by Lustron's reactivated Curtiss-Wright plant on 5th near the airport, and on a whim drove in and stopped to talk with Carl Strandlund. He walked out of the building as Lustron's new traffic manager. He recalled later, "I must have been something they liked."

In these early days at Columbus, Strandlund often had time to call in the younger management team and give them a pep talk that ranked with college football locker-room halftime rallies. Strandlund told them the company had great expectations for the future. It planned to soon be able to build a three-bedroom house with an attached garage (which did go on the market in late 1949), a four-bedroom house, and even apartments. It also planned to design and produce complete bathrooms for farmers for about $500 that would be sold through Sears, Roebuck & Company. While these were achievable extensions of the product line, the opportunity to complete the design and engineering was never found. Dick Reedy recalled, however, that the fellows went out of the meeting fired up and willing to put their whole effort into what they thought might become as big as General Motors someday.

Strandlund's first goal for the company in 1948 was to get 100 demonstration models fabricated and erected as quickly as possible. Some of the work was subcontracted out since the Columbus factory was still being set up with the new production equipment. However, with panels from Chicago Vit, and the help of other suppliers, they were able to prepare the units in much the same way that the original Esquire model had been assembled in Hinsdale.

The first house was shipped to Manhattan for the greatest exposure to the public. Lustron found that it had to use 250 reusable wooden crates (which cost $2,500) on three leased 35-foot trailers (which cost $500 each) to get the 30,000 parts weighing up to 35,000 pounds to the site. It even cost $500 each to lay out the crates from each trailer over three large lots to give the workmen, working with a cargo manifest, access to the parts as they needed them. The $4,500 in shipping charges was equal to the cost to manufacture the parts! When they finished, the crates were hauled back to Columbus on one truck for an additional $500. Reedy saw that this was a major problem and went to Strandlund to alert him. "Something has to be done to reduce the shipping costs."

"That's your job!" Strandlund replied with a twinkle in his eye.

A solution was not that apparent, and Reedy went to work at the back of the Columbus plant to solve the problem. He had an answer a month later.

Lustron erected this first model, a "Westchester" two-bedroom unit, on the northeast corner of 52nd Street and the Avenue of the Americas in Manhattan in New York City. The "Newsletter" for Friday, April 16, had the news that the New York City tours had begun on that Wednesday at noon with 1,500 people going through the house and a capacity crowd arriving on Thursday. A preview had been held on Tuesday night with New York, Connecticut and New Jersey government officials, and other honored guests, being the first to see the house which was furnished and decorated by

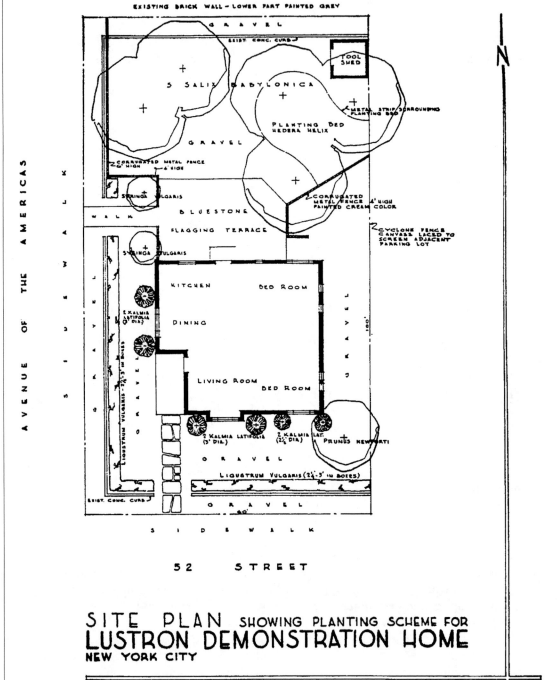

EXISTING BRICK WALL - LOWER PART PAINTED GREY

GRAVEL

EXIST. CONC. CURB.

TOOL SHED

5 SALIX BABYLONICA

PLANTING BED
HEDERA HELIX

METAL STRIP SURROUNDING
PLANTING BED

GRAVEL

2 CORRUGATED METAL FENCE
6' HIGH 4' HIGH

2 CORRUGATED
METAL FENCE 4' HIGH
PAINTED CREAM COLOR

SYRINGA VULGARIS

BLUESTONE

FLAGGING TERRACE

SIDEWALK

CYCLONE FENCE
CANVASS LACED TO
SCREEN ADJACENT
PARKING LOT

SYRINGA VULGARIS

KITCHEN BED ROOM

DINING

2 KALMIA
LATIFOLIA
(3' DIA.)

LIVING ROOM
BED ROOM

GRAVEL

GRAVEL

100'

2 KALMIA LATIFOLIA
(3' DIA.)

2 KALMIA LATIFOLIA

2 KALMIA LAT.
(2½' DIA.)

2 KALMIA LAT.

PRUNUS NEWPORTI

GRAVEL

LIGUSTRUM VULGARIS (2½-3' IN BOXES)

EXIST. CONC. CURB

GRAVEL
60'

SIDEWALK

52 STREET

AVENUE OF THE AMERICAS

SIDEWALK

N

SITE PLAN SHOWING PLANTING SCHEME FOR
LUSTRON DEMONSTRATION HOME
NEW YORK CITY

0 5 10 20

SCALE 1'=10'
DATE 3-26-48

LUSTRON

Mary Davies Gillies of *McCall's* magazine. Mrs. Emily Post said, "Intelligent planning has gone into this home."

The first festivities had begun earlier on Tuesday with a press conference at the Hotel Biltmore in which Carl Strandlund addressed the financial writers of the *Wall Street Journal, Journal of Commerce, New York Times* and the *Herald Tribune.* Syndicators like Acme, Wide World, Associated Press Features and NEA (Newspaper Enterprise Association) supplied some 500 papers with pictures and feature stories.

The *New York Times* wrote: "The two bedroom home is made on the principle of 'a place for everything and everything in its place.' The display home has been furnished by a staff of *McCall's* magazine in pleasing modern style for a total of under $2000 excluding the television set. Light woods and plaid fabrics are favored. In the master bedroom, the floor space may be used advantageously since no storage chests are required."

The rival *New York Herald Tribune* reported: "Women who find themselves keeping house in a Lustron Home shouldn't have too hard a time of it. For a living room, the budget has managed to provide a blond wood sectional couch, occasional chair and easy chair, tow [*sic*] blond end tables, a desk, occasional table, three piece green cocktail table, gray wool shag free-form rug and several modern lamps styled by Kurt Versen. Full length draw draperies are of Textron plaid in chartreuse, brown and gray tones. The chartreuse is repeated in the dinette. Dinette table and chairs are by Charles Eames. The home has more storage space than many twice its size."

The prominent New York radio announcer, Norman Brokenshire, said: "Young man, you are standing in the greatest single development in housing since they first put one stone on top of another."

Some 31,000 people inspected the Lustron model in the first ten days after it opened on April 14, 1948. A promotional brochure was passed out and many of the visitors were so impressed that they made out checks on the spot to place a down payment for their own house. All of the checks were refused as the factory was still months away from producing its first unit, although it was projected that the first might be made in June.

One of the Lustron men helping to move the crowds through the house got a little confused in the evening. Instead of asking them to move along, see the bedrooms, return and go out through the kitchen and utility room, he said: "Keep to the right, go see the bedrooms and go out through the ceiling."

On April 30, the night of the Artists and Models Ball, the music stopped at midnight and the spotlights turned to Carl Strandlund who stood while the grand prize was drawn for possession of the first Lustron Home. The Society of Illustrators, including Norman Rockwell and James Montgomery Flagg, had spent three months touring the countryside to sell well over 100,000 tickets. Nearly 300 people were present at the ball that night.

The New York City model proved to be highly effective in gaining recognition for the company's efforts to produce a high-quality, mass-production house. Lustron soon announced the three franchised dealers for the metropolitan area. Karstan Builders, a subsidiary of Gotham Construction Corporation, got New York City including all of Long Island, Westchester County to the north of the city, and Rockland County, west of the Hudson River in New Jersey. The remainder of New Jersey was assigned to Better Living Homes, Inc., of Maplewood; and C.B. Homes, Inc., of New Haven was given the Connecticut area.[17]

With over 60,000 having toured the

New York house, the list of inquiries at the Columbus office jumped to 200,000. The "Newsletter" of April 30 reported that the Milwaukee house, sharing the spotlight at the American Federation of Labor National Show in Milwaukee, and the Washington, D.C., model house would be the next two to be put up.

In the spring of 1948, the Lustron national advertising campaign began. The April 19 issue of *Life* magazine contained a two-page Lustron advertisement presenting the new home as "The House America Has Been Waiting For." The porcelain-enamel house promised a "new standard of Living" to buyers. It was convenient and efficient, the ad boasted, had an unusual system of radiant heating located in the ceiling (competitive Levitt Homes in Levittown, New Jersey, had radiant heating in the floors), and was available in a variety of designer colors. Ads were run later in *Time*, the *Saturday Evening Post*, *Foreign Service*, *Architectural Forum*, *Banking* and other trade journals and newspapers.

Harold Denton, head of the market development department, explained that "the two page layout in *Life* included a coupon that readers could submit for more information. This started the deluge. This one advertisement alone brought in more that 150,000 original inquiries, an all-time record for any *Life* ad. The first week's return was in excess of 50,000. The same ad was run in leading newspapers and pulled an additional 55,000 responses, making more than 200,000 inquiries from this ad alone. Not only did people write, they telephoned from all sections of the country. Telegrams and registered mail increased the swell. People came in person from as far south as Florida and from the far side of the Rockies in response to this ad. They all wanted to know about the Lustron Home.

"Although the inflow of letters has leveled off a bit, we still get between 5,000 and 10,000 original letters weekly. This does not include the many thousands of follow up letters that continue to come in. The most recent count [in November 1948] shows more than 320,000 original inquiries received."

One of the executive secretaries, Betty Wallach, was still enthusiastic in 2001 about the Lustron as an engineered product. However, she doesn't have the same enthusiasm for some of the management decisions in those early days. The two-page center-spread ad in *Life* had cost the company $50,000 which bothered the frugal Ohioans in the front office. Tucked away at the bottom of the ad in the lower right-hand corner was the simple coupon with room for a name and address and questions about the color of the houses or the way to attach pictures to the walls. The company only had about ten or 15 employees in the front office at that time and suddenly the post office began bringing in truckloads of mailbags stuffed with the coupons, each of which had to have a reply.[18]

The office manager asked Betty and the others to see if their aunts, mothers-in-law, or cousins could use a job opening and replying to the tens of thousands of coupons. Betty brought in her sister who was quickly hired and put to work. They soon had a dozen girls in a pool to sort the coupons by the questions asked. As each letter was opened, it was placed in a pile for the proper reply. Form letters were then prepared and all the people asking about the color of a Lustron were given letter A, while letter B went to those who wondered about hanging pictures.

The first Lustron advertisement also touted the new Columbus factory as a facility which used the "same mass-production, unit-assembly and precision methods that have made the motor car the greatest industrial achievement and eco-

nomic benefit of the century." Carl Koch, the designer of the Acorn House, who was hired by Strandlund to design more luxurious models of the Lustron, observed that the majority of the product stylists at the Columbus plant had previously worked in the automotive industry.

As John B. Jackson had noted, color began to play an important part in industrial design in the 1930s, not just for decorative purposes, but for the creation of atmosphere as well. Artist H. Edward Winter of Cleveland had suggested in 1946 that porcelain enamel promised "finer colors, better texture and more suitable design" in its architectural applications. Eventually, the Lustron was offered in four pastel shades: dove gray, maize yellow, surf blue and desert tan.

The Federal Housing Authority (FHA) cast a worried eye on the Lustron project in April 1948. This agency was responsible for issuing government loan insurance under Section 609 of Title VI, but the FHA could not approve Lustron homes for this insurance until they obtained the approval of their technical division engineers. Similar FHA caution had led to the failure of General Homes, a Columbus, Ohio, maker of aluminum prefabricated houses, which was forced into bankruptcy and a sale by auction in April 1948. The FHA Lustron engineering report, however, was very positive when it was issued in May.

The first units to be produced at Columbus were the exhibit models that were erected in attractive locations in a number of major cities. However, these were not run on the Columbus assembly lines, but hobbled together from various parts including panels from Chicago Vit. These models were placed at 3802 West Capitol Drive in Milwaukee, Wisconsin; at New Hampshire and E Street in the Foggy Bottom area of Washington, D.C.; on North Marine Drive at Wilson Street

on the lakeshore in Chicago; and in Detroit, Michigan; St. Louis, Missouri; Indianapolis, Indiana, and any number of other major markets.

The second of the exhibit houses was the Milwaukee home. Construction at the Capitol Drive site was slowed by more than two weeks of steady and heavy downpours that had drenched the city. Bob Runyan and the Columbus crew had watched in disbelief as the hole for the fuel oil tank filled with seven feet of water during the eight straight days of rain.

The Milwaukee model home opened to the public on Wednesday, May 19, at 1 P.M. and by 10 that night, 3,200 people had toured through the home despite the continuing rain. This house was furnished by Schuster's Department Store in a combination of traditional early American and modern furniture.

Elrose "Crazy Legs" Hirsh, "great football back for Wisconsin and professional clubs," spent most of Wednesday afternoon recording the opinions of visitors for his radio program in Madison, Wisconsin. Both the *Milwaukee Journal* and the *Milwaukee Sentinel* devoted big spreads to the new home.[19]

The parts for the Washington exhibit house left Columbus about May 16. By May 26, the third of the model houses was ready for a formal preview by the Washington press in the afternoon and members of Congress and other government officials that evening, and continuing on Thursday and Friday. The formal opening date was set for June 1st. Peerless Furniture Company, a well-known modern furniture house, was selected to decorate the house in Foggy Bottom.

Much like at the New York and Milwaukee openings, the "skies opened up at 10:30 A.M. on Wednesday and continued until late evening." Nonetheless, Arthur Godfrey devoted part of his radio show to the opening and the *Washington Post*, the

Times-Herald and the *Star* carried picture stories in their following Sunday editions.[20]

We have seen that a year earlier, the Veterans of Foreign Wars helped Strandlund get congressional assistance. They were given the opportunity to sponsor the house in Washington, D.C., and the VFW used the entrance admission funds for their veterans programs. Several other veterans groups were also closely tied to the Lustron introduction. The American Legion pushed the steel-home project in their own publications and lent public support. Amvets (the American Veterans of World War II) sponsored the Chicago demonstration model, the only Lustron to be built within the Chicago city limits because of building codes, and used the proceeds from the admission fees for their rehabilitation fund.

In June, the company reported that display homes were slated to be built in the next few weeks in Detroit, Des Moines, Chicago, and St. Louis with Columbus and Kansas City to follow.

When a 2-year-old girl named Terry, the daughter of a war veteran and his wife who lived in one room, wrote to Carl Strandlund with help from her parents, he wrote an elegant reply that was printed in the "Newsletter" of June 25, 1948:

> I'm Mr. Strandlund. And one of the finest things that ever happened to me was receiving your wonderful letter.
>
> Terry, I am building homes because of little boys and girls like you. You see, I have been through it all. When I was four years old, my father brought me to America and for a time, he worked on the docks in New York and we lived in places where no boys or girls should ever live.
>
> And then we hit our stride in this grand land and I have been fortunate enough to acquire places to live where all the past has been made up. But with it all, I have come to know how important it is that our nation provide decent homes for the finest children ever placed upon the earth.
>
> When I was a boy, it was a different world. Very few people had automobiles and several industrious and courageous men were tinkering with "horseless carriages" which many said would never be here to stay. But they are, and all my life I have remembered what those men did.
>
> Your letter was kind to my house. We can have homes like Lustron's because of the perfection of steel and the engineering genius which has produced a porcelain enamel—based upon trade secrets older than history—which lends itself to beautiful architecture and lifetime durability.
>
> I know you are interested in a home. But I am going to give you some information which will tell you why we are working out here to provide you and other little children with one of the fundamentals of living. We are placed upon this planet and deserve certain benefits. The sun is good for you, Terry, and so is the rain. Fresh air will make you big and strong and environment [*sic*] will make of you the kind of girl Mom dreams about when she has time. And with all this country offers, still we must have fine homes.
>
> Fifteen centuries or more before the dawn of the Christian era, someone heated a batch of minerals and produced a glasslike substance which he found could be fused to metal with the aid of heat. In the next two thousand years or so, men utilized this knowledge mainly to produce beautiful cloisonné vases, medallions, jewelry and other ornaments. Many of these have lasted through the centuries.
>
> But then, Terry, that's all a little deep for a girl who won't cut her teeth on industry and things like that for many years to come. You need a fine home and Mommy and Daddy need one so that their care and love of you will be a monument of pride and a foundation upon which you may build a good life.
>
> Little children need a feeling of

security—an anchor—which through the years ties up the strings of happiness, stability and character. And take my word for it, Terry, I am going to make sure that homes are available, and soon.

Terry, you say you figure the President of Lustron can do anything. Well, thanks—I'm sure I can't, but one thing I can do is provide you with a home.

And, Terry, I want you to tell Mommy and Daddy over your prayers tonight that you are going to have one of the first Lustron Homes. We will have a Washington dealer any day now and he will be instructed to see that you fine people will be settled in one of our homes.

Thank you for the letter. And remember throughout your life that when we want things and are willing to work hard for them, they usually come about.

Goodbye for now, Terry, but we'll meet again. I want to come and see you and your Mom and Daddy when you are all settled in your Lustron Home.

Sincerely yours,
Carl G. Strandlund[21]

Some 53 years later, it is difficult to determine if Terry and her family actually got one of the first Lustron Homes. Nevertheless, knowing Strandlund's character, it seems certain that he did the most he could do to get them one of the first commercial houses off the Columbus line.

The fourth demonstration house opened in Des Moines, Iowa, on July 17, and was erected by H. B. Buckham & Co., the dealer for the area. The most prestigious visitor was Governor Blue. While free of the rain that attended all the other openings, the heat reached 105°F on opening day. It had been so hot in Iowa during the erection of the home that the men went to work at 6:30 A.M. and retired at 2:30 in the afternoon.[22]

Bernie Bracker of CBS affiliate KSO interviewed Lustron's Dick Hanley and Vern Osch. There was even a broadcast from the Lustron Home with Governor Blue participating. The *Des Moines Register & Tribune* carried several feature stories on the opening, and Younkers Department Store, who furnished the display home, bought a substantial amount of advertising.

The fifth model home opened in Detroit, actually six miles from downtown, only a few days later. True to form, the opening was marred by rains. Mayor Van Antwerp cut the ribbon and both the press and radio covered the event with remarkable cooperation. The first week saw 32,575 people go through the house. Attendance peaked on Sunday with 7,315 walking through the building.[23]

On July 21, 1948, the RFC granted an additional loan of $10 million to the Lustron Corporation at 4 percent to be paid back in monthly installments of $1,250,000 beginning in March 1949, only nine months later. This raised the Lustron indebtedness to $25,500,000. There was no doubt, however, that the money was needed to complete the startup procedures and purchase the remainder of the equipment and the raw materials.

Modern Housing Corporation, run by Charlie and Bill DeWitt, the owners of the St. Louis Browns, scheduled the St. Louis Exhibit house to open on July 29. Famous Barr, the parent of the nationally known May Company, was picked to furnish the home. Delayed by weather, the home opened for private inspection on Saturday, July 31, 1948, with Mayor Aloys P. Kaufman of St. Louis and Mayor Lee Duggan of Richmond Heights getting a tour on Friday, a day earlier. Opening day was so hot that the temperature at midnight rivaled the heat of the noonday sun.[24]

Chicago's Lustron Home was originally scheduled to open on August 4, but the opening was delayed until August 11. Part of the problem was that Chicago building codes required plaster on the

walls and ceiling, which meant that a special variance had to be granted to the steel home before it could be opened. Nevertheless, 3,000 people showed up on the last Sunday in July to see how construction was going. On opening day, a police detail of six policemen was assigned to guide both foot and auto traffic. Eight streets near Marine Drive and Wilson Avenue next to Lake Shore Drive were shut off to control the crowds. Herbert Pashen's *Homes of Distinction* had John M. Smythe, a prominent furniture establishment, decorate the home.[25]

Talman Federal Savings agreed to finance the mortgages for the new homeowners in the Chicago area and was permitted to put their sign by the door. The *Chicago Tribune* and 17 other neighborhood papers ran a rotogravure full-page color ad showing the house, room by room. Some 50,000 sweating men and women braved the lines to see the structure in the first weeks. The Chicago variance was a temporary permit, and following the exhibit period, the house was disassembled and moved to a new site in McHenry, Illinois, some 50 miles northwest of the city.

In October the "Newsletter" predicted that Home openings would be arranged in Boston, Columbus, Pittsburgh, Cleveland, Youngstown and other cities. Two weeks later, the editor mentioned that "two homes are about to make the long trek to Alaska, and Boston will have a home to compete with its baked beans and codfish. Minneapolis is ready and so are a number of other communities."

A month later, the Boston house had a special showing, the Youngstown, Ohio, and Rock Island, Illinois, homes were under way, and a house had been shipped to Minneapolis.

The Anchorage and Fairbanks houses were army test homes to check on winter living conditions. The Anchorage house attracted so much public interest in December that Colonel Potter, who was in charge of the house, opened it for public inspection for a week. Parka clad Alaskans trooped through the house, according to the Lustron "Newsletter," and two businessmen asked about getting a dealership. The public was very impressed with the fact that the home was fireproof. In Anchorage, a home fire generally meant a total destruction of the building because of firefighters' water lines freezing. Early test results showed that the house easily maintained a temperature of 70°F for two days while the outside temperature was hovering at 35 below zero.[26]

The Youngstown model Home opened during the first week of January 1949, and the Atlanta model Home also opened that month. In a departure from the standard blue color shared by almost all of the model homes, the Atlanta house was a pale lime green. A month after the opening, a number of neighbors objected to the large increase in traffic on the street and the hundreds of people going through the house. Although the dealer cleared a nearby lot for use as a parking lot, it was still too small for the many cars that wanted to use it. At a city hearing, the dealer agreed early in February to close the house and end the tours. He moved his family in and he was still living there in the late 1990s.[27]

The Minneapolis model Home opened the second week of January, and, for a change, the weather cooperated. The day was unseasonably warm and the crowds were larger than expected.

The Pittsburgh house was to open the first week of February, but a number of preview sessions were scheduled earlier in January for a major steel company and for Westinghouse.

The actual production of houses for

sale began much later than expected. Some three and a half years had passed since the precipitous ending of the war in August 1945, and the majority of the servicemen had returned from overseas and set up home in the intervening period. Nevertheless, a serious housing shortage still haunted the country. The first Lustron house for public sale left the Columbus factory in the first week of January 1949 bound for Webster Groves, a western suburb of St. Louis.

The early predictions of housing shortages were all too correct. The talk of such shortages had led to a number of other optimistic plans for new housing ventures across the nation. Burnham Kelly observed that "the nation had been hearing about the postwar dream home for four years." As a result, magazine and book publishers offered plans, building manuals, and advice books to an eager public. McGraw-Hill's offerings included B. K. Johnstone's *Building or Buying a House: A Guide to Wise Investment* (in 1948). Doubleday presented Raymond Graff's *The Prefabricated House: A Practical Guide for the Prospective Buyer* (1947) and William H. Wise offered those with limited resources Hubbard Cobb's *Your Dream House: How to Build It for Less Than $3500* (1950).

Meanwhile, General Panel had obtained the Burbank, California, Lockheed Aircraft plant where the company had built engines in World War II. In a business arrangement with the Celotex Corporation, which had made prefabricated sandwich panel boards during the war, General Panel geared up to produce 10,000 prefabricated units per year. Because of inadequate financing and production delays caused by technical problems, the entire enterprise was a failure. By 1952, the company was out of business.

During the same period, Boston architect Carl Koch had developed the Acorn House, a prefabricated unit designed to unfold on site. Koch detailed the development of the Acorn House in his book, *At Home with Tomorrow*, in much the same heady atmosphere as General Panel and Lustron. As novel as the all-metal Lustron, the Acorn House was fabricated of plastic-impregnated paper. It was projected to cost $4,000 per unit. Koch noted in his book that the Acorn was one of his best ideas. He became involved at the same time in designing a new, upgraded Lustron model that will be discussed later.

While Wachsmann, Gropius and Carl Koch were involved with the development of prefabricated housing, William Levitt was approaching the problem in a more traditional fashion. Levittown, Long Island, was begun in 1947, and later the three large suburban subdivisions in New Jersey, Pennsylvania and New York led to Levity & Sons, Incorporated, becoming the most successful house builder in the eastern United States. Levity produced conventional units in large numbers while the innovative plans of both General Panel and Lustron ran aground because of under-capitalization and technical startup problems.

While the Lustron Corporation was still equipping its factory and paying for advertisements in the pages of *Life* magazine in the summer of 1948, *Life* was also reporting in the August 23 issue on Levity's successful and efficient assembly-line operation. The five house types offered at the Long Island development were really variations of a single design and were made of standard building materials erected on a concrete slab. *Life* noted that Levity's workmen each had special tasks, moving from house to house, and functioning as an assembly line in which the workers, rather than the product, moved along.

Raymond Graff's 1947 *The Prefabricated House: A Practical Guide for the*

Prospective Buyer listed over 80 manufacturers of prefabricated homes available to interested buyers. However, the author noted in the foreword to the volume that there were actually more than 400 prefab producers in the United States at the time.

The Lustron Corporation was not listed in Graff's guide even though the first prototype of the Lustron Home had been erected in the fall of 1946 in Hinsdale. The guide did include Greene's Ready Built Homes of Rockford, Illinois, which had been recognized in a November 1945 article in *House Beautiful* as "The First of the Postwar Prefabricated Houses." The magazine's very favorable comment on the new solar house included the observation that it could be assembled in a number of variations because of its system of interchangeable wall panels. Listed also was the General Panel Corporation of New York City whose Packaged House was first built in 1943, the result of years of effort by Walter Gropius and Konrad Wachsmann to develop a totally prefabricated home.

As Strandlund stood by the line in early January 1949 and watched the steel coils being converted into enameled parts, he must have clamped his teeth into his cigar and taken a few extra deep drags. The dream was bearing fruit, and it appeared that success lay before them.

The Columbus Factory

Strandlund and nine select men arrived by train in Columbus from Chicago on November 5, 1947, to start work on the project that was to capture the attention of the world. Each of the men was still there a year later and a member of Lustron's "One-year Club." Carl Strandlund had handpicked Wesley Pearce, D.W. Boylan, Gene Hows, Bob Runyan, Vern Osch, Harold Denton, Carl Willie, Iber Courson and Vince Trunda, many of whom had transferred from Chicago Vit in Cicero, Illinois. These men were to get the former Curtiss-Wright plant revamped into a great new facility to build Lustron Homes.

On December 4, Lustron Corporation ordered $1 million of machinery including $800,000 worth of presses that ranged up to 600 tons in size, together with the corresponding dies valued at $175,000. This order was the first significant order to be placed to equip the new Columbus factory. The plant, at 4200 East 5th Avenue, was actually composed of two buildings that covered 107 acres and had more than a million square feet of floor space. One of the two buildings was 1,400 feet long, 340 feet wide, and had an effective working height of 35 feet.

The March 19 "Newsletter" mentioned the purchase of over $7 million in machinery, equipment and other products. This included $3 million for enameling equipment and $2 million for presses.

Columbus was not known as an industrial town at that time. While it was the state capital and home to Ohio State University, executive secretary Betty Wallach recalled that only Curtiss-Wright and Timken Bearings had been major industries there. As such, Lustron had some initial difficulty in getting the bus company to extend a line out to the plant. Getting additional utility lines out to the plant was also a problem at first.

By April, Lustron had hired 500 men for the Columbus plant and planned to have 7,000 on the payroll by September. Strandlund had hired a number of auto production men to help run the plant since they were familiar with this type of assembly-line construction work. The manufacturing time of a house was estimated to be 400 man-hours from the time the raw material entered the plant until the structure was erected on its site. The price of a two-bedroom house was raised from the original projected $7,000 to $8,000 which would include all built-in fixtures, even the combination clothes- and dishwasher by Thor, the vanity table with a large wall mirror, lighting and bathroom fixtures, copper plumbing, automatic water heater, kitchen exhaust fan, all screens, the electrical outlets, and a 275-gallon oil tank. It did not, however, include the price of the property site.

In a letter to the Columbus *Dispatch* dated August 1, 1976, Carl Rolen recalled:

When the plant was [being] tooled up to get out a few sample houses, there

was no steel. Carl [Strandlund] came to me and wanted to know if I knew a big-name builder who would give me an order for some houses. We had no price or houses to deliver, and Truman would not have steel allocated without orders to fill.

I asked, "How many houses are you talking about?"

The answer was "4,000."

I said, "Del Webb would likely go along as he [is] planning strongly on Lustron houses."

I put in a call for Joe Ashton, [Del Webb's] vice president, and asked for a blanket wire order for 4,000 houses, price and delivery to be determined.

Joe said, "It's too much for me without consulting Webb," but he would call him at the New York City office and if OK, I'd get the wire this afternoon.

Webb at the time was half-owner of the New York Yankees. At four that afternoon, I received the wire ordering 4,000 Lustron houses. Carl and Wes Pearce, his secretary, took the train to Washington that night carrying the wire and received the allocations for steel.

In April 1948, I met Del Webb in New York City to show him the sample house. He was pleased. Later I met with Strandlund and Roy Hurley regarding starting on the Del Webb order and learned that Hurley Machine Company had [the Lustron franchise for] the 11 western states and that Webb would have to buy the houses from Hurley Machine Company, an appliance dealer in Phoenix.

I said[, ...] "If I can't sell Del Webb houses direct, I'll give you his answer: 'NO!'" Hurley Machine Company with 11 states didn't build a single house.

Byrne Organization, that did the 1200 house Harandale housing project at Baltimore, was now at Peoria starting Pekin Village for Caterpillar. Pekin Village was a new town for Caterpillar employees. I phoned Byrne to get Lustron houses in the project. The vice president of Caterpillar, in charge of the Pekin Village project, came with his wife to Columbus to look at the houses and facilities to produce houses for their Pekin Village. Next day I saw Strandlund about making plans to work with Byrne and Caterpillar making the switch to Lustron houses.

Strandlund said, "I want Jack Byrne to come crawling to me on his hands and knees."

I said, "What has Jack Byrne done to you?"

The answer was, "Nothing, I don't even know him."

Then I learned that the [franchise for the] state of Illinois was spoken for by a congressman. There went my two sales monuments that I was depending upon to build up sales and attract other large builders to Lustron houses.

Tom O'Sullivan, resident publicity man for Carl Boyer & Associates, New York City, at my request called Carl Boyer and asked him to come to Columbus to talk to me and try to influence Strandlund and get him down to earth. I had told Tom as early as February 1948 that Lustron was not going to go with all the blocks to sales. Carl Boyer couldn't believe what was going on, but couldn't change a thing.[28]

The May 14 "Newsletter" welcomed General Eugene Reybold, head of the U.S. Army Engineering Corps during WWII, as vice president in charge of operations for the Lustron Corporation. Reybold had been awarded the Distinguished Service Medal for leading the Engineering Corps through the war years.[29]

It is easy to lose track of the progress in equipping the Columbus Plant while the first exhibit houses were being shipped out. On June 4, 1948, Ernest Olsen, plant manager, reported in the "Newsletter" that the "two big gas furnaces on the west side of Building 3-A are approximately 90 percent erected." The spray lines and driers for these furnaces were being installed. Bricklayers were needed to complete the installation and a search was on locally for

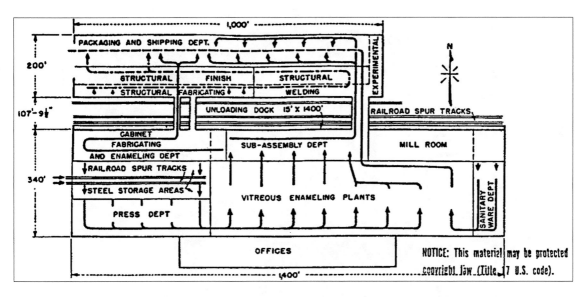

Layout of the material flow pattern in the Columbus Lustron factory.

men who could complete the job. All of the excavation work for the mill room on the north side of 3-A was done and 60 percent of the concrete was in place. The large wall panel 600 lb. press was being assembled in the west end to manufacture 2 × 8 foot panels for the interior of the homes. Two railroad tracks were being built inside the building and Columbus and Southern Ohio Power had installed an additional power line. The foundation for the 1,800-ton press for the bathtubs was ready and the conveyors were being installed. Strandlund had placed the largest order ever placed for porcelain enamel worth $1,206,455 with Chicago Vitreous Enamel Products Co. in Cicero.

The Lindberg Engineering Company of Chicago was contracted to supervise the machinery installation in the Columbus plant. Several batteries of presses (161 in all) ranging from 25 to 1,800 tons were set up as were two 180-foot porcelain enameling furnaces with the capacity for enameling 12,000 square feet of panels hourly. In addition, seven other smaller gas-fired furnaces and two electric furnaces were installed. There were 201 portable electric

welders, 67 spray booths, 19 bit shears for cutting steel, 16 dust collectors and 40,000 linear feet of overhead conveyors. There was other equipment, peripheral to the stamping, enameling and assembling operation, including ball-mill grinders, storage tanks for the frit, lathes, lift trucks, pickling machines and a water-cooling tower. The process of fitting out the factory with all the equipment necessary to produce the housing components took 19 months and was not fully completed until the first month of 1949.

Each house required 12.5 tons of steel and one ton of enamel. E. E. Howe of the Lustron Ceramic Division had created a stir when he told the frit manufacturers in January 1948 that in six months the Lustron Corporation would be needing enamels that would fuse at 1,300°F, much lower than conventional processes in use at that time. He got his wish. The lower fusing temperature was selected because it was below the lower critical point of steel (1,355°F) and this would permit Lustron to eliminate problems with distortion, maintain the strength of the steel, eliminate the use of supports for the panels in

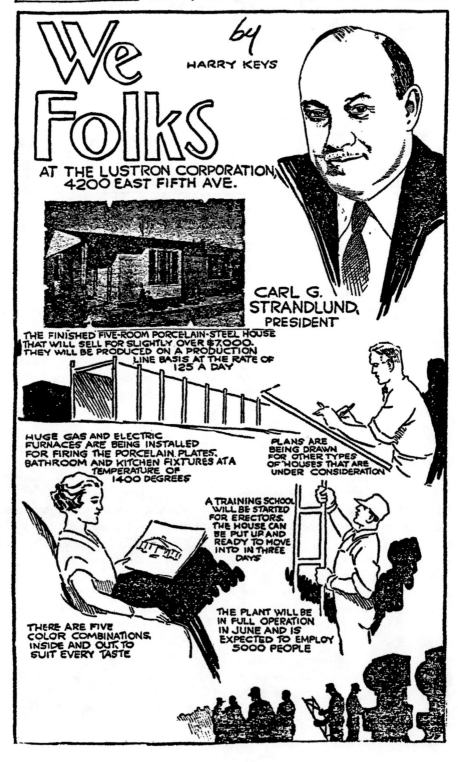

We Folks

by HARRY KEYS

AT THE LUSTRON CORPORATION, 4200 EAST FIFTH AVE.

CARL G. STRANDLUND, PRESIDENT

THE FINISHED FIVE-ROOM PORCELAIN-STEEL HOUSE THAT WILL SELL FOR SLIGHTLY OVER $7,000. THEY WILL BE PRODUCED ON A PRODUCTION LINE BASIS AT THE RATE OF 125 A DAY

HUGE GAS AND ELECTRIC FURNACES ARE BEING INSTALLED FOR FIRING THE PORCELAIN PLATES, BATHROOM AND KITCHEN FIXTURES AT A TEMPERATURE OF 1400 DEGREES

PLANS ARE BEING DRAWN FOR OTHER TYPES OF HOUSES THAT ARE UNDER CONSIDERATION

A TRAINING SCHOOL WILL BE STARTED FOR ERECTORS. THE HOUSE CAN BE PUT UP AND READY TO MOVE INTO IN THREE DAYS

THERE ARE FIVE COLOR COMBINATIONS, INSIDE AND OUT, TO SUIT EVERY TASTE

THE PLANT WILL BE IN FULL OPERATION IN JUNE AND IS EXPECTED TO EMPLOY 5000 PEOPLE

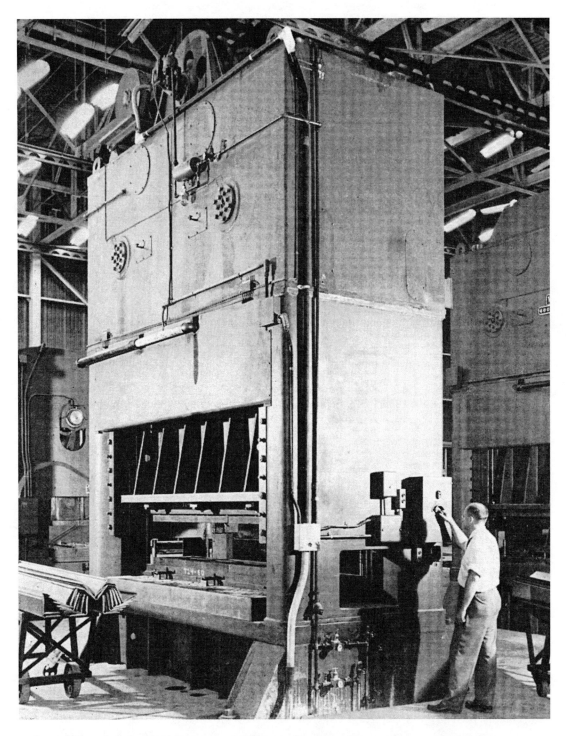

Above: "Two of the 'medium' size presses (600 tons) in the main press department for the production of architectural parts. Such items as exterior corners and roofing panels are fabricated on this type press. Largest Lustron presses are 1800 tons." Caption from Lustron brochure. (Courtesy Vince Trunda.) *Opposite:* From the *Columbus Dispatch*, April 18, 1948.

the oven, and permit the use of thinner sheets of steel. This significant development had a direct positive effect on the manufacturing of refrigerators, ranges, washers and other porcelain-coated appliances made by other suppliers.

Inside the immense factory, the two-foot by two-foot panels were stamped out from steel on large coils that were fed into a specially designed 600-ton punch press with a four stage progressive die. This would blank, form, cam and then pierce and emboss the metal to make a complete exterior panel. From this automatic setup, the panels were hung directly onto an overhead conveyor that took them to the pickling unit in the enameling department.

A similar progressive die was designed for the roof shingle panel on a 1,000-ton press using a four-foot-wide coil of steel. The die in this press notched and lanced first; then sequentially did a draw; a redraw; pierced the metal and finally trimmed the piece to complete it. These parts, too, were hung on an overhead conveyor to travel to the pickling unit and "pickled" in a 200-foot-long metal wash pickling machine in an acid bath which cleaned and etched the bare metal so it would be more receptive to the porcelain enamel coat. A nickel flash coating followed. The parts were then sprayed with the porcelain enamel finish and conveyed into the huge furnaces to be baked

Nine of the 11 furnaces were fed by the two largest pickling machines with a central wall dividing each to make them the equivalent of four machines. The other two furnaces were served by a smaller single tunnel-pickling machine. Each furnace represented an entire porcelain-enameling factory with the combined overall total capacity of 206,000 lbs. per hour. The first nine handled the architectural exterior and interior panels, while the last two enam-

eled the sanitary ware: the bathtub which was drawn in one stroke of a 1,800 ton press with no restrike, the lavatory, and the kitchen sink. The panels were completed by applying a vinyl plastic gasket to two of the edges with the use of an automatic machine. The gasket was then "vulcanized electronically through holes in the panel" to keep it securely in place.

The mill room, which prepared the frit, was 13,000 square feet in size. The largest ball mill was 8 feet × 8 feet in size and could handle a charge of 7,500 pounds. The other mills ranged down to 400 pounds. There were 42 agitated storage tanks, with 27 of these holding 925 gallons of the frit slurry. The others were able to hold 750 to 500 gallons of the various slurries produced.

Three types of spray booths were installed at Columbus. Despatch Oven, DeVilbiss, and finally Binks were all contracted because of the amount of equipment needed so quickly. Each house being fabricated required the use of a variety of milled frit sizes: an architectural base coat enamel; an architectural one-fire enamel; an architectural acid resistant covercoat; a sanitary ware ground coat; a sanitary ware nonacid resisting cover coat; and a sanitary ware acid-resisting cover coat for six varieties without the consideration of the color variations. Plant one and two made sanitary ware like bathtubs, lavatories and sinks. They were first sprayed with blue ground coat in plant one and fired, then sprayed with white cover coat in plant two and fired. Plants three, four, and five handled the interior parts in a one-coat, one-fire operation. Plants six through 11 processed the exterior panels and parts using the two-coat system of base coat and acid-resisting cover coat. While most of the enamel was sprayed by hand or machine, the exterior architectural panels were either dipped or slush-coated with the base enamel depending on the part

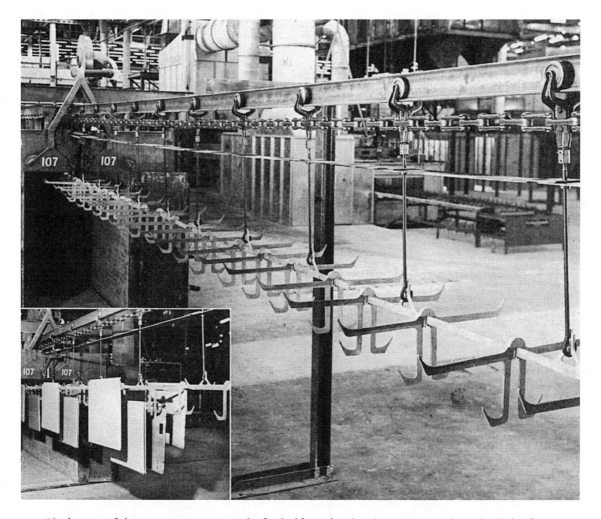

"A closeup of the conveyor system racks for holding the 2' × 2' exterior panels in the Boland furnace. These were designed and provided by Link-Belt." Caption from Lustron brochure. (Courtesy Vince Trunda.)

size. This gave the greatest protection to the parts directly exposed to the weather.

Wall framing sections were produced on roll-forming equipment. Coil stock was fed into equipment with 12 station rolls with flying cutoffs. The structural members and gussets were conveyed to five elaborate welding stations that consisted of three circular conveyors for wall sections and two stations for the roof truss section. Twelve of the welding gun stations were at different heights to put them at the right level for the weld. Each of the

26 wall sections called for 50 welds. Some 16,000 welds in all were needed for each house.

After welding, the wall frame section or roof truss was hung on an overhead conveyor and taken to the bonderite equipment. Lustron had the largest bonderizing, painting and oven line in the country which was able to handle loads up to 17 feet high and eight feet long. After bonderizing in a chemical bath, the parts were dried, spray painted, then dried at 450°F. The resulting paint job was a very

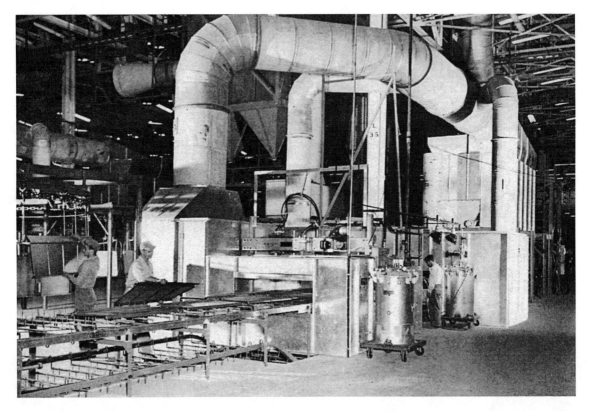

"These automatic spray booths applied the porcelain to the metal exterior panels." Caption from Lustron brochure. (Courtesy Vince Trunda.)

hard, shiny black finish which stood up to salt water and weathering tests better than anything else. Some 300 sections an hour were processed this way.

Carl Rolen, the sales manager, did not agree with engineering on all issues. "I was interested in keeping unnecessary expense out of the house. Ernie Olson and A. M. 'Tony' Montagno were in charge of equipment and plant layout. They came to me stating that Ralph Wise, then Chief Engineer, was insisting that they prepare for bonderizing all the steel framing. I had been a member of the Iron and Steel Institute and the Technical Committee of the Steel Deck Industry. Coatings of structural and light gauge steel for building often came up. Never was bonderizing ever required. Shop coats to protect in transit and weather on the job is all that

is needed. The Executive Vice-President called a meeting to decide the question, and even though I had results of title inspections, Wise insisted that steel would rust out as on cars. He had been designing locks for GM trunk lids. I told him that if you can imagine a car rusting out if it never left the sample room, I'd vote for bonderizing. The Executive Vice-President said that Wise was the boss [expletive deleted]! 'We will bonderize!'"

Despite this, Rolen thought that "Tony and Ernie had done a superior job equipping and producing."

To make one house, over 1,000 pieces had to be enameled and over 200 had a different shape or color. Each house had 7,000 square feet of porcelain-enameled surface. The frit was milled separately for 14 different end uses: the exterior walls;

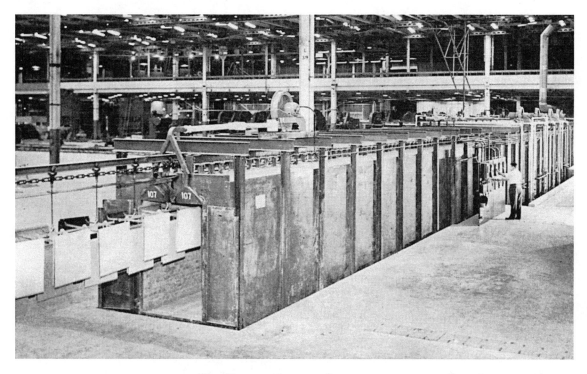

"Exterior 2' × 2' steels panels enter one of nine Boland continuous furnaces to bake the porcelain enamel." Caption from Lustron brochure. (Courtesy Vince Trunda.)

the roof and gutters; the gable ends and soffits; the exterior walls' acid coat; the exterior trim; the interior ceiling; the interior trim; the number one bedroom wall; the number two bedroom wall; the living room and dinette walls; the kitchen, utility and bathroom walls; the sanitary ware ground coat; the sanitary ware cover coat; and the sanitary ware acid coat.

The timing of the processes was coordinated so that there was no storage required for the manufactured parts other than for the milled frit. Raw steel moved though, was fabricated, enameled and conveyed to a trailer truck where other subassemblies and completed parts arrived to be placed in their proper place.

Dick Reedy had not been idle in trying to solve the high cost of shipping after being told by Strandlund that it was *his* problem. He hired two packaging engineers to determine the weight and cubic

feet of each part. The parts for the house weighed in at 35,000 pounds and, if properly packed, could all fit on one 35-foot tandem trailer. After working during the war for Curtiss-Wright which regularly made mock-ups of new items, Reedy decided to mock up a trailer and went to Russell Davis, the executive vice president, for $5,000 to get a trailer.

"No, you can't do that!" Davis told him.

Reedy then talked to a friend from Illinois who had a business transporting prefabricated home parts and mentioned needing a trailer. Roy told him, "I'll give you one!" and Reedy had the trailer pulled to the rear of the Columbus plant behind some partitions. Out of sight from the other activity, he prepared the mock-up with the help of Dan Larson, his shipping clerk. They put the exterior wall sections on board as the outer walls of the trailer

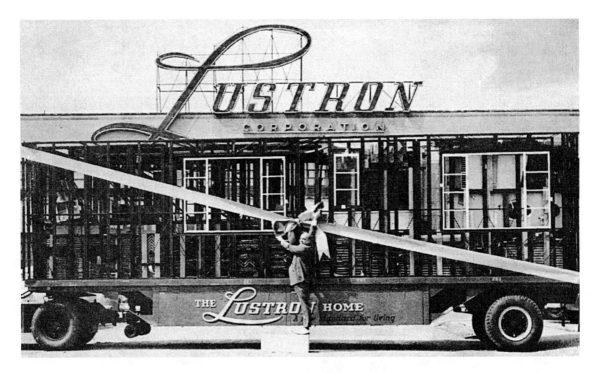

"President Strandlund 'wraps up' one of the first complete Lustron Homes to be shipped to the building site. This especially designed trailer carries all of the necessary sections and components of a complete Lustron Home." Caption from Lustron brochure. (Courtesy Vince Trunda.)

and put the smaller parts in boxes and shelves in the center. The house components were fitted onto the flatbed trailer in the order in which they would be taken off for assembly at the site. The nuts and bolts were held in a secure box mounted on the floor of the trailer while the wall framework and roof trusses supported everything else. None of the wooden crates used on the New York City shipment were needed now.

After a number of false starts to get the loading pattern right, they finally found one that would work. When they had the whole house loaded, Larson tied a big red ribbon on the trailer while Reedy went upstairs to Strandlund's office. He asked Carl to come out to the front of the factory and as Carl left the lobby, a big grin crossed his face.

"Damned if this isn't just what we need!" he exclaimed. A photographer captured the moment as Strandlund unwrapped his surprise package.

Reedy told Strandlund that the trailer could serve a dual purpose by hauling $20,000 worth of steel from the mills on the way back from the house site. In addition, the trailer could be used to inventory the unassembled Lustrons, loaded and ready to ship, as a mobile warehouse. Using a proposed eight-day float, a fleet of trailers could smooth out the shipping woes of the company.

Reedy planned to ship the trailer over longer distances by rail using a "piggy-back" method on a flatcar. However, when he went to Chicago to talk with seven railroads serving the Northwest, they turned him down. The Union Pacific, Northern Pacific, Great Northern, Milwaukee Road and Chicago & North Western all had

lumber accounts with thousands of carloads coming east. There was no interest in disturbing these customers by shipping steel houses west.

Reedy then went to the Atchison Topeka & Santa Fe and the Pennsylvania Railroad (which served Columbus with their mainline just a block south of Lustron's plant) to try to interest them. While a trial shipment was made, this never developed as it was an idea some 20 years ahead of its time.

After noticing empty oil barges returning to Texas on the Ohio River, Reedy contacted one barge operator about backhauling 18 loaded Lustron trailers on the deck of a barge from Ohio to Houston where they could be distributed. While there was room enough to do the job, the orders from the Southwest never amounted to the level necessary to get this plan afloat.[30]

Lustron contracted with Commercial Home Equipment of Chicago in 1948 to lease 400 tractors and 800 trailers to move the houses. Commercial Home then went directly to Fruehauf Trailer Company to have 800 trailers designed to Reedy's plans, at a cost of $4.5 million.

The plumbing unit framework was the first item to be set in place, squared up and the rest of the skeleton framework was then erected around it. Factory trained crews at the home site could assemble a house in three days. Use of the trailers saved the company about $90 million a year compared to the original wooden crate method used for New York City.

Chicago Vit's *Better Enameling* magazine remained supportive of Strandlund's Lustron effort after he left their company. It published "A Progressive Report on Lustron" in the August 1948 issue that contained a large color foldout with photographs of a Lustron house as well as a large floor plan of the Columbus factory. The article was obviously timed to coincide with the national advertising campaign launched by Lustron in the summer of 1948.

Lorenzo Semple joined the company in August of 1948. After graduating from the Naval Academy, he had worked for RCA and the Brooklyn Edison Company before joining the American Water Works and Electric Company in 1926. Here he managed some 70 public utility subsidiaries in 26 states over the next 20 years. He served as vice president of West Penn Electric in Western Pennsylvania, president of the subsidiary in Cuba, and finally as vice president of AWW&E Company itself.

In September 1948, Dick Reedy advised the "Newsletter" that the yellow Lustron truck, which could carry the entire packaged home, would be a prize exhibit in the Truck Rodeo Parade through the center of Columbus. It was anticipated that the driver would put the truck through a number of intricate maneuvers at the Fairgrounds on the weekend.

One serious problem that had to be resolved was the acquisition of a 15,000 KW transformer. Although several existed in some of the defense plants that were now idle, the Army-Navy Munitions Board had frozen the equipment. The only option was to buy a new unit from Allis-Chalmers, which normally had an 18-month delivery schedule. However, after demonstrating the urgent need, Allis-Chalmers was able to agree to a much-reduced 100-day delivery, which was actually accomplished in time to get the plant going.

The huge Lustron hydraulic presses began to convert the steel plate, and the vast gas-fired furnaces in the Columbus plant began to fuse the porcelain frit, on September 2, 1948, as the first run of panels passed through the spray booths and along the assembly-line conveyors. The

plant as a whole, however, was still not ready to go.

On the anniversary of the first year in Columbus, the original nine employees gathered with Carl Strandlund around a cake made in the shape of a Lustron Home. After a small ceremony, it was announced that the plant was now capable of turning out a house a day, that steel shipments from the mills to Columbus were on the increase, and that production was expected to greatly increase in the near future.

Joe Tucker joined Lustron in December 1948. An artillery officer in WWI, Joe went to work for Nichols & Shepard in Columbus, a farm implement company. When N&S became part of Oliver Company, Joe became vice president of sales. Carl Strandlund was one of Oliver's operating officers at the same time and the pair were known for producing and selling tractors far in excess of expectation. The two men combined to lift Oliver from insecurity to becoming a leader of the industry. Tucker went to the War Production Board during WWII and headed up the priorities department.[31]

When President Roosevelt and Mackenzie King, the Premier of Canada, signed the Hyde Park Agreement which set up a Canadian War Production Board, Tucker was named director and soon had the output of the Canadian war industries up to a high standard.

Tucker was then hired by the Canadian company, Massey Harris, who produced a self-powered combine for farm use. While war production was high, the food front, blessed with bumper crops, was hampered with antiquated, worn-out machinery that farmers had held on to during the Depression. Tucker proposed to get 500 of the one-man combines delivered to the Southwest to harvest flax and wheat and then move north and east with the harvest without remaining attached to one farm area. The Harvest Brigade cut one million acres, which had been given up as lost, and the food swelled the reserves in both America and Canada, and for the Allies as well. The next year, some 750 combines were used to harvest crops on two million acres, crops that would have been lost. Massey Harris grew to be the fourth-largest farm machinery producer in the world.

Strandlund approached Joe Tucker and explained the Lustron Corporation challenges in 1948, and Joe left Massey Harris to return to Columbus to tackle these new problems.

Some $12,500,000 worth of equipment, which had stood at the ready after the massive installation project to get the plant into production, began to operate in a coordinated fashion to produce the Lustron package. Through December 1948, the plant had debugged the equipment and the operating lines. The first house to be produced for public sale left Columbus in one of Reedy's yellow trailers in early January 1949 bound for Webster Groves, Missouri, and signaled the beginning of increasing regular production. Joe Tucker set a goal of 240 completed Homes to be manufactured during January, and the plant geared up to meet his expectations.

It appeared that nothing could stop them now.

The "Westchester" and "Newport" Models

With the Columbus plant up and running, although in a temporary "warm-up" phase, Strandlund held a press conference on October 24, 1948, to announce that four all-steel houses a week were being produced by the plant. Only three of the huge furnaces had been fired up at this time.

"The first design in this long range program, possibly the simplest" was the "Westchester" model that was very similar to the original "Esquire." The quality of manufacture and construction of the houses was universally excellent. The company promoted them as being "permanent," "lightning-safe," "decay-proof" and "termite and rodent proof." The Westchester was available in both a two- and three-bedroom model version. Later, matching garages, breezeways, patios, carports and screened porches were available as accessories.

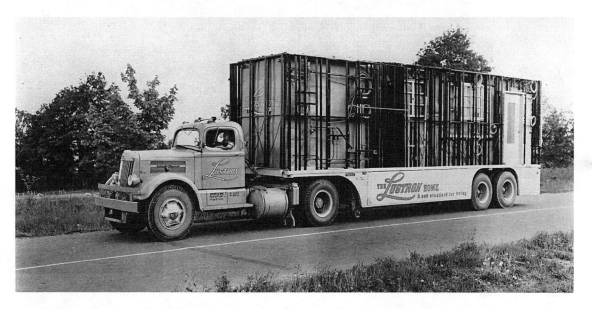

This bright yellow Lustron truck and trailer clearly shows the plumbing wall, other exterior frames and a front door. These special Fruehauf trailers were used to haul the house assemblies to the final site. They performed as rolling warehouses since they sat loaded at Columbus until the unit was sold, and remained on the site until the house was completed. (From the Clyde Foraker Files, Dan Foraker Collection.)

The newest kind of Heating for the newest kind of House

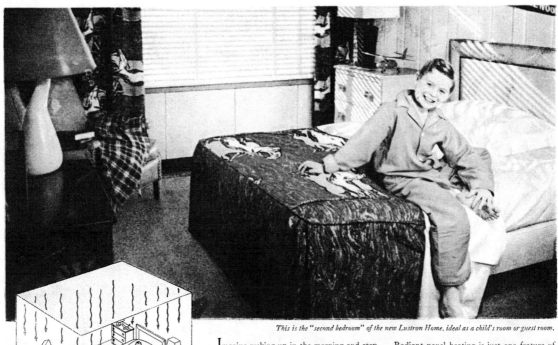

This is the "second bedroom" of the new Lustron Home, ideal as a child's room or guest room.

What a joy on a chilly morning—
Lustron's radiant panel heating

Just think what this means in daily comfort and well-being! The average difference in temperature between floors and ceilings in the Lustron Home is only three degrees. Like sun rays, heat rays from the ceiling warm every object in the room, smoothly, evenly. (See diagram.) Complete wall and ceiling insulation naturally makes for greater comfort, summer and winter. Tested in two years of severe winters under actual living conditions, Lustron's radiant panel heating system is simple, efficient and economical.

Imagine waking up in the morning and stepping out of bed onto a nice toasty-warm floor! That's one of the new joys of living that await you in the radiant-heated Lustron Home.

The entire ceiling is the source of smooth, even heat. It's like having the sun for a ceiling, for actual rays of heat are sent downward into each room, warming every inch and corner.

This means no chilly drafts where children play, no moving currents of heated air to carry dirt through the house, no dust-catching radiators and grilles to eat up valuable floor space. And the Lustron heating system is completely automatic — just set the thermostat.

For complete story of the Lustron Home, send 25¢ (coin only) for beautiful new 16-page booklet—all the details on why Lustron is America's "new standard for living."

LUSTRON CORPORATION, BOX 2023Z, Columbus 16, Ohio

Radiant panel heating is just one feature of this new precision-engineered house. The lifetime beauty of porcelain enamel is combined with the known strength and permanence of steel—a "first" for new materials in home building. Volume production keeps the price within the means of the average American family. Plan to inspect the Lustron demonstration home in your community soon.

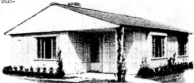

This Lustron advertisement featured the innovative heating system. Warm air flowed across the ceiling panels and they, in turn, radiated heat into the room. *Saturday Evening Post*, January 22, 1949, page 96.

The exterior of the two-bedroom Westchester can be easily recognized since it has a notched porch area clipped out at the front left of the living room–bedroom wall. There are two large windows on this wall with the living room window set in a protruding bay area. The end bedroom wall was modified over the two years of production and can be used to date any given house. The earliest houses featured pairs of small slit windows set high in the wall to light both bedrooms. This later became a small single window for each bedroom, and finally a moderate sized single window for each room. The back of the house had a large window for the bedroom, a vertical slender window for the bathroom, a back door and a paired window for the kitchen.

The three-bedroom Westchester had no porch area. There were two varieties produced: one had the two large windows of the 02 model plus an additional small window set high in the wall for the third bedroom; and the other had this small window set high for the first bedroom and between the two large windows which served the living room and the rear bedroom. The end bedroom wall had the same progression of window sizes during the two years of production.

The appearance of the house was designed on the general lines of the "modified ranch style," according to the advertising literature produced by the company. The windows were casement type with aluminum sashes, hinged to open outward by means of cranks at their base. Screens were included with the houses. The company literature also noted that "Special attention has been paid to cross ventilation of the bedrooms by the arrangement of the windows."

The foundation was a basic concrete slab in most instances, although houses could be and were in a very few instances built over basements. The foundation, walls and ceiling were all insulated "making the home wonderfully cool in summer and snug and warm in winter."

The specifications, which accompanied sets of erection plans provided with every house, called for a floor slab of no less than three inches in thickness. If the house was to be built on a foundation, its walls were not to exceed four inches in thickness. The concrete floor slab was to be placed over a sub base of gravel or crushed stone that was reinforced with a welded mesh of no. 6 gauge steel wire. The company emphasized that the "skeleton of the house is made of steel framing, factory welded into wall section and roof trusses. Porcelain finish steel panels form the roof [and] exterior and interior walls." Interlocking with each other, they were attached to the steel frame members with self-tapping sheet metal screws "in such a manner that the method of attachment shall not be exposed or visible." Compressed between the panels, "a permanent plastic sealing strip forms a gasket and assures an airtight enclosure. This all steel construction provides great durability and strength."

The attic space above the ceiling and the plenum chamber was to be insulated by three inches of glass wool with aluminum foil bonded to the inside face of the roof. Floors in the house were covered with ⅛ inch thick asphalt tile.

The houses could be purchased in one of four "carefully blended combinations" of exterior colors designed by Howard Ketchum, a renowned colorist. These were the surf blue, dove gray, maize yellow and desert tan. The interior colors were a neutral light gray, a blue, a yellow and a pink. The interior colors, apart from the neutral gray, were used in the bathroom and kitchen.

The kitchen was not equipped with either a stove or a refrigerator. It was, however, fitted with a Lustron manu-

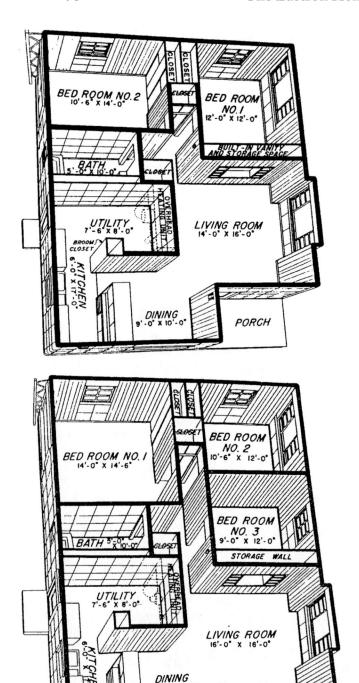

Floorplans of the two- and three-bedroom Westchesters.

factured sink, steel cabinets, a clothes dryer, an optional garbage disposal unit, and a combination clothes and dishwasher.

The combination clothes and dishwasher appliance, the Thor, was part of the Westchester Deluxe package that also included the bedroom vanity and the dinette-kitchen pass-through divider. The Thor appliance was built exclusively for Lustron (and was never duplicated again). It proved to be unreliable and frequently broke down. Both tank-type agitators were stored within the Lustron sink unit and were exchanged depending on the job to be done. Few of these appliances have lasted 50 years, but one of the Thor appliances is in the Chesterton, Indiana, home that operated for three years as a Lustron Museum.

The bathroom was equipped with a bathtub, toilet and sink plus an illuminated medicine cabinet with a mirror, a towel bar, robe hook, combination soap dish and grab bar over the tub, toilet paper holder, drinking glass holder, and a curtain rod for the shower. As noted earlier, the tub and sink were drawn in huge presses at the Lustron factory, while the rest of the furnishings were purchased from outside manufacturers, including the heating plant, water heater, floor coverings, insulation, hardware, electrical materials, screws and bolts, and the light fixtures.

Strandlund's theory was that although Lustron was giving an average family "a well designed, low cost house," it was also "giving this family an almost mainte-

nance-free house, fire resistant, termite proof and enduring." He also wanted to sell "the idea of style depreciation" where "the old models filter downward at lower cost and still [are] very good houses." This concept was based on the now traditional practices of automobile marketing.

The United States armed forces had a great interest in the Lustron houses as they were faced with housing problems on many of their new bases. The US Army Corps of Engineers bought two of the first production Lustrons in October and shipped them north to Alaska. One went to the Army Air Forces base at Fairbanks and the other to the army base at Anchorage. They proved to be more than adequate for the job, and the army planned to buy many more.

The Westchester, especially in the two-bedroom style, became the biggest seller for the company, particularly in the Westchester Deluxe package, and was by far the most popular model.

The 03 Westchester has only been found in 111 locations. The greatest number, 17, are

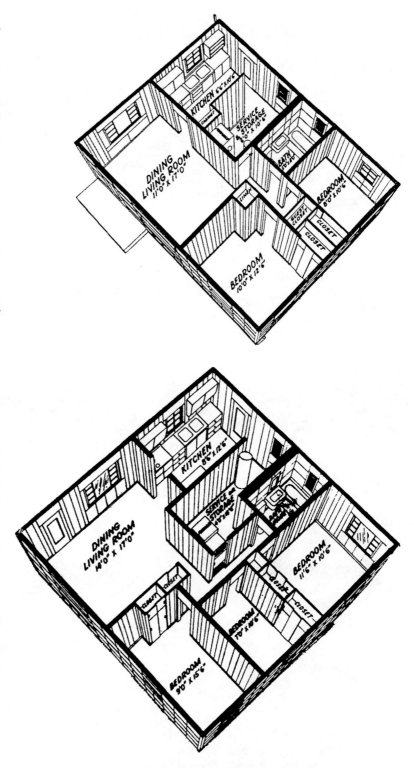

Floorplans of the two- and three-bedroom Newports.

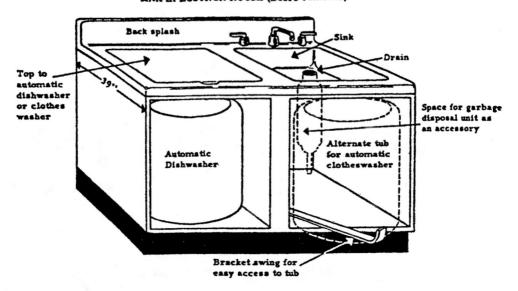

The Thor Dish Washer–Clothes Washer was built into the sink unit with the alternate tub stored under the sink. (Courtesy Vince Trunda.)

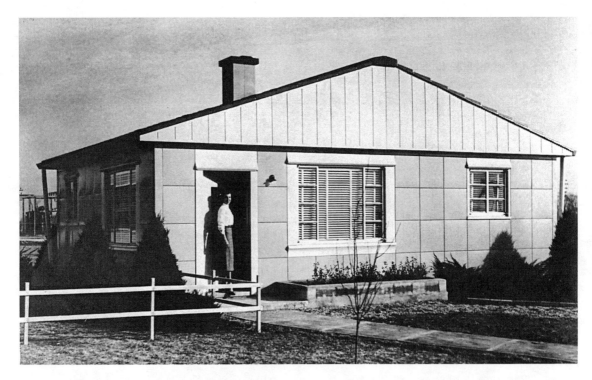

This Lustron Corporation photo shows the Newport house that was built in the front parking lot of the Columbus plant. Note the unusual styling of the long gable across the front wall and the short ridgepole of the roof parallel to the short sidewall of the house. (From the Clyde Foraker Files, Dan Foraker Collection.)

located at the Quantico Marine Base south of Washington in Virginia, and the largest number of 03 Westchesters in any town are four in Pittsfield, Illinois.

The "Newport" two- and three-bedroom models were introduced later in the manufacturing period with the first identified Newport built late in 1949. This house was serial number 2036 and was built in Birmingham, Alabama. Most of the small Newports began to leave the Columbus plant in February 1950. The Newport 021 two-bedroom model had a much smaller footprint than the Westchester at 31 by 23 feet. But the Newport was popular in outlying areas since the shipping charges had less impact on the final price. Priced at only $4,000 FOB at the factory, Dealers were pledged to sell it at $6,900 to $7,900 depending on local conditions. Although downsized from the Westchester, many of the conventional parts of the Westchester were used.

While at least one Newport was built in Columbus, and a few exist in Illinois and Iowa, they are the exception. There have only been 24 of the two-bedroom Newports discovered across the country. The biggest concentration was at Great Bend, Kansas.

The distinctive characteristic of the Newport was that the roof was set at 90 degrees from the norm. This gave the front wall the gable end of the Westchester. It defied conventional architectural practice, since the roof had a long gable but a very short ridgepole. The front door was moved to the left front of the front wall and a large bay window was set in the living room sidewall where the front door on the Westchester units was located.

Still more interesting was the return to a conventional standup furnace and standard forced-air circulation without the use of the plenum and radiant heating so featured in the Westchester models. Hot air circulated from a top vent of the furnace directly into the living room and return air was drawn from a bottom vent near the floor directly below. A second pair of vents blew directly into the hall leading to the bedrooms and a final hot air vent was ducted to the ceiling of the bathroom. This system was known as the "High Wall Discharge Heating System," but no papers have been found to explain the company's change of heart in regard to heating and air.

The two Newport houses in Fort Lauderdale are set in an exclusive section of town on the canals east of the business district and have both been subdivided into two apartments. In practice, the owners normally reside on large yachts that can moor next to the Newport's property and the houses serve only as a homebase.

Only one example of the three bedroom 033 Newport has been found. It is in Cedar Rapids, Iowa.

Released from Columbus while the company was under attack by the RFC, the Newport did not get wide distribution and was only marginally accepted by the public.

While Lustron offered a slightly larger Meadowbrook in both the two- and three-bedroom styles, neither of these designs have been found in the nationwide search.

Logistics and Pricing Strategy

Lustron homes were carried from Columbus to all parts of the nation on the specially built trailers that served to warehouse the components once they left the assembly line. The trailers, specially manufactured for Lustron by the Fruehauf Corporation, measured 32' 6" long and were designed to accommodate the house parts in compartments and on permanently installed racks. The tractors used to haul the trailers were built by the White Motor Company of Cleveland. Both tractors and trailers were painted a bright blue and yellow to "permit ready visibility and an appearance of neatness and cleanliness which is evident in the house." These trucks were later the subject of a great deal of debate and litigation in the RFC hearings due to the extraordinary expense incurred in building them to Lustron's specifications.

Lustron liked to pride itself on the fact that its houses were so simple to assemble that no one with the most rudimentary carpentry skills could fail to put one together. In fact, such thinking was behind Strandlund's hopes for an inexpensive, mass-produced house. He aspired to create housing which the ordinary man on the street could erect for himself, which, of course, had been the objective of every producer of prefabricated housing for the past century. Realistically, however, he knew that most of the houses would be built by professional labor and, to avoid problems with the trades and

crafts, he signed a master agreement as we have seen.

Due to his contractual obligations with organized labor plus the added problem of dealing with outdated building codes in many areas of the country, erection costs frequently soared much higher than Strandlund or others had projected. Costs attendant with connecting the houses to utilities, and the special insulation required in colder climates were a part of such expenses and varied tremendously in amount from one section of the country—even one town—to another. Thus a Lustron house that sold from the factory for $7,500 might eventually end up costing two to three thousand dollars more! In a day when the average pricetags on small, inexpensive frame homes totaled about $6,500 for structures the size of the Lustron, the $10,000 seemed, to many people, to be an exorbitant price to pay for a house that had no more floor space and was relatively plain in design.

The price structure of the company was also complex and very dependent on local conditions. Factors such as the price of the lot, the labor costs, and code variations played a large part in the final purchase figure. The Lustron Corporation also had a preset price list for its several models based on a "zone" code which, in effect, included transportation charges. (See Appendix E.) Houses delivered within the state of Ohio, nearest the factory at Columbus, were cheapest, while

those sent to Texas, at the extreme end of the continental United States covered by Lustron, were the most expensive. Base prices ranged from $4,110 for the basic two-bedroom Newport Model 023 delivered in Zone 1 (around Columbus) to $7,737 for the top of the line three-bedroom Westchester Deluxe delivered in Zone 48 in southwest Texas.

By the time a homeowner had added in the expense of installing the foundation slab, erection fees, and costs attendant with plumbing, electrical and insulation work, the price could jump another $2,500, not including the additional basic cost of the building lot. These charges depended on what pricing schedule prevailed in different localities. In Wilson, North Carolina, for example, a foundation slab for the two-bedroom Westchester model could be laid for only $700, while comparable work in Mansfield, Ohio, cost $1,372.73 in 1949. Erection costs also varied from a low of $540 in Wilson to $1,700 at the high end in Madison, Indiana, on the Ohio River. Yet, when one considers the base price of a delivered home in the calculations, Wilson was no bargain: the final price was $9,200 which placed it among the most expensive locations due to the high transportation costs of moving the loaded trailer there.

In the beginning, Lustron handed out exclusive dealer franchises to selected wealthy businessmen. The dealer in St. Louis was Modern Housing Corporation which was owned by Charles W. and William O. DeWitt, the owners of the St. Louis Browns baseball team. The company's manager was William DeWitt's father-in-law who was a lumber dealer and horse show judge. They had an office on North Grand Boulevard only a block from their office at Sportsman's Park, but it was later moved to Brentwood Boulevard near Litzsinger Road. The St. Louis Lustron demonstration house was put up only a

mile north of the office, but later it was sold and moved to another location. Eight Lustron houses were later built on one side of the street in a single block of Litzsinger Road in Brentwood, one of the biggest concentrations in the area.

Some dealerships covered areas large as metropolitan New York, the entire states of Connecticut, New Jersey, and Florida and in the Midwest, large portions of Michigan and Wisconsin. Eventually, when new dealers realized that more capital was required to set up franchises than they cared to venture or could raise, Lustron ceased the practice of dispensing exclusive dealerships and even began to try to wrest back the larger domains. They encountered stiff dealer resistance in this process. The company had difficulty in deciding just how many dealers it should have and how large the service areas should be.

Lustron also required the dealers to get the company's approval, in advance, of prices to be charged for houses in their areas, and it set the dealers' allowance for profit and expenses. Allowances were set on the basis of the projected volume of business that dealers were expected to have, but the agents protested that overhead on houses like Lustrons, which were essentially experimental in nature, was enormous and the profit allowance was too low. Lustron responded that the overhead should be lower than that for conventional builders because the company took care of providing such cost-saving services as national advertising and centralized purchasing. Dealers were required to pay in advance for houses before the factory made any deliveries. This requirement placed a heavy financial burden on the agents.

In the fall of 1948 and the early winter of 1949, the nationwide Lustron advertising campaign continued. Advertisements in trade magazines for dealer-

Present-day photograph of tan Lustron home in Belvidere, Illinois.

ships generated some 10,000 applications. Full-page color Lustron advertisements appeared in the September 13 and October 11 issues of *Life* magazine and the innovative radiant heating system located in the ceiling of the house was featured in the January 22, 1949, Lustron advertisement in the *Saturday Evening Post*.

Strandlund planned to have promotional materials in department stores as well, although this was hardly a radical strategy. An article in the *Architectural Record* of March 1946 indicated that both Wanamakers in New York and Philadelphia and Macy's in New York were involved in promoting prefabricated housing units.

Another variable that affected costs for the homebuyer was the labor costs for tradesmen. Chicago suburban plumbers,

who made the connections to the water and sewer lines in the slab, as well as to the bathroom and kitchen fixtures, worked for much more than the $2.50 an hour that a Des Moines plumber earned.

Local building codes also caused much more trouble than first expected. Chicago codes required plastered walls and ceilings for houses and this effectively disallowed any Lustrons from being built within the city limits. The model house at 4840 North Marine Drive (Lake Shore Drive and Lawrence) was consequently the only Lustron to be built in Chicago. Connecticut codes called for basements, but the local dealer was able to get an exemption from this requirement. Copper plumbing, which was used exclusively in the Lustron plumbing wall, was banned by many codes, including Atlanta, which

had been written during the days when cast iron pipe was the only thing available. Even Columbus had a requirement for stone or brick chimneys that initially caused a problem. The State of Tennessee forbade the use of tandem trailers in the weight range Lustron needed to use. Dick Reedy had to go to the Interstate Commerce Commission in Washington, D.C., to get federal pressure to allow the trucks to roll over federal highways in Tennessee to reach the markets in Georgia, Alabama and Florida.

Carl Rolen, sales manager for Lustron, recalled, "Sure, we had some troubles with codes, but nothing a more responsible builder couldn't handle in his own town. We had requests for specifications from some cities to submit to the building department. Unions and other selfish interest sections are responsible factors."

Hugh Cameron, who graduated from North Carolina State in 1942 and who was in the Army Air Corps (later, the Army Air Forces) for three and a half years in North Africa, Sicily, Italy, southern France and Germany, in the 27th Fighter Bomber Group, had been promoted to major at 21. He met Harold Denton in 1947 when he was released from the service and was hired by Denton as the head of the building code section. This group was to present the technical side of Lustron to approval agencies in cities and towns, but he relied on the local dealers to work the "politics" to get local approval.

Denton wrote to Cameron in 1988: "All [newspaper] writers refer to the trouble we had with codes. Actually, we had very little code or labor problems, as you know, and thanks to your efforts."[32]

The Federal Housing Authority gave the house a full stamp of approval and the FHA loan valuations averaged over 80 percent—remarkably high. Local FHA offices managed to frustrate the local

Lustron dealers by having their own local requirements. Indiana FHA offices insisted on having an overhead light in the bathroom, while Ohio did not care about this at all. Tennessee FHA required a door between the kitchen and the dining room, while other states approved the plan's open look that was utilized in the two Westchester models.

In St. Louis, after the local *Post-Dispatch* newspaper published editorials about the city code forcing Lustron to remain outside the city limit, the code was rewritten. In Detroit, one deed restricted construction on the property to brick. A hearing was held and Strandlund personally appeared and testified as did the original owner who regretted his decision, which had been made in 1909. The restriction was removed.

Lustron made the cover of the *Architectural Forum* in its June 1947 issue. Immediately following the story on five "Forum Yardstick Houses" which included the Kaiser Community Home bungalow and Levitt's conventional house (then being erected in large numbers in his Long Island development), the six-page article described the Lustron as attractive and durable, and noted its "low rate of depreciation, ease of maintenance, ease of cleaning and its proof against vermin, decay and fire."

During the latter half of 1948 and early 1949, things seemed to be promising for Strandlund's Lustron venture. The utilization of porcelain-enameled products seemed to appeal to Americans. The June 1948 issue of *Popular Science* magazine celebrated the Lustron as a product which "goes easy on your pocketbook."[33] The projected low cost of the new house apparently appealed to the veterans trying to get back on their feet after the war. The same veterans who were a primary audience for the Lustron house were remembered by a porcelain-enameled tower commemo-

rating the victory at Iwo Jima which had been erected on the Topeka fairgrounds at the summer 1948 Kansas state fair. The pylon included a porcelain-enameled mural of the famous flag raising on Mount Suribachi. Porcelain enamel was becoming the material of choice for many artisans.

On January 31, 1949, *Life* magazine published a "*Life* Round Table on Housing" which noted that "every poll on the subject shows that there exists in the back of the mind of every American, the dream of a house of his own." The round-table discussion featured the ideas of William Levitt, Carl Strandlund and housing consultant Frederick H. Allen. Levitt was credited with creating a revolution of size in the home building business. Allen proposed that a $100 million housing corporation based on the model of General Motors be created. Since the president of Lustron had originally requested a $50 million loan from the RFC to get the company going, later criticism of that request as too high must be viewed in the perspective of Allen's estimate of the capitalization requirements of such a venture as his. Strandlund noted that his new Lustron was a revolution in housing and the editors of *Life* agreed that the new Lustron was "a beautifully designed house."

Indeed it was. "The Lustron House," a promotional brochure, described a convenient, two-bedroom home with ample storage and closet space. The well-designed kitchen even had that Thor washing machine that could double as a dishwasher. The aluminum casement window frames did not have to be painted.

Another brochure given out at model Homes, "The Lustron Home: A New Standard of Living," described the unit as a durable product which was not a temporary house. The prospective buyer was informed that "While it will help to relieve the housing situation, this new idea in home construction is not an 'emergency' or stopgap project, but is planned on the long range basis of complete customer pride and satisfaction and as a new contribution to the art of living."[34]

Production Begins

The Lustron Corporation appeared to prosper as the freshly fabricated houses began to roll out the back door of the Columbus plant on 5th Avenue in the new yellow Fruehauf trailers in ever-increasing numbers. But back in Washington, the tide of opposition to the project began to build in direct proportion to the continuing loans that the RFC was making to Lustron on a more regular basis. While it was clear that the company needed the money to continue operations in the first critical months, the steady influx of public money to support the enterprise was equally obvious, and repugnant to the public officials entrusted to watch over it. The first waves of the new tide were almost unobserved back in Columbus, but soon could not be ignored.

The first production model to be placed on sale in the metropolitan New York area was built at 25 McGrady Street in Glen Cove, Long Island, by Karstan Builders. It went on the market on February 18, 1949, and was quickly purchased by one of hundreds of interested consumers.

A third RFC loan of $7 million was made in February, raising the debt of Lustron to $32.5 million. This loan was a short-term note designed to keep the factory running and to meet the payroll.

On February 25, 1949, volume production began for the first time at the Columbus plant with a reported 25 houses being produced daily by the 3,200 people employed. Later it was learned that this was actually a daily rate of 15 houses, but then, who was counting? Former congressional Representative Frank L. "Sunny" Sundstrom of New Jersey was now the vice president of distribution, sales and servicing at Columbus and took reporters through the plant when the production announcement was made. He noted that the company could break even if it could produce at least 35 units per day.

Some 250 houses had been produced up to this time, but almost all had been used for testing or demonstration in at least 100 cities across the East, Midwest and in the South.

The company was being run by an efficient handpicked staff. Russell G. Davis, who had been with Foote Brothers Gear & Machine Corporation, became the executive vice president of Lustron. General Eugene Reybold, former chief of the Corps of Engineers of the U.S. Army in World War II, was vice president in charge of production. Richard N. Jones was vice president in charge of sales, and Lorenzo Semple from the American Water Works and Electric Company, was vice president in charge of finance. Eugene E. Howe was head of the ceramic department, and Robert J. Runyan was chief engineer, both transferring from Chicago Vitreous Enamel Products Company. The plant superintendent was Ernest Olsen, formerly of the Oliver Machinery Company.

When production of the houses began, Strandlund made more appointments to ensure good control. Elmer D. (Ike) Walker was the former plant manager of Roberts & Mander Corporation in Hatboro, Pennsylvania, and became the manager of production planning. Lyman C. Athy was from the Ferro Enamel Corporation of Cleveland and had served with General Electric Company's enamel division at Schenectady, New York, Briggs Pluming Division at Detroit, Michigan, Pemco Corporation at Baltimore, Maryland, and International Products at Baltimore; he had a degree in both metallurgy (1923, Ohio State University) and ceramics (1941). He became production superintendent of the ceramics division.

Glen J. Holzberger was from Estate Stove Company where he had been in charge of all enameling for 20 years. He became assistant superintendent of the ceramic division. M. E. Lankford was from Chicago Bumper Division of Houdaille Hershey Corporation and became chief of the control laboratory. G. W. Lindberg was from the Frigidaire division of General Motors Corporation and had worked in enameling for Carnegie-Illinois Steel at Gary, Indiana; he became the chief of the chemical control laboratory. J. R. Karpowiez was the former assistant sheet superintendent at Chicago Vit and became the general foreman of inspection of the ceramic division. Finally, R. G. Sherman was also a former Chicago Vit employee who had also been chief physical tester for Revere Copper & Brass of Chicago. He became assistant general foremen of inspection of the ceramic division.

Although the production was now considered to be up and running, certain sections of the plant were able to outproduce others in these early days and this led to an imbalance of materials for the final house. To correct this overproduction-underproduction ratio, Lustron temporarily laid off 400 employees on February 22. Some 250 of these people had been producing parts by hand and their section was being converted to some automation. The other 150 were well ahead of scheduled production for their areas.

On March 16, 400 more were laid off after the roof trusses and exterior panel production units failed to keep up with the other plant production. The roof trusses section was working by hand and the work was shifted to partial automation not long after this to scale up output through the use of jigs and templates. The imbalance at times forced the plant to ship incomplete houses to the sites with some handmade parts arriving later. This became a serious problem with some of the first houses as the late parts did not always fit perfectly and some field adjustments had to be made to compensate.

An irate customer in New York made the papers when he finally went to court and filed suit against the franchised dealer there. After putting a down payment in his hands in July of 1948, the customer could not get a firm delivery date even after ten months of dialog. The case was settled out of court to his satisfaction not much later, but the incident did not help the company's image with the public.

By May, the New York papers reported that houses were being erected in Beacon Falls, Berlin, Darien, Fairfield, Manchester, Meriden, New Haven, North Haven and Old Greenwich in Connecticut. Long Island had "a large group" of three houses built on McGrady Street in Glen Cove. Others were built at Asharoken, Bellmore, Huntington and Rayville.[35]

One house was built at Palisades Amusement Park at Cliffside Park, New Jersey, where it opened on May 25. Admission was for the benefit of both the New York and New Jersey heart associations. The park planned to give the house

In Milford, Connecticut, this present-day photograph shows a Lustron home with a Lustron garage. (Courtesy Christopher Dick.)

at the end of the season to one of the visitors who made a Heart Association donation. This house had upholstered furniture, draperies and bedspreads of plastic Koroseal in place of conventional fabric. The living room used green and white striped plastic draperies, and the chairs were covered with Koroseal in a fern leaf pattern. Green rugs in this room and the dining room were of washable cotton. The boys' room had "virtually indestructible Formica" used as a top surface of a long table and the stools were "webbed in plastic." A studio couch was covered with Koroseal in a plaid pattern of rust, blue and white. Decorated by Patricia Harvey, the modern furniture was provided by Pascoe and the complimentary lamps were by Kyle Reed.[36]

The Strategic Air Command of the newly formed U.S. Air Force agreed to purchase 2,000 of the model 02 Westchester units in 1949. This was the single greatest order received and promised to

put the company over the break-even point. The units were to be erected at Carswell Air Force Base at Fort Worth, Texas; Walker AFB at Roswell, New Mexico; Biggs AFB at El Paso, Texas; Davis Monthan AFB at Tucson, Arizona; Chatham AFB at Savannah, Georgia; Bergstrom AFB at Austin, Texas; Rapid City AFB at Rapid City, South Dakota; Spokane AFB at Spokane, Washington; Smoky Hill AFB at Salina, Kansas; Castle AFB at Merced, California; and McDill AFB at Tampa, Florida. This order was obviously prompted by the creation of the United States Air Force from the former U.S. Army Air Forces, and those who drew it up may have overestimated the available funds for completing the bases. Later the same year, the huge contract was precipitously cancelled.[37]

By May, the conveyor belts at the Columbus plant were running at 20 feet per minute which meant that 100 houses *could* be produced for every 23 hours of

This well-maintained Bradenton, Florida, Lustron house is now used as an office.

continuous operation. This was the same as one house every 14 minutes into a trailer and out the door. However, only one eight-hour shift was in place with a small "makeup" shift used to balance the production demands. Lustron reported that the number of dealerships had increased to 143 accounts and that the factory had produced a total of 450 houses.

The United States Marines Corps ordered 60 of the model 02 Westchester houses for the base at Quantico, Virginia, just south of Washington, D.C. By May, 30 of the 60 had been completed and the team assigned to erecting the units was able to complete a house in less than 350 man-hours per house. The units were built for the use of the marine officers and some were assigned to certain enlisted men.

Many of these houses, if not all, remain on the grounds of Quantico today and are considered to be very desirable housing. They have been remodeled on two occasions and still retain their original appearance; the painted pastel exterior colors are somewhat unique.

Architectural Forum pointed out in its May issue that Lustron had two strikes against it: first, it had missed the peak of the housing shortage when there had been six customers competing for every house sold; and second, the units were not low-cost houses. The Lustron model 02 Westchester Deluxe sold for $10,000 in Wisconsin, $10,500 in New York, and for $11,000 in Illinois and Connecticut. Counterbalancing these problems was the "enormous market appeal of the Lustron."[38] The

porcelain-enamel finish gave a permanent rust resistance that was able to eliminate the 20 dollars a month maintenance reserve necessary for the upkeep of a similar sized house built of conventional materials. The one big disadvantage that *Architectural Forum* felt was obvious in metal houses—their high thermal conductivity—had been overcome by Strandlund through the use of glass fiber insulation and vinyl gaskets between the panels. The company had, in fact, capitalized on the conductivity in its provision of the low-cost radiant heating system. Lustron houses were selling well, while comparably priced conventional houses stood empty. The *Forum* reported that so many people had made down payments on the Lustron houses that one city in the East had over $200,000 in escrow waiting until the units were erected. Some of these buyers had put down 50 percent of the house purchase value in cash.

The *Forum* reported that a major sales handicap was the lack of a fixed national price for the Lustron houses. In Minneapolis, the substantially thicker foundation required to be built below the 48-inch frost line cost $400 more than the lighter foundation used in Miami.

Strandlund found that one market was lost to Lustron. The West Coast was too far to reach using conventional trucking over the highways of the late 1940s. To reach California and the other Pacific states, he needed rail transport, but the railroads quoted an exorbitant price of $1,668 to move a Lustron house to California. Strandlund learned that the railroads did offer good rates for carloads of like parts; thus, a carload of hot water heaters could move west for only $640. Strandlund offered to avoid filling a boxcar by driving a loaded trailer onto a flatcar at Columbus and driving it off on the West Coast, anticipating "piggy back service" by several years. The railroads

refused to budge and the result was that no Lustron houses were built west of the Rockies. The excessive freight charges would have been equivalent to 20 percent of the house value.

Late in 1949, architect Carl Koch of Boston was approached by the company and asked to design the new 1950 models. Koch was experienced in designing prefabricated houses, most notably the Acorn House, a structure that could literally be collapsed and moved around like a large aluminum tent. His associate, Leon Lipshutz, recalled that "Carl had a talent for publicity" and was known throughout the industry.[39]

Koch and his associates worked with the Lustron design staff (although at times this was an acrimonious association) to formulate a new model whose components were reduced from the 3,000 to 37 "by providing for the assembly of window sections, storage walls, plumbing walls and so forth in the plant itself" rather than on-site. The trucks carrying 3,000 parts often arrived with parts missing; or worse—the workers lost the parts during the assembly and erection of the house.

The new model featured two-by-eight-foot, load-bearing, solid wall sections that were interchangeable with similar sections containing door and window openings. The wall sections had a system of vertical ribbing to increase their strength, eliminate the heavy studs, and interlock tightly without the need of gaskets at the joints. This was a dramatic departure from the stud-and-panel construction of the earlier models.

The parts could be used in many combinations to create more spacious two- and three-bedroom homes with the option of an attached garage and a covered patio. By reducing the number of parts and increasing their interchangeability, Koch and his team created more variety in the appearance and floor plans of the

models for the customers. They also reduced the weight of the house from 12 tons to nine. The recommended interior color was several shades of gray so that, as Koch said, "the color motif ... could be established by the housewife herself by the generous use of color in rugs, fabrics, furniture, drapes and the like." It also featured, specifically at Strandlund's request, electrically operated windows.

The Lustron Corporation expected a high rate of return on its sales. Balancing the expected sales of $150 million against the invested $33 million gave a 4.5 ratio, far greater that the current 1.6 ratio found in the automobile industry. Yet expectation was not money in the bank, and the company needed still more loans to keep afloat.

11

The Tide Turns

The Senate Banking and Currency Subcommittee met in June of 1949 and had Harvey J. Gunderson, a director of the RFC, testify on the Lustron loans and their prospects. Gunderson told them that the Columbus plant was spending $1 million each month to operate, and he anticipated a request for another $3 million to be tacked onto the $32,500,000 already loaned to the company. Gunderson mentioned that the first houses had been mostly yellow or blue-green and that the company had decided to switch to gray with a green roof to present a more attractive look that would blend well in most neighborhoods. The first houses "look a little like hot dog stands," Gunderson told the Senate subcommittee.[40]

R. Harold Denton has observed that the turning point in the Lustron fortune was July 4, 1949. On that date, *Time* magazine published an article entitled "Bathtub Blues" which was very critical of the Lustron Company, its president and the RFC. The loans given to Lustron by the government were questioned. How long would the RFC "pour millions into Lustron?" the magazine asked. The article's long-lasting impact on Denton is clear, as he recalled both the title and the date without reference to his files.

It was unfortunate that this damaging national publicity in a popular news magazine appeared at the same time that the American public was beginning to be favorably impressed by the models of the new metal house. *City Limits*, the magazine of Bradford, Pennsylvania, featured the new Lustron model in town during the same month that *Time* was questioning the whole venture. Bradford was impressed by its Lustron, and so were those who visited the display models in other cities. Mrs. Denton preserved a guest book in which visitors to her Columbus, Ohio, Lustron wrote their reactions. "Practical and perfect" wrote one visitor, while another wrote, "The kind of house I want—no work."

Twenty-four houses were shipped out from the Columbus factory on July 7, 1949. This was the largest single day shipment up to that time and was equivalent to the production of one day's shift according to Joe Tucker, a senior vice president. The units were shipped to Ohio, Michigan, Indiana, Illinois, Wisconsin, Iowa, Kansas and Arkansas to the west, and to West Virginia, Pennsylvania, New York, Connecticut, New Jersey and Maryland in the east.[41]

One house was assembled on the fifth floor of Bamberger's, a large department store in Newark, New Jersey. Decorated with a $1,400 package of South Pacific themes, the house became a popular exhibit. The dining room featured a bleached mahogany dining room table and four rattan chairs with tropical fruit and floral prints on the cushions. A pale terra cotta–toned sectional sofa was in front of the living room bay window and was

85

In Des Moines, Iowa, this Lustron home owner has added a swimming pool to two surplus house kits.

complemented by three open arm chairs, two in pale birch and one lacquered in a "rich, dark brown," with matching cushions in terra cotta. A group of modern tables with an oriental look was used in the same room. The guest bedroom was fitted with studio couches and the decorator used wooden masks and photos of native islanders borrowed from the Philadelphia Museum to put on the walls. An artist was commissioned to paint maps of the Pacific islands directly on the enameled steel to offset the hangings.[42]

On July 21, the RFC announced the fourth and fifth loans to Lustron, this time for $2 million, to raise the debt to $34,500,000. These were actually two individual loans of $1 million each for working capital. Employment was up to 3,414, with 2,595 in the Columbus factory and 819 in the offices. The payroll for these people was averaging $880,000 a month.[43]

This loan package infuriated Republican Representative Frederick Smith of Ohio, a ranking member of the House Banking and Currency Committee. "I want to find out whether there is any truth to the reports that the Lustron Corporation has borrowed $34 million or more from the RFC while putting up only $800,000 as its share of the costs," Smith complained. On July 27, the House committee asked the RFC to disclose the amounts of the loans made to Lustron.[44]

Two days later, Strandlund told a press conference that he saw "nothing abnormal" in the RFC loans of "about 34 million" while private investment was "about $1 million," a creative use of the adverb. In addition, Strandlund men-

tioned the pledging of the patent right and "a lot of engineering, promotional work and other things" that should be considered as part of the private investment over and above the $1 million. Strandlund reminded Representative Smith, via the press conference, that the Emergency Housing Act "does not require that any private capital be put up." He also said that "the transaction should not be judged by conventional ideas."

Smith fumed over the comments and retorted that "There's a limit to how unconventional the RFC can be in lending $34 million or more" of the public funds.[45]

Smith became ill before the House hearings could be scheduled and he turned the probe over to Representative Albert W. Cole, Republican of Kansas.

"I am not afraid of the inquiry as such," Strandlund confidently told the reporters on August 3, but he then stunned the reporters by mentioning that Lustron would be asking the RFC for still more loans. "We have purchased all the equipment we need and are getting a real start on more production of houses," he told them. But the damage had been done.

During the last week of July, Lustron shipped 100 houses (an all time high for a week) and 42 houses on July 31 (an all time daily high). The forty-two houses went to 14 states in the East and Midwest. Some 3,150 people were employed on a single-shift basis at the Columbus plant at this time. Overall, Lustron had produced a total of 1,250 houses in the first 12 months of production.[46]

The House Banking and Currency Committee met first on August 4, 1949. "Is the RFC satisfied that this is a good loan?" Albert Cole began as he questioned Richard Dyas, chief of the housing branch of the Office of Loans.

"That is a question of philosophy. As a loan, and that may be the wrong name

of it, it has to be considered a pilot undertaking, an experiment. The question, It seems to me, is whether the experiment is working. I don't know how anyone can say definitely whether it is succeeding or failing. There are no yardsticks," Dyas replied.

Representative Cole reminded Dyas that only 1,253 houses had been produced.

"Yes," he replied, "but I don't believe the *test* of this company can or should be the number of houses it can produce." He felt that the venture could be considered a move on behalf of national defense.

Cole bitterly replied, "I hope in the future that the RFC doesn't interpret the statutes so broadly."

Strandlund appeared before the committee and told them that he had a letter of commitment from the government authorizing him to go forward with the project. The letter was signed by Wilson Wyatt. The RFC had received the approval of both the House and Senate Banking committees as well as an expression of approval from the White House before making the initial loan.

Cole lowered his voice and asked Dyas in another round of questioning if it was true that E. Merl Young, a former $7,193 a year trial examiner for the RFC who approved two Lustron loan applications in 1948, was now an $18,000 Lustron vice president. Both Dyas and general counsel James L. Dougherty told the committee that Young had nothing to do with approving the loans. "That is a matter decided only by the directors," Dyas said firmly.[47]

It is interesting to consider that Strandlund had not voluntarily hired Young away from the RFC, but had been forced to take him aboard by the RFC itself in the spring of 1948 to protect its own interests. Now Representative Cole put a new twist on the situation by implying a curious reward system highly favor-

able to Young. Young appears to have been a pawn moved by forces of control that had rewarded him for his assistance.

Cole's final thread of questions contended that for a small $1,000 investment, Strandlund and his wife had received 86,000 shares of the class B, no-par stock which gave the two of them complete control of the company.

Eleven days later, Representative Cole told a reporter that the RFC was "prepared to lend another $14,500,000 to the Lustron Corporation." RFC actually did hand over another $1 million to Lustron in early August. The debt rose to $35,500,000.

Not much later, American Community Builders, Inc., of Chicago announced plans to buy 2,000 houses with 1,000 to be the model 02 Deluxe Westchester and the other 1,000 to be the model 03 three-bedroom Deluxe Westchester. The plan, revealed on August 16, was for the houses to be built at Park Forest, Illinois, a planned community presently building in the prairie some 32 miles south of Chicago. The new town was next to the electrified Illinois Central Railroad which offered fast, clean suburban service to the Loop for residents who had to commute. ACB had already completed building 1,124 rental apartments, and 1,886 row-housing units were under construction.[48]

With a sigh of resignation, the Lustron Corporation laid off 400 workers on the next to the last week of August, and then followed up with a second layoff of 300 employees at the end of August. The reduction in force was blamed on production-line problems, but in hindsight, it was the end of the glory days.

At the same time, the RFC made still another loan of $2 million to raise Lustron's debt to $37,500,000. This was a total of $5 million in less than two months and the loans were seen as starting a trend of ominous debt building.

Strandlund found that the Lustron's basic problem had become one of financing. The Lustron Corporation demanded that each order be accompanied by cash. With up to 60 days for an owner to get an FHA loan, and the Lustron houses going up in only six days, a dealer had to have working capital of $50,000 to handle just one order a week. Looking over the options, Strandlund acted by forming the Lustron Mortgage Company and planned to fund it by asking for a $14,500,000 loan from the RFC, the very sum that Cole had mentioned. While this sum could be covered by two pending congressional bills, the RFC worried that the entire fund would channel directly to Lustron. They felt compelled to warn Congress on August 31 that the new Spence Housing Bill passed by the House of Representatives and the similar Sparkman Bill approved by the Senate Banking Committee would authorize the RFC to loan up to $50 million to aid the manufacturers of prefabricated housing. Since the RFC had already loaned $37,500,000 to Lustron, their new request for $14,500,000 would boost the total to $52 million and freeze out all the other manufacturers.

The plan appealed to Representative Monroney who wrote Section 8 of the Housing Act Amendment 102a. This would authorize the RFC to loan up to $25 million "for the purpose of aiding the distribution, erection and marketing of prefabricated houses manufactured with financial assistance under Section 102." This amendment would have permitted the Lustron Mortgage Corporation to take out an RFC loan and purchase houses from the Lustron Corporation. In turn, the Lustron Corporation would then be able to pay back some of the money it had borrowed from the RFC which Lustron had used to tool up the Columbus factory.

Representative Brown of Georgia

agreed that it was "only good business to use part of this money to send it to the consumer so that the RFC can get their money back."

Representative Wolcott argued against the plan since it seemed to serve no purpose other than to give money to one Lustron company so that another could pay some of the new funds back while holding still more of the public funds. (Wolcott had amazing foresight as to what really was about to take place.) The vote on October 13, 1949, was 72 against the measure to 64 in favor of passing it.

That same month, Representative Albert Cole, still unhappy with the House Banking and Currency Committee hearing results, called for an investigation of Lustron and the alleged mismanagement and waste of RFC funds. Cole said that Lustron had to produce "700 houses a month to break even," but that its October production would be less than 100 and that even these could not be sold. "Over $3 million worth of houses are crated and standing forlornly on trailers at the Lustron plant with no takers," Cole told the reporters.

The murky waters began to rise more quickly now. Joseph Tucker, senior vice president, and Lorenzo Semple, vice president in charge of finance, both resigned suddenly in October after the RFC demanded their removal. Strandlund began spending more time in Washington defending the company in the backlash of the investigations, and the Columbus plant had to run without any senior management for periods that were much too long.

Then on October 15, three directors resigned from the board "to get wider public representation in management." Paul Buckley, Fred M. Lowum and George Delp gave no other explanation, but the resignations seemed to be in response to the investigation of the House subcommittee.

The investigation had a direct effect on production at Columbus. From the high of 26 houses a day in August, the line slowed to produce only six units daily in October. Although 2,100 units had been completed, the financing problems had held the actual sales to only 1,700 houses. The plant held 365 firm orders on the books which were backed by the required 10 percent down payment, which left 35 units in the back waiting for buyers. The plant laid off nearly two thirds of the employees and retained only about 1,000 of the 3,400 who had been employed in July. In addition to the houses, the plant began to produce panels and other parts for one- and two-car matching garages, breezeways, patios and other ancillary parts.

There were plenty of buyers for the steel houses despite Cole's rhetoric. One unusual purchase in October was that of Cornell University's College of Home Economics which purchased two Lustrons for a study of farmhouse space requirement. Neither of these two units had the interior partitions installed, but they did have the complete bathroom and the utility room in place. The houses were erected at the rear of the Martha Van Rensselaer Hall where they were to serve as laboratory shells for the project.[49]

Lustron's problems with the press continued. *Newsweek*'s October 10, 1949, issue reminded readers that the company had already received $37,500,000 from the government and was asking for more. By that time, *Newsweek* saw the whole project as a gamble, especially since the Lustron plant was closed "for inventory," and was faced by a new problem of consumer financing. Noting that the dealers had to pay cash for Lustron units, the magazine hoped that "the financing problem might be worked out," but the tone of the article was decidedly negative. *Business Week* entered the fray with an October 29, 1949,

article entitled "What's Stalling Lustron?" Noting that the company was "up to its neck in trouble," the editors suggested that the company would survive if a change in management was made.

Things got worse in November with *Business Week* analyzing "The Lustron Affair" as an example of the perils of government financing. They ran a photograph of the Lustron house with the subhead "The House That Government Jack Built."

The RFC told *Business Week* (October 29 issue) that they wanted Strandlund to surrender 60,000 of his 86,000 shares of common stock which they proposed selling to one of several investment groups for $10 a share. One of these groups included Rex Jacobs of the F. L. Jacobs Company of Detroit, of whom we will hear more later.

The *Saturday Evening Post* picked up the theme in its November 5 issue, noting that Strandlund had a stable of racehorses, and that he stayed at the exclusive Mayflower Hotel when visiting Washington. The article, "Lustron—The House That Lots of Jack Built," implied that the project was a boondoggle. It noted that the Lustron factory in Columbus was an enormous facility, but "it is a big day even now when thirty houses leave the plant."

Not too many months after Representative Cole's revelation in Congress of Merl Young's relationship with the Lustron Corporation, Young resigned, in November 1949. The *Wall Street Journal*, in one of its stories, identified Young's wife as being the assistant to President Truman's personal secretary, Rose Conway. There was nothing wrong with this, but the possibility of a direct pipeline to the President's ear, bypassing Congress and cabinet, was an affront to those who supported "government by the book."

Not much later, Congress adjourned

for the year and brought to an end the investigations by Representative Cole. Strandlund breathed a big sigh of relief, packed his bags, and left the Mayflower Hotel to return to Columbus to redirect Lustron operations and prepare his next moves to save the company.

On November 11, Lustron announced that the American Community Builders proposal to purchase 2,000 houses to be built in Park Forest, Illinois, had been confirmed for about $20 million. The RFC revealed that it had approved $6,390,000 for American Community Builders, which was headed by Phillip M. Klutznick who had once been chief public housing executive in Washington. The RFC knew that Klutznick was likely to use the money to purchase the Lustron units as part of the 2,000 house order, but denied putting any pressure on ACB to utilize the public moneys in this way.[50]

However, it was not to be. By the end of the year, this contract, too, had been canceled.

Neither the Strategic Air Command order for 2,000 houses, nor the American Community Builders order for 2,000 houses came to fruition. Not one house from these two orders was sold; not one was erected. It was a bitter pill for Lustron to swallow after accepting these huge original orders.

Two days later, an article by Lee E. Cooper in the *New York Times* discussed the Wherry Act, passed by Congress during the summer, which provided for a military housing construction program. The Fort Dix, New Jersey, project called for housing some 300 families, and Lustron units were ideal for the plan according to military sources. The Westover Air Force Base in Massachusetts which needed 1,400 housing units also seemed ideal for Lustron units. While the article was upbeat and probably encouraged the men in

Columbus, nothing ever came of these opportunities.[51]

Fortune magazine ran a feature story in its November issue titled "The Lustron Affair" in which the primary idea expressed was that "the Lustron case has set a precedent. This is the first time the government has appropriated, in peacetime, any considerable sum for private venture capital."[52]

Forbes magazine published a far more damaging story titled "Wonderland Revisited" in its November 15 issue. Quoting liberally from Lewis Carroll's *Alice in Wonderland*, the author counterpointed the Lustron story with selected nonsense.[53]

A series of bipartisan debates in Indiana occurred at the cities of Richmond (east of Indianapolis) and Valparaiso (south of Gary) between Republican Senator Homer E. Capehart, who was baiting the Democrats, and Democratic Representative Andrew Jacobs, who was on the defensive. The Lustron waters were stirred again when Capehart declared that the Government was "squandering your money and mine over in Ohio on Lustron homes." Jacobs countered that former Republican Representative Frank Sutherland of New Jersey had made the RFC loan possible and that Republican Senator Ralph E. Flanders of Vermont had testified in favor of the loan.[54]

Capehart then blamed Democratic President Harry Truman for being instrumental in approving the loan. "The word came over that the President of the United States was insisting that the loan be made. When we investigated, we found that the place was filled with people from Missouri." (The Columbus plant was not "filled" with Missourians. Strandlund later swore that he hadn't "even one Missouri footballer on the payroll." This comment, too, needs explanation. Strandlund had played sandlot football as a youth and was an avid football fan. He had a close relationship with the University of Minnesota football coach Bernie Bierman and he had hired members of the Minnesota squad during the summer for the Columbus plant. When the local Ohio State University football squad members complained, Strandlund hired them too.)

On December 2, 1949, the consulting firm of Booz, Allen and Hamilton submitted a report to the RFC on the efficiency of Lustron. The report, which was on the whole more than a little favorable, unfortunately did not reach Strandlund until the following June. The Booz, Allen report cited Lustron's plant as being "laid out in such a way as to attain minimum operating costs." It noted that substantial cost reductions had been made during the short operating history of the firm, and that the plant was well located with respect to transportation, utilities, sources of supplies and markets. It stated that "every customer, which their representatives interviewed, [was] pleased with the house, and that Lustron [had] obtained favorable consumer acceptance." The report recommended that two executives be added to the Lustron management. This recommendation was contrary to the RFC demands that most of the top executive personnel be dismissed. "The top management level," the report stated, "is not the place to cut costs when a company is facing the management problems which Lustron faces. With the change in organization structure and the additional personnel suggested here, we believe that the top management structure and personnel would be adequate for efficient operation."

One of these additional positions was controlling the new marketing division; the other was one that had been established earlier, but was vacant when Booz, Allen and Hamilton made its report.

Things came to a head in late 1949

when the RFC terminated its loans to Lustron Corporation on December 28. Representative Albert Cole had written the RFC demanding to know if more loans had been made to Lustron (they had not) or whether Lustron had made any payments on the debt (it had not). The RFC spokesman told the reporters that Lustron had been building still more houses with the available stock of materials and had been selling these units at a loss to meet operating expenses.

The next day the RFC issued an ultimatum to Lustron to submit a plan of reorganization by January 6, 1950, for getting the company back on its feet.[55]

The same day, Strandlund told reporters that Lustron would seek another loan while stepping up production and reorganizing the structure of the company as of March 1. He told of firm commitments for 5,000 Homes for several large housing projects in addition to the regular sales. He was optimistic once more and reported that the monthly losses had plunged from $1 million a month to a mere $600,000. Actual sales had reached 2,000 units.

Unaware of the favorable Booz, Allen and Hamilton report that would have strengthened his resolve, Strandlund still steadfastly refused to give up control of the company or to give up his shares. He entrenched himself against further changes in personnel and submitted a reorganization plan on January 5, an hour before the deadline. Neither Strandlund nor the RFC would discuss the contents of the proposal although Strandlund felt it conformed to the wishes of the RFC. Five days later, the plan was rejected as "wholly unsatisfactory."

A week later, the RFC declared that Lustron "is in default" on the major part of the loans. It began to evaluate the advisability of foreclosure, receivership, or another legal action that would allow it to seize the assets of the Lustron Corporation.

Strandlund told reporters that the foreclosure option would give the government only five cents on the dollar if it was lucky. He proposed that there was a "99% chance for success without foreclosure." He asked for an eighth loan of $3 million to expand the sales force and pay other expenses, and a ninth loan of $2 million to use as a cash reserve. He also asked for firm contracts to supply some of the 250,000 housing units needed by the armed services.

The Lustron Corporation issued a press release on January 17, although dated December 31, 1949, which was sent to newspapers all over the country (Appendix A). It comprised a cover letter by Strandlund, and an accompanying "Fact Sheet"—a history of the company, descriptions of the houses and the Columbus factory, and a complete rundown of other information on sales, dealerships and operations. It revealed that there were 234 dealers in 35 states and one dealer in Venezuela. The 1,970 houses shipped were listed by state with the greatest number, 307, in Illinois and the fewest, two, in South Carolina. Five units had been exported (two to Alaska, two to Venezuela, and one to an unknown destination) and 11 units were designated as "Test & Demonstration" (Appendix A).

Newsweek's January 23, 1950, issue foresaw the RFC foreclosure on Lustron as a distinct possibility ("Hot Spot for Lustron"), and published an article asking "Whither Lustron?" in its February 27 issue. The February piece reported that the RFC had finally denied further funding for Lustron. Buyers, noted the article, were well satisfied with their Lustron homes, but the prices were still too high for the company to sell enough homes to stay in business. This adverse national publicity clearly undermined the

effectiveness of the Lustron advertising campaign.[56]

Clearly emerging from the events involving the RFC and Lustron in 1949 is a picture of friendly support in the form of granting loans and expressing confidence in Strandlund's management of the company at the outset, and then, by autumn, the beginning of overt moves to take control of the plant from him and transfer it to a committee appointed and directed by the RFC. On August 10, 1949, the last loan to Lustron was granted, followed by growing pressure on Carl Strandlund to replace all of the management and the board of directors with RFC people and eventually a proposal to replace Carl Strandlund, himself. The RFC also tried to force Strandlund to divest himself of the 60,000 shares of common stock he owned in the company and to submit a plan for the reorganization of the company by year's end using guidelines provided by the RFC. The reason the agency gave for this action was that this would improve the operating efficiency of the company and cut the number of unsold houses then in inventory.

Lustron buyers were more than enthusiastic with the homes. A letter to the editors of *Business Week* published in the February 23, 1950, issue was written by Bernard Kinsock of Cuba City, Wisconsin. Kinsock was delighted with his Lustron house and wanted the readers of *Business Week* to know it. He was tired of the constant barrage of negative reports about Lustron and suggested that these reports came "from those who have never been inside a Lustron or who will suffer financially from its erection."

As if in answer to *Newsweek*'s question about the future of Strandlund's operation, Lustron plant manager Eugene E. Howe suggested in the February issue of *Better Enameling* that Lustron could survive by broadening its market by selling porcelain-enamel housing components, including roof shingles for remodeling existing houses.

Howe's suggestions fell on deaf ears.

Four consecutive stories by Joseph Driscoll, the national correspondent for the *St. Louis Post-Dispatch*, were more thorough in their analysis of Lustron than any of the earlier treatments by the news magazines. Together called "$37,500,000 FIZZLE," the individual installments that were carried in many of the nation's papers were titled "The Lustron Corporation: Its Huge RFC Debt and Colorful Career of Promoter Strandlund"; "U.S. Put Up Millions for Houses When All He Sought to Build Was Oil Stations, Lustron Head Says"; "Lustron Head Criticizes RFC, Blames It in Part for Failure to Mass Produce Dream House"; and "Lustron Head, Seeking More RFC Cash, Still Insists He Can 'Revolutionize' Housing."[57]

Driscoll described Strandlund as being "broad shouldered, short legged, round faced. His voice is thin and high. A trim mustache tends to compensate for the receding hair on his shining scalp. He likes brown suits, green ties, white shirts." This style set the pace for the stories: clear, concise, but with the knife-edge of criticism lurking just below the surface.

Strandlund was questioned at length by Driscoll and stonewalled some of the questions about the RFC and the talk of takeover circulated by that agency. Then he and Driscoll got chummy. Carl, as he liked to be called by his friends, asked "Have you seen those beautiful houses we erected for the Marines at Quantico and for the atomic bomb engineers at Los Alamos? We have a dealer in Venezuela who erected a Lustron nest to the American Legation [in Caracas]. Great throngs of natives turned out to inspect the building and admire its clear American engineering technique. I've been told that one Lustron has done more for friendly rela-

tions down there than 10,000 Voices of America!" Carl modestly told him.

Driscoll probed and found that Strandlund apparently felt that the congressional criticism directed by Representative Cole of Kansas was not just based on concern for the public moneys, but was a "propaganda campaign of revenge" directed by former Representative Frank Sundstrom, who Strandlund had hired after he lost his re-election and then fired during the late summer of 1949. "Sunny" was released after Strandlund realized that the plant was producing more units than the sales department was able to move. It was clear that Strandlund felt that "Sunny" had influenced Cole to strike back at the company.

Strandlund revealed to Driscoll that his personal guarantee for the original RFC loan meant that he had "pledged his personal fortune toward their repayment." The restrictions of the loan agreement forbade Strandlund from taking "any undue risks such as flying by airplane."

Driscoll baited Strandlund by asking if he lived in a Lustron house himself and was startled to learn that although Strandlund and his wife lived in a conventional home on an estate north of Columbus in Westerville, they did have a full three bedroom model 03 Westchester house on the estate which they used as a guesthouse.

Amazingly, Driscoll's persistence did reveal exactly where the millions of dollars had gone. Of particular interest was the rent of the Columbus plant ($940,000), and the interest paid on the RFC loan ($1,586,000). Both of these sums had been returned directly to the government, yet the RFC had claimed in December 1949 that *no* payments had been made on the debt.

The RFC hired an outside firm to evaluate the problems with the Lustron sales. The biggest problem seemed to be that the houses (Westchesters 02 and 03) were no longer even moderately priced. The Westchester 02 had gone from the original proposed retail price of $7,000 into the $10,000 to $12,000 bracket. Strandlund faced this problem squarely and had the engineers develop a new model known as the Newport.

Although at least one model shipped as early as November 1949, the Newports went into general release in February 1950. But with the company under attack by the RFC, the Newport did not get wide distribution and was only marginally accepted by the public.

Meanwhile, the White House rose to Lustron's defense, albeit much like the stirring of some huge leviathan that shrugs its shoulders and then settles again into the sea of muck after being disturbed. David H. Stowe, an administrative assistant to President Truman and deputy to John R. Steelman, who was now the acting chairman of the National Security Resources Board, told the RFC to "think twice before clamping down on Lustron." Stowe added that the NSRB considered housing prefabrication an important part of the nation's defense plans!

Still, the warning was not enough to sway the RFC from its set path. On Valentine's Day 1950, it ordered foreclosure proceedings to be started against Lustron Corporation in the Federal District Court in Columbus, Ohio.

This was nearly the end for Lustron. As we shall see, there were many legal loopholes yet to be tested with a number of surprising twists and a bit of fate tossed in, but the game was essentially over. The Columbus plant kept operating for the next few months building Westchesters, Newports, garages and breezeways, but the jig was definitely up and everyone knew it. It was just a matter of picking at the bones.

Carl Strandlund and his wife found their house in Westerville, northeast of Columbus, to be too big for just the two of them, and soon shared it with her sister's family, the Sandborgs, including the young 16-year-old Ron Sandborg. (Collection of Ron Sandborg.)

Foreclosure

It was no valentine that the RFC laid before the press when it revealed that it had ordered foreclosure proceedings started against the Lustron Corporation in the Federal District Court in Columbus. The Lustron people knew that it was the beginning of the end for the company and for Strandlund's dream of a self-sufficient prefabricated housing factory and sales program.

The House Banking Committee was startled by the decision and voted the next day to see if the government should operate the plant to prefabricate housing for the armed forces. Louis Johnson, Secretary of Defense, and Harley Hise, chairman of the RFC, were invited to sit in at a closed-door meeting to discuss the idea.

Representative Albert Cole told a reporter, "This looks like an effort to put the Government into the prefabricated housing business. I don't think the Government had any business getting into it at all."[58]

The foreclosure suit was filed on February 22 against a mortgage of $36,466,273 and was assigned to United States District Judge Mell G. Underwood, who probably accepted the job as just another routine procedure. It was not to be so.

The Senate Banking Committee, chaired by Senator Burnet R. Maybank, Democrat of South Carolina, set a hearing on the foreclosure to be held in Columbus. Maybank mentioned that several companies were interested in Lustron if it was to become available, and other sources speculated that these included U.S. Steel's Gunnison Homes subsidiary which was producing wooden prefabricated housing, and Republic Steel Corporation which had no share in this market.

Judge Underwood appointed Clyde M. Foraker of Columbus as the receiver for the Lustron Corporation on March 6 for a trial period of 30 days. Foraker quickly resigned as chief of the field division of the Internal Revenue Department to take the new assignment.[59]

Foraker got his teeth into the bit with no hesitation and two days later fired all but two of the Lustron top officials to save the remaining funds. The payroll as a consequence dropped from $156,037 a month to $70,723 a month. Carl Strandlund was one of those "released." It was a staggering blow to Strandlund, but it was done. The plant limped along under Foraker's direction producing still more Westchesters, Newports and various other parts, but the pace had fallen well off and it was a token production as everyone waited for the next shoe to fall.[60]

Senator Flanders proposed in March that the loans to companies like Lustron should be handled by the Housing and Home Finance Agency (H&HFA) instead of the RFC.

The Congress of Industrial Organizations (CIO) accused the RFC of hos-

tility towards the new prefab industry when they saw the number of lost and potentially lost jobs at the Columbus plant.

On April 3, the receivership operation was extended for an indefinite period by Judge Underwood who felt that Foraker was doing a satisfactory job.[61]

A month later, on May 5, Judge Underwood approved an order to sell the Columbus plant, its machinery, the land and patent rights. It was apparently about this time that the machinery ceased stamping, the conveyors slowed to a stop, and the furnaces were scheduled to be shut down for the last time. The remaining employees were sent home except for a skeleton crew of 70 needed to handle the final details for the receiver. The battle to hold on was over. Or was it?[62]

Before the Lustron Corporation ceased all operations and the factory was closed, 2,680 Lustron Homes had been erected in the United States, the Territory of Alaska and in Venezuela in South America. A mere 30 were put up in 1948 and production hovered around 100 units per month in the early part of 1949. This peaked in July with 270 units shipped from Columbus just as the RFC began to exert pressure and the bad press publicity began. Shipments remained close to 200 units a month for the rest of the year and then declined until June 6, 1950, when the last house was shipped. Thirty-six cash orders were returned to prospective buyers on June 6 since they could not be filled.

By the end of 1949, there were 234 dealers in 35 states. Most of the units had been shipped to Illinois (307) and the fewest (2) went to South Carolina (Appendix A). Amazingly, 38 units were shipped to Venezuela and erected in the Caracas area, the only units to be built in a foreign country. Two units were built in the Territory of Alaska, as we have seen,

at two air force bases in Anchorage and Fairbanks.

Strandlund told Congress in 1951 that he suspected that the suit was intended to wrest control of the company from him because on May 16, 1950, the RFC attorneys had told Strandlund's lawyer that they would drop the lawsuit if he would relinquish his stock in the company. After agonizing over the matter, Strandlund "decided that it was wrong in principle to submit," and began to opt for ways to retain control despite the interference.

Strandlund went to court on May 22 and told the United States District Court that he could not pay off the $15,500,000 in notes that he had signed when the first RFC loan had been granted.

Foraker organized the sale of assets by auction for June 6 from a platform that was built in front of the building's entrance. Although a crowd of 300 people milled about, when deputy marshal Robert Sack called for bids, only the RFC called out their bid for $6 million. The bid still had to be confirmed by Judge Underwood on the following Friday at 2 P.M. to become binding. Then, in a separate transaction, an estimated $700,000 worth of unmortgaged steel intended for the houses was awarded to Lafayette Steel Co. of Detroit and Chicago for $645,000. The RFC now had exactly what it wanted: full control of the plant, and the removal of Strandlund from the enterprise. Even the agency itself was somewhat surprised at how easy it had been.[63]

Two days later, on Thursday, June 8, three Lustron Corporation dealers blocked the sale to the RFC. In Chicago, United States District Judge Phillip L. Sullivan issued a temporary injunction restraining Clyde Foraker from disposing of the plant. The three dealers — Evansville (Indiana) Lumber Company (which was owed $3,000), Land Development Company of

Chicago (owed $1,592), and Northwest Inc., of Lima, Ohio (owed $250)— together claimed a judgment for $4,842 and jointly had their lawyers go to Sullivan's home after court had closed for the day (since a judges' meeting the next day effectively closed the court until after the weekend) and pled for immediate action. They asked the court to reserve their right to proceed against the encumbered assets. Sullivan reviewed their case and gave them the restraining order. One lawyer, Michael Gesas, the dealers' attorney, carried the order to Midway and flew quickly directly to Columbus to serve it on Clyde M. Foraker and the RFC by hand, although he actually ended up appearing before Judge Underwood. Underwood realized that the restraining order had its own potentially damaging effect on the plant. At risk were the ceramic kilns that were being slowly and gradually cooled to prevent any damage. One interpretation of the restraining order would have restricted all activities in the plant and put the kilns at risk.

Underwood admonished Gesas that "In order to save your clients three or four thousand dollars, the taxpayers of the United States may lose hundreds of thousands of dollars between now and next Monday. This court is not attempting to dictate to Judge Sullivan, but this court was merely curious to know whether or not Judge Sullivan had been fully apprised of the dire consequences which might result from the entering of this order."

The lawyer replied, "Under broad equity powers that you possess, I think you can see a preservation of this property."

Judge Underwood flushed and shot back: "In other words, you would have this court modify Judge Sullivan's order?"

Gesas dropped his head slightly, and slowly said, "I wouldn't presume anything to this court with reference to modification."

Because of the new order, Underwood was unable to make a judgment on Friday to confirm or deny the two auction sales of Lustron assets that had occurred on Tuesday. Although Underwood could still discuss the case, Foraker and the RFC attorneys were forbidden to discuss the status of the auction because of the Federal Court's action.

On June 10, the Department of Justice agreed to investigate the Lustron Corporation without delay. "All evidence indicating criminal aspects are going to be investigated fully and completely and such action taken by the Department of Justice as the facts warrant." This was a direct result of the discovery of a canceled $10,000 check from the Lustron Corporation to Senator Joseph R. McCarthy of Wisconsin. The payment was for an article written by McCarthy and published as a promotional booklet by Lustron. Questioned by reporters, McCarthy told them, "I just sold to the highest bidder," and said that he considered the sale an ordinary competitive matter.

Strandlund relied heavily on the Booz, Allen and Hamilton report in his letter sent on June 13, 1950, to the Senate subcommittee investigating the RFC actions. He criticized the RFC for "hinting" that the report was unfavorable when, in reality, it was not. The Lustron chairman also included the sales figures to demonstrate that the company had firm orders for some 7,957 units at the end of November 1949. Most of these were to be built under contracts for housing projects in Park Forest, Illinois, Fort Dix in New Jersey, and Cleveland, Ohio. As of the end of February 1950, he was able to report the 2,223 houses had been erected across the country.

The RFC requested the dismissal of the June 8 restraining order, but Judge Sullivan in Chicago surprised them by issuing an involuntary bankruptcy order

The receiver's auction of the Lustron Corporation assets to satisfy the RFC foreclosure took place in front of the factory on the front steps on June 6, 1950. Some of the 300 people who showed up for the event can be seen. (From the Clyde Foraker Files, Dan Foraker Collection.)

Another view of the June 6, 1950, receiver's auction of Lustron Corporation assets clearly shows the brand new Lustron "Newport" house built in the parking lot. (From the Clyde Foraker Files, Dan Foraker Collection.)

for the Lustron Corporation and naming three receivers, while Judge Underwood at the same time confirmed Foraker's liquidation sale results!

On June 14, 1950, the RFC, with Judge Underwood's approval, attempted to take possession of the Lustron Columbus plant when U.S. Marshal Harold K. Claypool arrived to turn the plant over to the RFC at 11 A.M. EST. Twenty minutes later, at 10:20 A.M. CST, Judge Sullivan in Chicago signed an injunction barring the RFC from the plant it had just taken. The legal meshings became even more complex when Judge Underwood's receiver, Clyde Foraker, refused to deliver the plant to the RFC or to the U.S. Marshal because of Sullivan's injunction which was reported by telephone to his office. Judge Underwood then had deputy United States Marshal Ralph S. Quelette take possession of the plant on June 16, two days later, from his receiver and turn it over to the RFC!

Carl Strandlund was quick to see that Judge Sullivan's action was beneficial and a day later, on June 15, 1950, he filed a "solemn oath" that he was "President of Lustron Corporation, the above named bankrupt" and attached a list of creditors. This was filed in the District Court of the United States for the Northern District of Illinois, Eastern Division, as part of Case 50 B 447. The list had 236 creditors listed by name and address, including three railroads (the Baltimore & Ohio, the New York Central, and the Pennsylvania Railroad), the Mayflower Hotel in Washington, the War Assets Administration, and the Reconstruction Finance Corporation. The latter had originally had a Cleveland, Ohio, address typed in, but this was erased and a 208 South LaSalle Street, Chicago, Illinois, address was typed over it—the only correction of this kind on the list. Strandlund saw his fortune change with this turn of events.[64]

Strandlund was brought back to the witness table at a Senate Banking and Currency Subcommittee investigation on June 28. There he told the Senators that Joseph McCarthy was the only member of Congress to be paid for a service by Lustron. Strandlund called the booklet "very well written" and "excellent for our purposes." Lustron sold this booklet and another booklet written by other authors and received $46,000 in revenue, according to Strandlund. This was actually a bit of justification since the subcommittee later found that McCarthy's booklet alone had brought in $4,350 when sold at 29 cents each. Since Lustron had paid McCarthy $10,000 and paid $2,762 to print 20,000 copies, the sale of 15,000 booklets had resulted in a loss of $8,412 according to Clyde Foraker, Judge Underwood's receiver, in testimony on July 1.

In the proceedings concerning the Lustron bankruptcy, Walter Sczudlow, an RFC attorney, obtained a recess on June 21 when he told Judge Sullivan in Chicago that the RFC wanted to file an appeal with the Federal Appeals Court. Judge Sullivan granted Michael Gesas, the attorney representing the Lustron dealers, permission to question three RFC lawyers to see if they had violated Judge Sullivan's order of June 8 which had suspended the foreclosure proceedings. This questioning had to wait until the RFC appeal was settled, however.

Judge Sullivan denied an RFC motion made by attorney Stephen R. Chummers to dismiss Sullivan's injunction of June 8. Chummers felt that Judge Sullivan lacked jurisdiction since the Columbus court had been in possession since appointing Foraker as the receiver on March 6, and its order stood "undisturbed as an order of a court of equal dignity." Chummers went on with this rhetoric, saying he felt that the three dealers' case was damaged as it held "scurrilous mat-

ter" and included Judge Underwood in the presumed "guilt in any action RFC might have taken."

Judge Sullivan realized that the standoff between the Columbus court and the Chicago court would have to be resolved by a higher authority. He asked Referee Wallace Streeter on June 27 to decide whether his order blocking the sale to the RFC should stand. This action was prompted after Lafayette Steel Company asked the court to allow them to take possession of the steel they had purchased at the receiver's sale. Judge Sullivan had sympathy for this third party that had been trapped in the legal manipulations of the lawyers.

Meanwhile the RFC petitioned the United States Circuit Court of Appeals to rule the Chicago United States District Court out of bounds on the Lustron Corporation case. This action was taken on June 26, and on the same day the RFC chief of the investigation division, Paul J. Cotter, had startling news for the Senate Banking and Currency Subcommittee. Cotter told the Senators about an apparent wrongdoing. Lustron had contracted with Commercial Home Equipment Company of Chicago in 1948 to rent tractors and trailers to move the completed houses to their sites. CHE had failed to deliver 40 of the 200 tractors for which it charged Lustron rental each month, a "fraudulent overbilling of Lustron by Commercial Home in excess of $500,000," Cotter reported.[65]

Testimony later revealed that Commercial Home Equipment was owned by John and James Gottlieb who operated a Chicago trucking company, and Paul O. Buckley, who was a Lustron director. The company seems to have been set up primarily to bid on the Lustron tractor business. The Lustron contract with CHE required it to have at least $200,000 in capital on September 30, 1948, but

Cotter found that the company "had but $2000 in paid-in capital." Buckley had filed a CHE financial statement showing a capital of $252,000 on September 30, and Cotter felt that Buckley's "dual capacity" as both Lustron director and CHE owner was indicative of "fraud ... committed against the RFC." Cotter reported that Lustron had paid $3 million to CHE for tractor rental.

James Gottlieb testified in Washington on June 29 that the missing tractors were stored in Cleveland ready for use by Lustron. But under examination, he was forced to admit that CHE never even owned the 40 tractors that had been sold to another concern during the rental period. CHE continued to charge Lustron rental for the tractors even after the date they were sold. The two Gottlieb brothers and Paul Buckley were paid only $15,000 annual salary, but removed $334,000 in a single year for themselves in the form of loans from CHE. On August 11, the Senate subcommittee requested that the Department of Justice investigate the charges against Commercial Home Equipment.

Only two days earlier, Representative Albert Cole had demanded that the RFC explain why it had not discovered the overcharges earlier since the monthly payments had begun in November 1948 and extended to February 15, 1950. "It looks to me as though the RFC let someone get away with something right under their noses," Cole gloated. "I want to know what those men were doing there if the overcharges continued for so many months without their waking up to it." Cole reminded the press that the RFC had kept an engineer and a loan examiner at Lustron's Columbus plant full time since the first RFC loan was made.

Meanwhile, the token force of 70 that had been kept on at the plant had gone unpaid since the RFC purchased the

plant. Foraker had stopped paying their wages at that time. In July he pleaded for the courts to find a way to pay the men and this was accomplished not much later.

On August 18, Harley Hise, who had received his walking papers from the RFC but was waiting for his replacement to be named, wrote Representative Albert Cole, with copies to a number of other legislators, and placed the blame for the $37,500,000 loans on the broad back of Congress. Hise shrugged off the criticism of the Commercial Home Equipment overcharges by stating that the RFC was not a police agency, but only a loan agency. He reminded Cole that the RFC was the first to report the problem on June 24. "In making the Lustron and similar loans, this corporation has complied with what it believes to be ... the purposes and mandates of various special [congressional] statutes."[66]

Roy Fruehauf told *Business Week* an interesting variation of the Lustron story seen through the eyes of a supplier to the corporation. Fruehauf Trailer Company had known of the lucrative Lustron contract and knew that they could handle it as they sold more than half of the trailers on the road at that time. They were the best-equipped manufacturer to tool up for a big special order and would have no trouble building the specially designed trailers.[67]

Commercial Home Equipment offered Fruehauf a $4.5 million order to supply Lustron with 800 specially engineered trailers designed to haul the Lustron parts to the house site. Weekly payments of $25,000 would be made and, the contract stipulated, Fruehauf would have 40 percent of the purchase price before delivery of any trailer. Fruehauf signed in October 1947, well before the Columbus plant began operations.

In January 1948, Roy Fruehauf was visited by two RFC officials who insisted that he double production of the trailers or lose the contract. When he asked about the payments, he was told, "You know that the RFC is committed to spend $50 million on Lustron, so you can count on being paid in full for your trailers and don't worry about it."

Despite the RFC assurance, Fruehauf was still worried, but nevertheless increased production while the CHE payments remained at $25,000 weekly. Over the next two years, the trailers were delivered to CHE and the value of the rigs exceeded the payments by nearly $3 million. Fruehauf knew that Lustron "was Commercial's only source of income," and watched the rise and fall of Lustron's fortune with alarm.

Business Week reported that the "RFC named a committee composed of Rex C. Jacobs and F. J. Hunt—both of Detroit and both friends of RFC director Walter Dunham—to investigate Lustron management." Fruehauf heard that the report issued by these men concluded that "Lustron could be put on a paying basis with proper management of the type that Jacobs could provide." In December 1949, Fruehauf was told that "the RFC would have nothing to do with any Lustron proposal so long as Strandlund remained in control."

Business Week then reported in a column titled "The Fix" that "About a month later, Fruehauf got a call from Paul Buckley, a Lustron director [and part owner of Commercial Home Equipment], saying that the Lustron situation had come to a crisis and urging him to come to Washington that day. When he arrived, the same day, Buckley told him that there was only one man who could save the Lustron situation and that was a Washington attorney, Colonel Joseph Rosenbaum. Fruehauf testified that a few minutes later Rosenbaum entered and '...told me that he absolutely could save Lustron through

his friends at the RFC, Dunham and Willett [both RFC directors]' who he said were 'in his pocket.'"

Business Week's story continued: "Fruehauf's counsel warned him that this proposal bore all the earmarks of the Washington 'fix' and Fruehauf steered clear."

In the piece, Fruehauf concluded, "My experience, as you see, lends support to the complaint—that some RFC officials were determined all along to wreck Lustron unless they could get control for their friends."

In March 1951, Fruehauf announced that he was going to convert the 800 trailers from the Lustron operation back into conventional vans for sale at a price to recover the $2.5 million due on them plus the cost of conversion. It was a neat solution to a situation that nearly dragged Fruehauf Trailer Company into bankruptcy.

Meanwhile, in a suspicious action in September of 1950, the RFC transferred all activities and funds relating to prefabricated housing to the newly created Housing and Home Finance Agency (H&HFA) with the exception of the Lustron case. Later, it became a question as to which agency had the legitimate interest in the case. The Lustron officials were so baffled by the changes that when they submitted a new reorganization proposal to the RFC on December 28, they sent a copy to the H&HFA for its files

Strandlund wrote a lengthy letter to W. Elmer Harber, the chairman of the RFC, on December 28, 1950, in which he pled that "the Lustron operation and facilities be reactivated immediately." He went on to point out that the company was capable of manufacturing housing that was uniquely designed to meet the urgent requirements at defense installations. He wrote, "Lustron houses can be transported to distant posts of the military services and

new defense plants with the greatest economy of space and effort. They can be erected with an extreme economy in manpower and materials. Their overall erected cost to the government, as compared with the cost of conventional housing erected by conventional methods, could result in a saving greater than the government's entire investment in the Lustron venture."

He continued that while the company facilities were geared for the production of houses, it was also developing other structures such as barracks, warehouses, and supply depots for military applications. As the Cold War intensified, and the United States became enmeshed in a shooting war in Korea in the summer of 1950, Strandlund was not unaware of other possibilities for reactivating the plant. "The plant and its facilities can be speedily adapted to the manufacture of items not related to housing would they be deemed more important than housing in the whole defense picture." He also mentioned that Lustron houses could be taken down and re-erected elsewhere as dictated by military necessity.

Strandlund was most concerned about the RFC's decision to liquidate Lustron's assets in a way that would bring in only about $5 million. The cost to the government would then be at least $31.5 million for the project. He estimated that if the plant were reopened, a production output of only 50 houses per day would be sufficient to repay the original $37.5 million loan in its entirety. He did not mention how long this process would take.

"In the interest of promoting a speedy reactivation of the Lustron plant," Strandlund proposed the financial terms to which he and the company, and hopefully the RFC, could agree. He suggested that, first, the expenses of the receivership, including the bankruptcy court cost, be paid from a $1,800,000 fund held by the

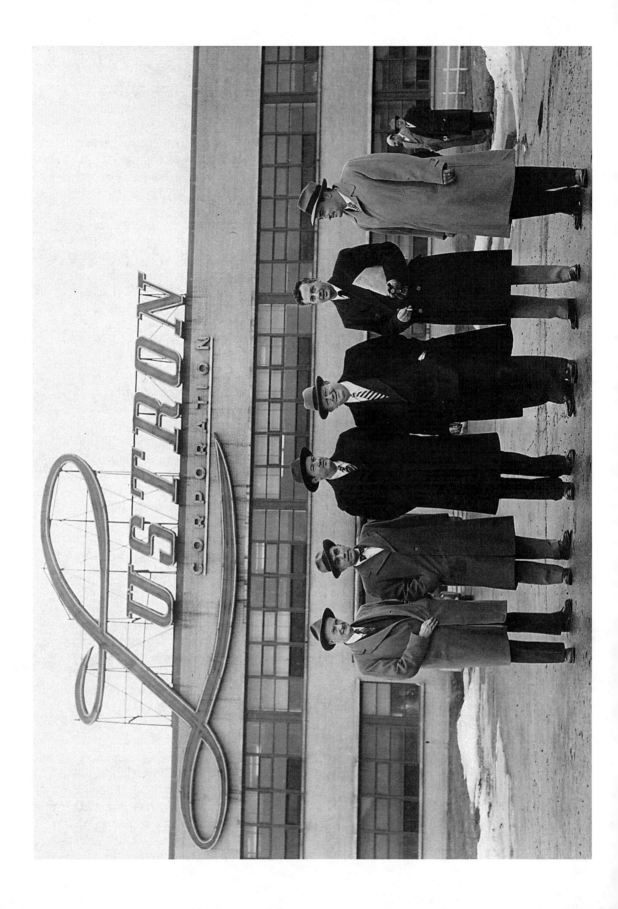

equity court receiver. All equity and bankruptcy suits against Lustron should be dismissed. The outstanding loans to Lustron should be consolidated and increased to $40 million to provide working capital for the company. The new loan would then carry an interest rate of 4 percent, and be payable in ten years. Interest would be paid out of the net earnings on a quarterly basis with 75 percent of the net income after taxes applied to amortization of the principal. The new loan would be secured by mortgaging the machinery and equipment of the company and by pledging all the class B stock of the firm, which was held by Strandlund and his wife, plus at least 67 percent of the outstanding class A stock. The creditors would be free to select the "entire board of directors and management of the company." Nonetheless, the offer clearly was not enough.

Strandlund went even further and proposed that the creditors be given full voting rights in the stock up to the creditors' recovery of $8.5 million in principal which would be the total of the estimated $5 million which the RFC said it could expect to receive from the liquidation of Lustron's assets, and the additional funds necessary to reactivate the plant.

Finally, he suggested that the lease agreement for trucks from Commercial Home Equipment Company be revised so that payments would be reduced by the implementation of a flat rental fee that would amortize payments over a seven-year period. Strandlund noted that about 50 percent of the original cost of manufacturing the trailers was still outstanding.

There is no record of a response to these suggestions for a settlement of the RFC action against Lustron and Strandlund. The company remained closed.

On February 13, 1951, a congressional hearing was held to consider how best to dispose of the Lustron plant. By that time it had been shut down for many months. Then, on March 15, Sen. John Sparkman's (Democrat, Alabama) Banking subcommittee sent a request to President Truman asking that the idle Lustron plant at Columbus be used to manufacture porcelain-enameled steel houses instead of converting the building into an airplane plant. However, the defense mobilizer, Charles E. Wilson, said he would follow the Defense Production Administration (DPA) order that the RFC turn over the plant to the U.S. Navy. The navy had earlier declared that it would turn the plant over to North American Aviation who would assemble jet fighters for the navy.

On March 29, 1951, President Truman upheld the decision to give the Lustron plant to the U.S. Navy. Senator Sparkman announced that Truman had upheld the DPA order to turn over the plant to the navy for aircraft production as revealed by M. G. Wedeman of the Naval Bureau of Aeronautics. The navy was expected to seize the plant at 4200 East Fifth Avenue in Columbus through an order of the U.S. District Court in Columbus. What complicated the move was the involvement of the Federal Bankruptcy Court in Chicago and its claim on the fate of the plant. However, it was presumed that the broad emergency powers

Opposite: The Senate Banking committee poses in front of the Columbus factory. At the left holding his coat closed is Clyde Foraker, the receiver. Then is Senator Frear of Delaware. Standing tall with a black coat is Senator Sparkman of Alabama, then Senator Capehart of Indiana next with a casual hand in his jacket pocket. Holding a cigarette, gloves and a manila envelope is Senator Sutton of Tennessee, and at the right in a tan coat is Robert Mina, an assistant to Senator Bricker of Ohio who was somewhere else in Columbus. (From the Clyde Foraker Files, Dan Foraker Collection.)

With the Senate Banking Committee in session in the Lustron plant on Monday, February 13, 1951, Carl Strandlund sits tense with his arms folded (second from left) while receiver Clyde Foraker leans forward on his cupped hand at right center. (From the Clyde Foraker Files, Dan Foraker Collection.)

for defense given the navy might supersede Judge Sullivan's orders.

Sparkman suggested that a panel of three to five members be assembled to analyze the committee's suggestion that North American Aviation build on nearby available land, and that the existing Lustron plant continue in use as a manufacturing plant for prefabricated siding. He pointed out that North American Aviation was already occupying the eastern half of the World War II Curtiss-Wright bomber plant while Lustron had the other

half and was waiting for a decision to reopen the plant.

The press reported that the Naval Bureau of Aeronautics seized the western half of the Curtiss-Wright buildings on April 20, 1951, under their special empowerment by the Defense Act of 1950. The transfer took place in receiver Foraker's office with representatives of the navy, and the RFC, and their counsel present. The Naval Bureau of Aeronautics then awarded the property to North American Aviation who had been frustrated for the

past three years in not being able to expand into the western half of the building. Now with full rights to the building, the company promptly began to move the old equipment out and install their own aircraft manufacturing lines.

The Reconstruction Finance Corporation was staggered by the new decision. Having just paid $6 million more to obtain the plant and the manufacturing equipment, they had proposed reopening it under a caretaker and restoring the production to earn back the amount that Lustron had defaulted on. With the navy stepping in, the RFC had $15 million worth of manufacturing equipment that had to be moved out to allow conversion of the plant to aircraft production. They had a loss of $37 million in loans that could not be repaid in any fashion with the factory seized, plus an additional $6 million auction price for a total loss exceeding $43 million.

The RFC pursued litigation to seek to recover its loan by filing a lawsuit in the United States District Court in Columbus in June of 1951. The suit charged that Strandlund was personally liable for the loan as guarantor and prohibited both him and his wife, Clara, from selling their shares without the permission of the RFC. By this time, Strandlund seemed ready to give up, once and for all, his dream of reopening the factory.

In a final and desperate letter, Strandlund wrote to the RFC on July 3, 1951, that he would be willing to transfer all of his and his wife's shares in Lustron to the RFC and to release the agency from "any and all liability, suits, actions, causes of actions and claims which we have or may have as shareholders of Lustron Corporation against you, growing out of the matters and things recently made public and of which you are aware respecting your management and handling of the Lustron loans." A condition of the offer

was that the RFC drop its suit against Lustron, Mrs. Strandlund and himself. He advised the RFC that his lawyers were prepared to initiate a countersuit for damages resulting from the RFC lawsuit if the case was not dismissed.

The RFC quietly accepted Strandlund's terms and dropped its action.

After months of juridical argument and legal manipulations, the Chicago United States District Court finally ordered the sale of Lustron's unmortgaged assets to satisfy the creditors in the bankruptcy action. Some 400 bidders showed up at the door: purchasing agents with a nose for a bargain; junk dealers; and the curious, including Columbus housewives, came to thumb through the 129-page catalog which listed the raw materials, tools, some of the Thor dishwasher–clothes washer units, water heaters, fans, and metal fasteners. Some 4,000 lots were auctioned off during the second week of July 1951 in Columbus in front of the plant. When it was over, the auction netted $430,000 which was far more that the $85,000 claimed by the three dealers who had sent their lawyers to Judge Sullivan's home a year earlier.[68]

What had begun as an RFC coup d'état to wrest control of Lustron from Strandlund, obtain the plant at farmsale prices, and make a substantial profit, was thwarted by the RFC's own meddling and ended in a rout. The Lustron Corporation withered away, the physical plant was seized by the U.S. Navy, and the equipment was ruined by removing it quickly from the Columbus facility.

One of the more unusual events involving Lustron and the RFC came to light in the summer of 1951. Early on, when the RFC took a blanket mortgage on all the machinery owned by Lustron, the total was calculated to be $15,500,000. Later, when Lustron bought a Chevrolet station wagon and applied for a title

This event sealed the fate of the Lustron Corporation once and for all. It is April 20, 1951, and Clyde Foraker, seated at the desk, prepares to assign the plant to the United States Navy. To the left is Captain B. B. Smith of the navy with a fresh cigar in his left hand. Clarence Graham, the receiver's lawyer, leans forward to move some papers, as James W. Shocknessy, counsel for the Reconstruction Finance Corporation, points to Foraker. At the far right, in a light suit with a bow tie, Earl Sass, counsel for the navy's Bureau of Aeronautics, seems poised to jump in. (A *Columbus Citizen* newspaper photograph from the Clyde Foraker Files, Dan Foraker Collection.)

certificate, the lien on the car was part of the overall mortgage, but had not been calculated separately. To expedite the issuance of the title, the entire mortgage was listed as "Chattel Mortgage, Reconstruction Finance Corporation, Cleveland, Ohio, May 26, $15,500,000." So, while the station wagon did not have the options like white-wall tires or a radio, it did have a heater—and the largest lien in history against a new car.

There were some additional death rattles of the Lustron Corporation. In March 1954, the three trustees appointed by Judge Sullivan—S. Harvey Klein, James B. McCahey, Jr., and Arthur P. Murphy— were still responding to legal interrogatories. Luduca Builders of Niagara Falls, New York, filed a demand for a "Bill of Particulars."

In July 1954, the trustees paid the claimants from Strandlund's list of credi-

tors that had been filed with Judge Sullivan on June 15, 1950. A new list was prepared with the amount claimed, the final reduced or amended claim, and the amount of the 25 percent payment awarded by the Court and other remarks. The Baltimore & Ohio Railroad had claimed $348.39 and was paid $87.10. Two of the original claimants were paid: Land Development of Chicago had claimed $3,602.11 and received $900.53, while Northwest, Inc., claimed $1,183.10 and received $295.78. Park Forest Homes, Inc., had the greatest claim of $3 million which was reduced by the Court to $40,000 and it was awarded $10,000. This was not the greatest payment. Homes of Distinction had claimed $95,394.30 which was reduced to $48,671.76, and the company was paid back $12,167.94.[69]

Finally, the Lustron Corporation gave up its last gasp on February 16, 1960, when the Trustees of the Estate of Lustron Corporation—Klein, Murphy and McCahey—petitioned to destroy all books, records and papers which were stored in Columbus, Ohio, and Chicago, Illinois. Not much later, they filed the final report and account and closed forever file 50 B 447.[70]

This was the end of Lustron Corporation, little noticed by the press, unremarked by the public, and a mere blowing away of the dust of the corpse of a gentle giant.

Congressional Speculation

Lustron, a household word universally recognized at mid-century thanks to the well-coordinated national advertising campaign, was smeared by adverse publicity in the mass market magazines read by the very same people most likely to buy one of the new metal houses. *Time*, *Newsweek*, the *Saturday Evening Post* and *Business Week* all reported their views of a company plagued by startup problems and significant cash shortages. The *Post* even hinted that some of the money was used to finance Strandlund's expansive lifestyle.

Perhaps the revelation of the unfortunate connection between Senator Joseph McCarthy and the Lustron Corporation helped to seal the fate of the company during the Senate hearings. Lustron published a small booklet titled "How to Own Your Own Home" which contained, among others, a small article contributed by McCarthy. Senator McCarthy was paid a handsome $10,000 fee by the company for his contribution to the booklet, even though this same article had earlier been rejected when offered free to *Life*, the *Saturday Evening Post* and *Collier's*. McCarthy's fee was revealed at the Lustron bankruptcy hearings in the summer of 1950 when McCarthy was under attack himself for his political views on Communism in America. Clearly the implication was that Lustron was rewarding McCarthy for his help in the Senate and the Capitol hallways while Lustron sought funding from the RFC.

The mood of the nation was swinging to embrace an emerging conservatism and this contributed to the growing public resentment of the government support for the prefabricated housing business. McCarthy's implied backstage influence was seen as manipulative to gain special favors for the company. While repugnant to the public, Lustron had been willing to use McCarthy's help to get to the financial resources of the government. Clearly, the American public was simply unaware of the huge financial resources necessary to tool up an enterprise of this type and the lead-time necessary to get everything working together in unison.

Early in 1951, the *Congressional Record* held a number of interesting speculations and curious tales that may lend even more credence to Strandlund's tale of an RFC conspiracy to take over Lustron's operations. It should be understood that representatives speaking on the House floor may say some things that are free from normal restraint. The statements made there are not necessarily sworn to be entirely true.

The testimony presented seemed to suggest that Merl Young had been a Kansas City grocery clerk at an early date before his wife, Lauretta, started working for Senator Harry S Truman. The new job meant that she had to follow Truman and the couple moved to Washington in 1940. Truman's secretary, Victor Messall, got Merl Young a government job as a $1,080-

a-year messenger. Merl soon was hired to examine loans for the Reconstruction Finance Corporation. Then in 1948, he left the RFC to work for Lustron and was quickly promoted to an $18,000 vice presidency. But at the same time, Merl had a second $10,000 job with the F.L. Jacobs Company of Detroit, a company that had received a $3 million RFC loan.

The Honorable Pat Sutton of Tennessee spoke on February 8, 1951, as a follow-up to his earlier speech of January 12 on Lustron's involvement with the RFC. After completing a background sketch of the company and its aspirations, Sutton brought up the employment of Merl Young. Young "at the request of RFC officials ... was placed upon the Lustron payroll at $12,000 a year. Later, at the request of an official of the RFC to the president of the Lustron Corporation, his salary was raised to $18,000 a year provided that increase was approved by the RFC Board in writing. That approval was given. It later developed that at the same time this financial wizard was drawing $10,000 a year from a firm headed by one Rex Jacobs."[71]

Merl Young was a close friend of Walter L. Dunham, one of the directors of the RFC. In September of 1949, Dunham decided to have an RFC survey made of the Columbus Lustron plant to find out why Lustron was failing. Dunham talked to James C. Windham, the former assistant of George Allen, the former head of the RFC who had resigned suddenly before the first Lustron loan was approved. Windham had left the RFC himself shortly after the F.L. Jacobs Company had received their $3 million loan and he became the company's treasurer. Windham was quick to suggest that Dunham call on Rex Jacobs, president of F.L. Jacobs Company, to make the Lustron survey.

Representative Sutton then told the House that an engineer was sent on July 6, 1949, to inspect the Lustron plant at Columbus. He was the very same Rex Jacobs "with whom Merl often fraternized and lolled in the Florida sunshine while visiting with Jacobs in his mansion down in the Sunshine State of Florida."

Rex Jacobs knew the RFC well. One of his close friends was Donald Dawson, a former RFC official, whose wife was in charge of all the RFC files. Dawson had moved on to become the President's personnel assistant. Dawson and his wife seem to have spent rent-free Miami Beach vacations in $30 rooms at the Saxony Hotel, which itself had been financed by RFC loans.

Jacobs "had barely entered the office when a long distance telephone call was received by the president of the Lustron Corporation from Washington inquiring if Mr. Jacobs had arrived." Jacobs wanted to sell his line of washing machines for the Lustron houses and "Merl Young would receive $15 a piece for each machine installed." Representative Sutton had calculated that if Lustron was producing 100 houses a day, Merl Young would have had "an additional income of $375,000 annually."

Sutton then explained that "the F.L. Jacobs Company of whom Rex Jacobs is the president ... was forced by the Department of Justice to renegotiate with the government and repay many millions of dollars in excess profits [from] producing necessities and munitions of war during World War II." "Jacobs voluntarily paid some $15 million in excess profits."

On January 12, 1951, Representative Sutton had given greater detail in his speech on the House floor. He reminded the representatives that testimony had been given that on May 4, 1949, Mr. Walter Dunham, an RFC director, had visited Lustron's Columbus plant. Then on June 29, Dunham had advised Strandlund that

Rex Jacobs would visit the plant. Merl Young "visited in the home of Rex Jacobs on the weekend of the Fourth of July in Detroit. On July 6, Rex Jacobs called at the Lustron plant." "Walter Dunham of the RFC called from Washington and asked if Mr. Jacobs was there."

When Jacobs sat down with Strandlund after the plant tour, he proposed selling his own line of washing machines to Lustron. Strandlund turned him down since he already had "an existing contract … with another company."

"Very shortly after the Jacobs proposal, … unfavorable publicity concerning the operation of the Lustron Corporation began to appear in the newspapers.…"

Rex Jacobs had arrived in Columbus to make the survey for the RFC and was gone two days later. Although he felt that Lustron was paying too much to haul its pre-fab houses to the customer locations as noted in his report, he did not notice that for six months Lustron had been paying $44,800 a month rent for 40 truck tractors that had never been received.

"After refusing to approve the loan which had already been worked out, the officials of the RFC began putting pressure on the president of Lustron Corporation to force him to give up 60,000 shares of his personal stock and control of the company to a new group headed by Rex Jacobs and some of his friends included among whom were Merl Young and Walter Dunham." "It is natural to assume that if the new group could not control Lustron Corporation, that they would not permit the company to operate."

Shortly after this, Merl Young came to Sutton's office and "he denied that he was ever on Rex Jacobs' payroll." A few days later, James Windham, "the secretary and treasurer of the F.L. Jacobs Manufacturing Company of which Rex Jacobs is the president" came to Sutton's office in Washington. Windham was "another for-

mer RFC employee," "being the Administrative Assistant to the Director of the Corporation at the time that Rex Jacobs procured a $3 million loan from the RFC." "Shortly after the loan was made, Mr. Windham joined the Jacobs firm." "I asked him if Merl Young was ever on their rolls. His answer was 'Yes.'"

If Representative Sutton was correct, then it appears that Rex Jacobs saw an opportunity to sell a great number of washing machines as part of a package with the Lustron Homes. While nothing was said of the machine's quality, one could assume that the units would not be "top of the line." Jacobs had a history of questionable business practices, namely the Department of Justice action on excess wartime profits that resulted in the company returning $15 million.

Jacobs knew many of the RFC people since he had his own $3 million loan and he had hired Windham as secretary and treasurer just after the loan was approved. Merl Young's appointment to Lustron and the subsequent salary increases specifically approved in writing by the RFC illustrate that he was still beholden to the RFC although not directly on its payroll. Sutton mentions Young's brothers, Herschel and Gene, the latter "in some way connected with Rex Jacobs for some seven months." Merl obviously knew Jacobs well if he stayed with him over the Fourth of July weekend. It is doubtful whether Strandlund gave much thought to Jacob's proposal since he had an existing contract for the combination dish washer–clothes washer built by Thor, and certainly he had little hint of the powerful influence that Jacobs, Young and Dunham would have on the Lustron Corporation's fortune.

The Senate investigating committee also uncovered some questionable business practices that had a significant effect on the Lustron Corporation.

Commercial Home Equipment Company, established by John and James Gottlieb, who operated a Chicago-based trucking company, entered the Lustron saga as the Columbus plant began to install equipment. The newly formed company had issued only 1,000 shares of stock and James Gottlieb, president of Commercial Home Equipment, originally owned them all, but later transferred 200 to his brother. Another partner was Paul O. Buckley who was on the board of Commercial Home Equipment and who was also issued 200 shares of stock. Curiously, Buckley served on the Lustron board of directors at the same time. In addition, he had a number of business connections with Joseph Rosenbaum's brother, Frank Rosenbaum, and he was connected to Barium Steel Corporation, an affiliate of Central Iron & Steel Company. Central Iron & Steel received a $6.3 million RFC loan in the summer of 1949. During the RFC debate on the Central Iron & Steel loan, only one RFC examiner, Hubert B. Steele, found no objection to the loan. Steele's daughter, Virginia, had worked as Merl Young's secretary at the RFC and later went to work for Joseph Rosenbaum's law firm.

Only a month after the RFC loan to Central Iron & Steel went through, Hubert Steele quit his job with the RFC and went to work for Joseph Rosenbaum's law firm which represented Barium Steel Corporation. On Steele's first day on the job, he received a check for $5,000, but Rosenbaum later said it had only been a four-month salary advance.

Rex Jacobs had a business association with Joseph Rosenbuam, a principal partner in Goodwin, Rosenbaum, Mechum & Bailen, a law firm that handled many of the RFC deals. Another person with close ties to the law firm was Joseph E. Casey, former Democratic congressman from Massachusetts. Casey had been given the opportunity to purchase a number of ships from the U.S. Maritime Commission and he then resold them to net a quarter of a million dollars. Casey was the attorney for Commercial Home Equipment Company.

Rosenbaum "loaned" Merl Young enough money to buy a house and also get Lauretta Young a new natural pastel mink coat for $9,500. Lauretta was now a White House stenographer.

Testimony at a Senate hearing after the collapse of Lustron revealed that Carl Strandlund, Lustron's president, had introduced John Gottlieb to Lustron vice president Russell Davis when the company decided to haul the houses in special custom-built trailers to the homesites. Commercial Home Equipment signed a contract with Lustron on September 1, 1948, that it would invest $200,000 in Lustron, although it was learned much later that the company only had been capitalized with $2,000 and had no more than that on September 30, 1948.

The Gottlieb brothers managed to arrange for temporary financing by borrowing $125,000 against the Lustron contract that gave them all but a small part of the Lustron haulage. They then went to White Motor Company in Cleveland and bought 160 tractors against an order for 200 tractors, and made a second trip to the Fruehauf Trailer Company of Detroit for 810 special trailers specifically built to haul the Lustron house kits.

Lustron began paying rent to Commercial Home Equipment for the first available tractors in November 1948, and after March of 1949, the company paid $1,120 per tractor per month for the use of all 200 tractors. As we have seen, though, only 160 tractors were actually ordered. As a consequence, from March onward, Lustron paid an additional $44,800 a month for phantom tractors. Although there was some concern within the company, no one actually took a count

of the tractors to confirm the 200 Lustron was paying for.

Commercial Home Equipment sold its tractors to the individual drivers who contracted to haul the Lustron homes from the factory to the site. However, Lustron directly paid the drivers' expenses and continued to pay rental on the tractors to CHE. Using the money from the tractor sales to the drivers, CHE then paid off the bill for the tractors purchased from White Motor.

This phantom fleet of 40 tractors was destined to haunt the company in the Senate investigation in 1950. Senator J. W. Fulbright, Democrat from Arkansas, was outraged that taxpayers had lost $500,000 for fraudulent overbilling by Commercial Home Equipment for the use of 200 tractors when only 160 were actually delivered to the company for use. Both James Boylan, Lustron controller, and George Burley, director of transportation, testified that they thought all of the tractors had been delivered to Lustron. When William H. Welsh, supervisor of motor transport, started to assign tractors, he began to worry over the apparent miscount and shortage. He testified that when he went to Russell G. Davis, executive vice president, to see if he could count the tractors, "Davis told me it was none of my business!" Was this the brusque answer of a businessman who had no time to waste on counting tractors, or was it a warning to stay clear of a recognized problem?

Welsh then told the hearing that Brian O'Rourke, truck dispatcher for Lustron, told him that there *were* 200 tractors on hand. When O'Rourke was questioned the same day, he was asked by Senator Paul Douglas (Democrat of Illinois), "Do you realize your carelessness has cost taxpayers $500,000? Don't you feel responsible in this case?" "No, I do not," O'Rourke quickly replied.

The next day's testimony revealed that Commercial Home Equipment had been paid a total of $2,990,000 by Lustron that included the weekly rental of $1,120 per tractor for the 40 phantom tractors. Although CHE had ordered the 40 extra tractors, the order was later canceled and White sold the 40 to their customers. While White Motor's bill for the tractors had been paid by CHE, the $4,054,619 for the Fruehauf trailers had been defaulted on, leaving Fruehauf holding the bag for $2,938,509.

When Lustron production fell below the daily estimates, especially after the layoffs of August 1949, the company renegotiated a new contract with CHE to obtain a lower rate, but this contract was *never signed*.

Worried about the Lustron loans, the RFC had placed Paul Boardman of their Cleveland office in the Columbus Lustron plant. Senator Charles Tobey, Republican of New Hampshire, asked Boardman about the tractors. "What do you think of this dirty work at the crossroads?"

Boardman could only say that he wasn't happy about it.

"Yes, but doesn't it make you damned mad?"

Boardman nodded his head resignedly.

Then Senator Maeder jumped in to ask: "Don't you feel embarrassed by the fact that a half million dollar fraud happened right under your nose?"

"Yes," Boardman agreed.

On the third day of testimony, Carl Strandlund went to the witness chair and testified that he had only just recently learned of the tractor shortfall. Unable to get him to change his story, they asked about the $10,000 paid to Senator McCarthy for the article in the Lustron booklet. Strandlund was unable to recall how many of the booklets had been sold.

On Friday, James Gottlieb denied that any fraud had occurred. He consid-

ered the payments to Buckley to be loans and he was sure that they would be repaid.

Strandlund believed to the end that the officials of the RFC had intentionally sabotaged the Lustron project after they failed to get control of the company for their friends. Roy Fruehauf shared this opinion as we have seen. The *Congressional Record* of January 12, 1951, contains the discussion on the floor of the House of Representatives that considered the tractor scheme, but nothing came of the charges. As damaging as this congressional testimony might have been, little resulted from it, and the associations that were revealed only showed an inner, seamier side of the Truman Administration. It was a "scratch my back and I'll scratch yours," laissez-faire style.

The final agonies of Lustron were widely publicized in the press. There can be little doubt that the spectacular demise of the company prevented any serious consideration of the actual merits of Strandlund's porcelain-enamel house for a considerable time thereafter.

The Lustron That Might Have Been

In 1948 Lustron president Carl Strandlund hired a consulting team of architects and planners to make suggestions for new Lustron models scheduled for production in 1950. The consulting team was headed by Boston architect Carl Koch and included his colleagues, Leon Lipshutz and Fritz Day, as well as MIT professor, Burnham Kelly, who was noted for his work on city planning and housing design and production.

Since the earliest of Koch's drawings for the project is dated July 3, 1948, the consulting team must have been hired sometime in the late spring of that year. As Carl Koch has noted in his study *At Home with Tomorrow*, he was impressed by the first tour of the huge Columbus facility which was at the time producing the initial Lustron units designed by the Chicago firm of Blass and Beckman.[72]

Koch has written that his agreement with Lustron was simply "to plan a house that was good looking, nicely proportioned—in a word, beautiful." Lustron's designers and engineers would then determine how to fabricate the units in metal. Since Strandlund saw the production and delivery of Lustrons as an industry similar to the production and delivery of automobiles, little thought was given to community planning, the variety of units, or to the aesthetics of site planning. Furthermore, although the general instruc-

tions seemed to leave the architects considerable range for creativity, there were problems inherent in the differing assumptions of the consulting team and the Lustron leadership.

Lustron was looking for an updated house, a new model that would offer an opportunity for Lustron owners to "trade up" or for new customers to keep up with the times. Koch and Burnham Kelly were concerned with the entire process of designing, manufacturing and erecting houses. Both men saw design, fabrication, delivery and erection as interdependent processes. Inevitably, the approach of the consulting team to the Lustron project was much broader and comprehensive than Strandlund and his associates had anticipated.

Architect Morris Beckman, the primary designer of the first Lustron model, has indicated that his work was limited by the concerns of Chicago Vit's engineers and the production limitations of the company's existing plant in 1945. The consulting team's comprehensive view of the role of the architect was quite different from Blass and Beckman's approach to the initial Lustron unit, the Esquire model built in Hinsdale, Illinois.

The consulting team studied the functions and layout of the Lustron plant as well as the loading, shipping, unloading and erection of the units. Concern

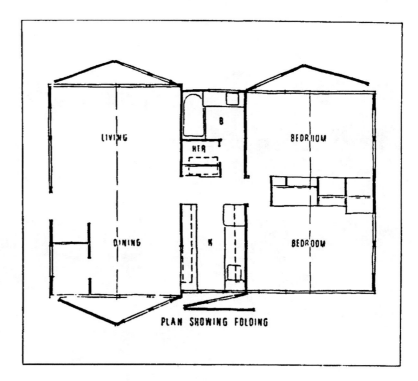

Carl Koch's Acorn House is shown here both folded and unfolded. His concern for maximum preassembly of houses at the factory also dominated his planning of the Lustron house for Strandlund.

with the excessive number of parts to be assembled on-site led the team to develop systems of increased pre-assembly of modules for the houses at the factory. Three years earlier, Strandlund's own indictment of the construction of homes at the 1945 meeting of the Eastern Enamelers Club was that builders were still using traditional methods of cutting and assembling raw materials on the building site. Yet when the Lustron plant had been designed, according to Carl Koch, "Little thought had been given to the preassembly of parts in the factory." It was clear that the consulting team would not only propose new designs, but would suggest further mechanization, factory assembly and mechanized loading in the production of these new designs. In short, the production men and engineers would also receive some challenging suggestions.

Both Koch and Kelly have observed during interviews that they hoped to avoid repetitious uniformity in the Lustron houses. In both the design of the two- and three-bedroom versions of the house, in the "Four Sided Elevation" drawing, and in the suggested plans for a Lustron tract in the Koch drawings for the project, it is clear that the design team was concerned with the creation of aesthetically pleasing Lustron tracts which featured irregularity rather than a simple grid plan.

The earliest dated drawing from the project, labeled "Development of Scheme #3," indicates that the small porch of the two-bedroom Westchester models would be eliminated, as would the china closet/pass-through that separated the kitchen from the dining area. However, folding room dividers could be used to separate the dinette from the kitchen and the living

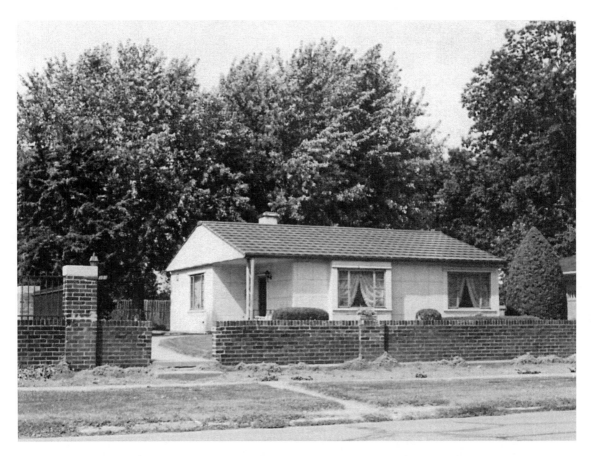

This pretty lot in South Bend, Indiana, is a nice setting for a Lustron home.

area. The bay window on the long front wall was to be replaced by four large windows. Additional space would also be saved by replacing the swinging interior doors with sliding pocket doors. Perhaps the design team took a cue for this latter innovation from Strandlund himself who indicated at a meeting with them that Lustron would offer the public a house that was a quality product. He told Kelly that "Quality is when you are having people for cocktails and you push a button and the wall slides open."

The new 1950 models would not yet incorporate Strandlund's sliding exterior walls, but they did incorporate the space-saving recessed sliding doors, as well as another innovation which was Strand-lund's idea and which Koch initially resisted—Americans could look forward to electric windows in their new 1950 Lus-trons. Koch has written that he was reluctant to incorporate electric windows in the design because he felt that they would be too expensive. However, Strandlund's production specialists calculated the cost to be $3.50 per window in mass-produced units and the electric windows were thus included in the plans.

These were all, nonetheless, minor alterations. The major innovation offered by Koch's team was the introduction of a number of interchangeable wall and window units as well as interior closets, cabinets, bookshelves, and utility units. All units would be eight feet high and would

be constructed in multiples of two-foot wide sections, allowing the architect and designer to offer a substantial variety of combinations. The vertical creases of the interior panels would be incorporated in the exterior panels that would also be eight feet high. The creases were visually attractive and evoked the look of grooved wood siding.

Furthermore, the "Wall Panel" drawing suggests a textured surface rather than a smooth one for some areas of the exterior panels. It is clear that the architects were attempting to solve what Burnham Kelly, in an interview, called "the problem of all those joints" and the monotonous satin finishes of the porcelain-enamel panels. Eight-foot high vertical panels would offer some variation on the satin finish.

Kelly also indicated that a spattered effect on some rejected panels which were considered substandard by Lustron would actually add to the visual appeal of the house. It would at the same time, Kelly realized, cut down on the number of panels rejected for shipment.

There can be little doubt as to how that suggestion struck Strandlund and the other porcelain-enamel specialists who worked at the Columbus facility. To them, the spattered effect would have been unconscionable. They could no more envision a spattered 1950 Lustron than a spattered 1950 Packard or Cadillac.

Of course, the design of the pre-assembled interchangeable units was part of a larger concern of the consulting team to eliminate the metal studwork from which Lustron's two-foot square enameled panels were hung. The walls on the projected new models would be self-supporting and the process of loading the houses at the factory as well as unloading them at the site would be vastly simplified. The number of joints would be decreased, the number of parts to be assembled

reduced from 3,000 to 37, and the weight of the houses reduced by three tons. The higher the proportion of factory-assembled parts, the less the chipping of the enameled parts on site during the erection of the house.

The projected 1950 model Lustron offered more variations and a more pleasing design than the units being produced at Columbus in 1948. The house looked less commercial and more domestic. The vertical exterior creases were an improvement. At the same time, the durable and practical interior and exterior porcelain enamel surfaces were continued. The new models could no doubt have been erected much faster and would have fit into America's growing suburban areas more readily. Actually, the only component of the initial models which would have remained untouched was the roof. The embossed, tile-effect, steel roof had struck Koch and his colleagues as particularly unattractive, but the consulting team's suggestions for a different design fell on deaf ears. In that case, the extant design was defended by the company as an economical use of steel and the Lustron leadership pointed out that a good deal of machinery was geared up to produce the roof tiles. As Koch has noted, "the roof tile was not going to be changed and that was that."

The hiring of the consulting team in 1948 makes it quite clear that Carl Strandlund was a manager of considerable foresight and energy. While in the midst of a flurry of problems in the startup phase of the enterprise, he was determined to adjust the product line to public taste and market forces. He was the classical entrepreneur. As Burnham Kelly recalled in an interview, "Strandlund had all the confidence in the world."

Adjustment to the market was rapid. The company began to produce the three-bedroom Westchester even before Koch's team had completed its work, and accord-

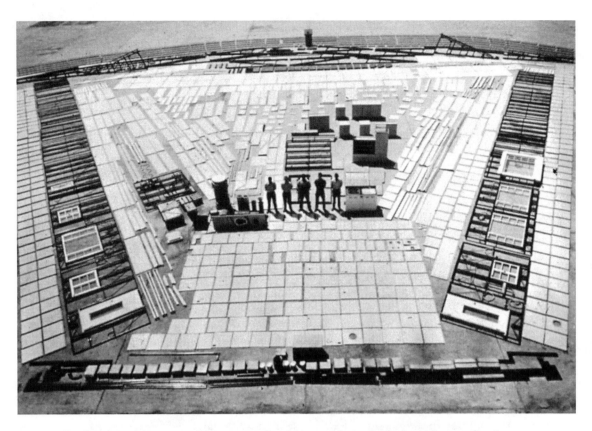

Laid out in this geometric pattern, the sheer number of panels and parts for the average Westchester two-bedroom house was staggering. (Photograph by Arnold Newman, 1949, Columbus, Ohio, from the Tom Fetters Collection.)

ing to Harold Denton, garage and breezeway additions for the basic units were actually envisioned before the consulting team made its report. The undated brochure "Garage and Breezeway Variations with Lustron Houses" introduced porcelain panels for garages and stated that "garages, breezeways and porches can be custom-made by your dealer using local materials in combination with materials supplied by Lustron."

Variety of product line and sensitivity to changing tastes in houses was as far as the Lustron leadership was willing to go. Although Strandlund hoped to manufacture thousands of units per year, he did not commit the firm to the planning of housing tracts. The principal short-

coming of the company, according to both Koch and Kelly in separate interviews, was the lack of concern for community development. Koch was concerned with the lack of variety in Lustron's initial units, and both he and Kelly were concerned that Strandlund and his advisors had not thought to develop lands for large communities of Lustron houses. Kelly suggested that "If Lustron had survived and tied in with a developer like the Rouse Corporation which built Columbia, Maryland, they might have gone beyond conceiving a durable *house* to creating a *place* where living is comfortable."

For all of their criticism, however, both architect Koch and planner Kelly felt that Lustron had the potential to succeed.

Had the political and financial pressures which developed in 1949 not proven insurmountable, a Lustron Corporation engaged in the production of low-cost houses would probably be around today. Consumers would be able to finance their houses through a subsidiary corporation similar to the General Motors Acceptance Corporation, while tracts of Lustrons would be planned and developed through the services of a community-development company like the Rouse Corporation. Growing families could trade up to larger and more luxurious Lustrons or add on to the original units.

As Carl Koch has suggested, older couples might remove part of the original house and contract the living space as children left home, and other homeowners might add small but completely self-contained Lustron quarters for aging parents.

The preassembly of Lustrons might have been developed even beyond the plans of Carl Koch's consulting team, much as the modular-home and mobile-home industries of recent years have demonstrated. Preassembled sections complete with roofs could have been trucked to sites and bolted on slabs or foundations. Carl Strandlund, instead of selling stainless steel diners in New York City in the 1950s, might have achieved his goal of offering a decent house for every American and the Lustron Corporation might well have demonstrated that the factory made house is, in the long run, a sensible solution to the need for inexpensive, durable and efficient shelter in the modern world.

Lustron Lingers On

Fifty years have elapsed since the last Lustron units left the receiver-controlled Columbus plant as the last employees sought to fill the final customer orders with the parts on hand. Some of these units were not erected upon arrival at their sites and were only assembled some months, or in some cases years, later. A few units have been lost to severe weather, vandalism or apathy, but it can be estimated that at least 2,200 of the 2,500 units originally produced are still standing and fully functional as low-maintenance, pest-free homes. The new threat to the houses is the "Gentrification" of neighborhoods in which older homes on large lots are removed and replaced with newer and larger homes. The current loss rate to gentrification is probably one house a month across the country.

The Lustron houses have been completely assimilated into their largely middle-class American neighborhoods and are no longer looked upon as curiosities. Over half of the American population has been born since the last house was put up and they have never heard of the Lustron Home, or of Carl Strandlund, or of the rise and fall of the Lustron Corporation. Yet, for many, the houses are still making a dramatic impact, as they become available in the real-estate market.

There is an initial reluctance among the uninitiated to consider living in an all-metal, porcelain-coated, two- or three-bedroom structure that is so clearly different from anything else on the market. But the units remain remarkably attractive as starter homes and retirement homes for both young and old couples. It is the enthusiasm of the present owners that truly sells the houses though. Given the chance, each owner becomes an ardent advocate of the advantages that are not so obvious to the casual observer.

Do you see this house? Last winter it was 23 degrees below zero with a north wind blowing and I sat in the living room with a tee-shirt and pants and socks on and was warm as toast! See those big bay windows? They never let in so much as a draft during that night.
My wife and I came out to look at this house when it was for sale. We had never seen anything like it. It needed a little work, but she asked me, "Can we fix it up?" and I said we could. We've done quite a bit with it since the last owner had not cared for it that well [Colchester, Illinois, owner].

New Lustron owners have become more innovative with the sterile design of the 02 and 03 Westchester models. In Aurora, Illinois, an owner raised the floor in the dining room by three inches so that guests step up into the area, cross through, and step down into the kitchen. This simple idea makes a dramatic expression for the area that in most of the units is nondescript. Another owner in Lombard, Illinois, removed the equipment in the utility room and placed it in the bathroom closet.

This Evansville, Illinois, home owner has updated the look of his Lustron Home with stone. (Courtesy Andy Krietzer.)

He then moved the kitchen into the former utility room and with the removal of the pass-through divider created a much larger dining area. This same owner installed plasterboard over the inner wall of the dining room and dramatically changed the look of the area to that of a more open 1980s living-dining area.

Not a few of the houses have had dens or television rooms added to the nominal back of the house, with the kitchen door used as access. Nearly every one of these extra rooms has been built of conventional building materials, although some owners have found secondhand Lustron parts that they used for a more pleasing design. Some owners have actually added rooms to the bedroom end of the

house by cutting an access opening into the wall of the basic structure, but this last type of construction requires engineering to retain the wall strength and is uncommon.

Few owners have modified the basic Lustron structure as much as the owner in Normal, Illinois, who extended the home with the dramatic use of face brick in a stylish design. Other owners, however, have completely covered the exterior Lustron panels with dark timber such as pine or birch as can be seen in Arlington Heights and Lincolnshire, Illinois. Residing with enameled aluminum siding as found in Lombard, Brookfield and Peoria, Illinois, is far more common. Some of these alterations were required after severe

fire damage to the original panels, but often the siding was applied to offer a cosmetic alteration that gave the unit even more anonymity.

Prices of the Lustron units have become far more widely spread than when they were first offered by the Lustron Corporation. At that time, the price was composed of the standard unit price, a transportation surcharge based on the distance from Columbus, the value of the property, and a charge for erection. This translated into a price that ranged between $8,000 and $15,000. Today the pricing has become more highly influenced by geographical location and the local real-estate conditions. In some rural areas of south central Iowa, Lustron units have sold recently for as low as $8,000 at auction in quick sales. Foreclosed houses have been obtained by merely picking up the payments of the pre-existing contract. On the other hand, in highly desirable suburban locations of metropolitan Chicago, these same two-bedroom Westchester units have sold for $138,000. It is very likely that the New York suburban area has seen pricing well in excess of this value.

The Lustron Home attracted new interest in the late 1980s as newspapers began to print feature stories on the units in their circulation areas. Among the newspapers with significant articles were the *Chicago Sun-Times*, the *Chicago Tribune*, the *Des Moines Register*, the *Milwaukee Journal*, the *Kansas City Star*, and the *Washington Post*. This author was even interviewed by an Iowa City, Iowa, PBS radio station over the air in 1989. A number of prominent historical societies have become aware of the presence and significance of the Lustron units in their areas. The predominant research has been led by the Ohio Historical Society that is interested in Ohio sites as well as midwestern locations. The Iowa State Historical Society made a survey of the

units within Iowa, as did the North Dakota Historical Society for its area.

Time has shown that the Lustron house was as feasible and durable a product as Strandlund claimed it to be the day that he entered Harold Denton's office in Washington in 1946 trying to procure steel. The consumer survey published in the April 1947 *Better Enameling* magazine found that Americans liked porcelain-enamel products and this has proved to be accurate.

The customers who purchased Lustrons were generally well-pleased with the high quality of the product. A survey of 320 Lustron homeowners was conducted in 1953 by the advertising agency of Batten, Barton, Durstine & Osborn for the United States Steel Corporation. Two hundred owners returned the questionnaire representing a very high 62.5 percent of the number surveyed. This was, however, a very small sample of the 2,500 owners scattered across the eastern and central part of the United States, but it provided a good look at the options of the people who had owned and occupied the Lustron for more than three years.

Owners were enthusiastic about the design, low maintenance and the steel and porcelain construction of the houses. They were most critical of the ceiling radiant-heating system. Other suggestions focused on access from the kitchen to the bath and bedrooms without passing through the living room, having a larger kitchen, having a basement as a standard option, and having the ability to add onto the house to expand its size using Lustron parts, and finally, a larger utility room. The overwhelming majority of the surveyed owners were happy with their Westchesters, Newports and Meadowbrooks. In fact, BBD&O found that almost 97 percent of the respondents who had previously owned a house preferred the all-metal Lustron.

A significant number of the Lustrons built are still extant and most have needed only minimal repairs. For example, the 60 Lustrons built for the United States Marines at Quantico, Virginia, still stand although they have been remodeled professionally several times. They remain high on the list of preferred housing at this base.

Of the 2,000 Lustrons documented and photographed by this author and a network of enthusiasts who have made the only intensive search for the remaining houses, most are in near mint condition. Lustron Research, a nonprofit organization, continues to add to the known history. In 2000, Lustron Research prepared a half-hour video program on Lustron Homes in Lombard, Illinois, for the Lombard Historical Society. The program was scheduled by the local access cable station as a daily feature for two months and received warm reviews.

Owners remain proud of their possession and many former owners are known to return just to visit their original metal homes. "I think it must have a hold on people," said Laura Glasgow of Marshalltown, Iowa, in one interview. She and her husband are the fourth owners of the house there and she told the reporter "The son of the original owner has stopped by with his wife when he was back from California; the son's daughter stopped by a few years later; and the second family's children have stopped by."

Owners Russ and Helen Miller of Dixon, Illinois, say, "It's too bad they had to quit constructing the Lustron Home. We *love* our home and wouldn't trade it for any other. If taken care of properly, it can stay the same as it was originally. There is very little upkeep needed although we had to replace the furnace, but everything else is the same. The radiant heat from the ceiling panels is grand — warm, even heat and also economical. If taken care of, it is a *wonderful*, comfortable home, especially for us now that we are elderly.

"Mr. Strandlund, the originator of the home, was gypped when he had to quit manufacturing Lustron. We've enjoyed every moment in our home and can't praise it enough!"

Another owner, Mrs. Helen Phipps, remembers that the low cost was a significant factor in her family's decision to buy a Lustron Home. "It was an economy house when we needed economy the worst way, a young family raising young children," she recalls. "We did not even carry insurance as we knew that it could not burn. Radiant heat was great, except if you sat too long with your legs under a table or desk. Then they got cold as the heat radiated out of the ceiling.

"It was advertised to be vermin free and we found we had mice. So I called the contractor and he said to go around the outside of the house and stuff steel wool in every crevice that I could find. That solved the problem for many years." (Mrs. Phipps' house was built in the small farm village of Mansfield, Illinois, west of Champaign, and these were field mice that created the problem.)

Comments gathered 40 and 50 years later are still full of praise from the first, second, third, fourth and higher owners. A few new suggestions were added such as having slightly rounded corners for the rooms to soften the appearance and to ease cleaning. One person was pleased with the lower fire insurance because of the metal construction, while others found insurance to be a problem since there were no replacement parts available.

Living in a Lustron during a hailstorm was like "being in a popcorn popper." Snow often slid off the roof in a sudden avalanche creating "an unnerving sound," but there was reduced wear and tear on the roof panels from the freeze-

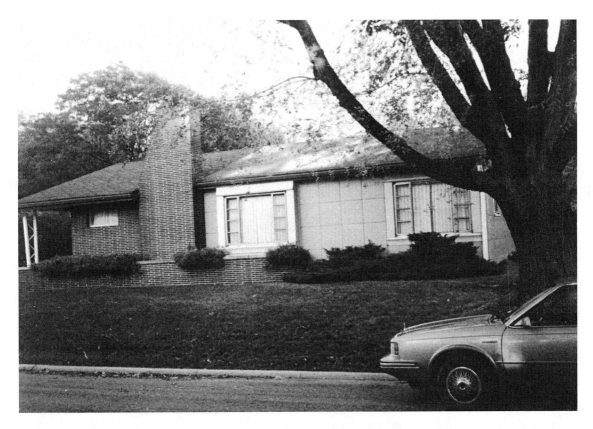

A brick addition supplements living space for this Lustron home owner in Normal, Illinois.

thaw cycles or the ice damming that often occurs in the northern climates. At night, the houses seem "cozier," but owners usually complained about the inability to hang pictures by simply driving a nail into the walls: Lustron owners had to rely on magnets to support pictures.

Only two current owners, both having purchased their unit in the last few years, expressed regret that they had acquired the home. One of these had found the radiant heating to be inadequate, while the other had discovered serious structural problems that had been caused by the settling of the original concrete slab. That left 99.5 percent of the owners that were either inexpressive in their feelings or irrepressible in their enthusiasm for their Lustron. Considering that the homes are now 50 years old, this

loyalty and, yes, devotion, are based solidly on a remarkable ability of the structure to still deliver exactly what was promised back when Truman was President and the world had just entered the Atomic Age.

Mr. Bill Williams of Kansas City, Missouri, was a new owner of about one-year in 1990. "This house has the original furnace in it and it stays at 70 to 75 degrees even in subzero weather. The old windows are not tight, and I have had to seal them on the north side of the house to achieve this warmth. The doors close smoothly and seem like new. There is no dust blown all over by a forced air furnace and things stay clean for long periods of time.

"It does seem to attract a great deal of lightning. You can count on several hits in the yard in every storm. They may be

hitting the house, but you can't tell." (This was the only house to be reported with an affinity for attracting lightning.)

Mrs. Catherine Jensen of Graettinger, Iowa, wrote, "Just a note from another happy 'Lustron' owner. I own my three bedroom Lustron that we put up in 1948. Another Lustron three bedroom was put up one block from us about three months after ours went up. I've lived in the house from the time it was up and *I LOVE IT!*

"Up-keep is nil. I did have to spend about $2000 on it for an air conditioner, which was a lifesaver each summer, when we put the house up. My husband decided we needed a small basement for the water heater and the water softener, so we paid for a 8 × 8 foot basement with a crawl space under the house which keeps the house drier. The house is supported on pre-cast joists. It is forty years old and as good as new!

"People have expressed interest in the house and many have wanted to 'get one like it.' Too bad it isn't possible. All I can say—it was the best $10,500 investment we've ever made. At the time we also put up a Lustron garage—$1,500—which has the wood joists, not the metal ones. It is a two car unit."

Further west in Wood River, Nebraska, Eleanor Brittin wrote of her husband's employment by a Lustron builder. "My husband, Earle, was an employee of Darrell McOstrich of Grand Island, Nebraska, who had the contract for putting up the Lustron houses in this area. There is one here in Wood River owned by Wilbur McCumber. Also, Earle helped put up houses in Ord, Osceola, Oxford, McCook, two on ranches near Thedford, five in Grand Island, two in Kansas—one each at Atwood and St. Francis. Earle was the electrician and plumber.

"He remembered the truck flat box coming to the spot after the foundation was ready. The first day of assembly was a long hard day. Louise McOstrich, the wife of Darrell, would bring them milk and coffee. There usually were eight on a crew including two laborers. At one time, McOstrich had seven more houses sold and had the downpayment. When there was no shipment, he went to Ohio and found his seven with the names and numbers on them, but the RFC had foreclosed on them. He then went to building prefab houses. One Christmas, Louise McOstrich gave each of the employees a blue necktie with a Lustron house painted on it!"

If one talks to an owner, almost without exception, one hears the pride these people have in their houses. They will guide a visitor to the various rooms and show them the features they like the best. From Pennsylvania to Kansas, from Minnesota to Florida, the stories are the same. "This is an exceptionally fine house with little maintenance and perfect for a newly married couple or a retired couple who does not want to be hamstrung with maintenance problems." There was the woman in Toledo, Ohio, who watched a heavy storm blow by and saw some water leakage by the front door; then she discovered that her neighbor's house had been blown down by a tornado. There was the Storm Lake, Iowa, couple who were warned that the Lustron house would be extremely dangerous in the summer lightning storms that sweep through the area, but who found security in the thoroughly grounded structure. There are those who have added conventional building material wings, porches, and other additions to their homes and learn of the difference in yearly maintenance. There are those who have placed their houses over basements and rejoice at the amazing amount of space made available.

Finally, a word or two are necessary about the few nonstandard Lustron

creations that were built with standard parts, but to designs modified well beyond the conventional company blueprints.

In Normal, Illinois, a Westchester 03 gray Lustron house was extended in length with a large brick addition of the living room end. A tall vertical design block that breaks the lines of this house in the form of a truncated red brick chimney at the transition between the brick addition and the Lustron gives the structure some unusual character. The roof of this house has been replaced with conventional asphalt shingles that tend to mute the drama of the structure by emphasizing the structural components. Located at 12 University Court and close to the campus of Illinois State University, the house dominates its small neighborhood in a pleasant and appealing way.

Another remodeled Westchester 03 gray Lustron home is in western Illinois and it has utilized the two-car Lustron garage and breezeway connection as an additional room and hall passage. This home is at 840 Oak Street in Hamilton, across the river from Keokuk, Iowa, on the Mississippi River bluffs. It is likely that this represents a retrofit remodeling carried out a number of years after the initial structures were assembled. To compensate for the loss of the garage to living space, a new two-car garage was built at the back of the lot with access to the alley. This house, too, used good design theory to prepare a very attractive variation of the standard model.

"I purchased a two bedroom, blue Lustron in August of 1949 and it was built in Wall Lake, Iowa, where we lived until 1973," veterinarian Ray Hull explained. "When we purchased the house, I also had a double garage built out of Lustron blue siding and the regular Lustron porcelain shingles on a wood frame. Then, in 1960, we built on to the main house. I contacted the RFC and they directed me to some

company in Ohio that could still make the two foot square blue siding panels. I purchased about 100 — enough that we built a 20 foot long extension beyond the two bedrooms. We then removed the Lustron roofing panels from the garage for the house roof and the outside of the house is 100% all Lustron material. No one can detect that it has an addition on it from the outside. The garage was then reshingled with regular asphalt shingles. The house is now about 55 feet long.

"The addition was converted into two bedrooms with a lot of closets and it is finished on the inside in regular sheet-rock with oak paneling, birch trimming and hardwood floors. We heated the addition with electric ceiling heat.

"We then removed the living room bookcase-bedroom vanity wall in the original house which makes the living room the full length of the original house! A fancy stone divider blocks the view of the bathroom from the living room."

Ray Hull's imaginative remodeling remains unique in the files of Lustron houses.

The houses on the mountaintop at Clarks Summit high above Scranton, Pennsylvania, are among the highest built. One of these houses had the original hot-air radiant-heating system replaced by an oil-fired, single-zone, circulating-hot-water baseboard system. The occupants found the house to be inherently cold. "Winters were colder then and the baseboard system could not keep up," Gayle Muller reported. "Pictures were impossible to hang. We chose to hang a few with a type of picture hook attached to a fabric tape that one licks and sticks to the wall. That would work for about six months or so until the picture would crash to the floor.

"We often had heavy snowfalls and there was many a time on a bright sunny

winter day when, with a loud rumbling rush, the entire contents of the south roof would slide off like an avalanche to block the kitchen door.

"Stranger, though, was the winter night when the temperature hung just around freezing. We would awake to hear what we at first thought were footsteps on our roof. Creeping to the window, we saw a thick blanket of snow covering every branch and twig. As the muffled sounds continued, we concluded that the wet snow was evidently so heavy that the rising heat from the poorly insulated ceiling was causing the metal roof to go through a series of expansions and contractions. We then breathed a sigh of relief and went back to listening to the sound ...—first from one end of the roof, then from the other."

Near Madison, at Monona, Wisconsin, only a few blocks from Lake Monona, the home of Dennis Robertson is a three-story house with a wing to the right and a deck built out over sloping land at the rear. It is not one to catch the eye of a Lustron enthusiast, but the three-bedroom Westchester masquerades as the small wing of the structure. Only the window placement and the bay in the front wall confirm what is so well-hidden beneath the cosmetics.[73]

Robertson had several early failures in working with the Lustron unit, but soon solved a number of these problems. "I had to change the angle of the roof, and doing so by traditional methods would have required removal of the existing roof trusses and the roofing materials at a prohibitive cost. I ultimately solved this problem by having a 'scissors truss' designed locally and it is simply installed directly over the existing roof." He continued: "The original windows were totally inadequate for Wisconsin's harsh winters. In addition to heat loss, there was massive condensation on the inside of the windows. This problem could not have been solved but for the recent availability of self tapping two inch screws used in conjunction with an electric screw shooter or drill. Using these products, my three carpenters were able to reframe the window and door openings in less than a day.

"Ten years ago, trying to sheet-rock the interior would have been financially impossible because of the need to install furring strips or otherwise modify the inside framing. Sheet-rockers using self-tapping steel screws were able to sheet-rock the interior of the home with no more difficulty than the rest of the wood-framed house was sheet-rocked, and it took less than a day.

"Installing sheet-rock on the ceiling nullified the existing radiant heating system. However, the original heating system plans permitted me to convert the radiant system into a simply functioning hot air system. Using plans of the ductwork, I was able to get a local heating contractor to make elbows to fit on the end of the existing ductwork and remove the cold air return to the furnace. I accomplished all this myself, as no local heating contractor was willing to do it except by more modern and expensive methods such as using flexible insulated tubing.

"I was finally able to master the art of removing and changing the walls of the house after considerable individual effort. The original owner had already created a basement under the house which was ingenious in itself."

Robertson's house defies the eye which seeks to find the Lustron lurking beneath the shell, but the overall effect of the house is pleasing and well suited to the neighborhood which houses several other conventional Lustrons, one only a half-block away.

Probably the last Lustron to be built was erected in Des Moines, Iowa, in the mid–1970s, some 25 years after the com-

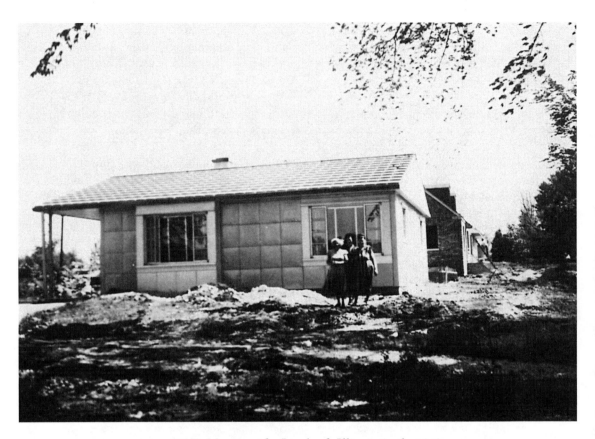

305 E. Morningside, Lombard, Illinois, in the 1940s.

pany was liquidated. This actually was a modification of an existing Westchester gray 03 model that had been built in 1949 for Calvert D. Weeks of the Fitch (Shampoo) Company. Two surplus Westchester gray unassembled units were purchased and added to the original structure using plans developed by Amos Emary & Associates of Des Moines. This house at 4111 Tonawanda Drive became one of the most remarkable of the rebuilt Lustrons. Using the supply of building panels and with the addition of architectural wood as a design break, the remodeled house featured a completed indoor swimming pool with an entire wall of glass on one side facing the woods, a greenhouse that formed part of the passage to the pool room, and additional bedrooms winging away from the original structure. This magnificent Lus-

tron was sold by Weeks in 1988 to new owner, Charles Muelhaupt.

At Deland, Illinois, a small village west of Champaign in the central part of the state, a welding shop at 530 Highway Avenue was hobbled together from what appears to be a Newport unit and a two-car Lustron garage in yet another gray structure. Assembled unconventionally, it is possible that this was originally a true Newport unit that had served as a home before this final modification. Extending back from the road, the structure is essentially one long rectangular building with a mismatched roofline due to the conjunction of house and garage with a common exterior wall forcing the offset roofline to work against the design integrity of the units.

The most wondrous and imaginative

305 E. Morningside, Lombard, Illinois. Photograph taken recently.

Lustron structure known is in Canton, Ohio. This is the Top-of-the-Mark Motel at 4135 Lincoln Street East in that city. The motel consists of three large motel structures which each have a long rectangular shape. There are ten units in each of these buildings with the basic motel room and bath at the front and a full garage at the rear of each unit. Thirty-six feet wide at the narrow end (or the length of each motel room unit), the buildings are essentially plain in design with one small window and a door at the front of each unit. Alternate units shift the door and window from side to side resulting in paired doors and paired windows in place of the static window-door, window-door variation.

After the failure of the Lustron Corporation, the owners of the Top-of-the-Mark Motel apparently purchased all of the required structural material from the remaining inventory at Columbus in one of the final sales of unmortgaged goods.

These are certainly not the only highly modified Lustrons in existence, but to date they are the only ones documented. Their discovery affirms the flexibility of the basic Lustron design and serves to illustrate that given the opportunity, the Lustron Corporation itself might have offered any number of modifications to and innovations of the six basic designs that did reach the market.

Postmortem

Blessed with the hindsight of some 50 years, our insight on the Lustron episode could remind us of the advent of a previously unheard of comet. These astral bodies are often heralded as a major stellar event, but the actual presence in the nighttime sky doesn't meet the expectation and soon they have passed into the inky depths of outer space.

So too with Lustron that burst on the postwar era with hype and hullabaloo based on the existence of one small tin-can house plunked into a formal garden and created from the standard architectural parts of gas stations. After successfully battling in the halls and back rooms of Congress for a full-scale production line, the company's effort resulted in sluggish production that dribbled from the gates of the Columbus plant and was minuscule compared to what the factory was capable of producing.

The watchdogs of government, baited by the lobbying of trade unions and builders who felt threatened in their livelihood, began to snip and tear at the fabric of Lustron's organization well before the plant had even produced a hundred houses. Far more of Lustron's time had to be devoted to warding off these attacks than to handling the normal day-to-day problems that were formidable in these early months.

Did Lustron recognize the forces gathering to stop it in its tracks? It's unlikely although the company tried to resist the growing tide of congressional inquiry. The company could only stick fingers into the dike holes as they appeared, as the swells of protest rose, and the entire dike was eventually breached.

What really was wrong with the project?

First, the venture was not one that Chicago Vit really wanted to get involved in. It was directly aimed at solving an immense short-term problem: that of providing housing for returning war veterans from the greatest war in history. Chicago Vit preferred to produce small attractive commercial buildings that could be sold directly to corporations that were well-funded and could pace their need to the trial growth pattern of the market as determined by the sales and demographics of the area.

Chicago Vit was practiced in this business and well able to handle it with their existing plant in Cicero. They were not capitalized to establish a huge mass-production facility that had an obvious short-term need. Unless a market could be developed for new models, much like the designer conscious automobile industry, the project was constrained by the eventual arrival of the last ship bearing returning veterans. Detroit had learned that once everyone that could afford a car had bought a car, the sales would plummet unless they could produce new and improved models that appealed to other desires of the public: color in place of

black; safety features; fins and other design features; and chrome, lots of chrome.

Second, the funding of the entire operation with borrowed government capital with associated short-term payback periods was a poor basis of capitalization for any enterprise. The basic concept of the separation of government and industry had blurred during the war when the government directed factory production, and was abrogated again here by the funding agreement. But then, considering the perception of the problem, what other choice could have been made?

Third, the scale of the new operation was far too big for an emerging industry that was yet to be proven. Much of the money that Lustron spent on dies and presses, ovens and ballmills was based on eventual high-growth sales and production that failed to materialize. The purchase of the huge hydraulic press for forming slightly longer bathtubs was a monumental error. Lustron could well have spent the first years using conventional tubs from plumbing sources and later added this equipment if it then proved economical. The dominating presence of this huge hydraulic press came to symbolize the project since it could produce tubs much faster than the plant could produce complete houses and thus it sat idle much of the time. This lost production time might have been put to good use *if* the tubs had been of conventional length, but since they were not, there was no interest in them by conventional builders and a secondary income source was lost.

Fourth, the economics of the industry was not conducive to quick payments for these expensive units. Housing traditionally had been considered the biggest single investment of the average family and was seldom, if ever, paid off in one lump sum. Certainly the returning veterans had no nest egg this large, and they required a financing program spread out over decades to buy their homes. Yet Lustron seemed to expect cash on the line for its units, and indeed, it was essential that the cash flow and house production be balanced. This problem was only seriously addressed early in 1950 when Lustron president Carl Strandlund set up the mortgaging business based on the methods of some of the automobile organizations.

Fifth, the company was subjected to some incredibly bad press. While its own handouts were upbeat and glowing, the daily papers and new magazines of the day were filled with stories and articles smearing the company with the muckraker's brush. "Wonderland Revisited," a feature with each lead paragraph introduced by a bit of nonsense from Lewis Carroll's classic, was particularly damaging. The public perception of the company, buoyed up by the demonstration models, was certainly dampened by the constant reports of a congressional inquiry, ever-increasing multimillion dollar loans, and reports of layoffs at a plant that should have been hiring and increasing production, if all was well.

Finally, sixth, the association of the company with several high-placed but ill-chosen men damaged the business dealings of Lustron when the public became aware of them. While using an article provided by Senator McCarthy for a promotional handout was not a bad idea, the exorbitant fee paid for the literature was suggestive of a payoff or of influence peddling. McCarthy was probably the best-known senator in Congress at that time because of his inquiries into Communist infiltration of various businesses, particularly Hollywood. Lustron must have considered that having any form of McCarthy patronage was certainly better for Lustron's image than having none.

As for the former United States

representative, "Sunny" Sundstrom, hired by Lustron, even Strandlund became disenchanted with him after only a few months at Columbus. Yet, when released from the company, Sunny seems to have sought revenge for the slight by using his friends in Congress to begin more investigations into the loans.

What was right with the project?

The final product was right: the 2600 Westchester 02 and 03 models that sprang up across the country in every state east of the Rockies. They are still standing proudly, gleaming and glistening, vanguards of a fledgling industry that turned later to conventional materials, strong and secure, warm and wholesome, and, perhaps best of all, fully assimilated into their neighborhoods so that only the trained eye will pick them out for what they are: sentinels of steel that prove Strandlund and Lustron were right. They are not monuments to Strandlund, but living, breathing attractive homes that still find ready buyers. Yet a surprising number have never been resold and are still inhabited by the original owners—a singular accomplishment for such a radical architectural deviation from the 1940s norm.

Factory-built homes returned in a new form in the 1980s when modular houses came on the scene. Epoch Corporation of Concord, New Hampshire, Contempri Homes, Inc., of Taylor, Pennsylvania, and Deluxe Homes of Pennsylvania at Berwick, all had assembly-line construction of modules. Their modules were small portions of a house that was 90 percent complete, but lacked an exterior cover. As many as 20 modules a day could roll off the lines. They used conventional lumber, drywall and plywood, together with wires, windows, carpet and cabinets, doors, pipes and sinks. The final product, which varied from Cape Cod to French Chalet, could be easily customized. *Insight Magazine* in its January 29, 1990, issue had a three-page story on this new style of building that had become popular on the East Coast.

Unlike Lustron's six models, up to 120 different plans were available in 1990, avoiding the problem of "masses of identical houses with a severely institutional look." Here the savings originate in lower labor costs in rural Pennsylvania when compared to labor in New York City. A union carpenter with wages and benefits cost $35 an hour in 1990 in the metropolis and half that at the modular factory. While not financed or equipped at the level of the Columbus factory, the current plants are perhaps better balanced to the actual market. In addition, there is not the double-edged sword of a huge market of returning veterans to satisfy.

The Lustron house sits quietly in its neighborhood doing what it was designed to do best. Unlike the contemporary Tucker Torpedo*—only 50 automobiles were made, and most of these are housed today in select museums—the Lustron Westchester Homes are *not* housed in museums, but continue to provide excellent housing for their owners some 50 years later, generally unmarred and undimmed by the passage of time.

Preston Tucker, who had a similar government-funded project, was a "promoter and would-be manufacturer of the Tucker almost-automobile, and but recently acquitted of mail fraud," according to Joseph Driscoll of the St. Louis Post-Dispatch. *"Strandlund, with years of industrial success behind him waxes understandably unhappy when anyone dares to mention him in the same breath with Preston Tucker." Strandlund clearly felt that Tucker was an undisciplined entrepreneurial promoter far adrift from his own well-engineered program.*

Strandlund Letter to Press and Accompanying Fact Sheet

LUSTRON CORPORATION, 4200 EAST FIFTH AVENUE, COLUMBUS, OHIO

December 31, 1949

Dear Editor:

For some time, the Lustron Corporation has been in the news. As you know, it has suffered many growing pains. It is emerging as a strong, healthy company.

As we come to the end of 1949, we are proud to point to the nearly 2000 Lustron Homes sheltering as many families. These families are the best spokesmen for the fine quality of our product and the ultimate success of Lustron.

It is true that we have had marketing difficulties. In our early stages we could not supply homes in sufficient quantity to permit dealers to keep their specially trained AFL crews continuously busy erecting homes. This forced us to delay expansion of our dealer organization. Then, while we were testing our production capacity and costs, we built up an inventory of houses, all of which have now been sold. Now that we are finally tooled, and in a position to produce fine homes faster than they have ever been turned out before, we are taking steps to expand our dealer organization on a sound, profitable basis.

Enclosed you will find a folder of photographs and factual information about the Lustron Corporation which you may wish to place in your morgue for ready reference. We want you to have it as background when you think a Lustron story merits your attention.

Please feel free to call on us at any time if you want additional information about Lustron. We would also be very glad to have you or any of your associates visit our plant in Columbus.

Sincerely,

Carl G. Strandlund
President

A N E W S T A N D A R D F O R L I V I N G

FACT SHEET

Lustron Corporation
4200 East Fifth Avenue
Columbus 16, Ohio

<u>The House</u>

 Precision built Lustron Homes are manufactured by straight line production methods. This newest application of lifetime porcelain finish on steel marks a radical departure from conventional building methods. Standard 2' x 2' exterior wall panels, standard 2' x 8' interior wall panels, standard 4' x 4' ceiling panels and shaped roof panels cover the interior and exterior of the home. All are designed as basic porcelain panels, coated on both sides to insure permanence.

<u>CONSTRUCTION</u> The skeleton of the house is made of steel framing, factory-welded into wall sections and roof trusses. Porcelain finish steel panels cover the roof, exterior and interior walls. Interlocking with each other, they are attached to the frame with concealed screws. Compressed between the panels is a permanent plastic sealing strip which forms a gasket and assures an air tight moisture resistant enclosure. This all steel construction provides great durability and strength.

<u>DESIGN</u> A choice of several colors in carefully blended combinations is available for the exterior. Interiors are finished in rich neutral tones which blend with any furniture or decorating scheme and which never need painting. Lustron colors have been carefully designed with the help of Howard Ketchum, Inc., one of the nation's foremost color experts. General lines follow the one-story modified ranch style architecture which has proved so popular in the past few years.

<u>ROOF</u> Specially shaped roof panels are designed both for strength and rugged appearance. The panels are finished on both sides with lifetime porcelain on steel. They are fastened to the steel roof trusses with concealed screws, giving the house a permanent and unusually attractive roof.

<u>PERMANENCE</u> The nature of lifetime porcelain finish is such that a Lustron Home never needs re-roofing or painting. The home is built of consistently high quality materials. Fire-safe, Lustron Homes receive the same low insurance rates as solid masonry construction. Rat-proof, decay-proof, termite and rodent-proof. The Lustron finish will not fade, crack or peel. Damage resulting from abuse can be easily repaired. All-aluminum sash windows open out, are easily operated from inside by crank type handles. Screens are included.

<u>FOUNDATION</u> The house is erected on a concrete slab. No basement, no expensive excavation necessary. Foundation is insulated with the best known material for foundation insulation.

<u>INSULATION</u> Walls and ceiling are fully insulated with high quality, fire resistant permanent material, making the home wonderfully cool in summer and snug and warm in winter. Special attention has been paid to cross ventilation of the bedrooms by the arrangement of the windows.

<u>MODELS</u> At present the Lustron Home is available in two Westchester DeLuxe Models. One is a two bedroom home of 1093 square feet, including a porch. The other is a three bedroom plan containing 1217 square feet. Both are equipped with

many deluxe features including built-in bookshelves, bedroom vanity-storagewall, eleven closets and overhead storage cabinets, oil or gas radiant panel heating, dishwasher-clotheswasher combination, china cabinet passthrough, large picture windows, large service and storage area.

GARAGES The same exterior wall and roof panels which are used in the Lustron Home are sold to Lustron dealers in packages for one-and two-car garages to match the houses. These are fastened to wood framing supplied by the dealers. Breezeways, patios, carports, screened porches can be added by the dealer, at the customer's option, using Lustron panels in combination with conventional materials to give unlimited variety to Lustron Homes.

PRICE Lustron cannot quote a delivered and erected price for any home. To the factory cost of the house and transportation charges, the local builder-dealer adds the cost of erection labor, which amounts to 300 to 400 man hours at prevailing carpenter rates. Plumbing requires 40 hours, electrical work 25 hours, asphalt tile installation 12 to 16 hours. Site preparation, installation of electric, water, gas (or oil tank), and sewage lines is additional, as is the design and preparation of walks, driveways, landscaping and the addition of garages, breezeways and other features at the customer's option. Many of these costs vary according to size and condition of the lot.

The Plant

THE LUSTRON CORPORATION plant is leased from the War Assets Administration at $35,000 per month. It is located directly east of Columbus, Ohio, near the Pennsylvania and B & O railroads. It is conveniently accessible to US highways 40, 62, and 33, a stone's throw from the Columbus airport.

In area it comprises 1,100,000 square feet of floor space in two huge buildings having floor space under roof equivalent to 22 football fields. Within the plant there has been installed $15,000,000 worth of furnaces, presses, dies, welding machines and other tools necessary to turn out homes on full three-shift operation at the rate of 100 per day. Best production record to date is 27 in a single eight-hour shift. Forty-two houses have been shipped in one day.

Engineering of the plant has placed fabricating and processing equipment for manufacture of panels, cabinets, and sanitary ware in one building. The second building provides fabrication and assembly of structural members along with the integration of manufactured pieces with purchased parts. Huge truck-trailers serve as the assembly line package. These trailers are loaded inversely to the order in which parts are needed during house erection, so that they serve as warehouses on the construction site.

Production is controlled by orders on hand, with virtually no warehouse space for completed houses. Parts are fabricated on 163 presses, ranging from 30 to 1800 ton capacity. The largest of these presses can draw a bathtub in a single operation. Three huge automatic presses can turn out 2' x 2' panels in steady stream. The manufacturing processes are sustained and production flow maintained by more than 8 miles of constantly moving conveyors.

The largest porcelain enameling setup in the world is housed in one building where eleven specially designed furnaces with their accessory equipment might be considered as eleven enameling plants. Two of the eleven furnaces, electric ones, have the largest rated capacity of any in the world. The other nine furnaces are much larger than those commonly employed in the porcelain industry.

Welding is an important process in the manufacture of the Lustron Home. Here too, the Lustron plant is equipped to do projection and spot welding. One of the most complicated industrial welding applications is the automatic machine used in the assembly of roof trusses, in which 31 welds are completed in a 40-second cycle.

One important Lustron development is the use of cold rolled automobile body sheet steel of standard gauges. Ceramic engineers developed the process and materials to enable firing the porcelain at much lower temperatures than other plants. By permitting lower firing temperatures, this method cuts fuel costs, decreases warpage, and reduces tooling materially. Also of a revolutionary nature, was the use of cover coat porcelain enamel directly to the steel with the elimination of the conventional base or ground coat.

All labor within the plant is A.F. of L., workers being members of the carpenters, plumbers, or electricians unions.

Transportation

Lustron homes are carried from the Columbus, Ohio plant on specially built trailers to the site where they are to be erected. The country has been divided into zones, to permit uniform delivery prices at points equidistant from the factory.

Trailers used in the movement of the houses from the factory to the site are loaded on the plant assembly line, in proper rotation to permit rapid unloading and erection in the field. When it is necessary to ship homes by rail, the trailer is placed on a flat car, or specially crated to comply with railroad classifications. Tests are being conducted for export shipments, both by special crating and by shipping the loaded trailer.

The overall length of the Lustron truck and trailer is 45 feet. Trailer length is 32'6", width 8' and overall height 12'3".

Trailers are designed to accommodate the parts of the house without crating. Compartments and racks are designed to prevent damage to the materials while in transit, as well as during loading and unloading operations.

Tractors and trailers are leased by Lustron. Combination trailer-tractors are brightly colored in blue and yellow to permit ready visibility and an appearance of neatness and cleanliness which is evident in the house. On December 31, 1949, there were 800 of these specially designed trailers and 200 tractors available to Lustron.

Dealers

Builder-dealers are franchised to erect houses within a given geographical area. Prerequisite to receiving a franchise is experience in the construction and sales field, a good credit record, sufficient working capital and willingness to use AFL union labor.

At the end of 1949, Lustron has 234 dealers located in 35 states, and one in Venezuela. The dealer organization is growing constantly.

Dealers are responsible for initiating their own sales, and for construct-
ing the homes. Any variations from the standard plans are the responsibility of
the dealers.

Lustron conducts a Sales and Management Training Clinic at the factory to
train dealers in the successful operation of a dealership.

Erection

A standard erection procedure has been prescribed by the Service Depart-
ment of the Lustron Corporation, which is responsible for instruction of dealer
erection crews, quality control of erection in the field, and replacement of parts
damaged in shipment.

When the first Lustron homes were erected, workmen required as many as
1500 hours to piece the buildings together in the field. Engineering developments
and improved erection methods have cut this time to an average of 350 hours—with
some houses being put up in as few as 250 hours. Normal building time is approxi-
mately two weeks. AF of L carpenters, electricians and plumbers are used for all
field construction labor.

Lustron maintains an Erection Training School at the factory to train
dealers' supervisors and foremen in efficient erection methods.

Home Finance

Lustron homes are being financed through all sources of mortgage finan-
cing. Loans have been made by many of the largest insurance companies through
their branch offices throughout the country. Savings and loan associations have
been prominent in Lustron customer financing, making a large number of loans with-
out government guarantee.

Almost all Federal Housing Administration offices east of the Rocky
Mountains have by now processed mortgage insurance applications on Lustron homes.
Field offices of the Veterans Administration have guaranteed second mortgage
loans to veterans in many localities thereby enabling them to buy Lustron homes
with little or no down payments. The amounts which the lending institutions,
FHA and VA, are willing to loan or guarantee are being gradually raised as the
Lustron home demonstrates its potentialities for market acceptability and owner
satisfaction.

Lustron Corporation and the Galbreath Mortgage Company, of Columbus, Ohio,
have developed a plan for interim financing of dealers which has been acclaimed
by everyone in the home manufacturing industry as a distinct contribution to the
solution of one of the major problems of the industry. The plan has been made
available to one other company and the Galbreath Mortgage Company has received
overtures for its extension to many others. Under the plan, Lustron dealers may
receive a loan for erection costs plus payment for the Lustron house package as
it leaves the gate on the Lustron special trailer.

Shipments and Inventory

Shipments of Lustron Homes have diminished completely the inventory of homes built up during the production testing of the factory. At the present time, only a minimum inventory of ten or fifteen houses is maintained to provide for color and other options to meet the needs of customers and zoning regulations.

Shipments by states to and including December 31, 1949, have been as follows:

Alabama	15	New Jersey	12
Arkansas	12	New Mexico	7
Connecticut	42	New York	103
District of Columbia	20	North Carolina	339
Florida	16	North Dakota	12
Georgia	18	Ohio	275
Illinois	307	Oklahoma	8
Indiana	142	Pennsylvania	116
Iowa	112	South Carolina	2
Kansas	70	South Dakota	27
Kentucky	28	Tennessee	29
Louisiana	22	Texas	13
Maryland	7	Virginia	81
Massachusetts	22	West Virginia	64
Michigan	48	Wisconsin	129
Minnesota	29	Export	5
Mississippi	5	Test & Demonstration	11
Missouri	97		
Nebraska	25	TOTAL SHIPMENTS	1970

Public Acceptance

A total of 404,061 letters and written inquiries have been received by Lustron Corporation since April 1948, when its national advertising began. In addition, it is estimated that more than two million people have visited and inspected demonstration Lustron Homes in communities throughout the country east of the Rocky Mountains.

Independent surveys of Lustron homeowners show almost universal satisfaction with the Lustron Home by those who have invested their money and who are in the best position to judge. In localities where a number of Lustron Homes have been erected, dealers report no difficulty securing additional sales. Public acceptance or customer orders have not been serious problems in most localities.

Sales have held up surprisingly well in November and December, and prospects are good for January and February, in spite of winter weather.

As dealers become better organized to handle the widespread demand for Lustron Homes, and as financing arrangements are being simplified, the sales prospects for the months ahead look very good.

Current Financial Summary

Lustron has not borrowed any money from RFC since September 13, 1949. At the present time, Lustron has liquid assets in the form of cash and receivables of over two and a half million dollars. The only money needed now is to

provide for additional working capital on a stepped up program beginning in March— dictated by an improvement in sales.

Expenses of creating the manufacturing facilities were at a peak in June 1949. Losses as of November have been reduced by almost one million dollars per month. The loss in November was $628,431.83, which included $158,734.56 for interest and rent paid back to the government, $107,370.93 charged off for depreciation and amortization of equipment already paid for, and $159,180.54 charged off for unused mileage which is subject to recovery when volume increases, leaving a net loss excluding these fixed charges of $203,145.80 for November.

The last loans from RFC were granted on a short term basis with the understanding that re-payments would be scheduled by RFC to meet Lustron's ability to pay.

December 31, 1949

Engineering Development
of the Lustron Home

ENGINEERING DEVELOPMENT OF THE

LUSTRON HOME

By: Robert Runyan
 Chief Engineer
 Lustron Corporation
 Columbus, Ohio

The Lustron Home is an outgrowth of the progress made in the commercial
field for the past 15 years in the use of procelain enameled steel. During
the time this material has proven itself to be outstanding for use in building
because of its durability and recpod of low maintenance cost. While the use
of this material represents a radical departure from conventional building
methods, a careful study of all factors would indicate that the big reason
it has never been tried on a large scale before is that no one had give the
possibilities enough consideration.

After long research and experimentation, the major oil companies have
found that porcelain enameled buildings have the lowest maintenance costs of
any other construction. The adaptation of porcelain enameled, all-steel
products to home construction is the result of the success of buildings
constructed to withstand rough usuage and yet containing the elements of
beauty and better living.

Heavy industry in America long ago turned to steel. Through the
development of the present day automobile, railroad cars and aircraft, the
way has become clear for the development of a new and lasting type of home.

The designing of a home is more complex than that of other high
production units. Lustron's Home has involved expert engineering from many
fields. Architects, mechanical, production, cost, ceramic, erection, heating,
electrical, structural and plumbing engineers and experts were called upon
to engineer the home as a complete unit.

Architects developed a simple, one-floor plan, five-room home with
lines that could be re-produced in high production. With leeway for

- 2 -

imagination and technical spread, the big job was to design and develop a home which would be more liveable than other homes in the $10,000 and below types.

Mechanical engineers developed a home which could be manufactured and assembled from produced parts the same as automobiles, airplanes, railroad cars and the like.

Structural engineers devised simplified structurally strong walls and roof trusses that would withstand the diversified necessities of different climatic conditions.

Heating engineers again simplified and combined proven heating systems into the Lustron radiant heating through ceiling innovations.

Plumbing engineers developed a standard fabricated plumbing system which is mechanically sound and minimizes on site problems.

Electrical engineers incorporated ideas from the automotive and aircraft industries in the perfection of a wiring and lighting system.

Ceramic engineers and production experts met the problem of developing a one-coat, low-temperature enamel which reduced the amount of production equipment necessary and saved hours in the enameling process. This was a new development to the industry.

Tools and machinery on a large scale, with unprecedented capacities and sizes, faced production engineers in the developing of Lustron Homes. It was their thought that, to speed operations, they must use high production machines, such as Yoder Rolls, specially adapted resistance welding equipment and high-speed presses. By using high-speed equipment of this type they would speed up operations and cut down the total amount of equipment necessary to meet the projected production schedule as complete as possible. The Erection Engineers coordinated their thinking with production and shipping departments to produce units that were complete assemblies and made up shipping packages that could be sent to the field and assembled on the site with a minimum amount

- 3 -

of erection time. It was their analysis that plumbing, wiring and heating
were time-consuming jobs which had to be met with efficient plans and co-
ordinated effort.

The new Lustron Home is the result of this engineering. The present
model is the culmination of nearly 200,000 man hours of planning, drafting,
designing and weighing of production problems. More than 100 engineers are
now busy on future Lustron designs and models.

Technically, the engineering problems of the basic structure are a
fact. The 138 stud sections, 210 stud spacers and 307 intermediate spacers
were designed as the basic structural section. These parts could be repro-
duced on Yoder Mills at low cost. They could be assembled in fixtures and
welded to give sturdy, light-weight structures which can be assembled and
handled easily in the field.

Roof trusses are made up of one thousand of the basic structural section,
three hundred twenty No. 02-502-12 gusset plates, two hundred seventy feet
of 3/8" round rod, standard bearing plate, and connectors. These are placed
in an assembly fixture and welded by specially adapted spot and projection
welders. Structural wall sections are anchored to the foundation with an
average of two bolts per section, and each section is bolted to the next
adjacent section with only three bolts. The roof trusses are fixed by
two bolts on each end and lateral bracing is made by two bolts per truss.
There are 168 standard exterior 2' X 2' wall panels, 48 standard interior
8' X 2' wall panels, 53 standard 4' X 4' ceiling panels and 242 roof panels,
all designed as basic panels to cover the exterior and interior of the home.
These panels are stampings which are produced on fast-acting presses in
progressive operations to give a low fabricating cost. By running these
parts through a continuous pickling, a continuous spray, and 200' continuous
furnaces there is a steady flow of panels from the fabricating line to the
final assembly.

- 4 -

The plumbing is built up and fits within the structural wall section. In the field, one connection is made to the sewer, another to the water supply, the lines between the kitchen and bath plumbing walls are connected and the fixtures installed to give the minimum amount of on-the-site labor.

Electrical wiring is made up of boxes shop-welded to the structure, BX cable, pre-cut to fit at one end, connected to a box and the lenght coiled up and taped to the structure so that in field erection the tapes may be cut and the BX uncoiled and attached to the next box.

The furnace within the house is a simplified unit which is hung to the ceiling and attached by four bolts. The distribution of heat has been accomplished by channeling air above the ceiling and below the pelnum insulation suspended between the trusses. There are baffle plates shop-welded to the trusses and baffle plates which are hung between the trusses in the field.

The eight cabinets and closet areas of the home form partition walls within the house. These cabinets are put in place after the ceiling panels, and interior panels have been erected. The cabinets have many built-in features which add more efficiency to each room, plus a wealth of storage space.

As I have pointed out, the standardization and duplication of piece parts fabricated, the simplification of parts in corporation of high-speed fabricating equipment have knitted together to give a low cost product.

With cost engineers analyzing and comparing the house with similar products manufactured by other steel fabricators on a cost per pound basis, more simplifications and standardization of parts in prodcution were brought about.

Erection consultants and engineers worked out site problems, with a view towarda development of a standard foundation, easily leveled and

- 5 -

squared-up. Working with the shipping department in coordinated effort to
solve packaging and shipping, erection men planned the loading and unloading
operations which would end on the erection sites with home parts easily available
for step-bystep erection and completion of the home. Setting erection time at
130 to 140 man-hours per home, the erection engineers successfully analyzed
field assemblies with the continuing aim of cutting down the home assembly
time.

The Lustron Home is a composit of many planned and engineered homes.
All were combined with the idea of producing a home acceptable to the
American public and adaptable to production methods. The work of all the
involved engineering groups culminated in this 20th Century engineered home.

Lustron House Shipments

1948	30	
Jan. 1949	96	
Feb. 1949	78	
Mar. 1949	117	Prototype and test period
Apr. 1949	146	
May 1949	168	
June 1949	203	
July 1949	270	Plant tested and ready to operate
		RFC pressure and bad publicity campaign started
Aug. 1949	190	
Sept. 1949	200	
Oct. 1949	173	
Nov. 1949		
Dec. 1949	134	
Jan. 1950	125	
Feb. 1950	119	RFC filed foreclosure suit
Mar. 1950	80	Receiver appointed
Apr. 1950	65	
May 1 to June 6	130	Foreclosure sale on June 6
Total	2498	

Note: 36 cash orders were returned to dealers on June 6 which could not be filled because of the foreclosure sale. If full cash had not been required for each order before shipment, there would have been many more orders pending at the time of sale. Dealer interest and public demand [were] ... still very high in spite of the foreclosure suit and bad publicity.

This page is the source for the often quoted 2,498 Lustron Homes manufactured. This sheet does not match the Shipping Record (Appendix D) which shows 2,680 houses shipped from Columbus. The Shipping Record appears to be more accurate based on the survey of serial numbers.

Lustron Manufacturing and Shipping Record from Company Files

Month/Year	Built	Total Built	Shipped	Total Shipped	Left at Columbus
April 1948	2	2	1	1	1
May 1948	2	4	1	2	2
June 1948		4	2	4	0
July 1948	5	9	3	7	2
August 1948	1	10	3	10	0
September 1948	0	10	0	10	0
October 1948	7	17	4	14	3
November 1948	13	30	7	21	9
December 1948	10	40	9	30	10
January 1949	123	163	96	126	37
February 1949	107	270	78	204	66
March 1949	105	375	117	321	54
April 1949	135	510	116	437	73
May 1949	187	697	168	605	92
June 1949	297	994	203	808	**186**
July 1949	**375**	1369	**270**	1348	21
August 1949	310	1679	190	1538	141
September 1949	126	1805	200	1738	67
October 1949	52	1857	?	?	?
November 1949	27	1884	173	1911	?
December 1949	?	?	174	2185	?
January 1950	?	?	125	2210	?
February 1950	?	?	119	2405	?
March 1950	?	?	80	2485	?
April 1950	0	?	65	2550	130
May 1950	0	?	130	**2680**	0

In a two-year span of manufacturing and shipping, Lustron made the most houses (375) in July 1949, before the layoffs began.

The greatest number of houses shipped was 270 in July 1949 and the total number of houses shipped was 2,680. The largest number of houses sitting at Columbus to be shipped was 186 in June 1949.

Based on two lists: Houses Manufactured by Month Up to Nov. 49, and Houses Shipped in 1948 and by month till June 6, 1950.

Zone and Price List

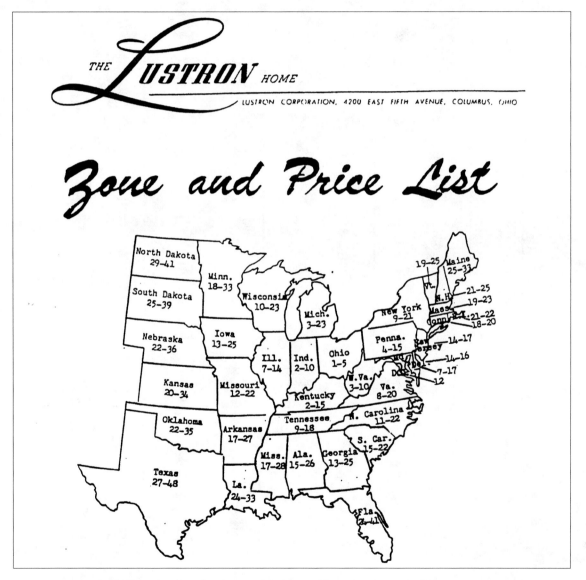

Marketing of the houses was limited to the Midwest, East Coast and the South. (Lustron Corporation Records, Ohio Historical Society, Columbus, Ohio.)

DELIVERED PRICES

Lustron House Package

ZONE	NEWPORT		MEADOWBROOK		WESTCHESTER STANDARD		WESTCHESTER DE LUXE	
	Model		Model		Model		Model	
	023	033	022	032	021	031	02	03
f o b	4110	5065	4510	5413	5213	5765	5407	6482
1	4190	5145	4590	5490	5290	5845	5487	6562
2	4215	5170	4615	5515	5315	5870	5512	6587
3	4240	5195	4640	5540	5340	5895	5537	6612
4	4265	5220	4665	5565	5365	5920	5562	6037
5	4290	5245	4690	5590	5390	5945	5587	6662
6	4315	5270	4715	5615	5415	5970	5612	6687
7	4340	5295	4740	5640	5440	5995	5637	6712
8	4365	5320	4765	5665	5465	6020	5662	6737
9	4390	5345	4790	5690	5490	6045	5687	6762
10	4415	5370	4815	5715	5515	6070	5712	6787
11	4440	5395	4840	5740	5540	6095	5737	6812
12	4465	5420	4865	5765	5565	6120	5762	6837
13	4490	5445	4890	5790	5590	6145	5787	6862
14	4515	5470	4915	5815	5615	6170	5812	6887
15	4540	5495	4940	5840	5640	6195	5837	6912
16	4565	5520	4965	5865	5665	6220	5862	6937
17	4590	5545	4990	5890	5690	6245	5887	6962
18	4615	5570	5015	5915	5715	6270	5912	6987
19	4640	5595	5040	5940	5740	6295	5937	7012
20	4665	5620	5065	5965	5765	6320	5962	7037
21	4690	5645	5090	5990	5790	6345	5987	7062
22	4715	5670	5115	6015	5815	6370	6012	7087
23	4740	5695	5140	6040	5840	6395	6037	7112
24	4765	5720	5165	6065	5865	6420	6062	7137
25	4790	5745	5190	6090	5890	6445	6087	7162
26	4815	5770	5215	6115	5915	6470	6112	7187
27	4840	5795	5240	6140	5940	6495	6137	7212
28	4865	5820	5265	6165	5965	6520	6162	7237
29	4890	5845	5290	6190	5990	6545	6187	7262
30	4915	5870	5315	6215	6015	6570	6212	7287
31	4940	5895	5340	6240	6040	6595	6237	7312
32	4965	5920	5365	6265	6065	6620	6262	7337
33	4990	5945	5390	6290	6090	6645	6287	7362
34	5015	5970	5415	6315	6115	6670	6312	7387
35	5040	5995	5440	6340	6140	6695	6337	7412
36	5065	6020	5465	6365	6165	6720	6362	7437
37	5090	6045	5490	6390	6190	6745	6387	7462
38	5115	6070	5515	6415	6215	6770	6412	7487
39	5140	6095	5540	6440	6240	6795	6437	7512
40	5165	6120	5565	6465	6265	6820	6462	7537

- 2 -
DELIVERED PRICES
Lustron House Package
(Continued)

ZONE	NEWPORT		MEADOWBROOK		WESTCHESTER STANDARD		WESTCHESTER DE LUXE	
	Model		Model		Model		Model	
	023	033	022	032	021	031	02	03
41	5190	6145	5590	6490	6290	6845	6487	7562
42	5215	6170	5615	6515	6315	6870	6512	7587
43	5240	6195	5640	6540	6340	6895	6537	7612
44	5265	6220	5665	6565	6365	6920	6562	7637
45	5290	6245	5690	6590	6390	6945	6587	7662
46	5315	6270	5715	6615	6415	6970	6612	7687
47	5340	6295	5740	6640	6440	6995	6637	7712
48	5365	6320	5765	6665	6465	7020	6662	7737

NOTE:

1. Lustron WESTCHESTER Deluxe and Standard models have identical floor plans but differ in following respects:

	Deluxe	Standard
Vanity-bookcase	yes	no
China-pass-through	yes	no
Ceiling radiant heat	yes	no
Bay window	yes	no
Bathroom vanity	yes	no
Kitchen panels	2' x 2'	2' x 8'
Floor tile	yes	no

2. Lustron WESTCHESTER Deluxe models include ceiling radiant panel heat and all present built-in and structural features. Includes asphalt tile in package.

3. Lustron WESTCHESTER Standard, MEADOWBROOK, and NEWPORT series have conventional heating system, minimum built-in features, floor covering supplied by builder.

4. Prices do not include foundation package.

5. All prices include Thor dishwasher-clotheswasher. Substitution of double sink will reduce price $215.

6. Exterior colors for all models same as present 02 and 03.

7. Prices do not include freight charges for overage shipments.

Prices are subject to change without notice.

November 10, 1949

COMPARATIVE COSTS OF LUSTRON TWO-BEDROOM HOUSE
MODEL 02

ITEM	COLUMBUS IND.	WILSON N.C.	DOVER OHIO	BLOOMING-TON, IND.	MARION IND.
Foundation	$ 828.50	$ 700.00	$ 789.24	$ 891.54	$856.02
House Pkg. Delivered	5587.00	6229.00	5677.36	5612.00	5562.00
Erection	700.00	540.00	684.00	1279.00	937.55
Plumbing	185.00	250.00	168.16	219.87	117.37
Electrical	90.00	125.00	190.00	75.00	111.37
Insulation & Floor Tile	100.00	146.00	250.00	97.10	140.49
Total Cost	$7490.50	$7990.00	$7758.76	$8174.51	$7725.00
Profit & Overhead	910.00	1210.00		950.00	275.00
SELLING PRICE	$8400.50	$9200.00		$9124.51	$8000.00

ITEM	MADISON IND.	MANSFIELD OHIO	LOUIS-VILLE,KY.	SANDUSKY OHIO	URBANA OHIO
Foundation	$ 700.00	$1372.73	$ 800.00	$1414.36	$1025.00
House Pkg. Delivered	5562.00	5667.85	5612.00	5512.00	5737.00
Erection	1700.00	953.75	796.57	1190.03	900.00
Plumbing	100.00	131.30	280.00	200.00	140.00
Electrical	100.00	125.31	168.00	103.12	81.00
Insulation & Floor Tile	95.00	120.00	110.00	164.00	150.00
Total Cost	$8257.00	$8370.94	$7766.57	$8583.51	$8033.00
Profit & Overhead	950.00	172.04	920.00	971.65	942.00
SELLING PRICE	$9207.00	$8542.98	$8686.57	$9555.16	$8975.00

ITEM	MEDINA OHIO	ALLENTOWN PA.	DARLINGTON WIS.
Foundation	$ 914.80	$ 920.00	$1000.00
House Pkg. Delivered	5487.00	5737.00	5812.00
Erection	1039.36	967.00	800.00
Plumbing	440.94	300.00	150.00
Electrical	140.69	115.00	75.00
Insulation & Floor Tile	230.03	140.00	159.00
Total Cost	$8252.82	$8179.00	$7996.00
Profit & Overhead	632.00	1396.00	900.00
SELLING PRICE	$8884.82	$9575.00	$8896.00

Cost data supplied by Lustron dealers.

LUSTRON HOUSES - F.O.B. PRICES AND ESTIMATED

SALES PRICES

Model description	Size	Sq. ft.	F.O.B. Price		Est. Sales Price	
			Amount	Sq. ft.	Amount	Sq. ft.
Newport 022 - 2-bedroom	31'x 23'	713	$4110	$5.76	$7000	$9.81
Newport 033 - 3-bedroom	31'x 31'	961	$5065	$5.27	$8200	$8.53
Meadowbrook 022 - 2-bedroom	31'x 25'	775	$4510	$5.82	$7400	$9.55
Meadowbrook 032 - 3-bedroom	31'x 33'	1023	$5410	$5.29	$8700	$8.50
Westchester Standard 021 2-bedroom	31'x 35'	1085	$5210	$4.80	$8600	$7.92
Westchester Standard 031 3-bedroom	31'x 39'	1209	$5765	$4.77	$9300	$7.69
Westchester Deluxe 02 2-bedroom	31'x 35'	1085	$5407	$4.98	$9000	$8.29
Westchester Deluxe 03 3-bedroom	31'x 39'	1209	$6482	$5.36	$10000	$8.27

Estimated sales price excludes land but includes normal profit and overhead. Includes transportation allowance for radius of 200-400 miles from Columbus. Actual sales prices depend upon distance from Columbus and local construction costs.

Lustron Letters to a Customer, 1949

THE *LUSTRON* HOME

LUSTRON CORPORATION, 4200 EAST FIFTH AVENUE, COLUMBUS, OHIO

August 25, 1949

Mr. H. S. Gutenstein,
Ambulatory Pneumatic Splint Mfg. Co.,
1851 West Ogden Avenue,
Chicago 12, Illinois

Dear Mr. Gutenstein:

Thank you for your letter of August 22; we are happy to know that you will soon be the owner of a Lustron Home, and that you admire its unique features and advantages.

We do not have a book of instructions for care of the Lustron Home as yet; however, we are planning to compile one in the near future.

By way of mention, we would like to caution you not to use an oil or wax paste on the asphalt tile floor. With a liquid wax you can obtain much better results.

We are enclosing a booklet which may be helpful to you. If you have any further queries, please do not hesitate to write to us again, as we want you to be pleased with your Lustron Home in every respect.

Yours very truly,

LUSTRON CORPORATION

Helen M. Keys
Market Development Department

Enclosures

LUSTRON CORPORATION, 4200 EAST FIFTH AVENUE, COLUMBUS, OHIO

November 28, 1949

Mr. Hanns S. Gutenstein
303 Loy Street
Lombard, Illinois

Dear Mr. Gutenstein:

Thank you for your letter of November 19. We are very glad to know that you are pleased with your Lustron Home.

Enclosed is a chart which shows the numbers of Lustron colors as they correspond to the areas in the Lustron Home. It should be of help to you in using the touch-up paint.

As concerns your questions concerning the heating system, I have referred the matter to our Service Department, and they advise as follows:

A. Start and stop of the circulation blower is controlled by the temperature inside the furnace. The blower should not operate until a certain temperature has been built up inside the furnace, and should not stop after the burner goes off until the temperature in this bonnet is reduced to a predetermined temperature.

B. Your furnace adjustment should be set on "Winter", as the "Summer" adjustment is used on conventional convection-style heating systems where it may be advisable to have a movement of air in the house during the summer months.

Garages are now available, in single or double style, and our dealers have been notified of their availability. If you will con- . tact your dealer again, we believe he will now be able to give you complete information.

Thank you again.

Yours very truly,

LUSTRON CORPORATION
Helen M. Keys
Helen M. Keys
Market Development Department

Enclosure

A N E W S T A N D A R D F O R L I V I N G

Annotated List of Articles from Better Enameling

Sept. 1943: p. 17 "C. G. Strandlund Becomes Vice President and General Manager of Chicago Vit"

May 1944: p. 11 "Carl Strandlund Honored" (Awarded "War Workers Award" by the *Chicago Tribune*)

Jan. 1946: pp. 10–12 "Potentialities of Porcelain Enamel," by Carl Strandlund (This article mentions the visit of Secretary of Commerce Henry A. Wallace and John Blanford, Head of National Housing Agency, to Chicago Vit to see "colored portrayal of a porcelain enameled bungalow")

Dec. 1946: pp. 11–19 "Picture Tour Through Lustron Demo Home, Hinsdale, IL"

Oct. 1948: pp. 32–33 "Lustron Appointments" (List of seven midlevel managers appointed to Lustron Corporation)

Vol. 19 (1948): "A Progress Report on Lustron" (Photographs of the interior of the manufacturing plant at Columbus, OH, and floor plan of the enameling section)

July 1949: p. 29 "Lustron Appoints Matheson General Manager of Sales" (W. A. Matheson)

August 1949: p. 28 "Lustron Daily Production Reaches 24 Homes" (Mentions that homes were sent by truck to Ohio, Illinois, Indiana, Maryland, Wisconsin, Connecticut, Massachusetts, Kansas, Iowa, Pennsylvania, New York, West Virginia, Arkansas, and Michigan)

Oct. 1949: p. 34 "Lustron Promotes Fisher" (Carl Fisher promoted to Purchasing Manager)

Feb. 1950: pp. 13–14 "Porcelain Enamel in Home Construction" (Sales pitch for using porcelain enamel, listing advantages. The following statement is included: "The use of Porcelain Enamel for home construction has been proved in the Lustron Home. However, I would like to point out that the wide publicity attached to the Lustron Home has tended to obscure the possibilities of Porcelain Enamel itself. Contrary to the popular conception, the Lustron Home is not a prefabricated house, but a manufactured product consisting of an assembly of many basic parts and materials.")

July 1950: p. 31 "Howe Rejoins Chicago Vit" (E. E. Howe returned to Chicago Vit after serving as the head of enameling operations at Lustron Corporation)

Directory of Known Lustron Homes by State

"M" indicates a model number, "S" a serial number. MODEL indicates a model home.

Alabama

Birmingham 2420 Cahaba Road (M023, Tan, S2056); 2424 Cahaba Road (M02, Gray, S1969); 430 Columbiana Road (M023). *Florence* 321 Beverly (M02, Gray, S1396); 1145 Wildwood Park Road (M02, Blue); 1822 Ridge Avenue (M02, Tan, S2019). *Huntsville* 1105 Harrison Avenue (M02, Gray, S1102). *Jackson* 519 College Street (M02, Dk Tan); 116 W. Pearl Street (M02, Tan). *Sheffield* 211 Pickwick Street (M02); 1406 34th Street (M02, Yellow, MODEL). *Tuscaloosa* 27 Parkview Drive (M02, Tan, S632). *Tuscumbia* 211 Pickwick Street (M02, Yellow).

Alaska

Anchorage (Elmandorf Air Force Base) Bldg 21-400 (M02, S10, Razed c. 1981). *Fairbanks (Ladd Air Force Base)* Bldg 657 (then 4006) M02, S11, Razed c. 1992).

Connecticut

Bristol 41 Barbara Road. *Cos Cobb* (see *Old Greenwich*) Cedar Street (M02, Gray). *Darien* 159 Hoyt Street (M02, Blue); Seagate Road. *Easton* Jessie Lee Road; Sport Hill Road (M02, Re-sided). *Fairfield* Fairfield Beach Road (M02, Re-sided, Razed 1993); Lalley Boulevard; 76 Pratt Street (M02, Yellow); Rowland Drive (M02, Re-sided); 176 Wakeman Road (M02, Tan). *Hamden* 2029 Dixwell Avenue (M02, Re-sided); 10 Hilltop Terrace (M02, Blue). *Meriden* 312 Reservoir Avenue (M02, Blue); East Main @ Hillcrest Terrace (Yellow). *Milford* 27 Dock Road (M02, Re-sided); 62 Orland Drive (M02, Blue, S311); 30 Adams Street (M02, Gray, 2 car). *New Canaan* Carter Street (M02, Yellow). *Norwalk* 13 Dock Street (M02, Gray). *Old Greenwich* 12 Stuart Drive (M03, White siding). *Orange* 227 Old Tavern Road (M02, Tan). *Plainville* Cook Street @ Betsy Road. *Rockville* 40 Davis Avenue (M02, Gray, S1486). *Stamford* 75 Hillendale Avenue (Gray); Underhill Street (M02, Gray); 37 Unity Road (M02, Yellow); Unity Road (M02, Yellow); 37 Unity Road (Re-sided); 77 Weed Avenue (M02, Gray). *Stratford* 500 Soundview Avenue. *Westport* 16 Hilltop Terrace (M02, Tan).

District of Columbia

Washington "Foggy Bottom area" (M02, Blue, S3); New Hampshire @ E Street, NW (MODEL).

Florida

Bradenton 2723 Manatee Avenue West (M02, Tan, S1790); 2201 15th Avenue West (M02, Yellow); 2205 15th Avenue West (M02, Blue-green). *Eglin Air Force Base*

(M02). *Fort Lauderdale* 108 Hendricks Isle Street (M023, Blue-green); 110 Hendricks Isle Street (M023, Yellow). *Miami* 5200 Biscayne Boulevard (M02, Blue, MODEL, S8). *Ruskin* Route 41 (Yellow). *Sarasota* 1805 Hibisons Street (M02, Blue-green). *Tampa* 1011 E. Crenshaw (M02, Blue-green, S2031, 1½); 3618 El Prado (M02, Gray); 3819 El Prado (M02, Yellow, S372, 1 car).

Georgia

Albany 1109 Peachtree Terrace (M02); 1001 Second Avenue (M02, Gray); 1005 Second Avenue (M02, Gray); 1200 Fifth Avenue (M02, Gray); 805 Seventh Avenue (M02, Blue); 920 Seventh Avenue (M02); 711 Ninth Avenue (M02, Gray); 911 Ninth Avenue (M02). *Americus* 547 Oak Avenue (M02, Tan). *Atlanta* 1692 Brewers Boulevard (M03, Tan, S2201); 832 Burchill Street (M02, Gray); 735 Longwood (M02, Razed); 1976 Northside Drive (M02, Green, S20). *Columbus* ... Pelham Drive (Razed). *Decatur* 513 Drexel Avenue (M02, Yellow); 2071 Sylvania Drive (M02, Yellow); 2081 Sylvania Drive (M02, Gray). *Macon* 3498 Mckenzie Drive (M023, Gray, 2 bedroom); ... Nottingham Drive. *Stone Mountain* 721 King Road (M02).

Illinois

Addison 104 Iowa (M02, Yellow). *Albion* 27 W. Poplar (M02, Tan). *Algonquin* 1603 N. River Road (M02, Blue, 2 car). *Arlington Heights* 102 S. Chestnut (M02, Yellow); 836 N. Dunton (M02, Yellow); 728 N. Kennecott (M02, Wood Siding, S2147); 813 N. Mitchell (M02, Yellow, S1236); 831 N. Mitchell (M02, Yellow, Razed 2000); 912 N. Mitchell (M02, Blue-green, S996); 923 N. Walnut (M02, Gray). *Ashland* Route 1 (M03, Yellow, S1817). *Aurora* 700 George Avenue (M02, Gray); 1608 W. Galena Street (M02, Yellow); 1702 W. Galena Street (M02, Gray); 16 Rosedale Street (M02, Blue-green); 32 Rosedale Street (M02, Tan); 34 Rosedale Street (M02, Gray); 119 Rosedale Street (M02, Blue-green, MODEL). *Bedford Park* 7710 W. 66th Place (M02, Tan); 7840 W. 66th Place (M02,

Blue-green, S1650). *Belleville* 7100 W. "A" Street (M02, Re-sided); 7116 W. "A" Street (M02, Blue, 2 car); 75 Friendly Drive (M02, Blue); 7817 W. Main Street (M02, Yellow, Power Windows); 7500 Melba Drive (M02, Tan); 600 Pennsylvania (M02, Yellow); 411 Sherman (M02, Yellow); 600 N. 74th Street (M02, Blue-green). *Belvidere* 518 W. Boone (M03, Blue); 420 E. Madison (M02, Tan, 2 car); 1039 Maple (M02, Blue); 415 N. State (M02, Blue). *Bensenville* 137 S. Ellis Avenue (M02, Gray [Painted Salmon], Razed 1999). *Bloomington* 704 Mercer Street (M02, Gray); 3 Oakland Court (M02, Tan). *Brookfield* 3943 S. Arthur Street (M02, Yellow); 3926 Elm Street (M02, Yellow); 4245 Forest (M02, Yellow); 4215 S. Grove (M02, Tan); 4244 S. Grove (M02, Gray, S1521); 3146 S. Harrison (M02, Yellow); 9527 Henrietta Street (M02, Tan, S2022); 3201 S. Madison (M02, Gray); 3300 S. Madison (M02, Tan, Basement); 4000 S. Madison (M02, Tan [Green Siding]); 3930 S. Park (M02, Yellow); 3937 S. Park (M02, Gray); 4221 Prairie (M02, Gray); 3948 S. Raymond (M02, Yellow); 3435 Sunnyside (M02, Yellow, S1578). *Cambridge* 205 West Locust (M02, Gray). *Canton* 51 N. Second Avenue (M02, Gray). *Carlinville* RFD (M03, Gray). *Carthage* 710 Buchanan (M02, Tan); 502 Washington (M02, Gray). *Centralia* 325 Marquis (M02, Gray); 330 Marquis (M02, Yellow); 1526 W. McCord (M02, Gray); 1527 W. McCord (M02); 211 S. Perrine (M02, Gray). *Champaign* 1109 W. Clark (M02, Gray, S2249, Basement); 818 W. Columbia (M02, Yellow); 1213 Daniel Street (M02, Tan); 302 S. Elmwood (M02, Blue-green, MODEL); 1201 W. Green (M02, Gray, S518); 1011 W. Hill (M02, Gray, S2391); W. John Street; 1210 W. Williams Street (M02, Blue-green). *Chicago* 4840 N. Marine Drive (M02, Yellow, 7, Removed, MODEL). *Cicero* 6116 W. Cermack (22nd); 1627 56th Court (M02, Tan, S1950). *Clinton* 816 W. South Street (M03, Tan, S2487). *Colchester* Argyle Lake Road (M02, Gray, S1370). *Colfax* 102 High (M02, Blue). *Columbia* 602 Old Illinois Route 3 (M02, Yellow). *Danville* 211 Dodge Street (M02, Tan); 1657 N. Gilbert Street (M02, Yellow); 1145 Lake Ridge Drive. *Decatur* 17 Greenridge (Yellow); ... Ken-

wood Avenue (M02, Yellow); 1900 E. Main (Yellow). *Deland* 530 Highway Avenue (MX, Gray, Welding Shop Hybrid). *Des Plaines* 1700 Lincoln (River & Oakton); 728 W. Oakton (M02, Yellow); 352 Washington (M02, Yellow); 1001 Webster Lane (M02, Yellow); 1014 Webster Lane (M02, Tan); 382 Woodbridge (M02, Yellow, S1506). *Dixon* 1024 E. Chamberlan (M03, Blue-green, S2304, 1½, BW); 715 McKinney (M03, Blue-green, S2278); 606 E. Morgan (M03, Yellow, S2233); 619 Spruce (M02, Yellow, S1991, 1½); 712 Washington (M02, Yellow, S2038, 1 car, BW); 516 Fourth Avenue (M02, Gray). *Downers Grove* 4501 Bryan Street (M02, Yellow, S1268); 5138 Florence Avenue (M02, Gray); 5235 S. Park (M02, Yellow, S1283); 5332 S. Park (M02, Gray, S2145). *Dwight* Spenser Street (M02); 410 S. St. Louis Street (M02, Yellow, S2415, Basement). *Edwardsville* Poag near Wanda Road (M02, Tan); 1320 Grand Avenue (M02, Yellow). *Elgin* 1171 Hill Avenue (M02, Gray, S1088); 1331 Sherwood Avenue (M02, Tan). *Elmhurst* 603 Rex Boulevard (M02, Blue-green, Razed c. 1999); 451 S. York (M02, Yellow, Razed 1996, 1 car). *Evanston* 2320 Prospect Avenue (M02, Yellow). *Fairbury* 408 E. Hickory (M02, Gray); 409 W. Pine (M03, Blue-green, 1 car). *Fairview Heights* 9938 Old Lincoln Trail (M02, Blue). *Farina* Highway 39, south of Effingham (Blue). *Farmer City* 619 N. William Street (M03, Tan). *Freeport* ... W. Empire Street; ... W. Empire Street; 305 N. Holden; 906 Monroe; 220 W. South Street (M02, Blue). *Geneva* 432 Austin (M02, Yellow, S724); Oakwood @ School (M02, Gray). *Gibson City* 1009 Lott Boulevard (M02, Yellow, S1510, 1 car, BW). *Glen Ellyn* 909 Crescent Boulevard (M02 Gray [Moved to 180 Cumnor], 2 car); 0 N. 180 Cumnor Street (M02, Gray). *Grand Ridge* 315 W. Main (M02, Blue-green). *Griggs-ville* (02, Yellow). *Hamilton* 838 Main Street (M02, Gray); 840 Oak Street (M03, Gray, 2 car BW). *Harvard* 1105 N. Hart (M02, Yellow); 200 S. Johnson (M02, Tan). *Havana* Route 136 East (Green). *Hazel Crest* ... 170th Street. *Highland* 1423 Laurel; 217 Main; Poplar @ 9th. *Hinsdale* 7210 S. Madison Street (M02 Prototype, Blue, Razed c. 1995). *Homewood* 18420 Dundee

(M02, Yellow); 1401 Linden; 1700 Linden; 18329 Perth (M02, Blue-green); 183rd @ Stewart. *Jacksonville* 419 N. Laurel Drive (M02, Tan, S894, 1 car). *Joliet* 819 Mason Street (M02, Gray); 110 Midland Street (M02, Tan, S1165); 1525 Taylor (stucco). *LaSalle* 812 McArthur (M02, Blue). *Leland* 230 Cedar (M03, Tan, S1980). *Lemont* 135th Street @ Archer (M02, Gray, Razed 1995). *LeRoy* 202 E. Pine (M02, Gray). *Lincolnshire* 1 Stone Gate Circle (M02, Gray); 2 Stone Gate Circle (M02, Yellow); 3 Stone Gate Circle (M02, Gray); 4 Stone Gate Circle (M02, Gray); 5 Stone Gate Circle (M02, Yellow, S725); 6 Stone Gate Circle (M02, Gray); 7 Stone Gate Circle (M02, Gray [Wood Siding], S819); 8 Stone Gate Circle (M02, Yellow); 9 Stone Gate Circle (M02, Gray); 10 Stone Gate Circle (M02, Gray); 11 Stone Gate Circle (M02, Yellow, 1 car); 12 Stone Gate Circle (M02, Gray). *Litchfield* 310 N. Montgomery (Yellow); Route 136. *Little York* 110 S. Walnut Street (M02, Yellow). *Lombard* 534 Ahrens (M02, Blue-green); 326 Brookfield (M02, Yellow); 823 E. Division (M02, Blue-green); 836 E. Division (M02, Yellow, S1615); 916 E. Division (M02, Gray, S1713); 1117 E. Division (M02, Gray); 1123 E. Division (M02, Blue-green); 1127 E. Division (M02, Tan, S1210); 454 S. Edgewood (M02, Blue-green, S1705); 504 S. Edgewood (M02, Gray); 117 N. Elizabeth (M02, Gray); 362 N. Elizabeth (M02, Gray); 537 S. Fairfield (M02, Gray); 626 S. Fairfield (M02, Gray, S1392); 214 N. Garfield (M02, Yellow, S743); 226 N. Garfield (M02, Gray, S1042); 243 N. Garfield (M02, Blue-green); 247 N. Garfield (M02, Gray, S1109); 250 N. Garfield (M02, Yellow); 112 W. Greenfield (M02, Yellow, S1515); 232 W. Grove (M02, Yellow); 255 W. Harrison (M02, Yellow, S1519, Razed 9/2001); 303 W. Harrison (M02, Gray); 303 W. Loy Street (M02, Blue-green, S1253); 257 E. Madison (M02, Tan); 315 E. Madison (M02, Gray); 321 E. Madison (M02, Yellow, S1609); 557 S. Martha (M02, Yellow, S1285); 305 E. Morningside (M02, Gray, S2047); 304 N. Park (M02, Gray, Re-sided); 65 S. Second Avenue (M02, Yellow, S1576); 507 S. Stewart (M02, Tan, S1891); 524 S. Stewart (M02, Gray, S2046); 532 S. Stewart (M02, Yellow, S1607); 417 S. Third Street (M02, Tan,

S1125, Razed 7-2001); 39 S. Westmore Road (M02, Tan, S1185). *Macomb* 67 N. Chandler Boulevard (M02, Blue-green); 537 Dudley Street (M02, Yellow, S2330, 3 car, Basement); 309 Edwards (M02, Yellow); 730 E. Franklin (M02, Gray); 1707 W. Jackson (M02, Gray). *Mansfield* 102 N. Main Street (M02, Gray, S1887, 1½); 307 N. Main Street (M02, Gray). *Marengo* 741 E. Prairie; 333 East Avenue. *Mascoutah* 1205 W. Madison (M02, Yellow, S742, 2 car). *Mattoon* 3117 Walnut Avenue (M02, Gray). *McHenry* 2423 Mogra (Gray, Basement). *Mendota* 1007 Michigan (?) (M02). *Meredosia* 1475 E. Chrisman (M02, Yellow, S749, 2 car). *Moline* 35th @ 23rd (near here); 36th Street. *Monmouth* 223 Pine Park (M03, Yellow, 2 car); 201 Sunny Lane (M03, Tan, S2125); 222 Fourth (M02, Gray, 1 car). *Monticello* 501 N. Charter Street (M03, Tan); 40 N. Circle Drive (M02, Yellow, S1552, 1 car); 300 E. William Street (M02, Gray). *Morton Grove* 9505 Western (M02, Gray). *Mount Carmel* 214 W. Fourth Street (M02, Blue-green). *Mount Morris* 108 E. Brayton Road (M02, Tan, S1124, 2 car); 11 W. First Street (M02, Blue, S1635); 407 W. First Street (M02, Yellow); 409 W. First Street (M02, Gray); 411 W. First Street (M02, Blue-green); 501 W. First Street (M02, Gray, Hidden); 503 W. First Street (M02, Yellow); 105 N. Hannah Avenue (M02, Gray); 107 N. Hannah Avenue (M02, Yellow, S1610); 113 N. Hannah Avenue (M02, Tan); 204 W. Hitt (U.S. #64) (M02, Blue-green, S1327); 406 Sunset Lane (M02, Yellow); 501 Sunset Lane (M02, Blue, S1340, MODEL); 503 Sunset Lane (M02, Tan); 505 Sunset Lane (M02, Gray); 506 Sunset Lane (M02, Tan). *Mount Prospect* 905 S. Busse Road (M02, Yellow, S2097). *Mount Vernon* E. Highway 142 @ I 64. *Moweaqua* RR2 Box 171 (M02, Yellow, S716, 1 car); RR2 Box 171 (M03, Yellow, S1816). *Naperville* Webster north of BN tracks. *Normal* 12 University Court (M02, Gray [Remodeled with Brick]). *Oak Lawn* 9818 53rd Avenue (M02, Gray). *Olney* 605 N. Boone (M02, Tan); 416 E. Chestnut (M02, Tan); 1077 S. Morgan (M02, Tan); 825 N. Silver (M02, Gray); 1005 E. South Avenue (M02, Tan); 1007 E. South Avenue (M02, Blue); 1009 E. South Avenue (M02, Yellow); 1011 E. South

Avenue (M02, Gray). *Onarga* 709 W. Seminary (M02, Yellow); 207 E. Wilson (M02, Blue). *Orion* South of Bowling Alley; South of Bowling Alley; 1110 13th Street (M02, Yellow). *Palatine* 221 S. Bothwell Street (M02, Gray); 253 S. Bothwell Street (M02, Blue-green); 179 S. Greeley (M02, Tan); 123 S. Hale (M02, Yellow); 129 S. Hale (M02, Tan, S1158); 232 S. Hale (M02, Yellow); 325 S. Hale (M02, Gray); 240 S. Plum Grove Road (M02, Yellow); 249 S. Oak (M02, Tan, S675); 344 N. Schubert (M02, Yellow). *Peoria* 1517 Bigelow (M02, Gray); 918 Corrington (M02, Gray, S1112); 824 Fairoaks (M02, Gray, S1868); 727 Ridge (M02, Gray [Cream siding], S1027); 813 Ridge (M02, Green siding, S1192). *Peoria Heights* 1425 Glen (M02, Gray, S1076). *Peotone* 425 E. Main Street (M02, Yellow); 216 Second Street (M02, Yellow). *Pisgah* Rt 104 (Seven miles south). *Pittsfield* 303 E. Clare (M03, Tan, S2379 2 car, BW, Basement); 305 E. Clare (M03, Gray); 620 W. Grant (M02, Yellow); 306 S. Jackson (M03, Gray); 600 W. Jefferson (M02, Yellow, Power Windows); RR3 Box 134 New Salem Road (M03, Re-sided). *Pleasant Plains* 416 N. Clay (M02, Yellow, S1215). *Poag (Edwardsville)* Poag @ Wanda Road. *Polo* 410 Dixon Street (M02, Blue-green). *Pontiac* 214 W. Grove Street (M02, Gray, S1570); 215 W. Humiston Street (M02, Blue-green, S2005, 1 car); 425 W. Water (M02, Blue siding). *Prospect Heights* 101 Camp McDonald Road (M03, Blue-green, 1 car, BW). *Quincy* 2407 Elm (M02); 2409 Elm (M02, Tan); 419 S. 22nd Street (M02, Yellow); 1530 Washington (S2509). *Rochester* RR2 Box 114A. *Rockford* 600 block N. Ashland; 3516 Carolina Avenue (M02, Yellow); 1629 Greenwood Street (M02, Gray); 2918 Hillside Court (M02, Tan); 2028 Idaho Parkway (M02, Yellow); 2021 Kilburn Avenue (M02, Blue-green); 2024 Kilburn Avenue (M02, Yellow, S2440); 3108 Maryland (M02, Blue); 511 Oak (M02, Yellow); 1908 Ohio (M023, Tan); 1625 Oregon Street (M02, Gray); 1905 Oregon Street (M03, Blue); 4012 Pinecrest; 1516 River Bluff Boulevard (M03, Gray); 539 S. Rockford Avenue (M03, Blue); 1607 N. Rockton Avenue (M02, Yellow [Re-sided], 1 car); 1512 Rural Street (M02, Yellow); 2425 Vernon Street (M02, Blue-green); 630 Welty

Avenue (M02, Blue-green, S2065); 3208 West Gate Parkway (M02, Blue); West Gate Parkway (M02, Blue); West Gate Parkway (M02, Blue); 2428 Younge Avenue (M02, Tan); 906 S. 20th (M02, Yellow, S2035); 1620 26th Street (M02, Tan). *Rock Island* 3316 Seventh Avenue (M02, Yellow); 2920 Ninth Street; 2113 22nd Avenue; 2507 28th Avenue. *Roselle* 23 W. 470 Ardmore (M02, Gray). *Sandwich* 815 Eddy (M02, Tan, S653). *Sauneman* 77 North Street (M02, Yellow). *Savannah* 719 N. 4th Street. *Sheridan* South of Prison (M03, Blue-green). *Skokie* 8557 Central Park (M02, Blue-green); 8119 N. Laramie (M02, Yellow [Re-sided], Disassembled 2001). *Somonauck* 445 E. Dale (Newport, Tan). *South Beloit* 2000 Blackhawk Boulevard (Blue-green). *Springfield* 2255 S. College (M02, Gray, S528); 2327 S. Pasfield (M02, Gray); 2424 S. Pasfield (M02, Tan, S2159); 2517 S. State (M02, Gray, S2164); 3141 S. Second Street (M02, Yellow). *Strawn* 115 Ebersol (M02, Blue-green, S1631). *Sycamore* 942 DeKalb (M02, Yellow). *Urbana* Broadway @ University (M02, Razed, 2 car); 110 S. Glover Street (M02, Tan); 504 S. Lincoln (M02, Tan). *Villa Park* 17 W. 411 Manor (M02, Gray, S2135). *Waterloo* 803 Creston Court (M02, Tan). *Watseka* 950 Western (M02, Painted); 953 Western (M02, Tan, S646). *West Chicago* 109 E. York Street (M02, Gray). *Westmont* 100 N. Warwick Avenue (M02, Gray). *Wheaton* ... Blanchard Avenue, South (M02, Gray, Razed 1994); 1000 N. Cross @ Oak (M02, Yellow Razed). *Wilmette* 2545 Lake Street (M02, Yellow). *Windsor* 420 N. Locust (M02, Gray). *Woodstock* 605 W. Judd Street (M03, Tan, S2432). *York Center* 615 Rochdale Circle (M02, Gray, S2072). *Yorkville* 801 S. Main Street (M02, Tan).

Indiana

Albany 925 E. State Street (M03, Gray). *Anderson* 913 W. Vineyard (M02, Yellow); 1729 W. 11th Street (Gray). *Angola* 314 E. Gilmore (M02, Blue, S1288). *Auburn* 707 S. Ohio Street (M02, Tan); 909 N. Van Buren Street (M02, Blue-green). *Beech Grove (Indianapolis)* 210 S. 10th Street

(M02, Tan). *Beverly Shores* 104 Lake Front Drive (Razed); 303 Lake Front Drive (M02, Blue-green, S1707); 800 E. Lake Front Drive (M02, Yellow); Lake Front Drive @ Windsor (M03, Gray, S2263); State Park Road (M02, Blue-green). *Bloomington* 400 S. Highland (M02, Tan); 402 S. Highland (M02, Tan); 1317 E. Hunter Avenue (M02, Gray); 1040 E. Maxwell Lane (M02, Brick facing); 1901 E. Maxwell Lane (M02, Gray); 309 S. Mitchell (M02, Blue, MODEL); 300 S. Smith Road (M02, Yellow). *Brazil* ... E. U.S. 40 (M02, Gray [Re-sided]); W. State Route 340 (M02, Gray). *Brownstown* 111 E. Commerce Street (M02, Tan). *Burney* 748 City Road, 850 West (M02, Yellow). *Cambridge City (Richmond)* 63 U.S. 40 & State Route #1 (M02, Tan). *Cedar Lake* 7229 Constitution (M02, Tan). *Chesterton* 411 Bowser Street (Museum) (M03, Yellow, S2329, 2½); 739 Timber Court (M03, Gray, Garage). *Columbia City* 2857 E. Muncie Road (M02, Tan, S849). *Columbus* 1811 Laurel Drive (M02, Blue); 3121 National Road (M02, Painted White). *Danville (Indianapolis)* 49 Maple Street (M02, Yellow). *Elkhart* 222 S. West Boulevard (M02, Gray). *Evansville* 1419 Brookside Drive (M03, Gray); 1423 Brookside Drive (M02, Blue); 1619 Brookside Drive (M02, Tan); 6118 Hogue Road (M02, Tan); 418 Kelsey Avenue (M02, Gray, S2206); 2520 Knob Hill Drive (M02, Yellow); 5925 Lakeland Avenue (M02, Brick Siding); 6001 Lakeland Avenue (M03, Stone Siding); 1158 Lincoln Avenue (Razed); 3011 Lincoln Avenue (M02, Gray, S2078, MODEL); 5821 Madison Avenue (M02, Tan, S1581, 1½); 2650 W. Maryland Street (M03, Gray, S2365); 3617 New Harmony Road (M02, Gray); 723 Sonntag Avenue (M02, Gray); 763 Sonntag Avenue (M02, Yellow); 3918 Upper Mount Vernon Road (M02, Tan). *Fort Wayne* 316 W. Fleming Avenue (M02, Gray); 1928 Glenwood (M02, Gray, 2 car); 415 W. Maple Grove Avenue (M02, Blue-green); 2510 N. Oakridge Road (M02, Gray, 1 car); 3214 N. Parnell Avenue (M02, Blue-green); 4127 S. Rosewood (M02, Tan, S835); 1133 Somerset Lane (M02, Gray); 4105 S. Webster Street (M02, Tan). *Gary* Glen Park area. *Greendale* 82 Cook Avenue (M02, Re-sided); 86 Cook Avenue (M02, Gray);

230 Cook Avenue (M02, Tan); 226 Parkside (M02, Re-sided); 863 Sunset Lane (M02, Re-sided). *Greenfield (Indianapolis)* 720 N. East Street (M02, Yellow); 737 S. State Street (M02, Tan). *Greenwood* 1159 N. Bluff Road (M02, Re-sided). *Hammond* 1409 Amy Street (M02, Tan); 1530 Davis Street (M02, Gray); 2047 E. 169th Street (M02, Blue-green); 2121 E. 169th Street (M02, Tan). *Hanover* 104 Crowe Street (M02, Blue). *Indianapolis* 6212 S. Acton Road (M02, Blue); 2079 E. Broad Ripple Avenue (M02, Tan); 6452 N. Broadway (M02, Blue-green); 3101 Campbell (M02, Blue-green); 6212 N. Central (M02, Yellow); 6321 N. Central (M02, Gray); 6435 N. Central (M02, Gray); 6466 N. Central (M02, Tan); 8081 W. Crawfordsville Road (M02, Tan); 3646 N. Denny (M02, Tan); 3920 Denwood (M02, Blue-green); 3623 Gladstone (M02, Stone facing); 1029 Hawthorne Lane (M02, Yellow); 5636 N. Indianola (M02, Yellow); 1908 E. Kessler N. Drive (M02, Yellow); 1718 Leland Avenue (S1528); 5340 E. Saint Joseph Street (M02, Blue-green); 5402 S. Shelby; 3825 N. Sherman Drive (M02, Blue-green, 2 car); 3819 E. 42nd Street (M02, Gray, S1744); 3821 E. 42nd Street (M02, Gray); 2001 E. 62nd Street (M02, Tan); 3880 W. 92nd Street (M02, Tan). *Kentland* 315 Ray Street (M02, Yellow). *La Porte* 2400 S. Monroe (M02, Gray). *Lawrenceburg* 504 Willow Street (Rising Sun) (M02, Blue). *Lebanon* 1005 N. East Street (M02, Tan); 111 N. Lebanon Street (M02, Re-sided). *Madison* 1445 Michigan Road (M02, Blue). *Marion* 3501 S. Galletin (M02, Tan); 1320 N. Wabash (M02, Tan); 4601 S. Washington (M02, Tan); 909 W. Sixth Street (M02, Gray); 318 E. Seventh Street (M02, Yellow). *Michigan City* 222 N. Carroll Avenue (M02, Gray); 115 DeWolfe (M02, Yellow); 114 Stimson Court (Newport, Gray). *Milan* 813 Warn Street. *Millers Beach (Gary)* 9317 Lakeshore Drive (M02, Yellow). *Missawauka* 3418 Missawauka Avenue (M02, Yellow). *Muncie* 3108 Amherst Road (M02, Blue-green); 3116 Amherst Road (M02, Yellow [Re-sided]); 3004 W. Devon Road (M02, Gray [Re-sided]); 3109 W. Devon Road (M02, Blue-green); 5100 Everett Road (M02, Gray, S1373); 1627 S. Mulberry Street (M02, S1087). *Newburgh*

5655 Frame Road (M02, Tan). *Oaklanden (Indianapolis)* 6546 N. Olvay Street (M02, Yellow). *Oldenburg* 2020 S. State Route 229 (M02, Blue-green). *Ossian* 8577 N. State Route 1 (M02, Gray). *Peru* 500 N. Broadway (M02, Yellow). *Porter* 419 Franklin Street (M02, Yellow, S1551). *Redkey* 203 N. Spencer (M02, Gray, S2235, 2 car). *Remington* 108 N. Indiana Street (M03, Yellow). *Richmond* 3228 E. Avon Lake (M02, Blue-green); 168 S.W. 13th Street (M03, Tan, S1896); 200 S. 34th Street (M02, Gray, S1429, 2 car). *Rising Sun* 504 Willow Street (M02, Tan). *Schereville* 1319 U.S. 30 West (M02, Tan). *Shirkleville* State Route 150 (M02, Tan, Abandoned). *South Bend* 1211 Black Oak (M02, Tan siding, 1 car); 303 N. Ironwood (M02, Yellow); 1920 Kessler Boulevard (M02, Blue-green); 2131 N. Olive Street (M02, Yellow); 2417 Samson (M02, Gray). *Stravehn* 5151 E. Walnut Street (M02, Tan). *Terre Haute* 827 S. Center Avenue (M02, Yellow); 204 McKinley; 850 Oak Drive (M02, Yellow); 3318 Oak Avenue (M02, Blue-green); 3105 Wabash Street (M02, Blue-green); 3313 Wabash Street. *Tipton* 308 N. Independence (M02, Blue-green, 1 car). *Valparaiso* 106 Hickory Street (M02, Yellow). *Westfield (Indianapolis)* 327 N. Union Street (M02, Yellow).

Iowa

Alta 413 Cherokee (M02, Blue-green). *Ames* 2601 Hunt Street (M03, Gray, Basement). *Arcadia* South of Main Street (M02). *Atlantic* 1 Cass Street Tan, S685, 1 car); 1108 Cedar Street (Gray, S1057, 2 car); La Vista Place; 15 West 14th @ Chestnut. *Bettendorf* 937 Mississippi Boulevard (M02, Gray); 1109 Mississippi Boulevard (M02, Yellow, S697). *Boone* 1308 First Street. *Burlington* 2223 S. Main Street (M02, Yellow); 1809 Mason Road (M023, Gray, SD3152); 1622 Pine Street (M02, Yellow); 1737 Pine Street (M02, Yellow, S1556); 2608 Sunnyside (M02, Blue-green). *Carlisle* 210 School Street (M02, Tan); South Street (S864). *Cedar Rapids* 2080 Eastern Boulevard S.E. (Yellow); 2567 Meadowbrook Dr S.E. (M02, Yellow); 2003 Williams Boule-

vard S.W. (M02, Tan, S1200); 2009 Williams Boulevard S.W. (M02, Yellow, S2102); 2124 First Avenue N.E. (M02, Yellow, MODEL); 3610 First Avenue N.E. (M03, Gray); 3634 First Avenue N.E. (Gray); 1500 C Avenue N.W. (M02, Yellow, Remodeled); 645 35th Street N.E. (M033, Gray, Newport). *Clarion* 905 Central Avenue East. *Clinton* 1101 N. Fourth Street (M02, Blue-green, S1638, 2 car). *Coralville* 708 11th Street (M02, Gray, S1096). *Council Bluffs* 180 Linden Avenue (Gray); 257 Linden Avenue (M02, Blue-green, S2397); 222 N. Second Street (Gray). *Creston* West Adams Street. *Dallas Center* 305 Kellogg Avenue (Yellow, S720). *Davenport* 1622 Broadlawn (M02, Tan); 4002 N. Division (M02, Gray, 1 car); 4018 N. Division (M02, Tan, 1 car); 4036 N. Division (M02, Gray, S1759, 1½); 7627 N. West Boulevard (M02, Tan, S1711). *Des Moines* 1669 Beaver Avenue (M02, Gray); 1703 Beaver Avenue (M02, Yellow, S701, 1 car); 6610 Carpenter (S406); 4343 Chamberlain (M02, Blue, S4, 1 car, MODEL); Dickinson Road (Yellow, S1617, 2 car); 4504 Fleur Drive (M02, Gray, S1374); 5827 Kingman (M02, Gray, 1 car); 6207 Pleasant (S35); 1136 Polk Boulevard (M02, Gray, S2516, 2 car); 4111 Tonawanda Drive (MSX, Gray, Remodeled); 3322 University Avenue (M02, Blue-green, S582, 1 car); 3408 Woodland (M03, Yellow); 2826 38th Street (M02, Yellow, S719); 3706 53rd Street (M02, Gray, S545); 1437 57th Street (M02, Blue-green, S111, 1 car); 1314 63rd Street (Yellow, S694); 1328 63rd Street (M02, Yellow). *Donaldson* 816 University (M03, Yellow, S2410). *Dubuque* 2048 Avalon Road; 514 Cooper Place; 1460 S. Grandview Avenue (M02, Blue [Painted white]); 887 W. Locust Street (Blue-green). *Elgin* 909 N. Main Street (M02, Yellow). *Fort Dodge* 415 Loomis Avenue (M02, Gray, S556); 102 S. First (Moved to 3213 Fifth Ave); 927 N. Third (M02, Yellow); 3213 Fifth Avenue (Gray, Basement); 1319 N. 16th Street (M02 [Porch filled out with panels like an 03 model], Tan, S890, 1 car); 824 N. 20th Street (M02, Tan, S655). *Fort Madison* 1832 Avenue D (M03, Tan, S2016); 2423 Avenue G (M02, Yellow, S1995). *Glidden* 407 Nevada Street (M02, Blue-green, S2212). *Goldfield* 206 N. Water (M03, Tan, S2126, 1 car, BW). *Graettinger*

203 S. Brown (M03, Gray, S1771, 2 car, Basement); 311 S. Brown (M03, Tan). *Grimes* 209 N. Jacob (M02, Gray, S2115, 2 car). *Grinnel* 601 Tenth Avenue (M02, Tan, 2 car). *Hampton* 508 Federal Street, S. *Harlan* 1310 Willow Street (M02, Tan, S1875). *Holstein* 522 S. Main Street (M02, Yellow). *Humboldt* 204 Third Avenue, North (Tan); 504 Seventh Avenue, North (Yellow). *Humeston* 208 S. Eaton (M02, Blue-green, S1708, 1 car, BW). *Indianola* 609 W. Salem (M02, Gray, S1063, 1 car); 1376 Highway 65/69 S. (M02, Yellow). *Iowa City* 705 Clark Street (M02, Blue-green, S915); 709 Clark Street (M02, Gray); 1815 E. Court Street (M03, Gray, S2545, 2 car, BW); 805 Melrose Avenue (M02, Yellow, S669); 29 Prospect Place (M02, Gray, S1430); 627 Third Avenue (M02, Gray, S1428). *Iowa Falls* 2017 Washington Avenue (M02, Yellow, S1237, 1½). *Keokuk* 400 Boulevard Road (M02, Gray, S2349); 406 Boulevard Road (M02, Yellow, S1555); 928 N. Twelth Street (M02, Yellow, S1592). *Knoxville* 905 E. Montgomery Street (M02, Gray, S1036, 1 car). *Lake City* 320 E. Adams Street (M03, Gray, S1734); 215 N. Woodlawn (Blue-green, S945). *Laurens* 327 S. Third Street (M02, Gray, S1094). *Lowden* Route 30 (M02, Yellow). *Lynnville* 402 Cross Street (M02, Tan, 1 car). *Manchester* 828 E. Union Street (M03, Gray, S2428, 2 car). *Marengo* 701 Court Street (M02, Yellow, S1235). *Marshalltown* 304 W. Boone (M02, gray, S523, 1 car); 8 Edgeland Drive (M02, Yellow); 619 Forest Boulevard (M02, Blue, S172); 1502 Kalsem Boulevard (M02, Yellow, S1275, 1 car); 1010 W. State Street (M02, Yellow, S442); 901 Innis Boulevard (M02, Yellow); 518 N. 15th Street (M02, Gray, 1 car). *Messervey* 94 Minnesota Street (M02, Blue-green). *Milo* 1558 190th Avenue. *Norwalk* 903 Elm Avenue (M02, Blue-green). *Paullina* 304 S. Willow (M03, Yellow, S1619, 1½). *Pella* 223 S. Main Street; 1356 Main Street (M02, Tan, S686). *Pomeroy* Caruga Street (S1247). *Red Oak* 501 Corning (Gray). *Sigourney* 415 S. Main Street (M02, Yellow, S2184). *Sioux City* 3300 Dearborn (M02, Yellow); 100 Midvale Avenue (M02, Yellow); 3325 Nebraska Street (Gray). *Storm Lake* 520 Barton Street (M02, Tan, S2060). *Tama* 611

Garfield Street (M02, Tan, S689, 1 car). *Tipton* 400 East Street (M02, Gray, S2443). *Villisca* 113 N. Fourth Avenue (M03, Gray). *Vinton* 306 East 6th Street (Blue-green). *Wall Lake* 511 Ward Street (M02, Blue, S946, 2 car). *Waterloo* 153 E. Byron (M02, Yellow); 205 E. Byron (M02, Blue-green); 223 Cornwall Avenue (M02, Tan, S1000); 220 Forest (M02, Tan); 222 Kenilworth (M02, Blue); 255 Kenilworth (M02, Tan, S850); 715 E. Mitchell (M02, Blue-green); 2020 W. Third Street (M02, Tan, S1959). *Waukon* 406 Rossville Road (M03, Tan, S2453). *Webster City* 1503 Grove Street (M02, Yellow, S1602, 1½); 1520 Grove Street (M02, Yellow, S1280, 1½); 912 Webster Street (M02, Blue-green, S1313, 1½). *Windsor Heights* 6901 Forest Court (M02, Gray, S1020); 6903 Forest Court (M02, Yellow); 1314 63rd Street (M02, Yellow); 1440 63rd Street (M02, Yellow, S2437).

Kansas

Abilene 208 N.E. 12th Street (M02, Yellow, S727). *Albert* 4001 Worden Street. *Alma* 209 E. Fourth Street (Gray). *Ashland* 420 Cedar. *Atwood* 104 Logan Street. *Bushton* 3 Miles South (Farm Area) (M03, Blue). *Dighton* 3 Miles West and 2.5 Miles N. (Basement). *Dodge City* 804 Fourth Street. *Ellinwood* 523 W. Sixth Street. *Ellsworth* 305 W. Eighth Street (M02, Blue, 1 car). *Emporia* Commerce Street; 617 Lincoln. *Ford* 106 E. Ninth Street. *Fowler* Pine Street (Yellow, Garage). *Garden City* 310 Hudson (M02, Yellow); 312 Hudson (M02, Gray); 407 Laurel Street; 405 N. Fourth Street (M03, Blue [MODEL]); 1016 N. Fourth Street (M02, Gray); 1203 N. Ninth Street (M02, Yellow); 211 N. Eleventh Street (M02, Yellow); 901 N. Eleventh Street (M03, Tan, S2353, 1½). *Great Bend* 1412 Broadway (M02, Gray); 1416 Broadway (M02, Gray, 1½); 1424 Broadway; 1444 Broadway (M02, Yellow); 3410 Broadway (Tan); 2501 Cheyenne (M02, Blue, 1½); 1307 Coolidge (M023, Gray, S2552); 1310 Coolidge (M023, Blue); 1406 Coolidge (M023, Yellow); 2601 Coronado (M02, Blue); 1301 Harding (M023, Gray); 1317

Harding (M023, Gray); 1410 Harding (M023, Tan, S2530); 1411 Harding (M023, Tan); 1417 Harding (M023, Blue); 1701 Main Street (Sears Store—Enameled Panels); 2525 McBride (M02, Tan); 2622 Paseo (M02, Yellow); 2525 Russell Parkway (M02, Gray, 1½); 1411 Wilson (M023, Gray, S2312); 15 N.W. 70th Avenue (M03, Tan, S1815). *Greensburg* 217 W. Garfield Street (Tan); 508 S. Main Street; 708 S. Sycamore Street. *Hays* 213 E. 18th Street (M02, Re-sided, S863); 100 E. 19th Street (M03, Gray); 308 E. 20th Street (M02, Gray); 310 E. 20th Street (M02, Tan, S1934); 316 E. 20th Street (Green); 400 E. 20th Street (M02, Yellow, S2230); 103 W. 20th Street (M02, Tan). *Hoisington* 222 E. Ninth Street (M02, Blue-green, Destroyed by F4 Tornado in April 2001); FAS 47 North. *Holton* 315 W. Fifth Street. *Hutchinson* 21 E. 27th Street. *Johnson* 303 N. Long Street406 N. Long Street. *Junction City* Chestnut Street. *Kansas City* 4621 Lloyd Street (M02, Tan); 7218 State Street (M02, Gray, S1080). *Kearny County, North* Rural (M03, S2205). *Kinsley* 703 E. Fourth Street (M02, Gray). *Larned* 612 Mann Avenue (M02, Gray); 721 Martin Avenue (M02, Rose, S601); 823 Starks Drive (Yellow); 1421 State (M02); 1124 Toles; 505 W. Fifth (M02, Gray); 841 W. Eighth Street (M023, Gray, 2 car); 507 W. 15th Street (M023, Tan). *Leavenworth* 740 Thorton (M02, Gray). *Leoti* Between Leoti and Lakin (M02, Gray). *Liberal* 214 W. Coolidge Street (M02, Tan, S886). *Medicine Lodge* Rural Area. *Ness City* 302 E. Cedar Street (M02, Yellow, S1522); 223 N. Iowa Street (M02, Gray). *Newton* 408 Mead Street. *Norton* 305 W. Warsaw. *Russell* 536 Oakdale; 553 Oakdale (Gray); 614 Oakdale; 620 Oakdale (M02, Yellow); 615 Sunset. *St. Francis* 417 E. Spenser. *Smith Center* 214 Park Street (M02, Tan, S843); 216 Park Street (M02). *Susank* 4 miles North, 0.5 East; 1½ miles north on County Road 230. *Sun Center* Rural Area. *Syracuse* East side of town. *Topeka* 2015 Macvicar (Destroyed by Tornado); 4305 S.W. Windsor Court; 3505 S.W. Tenth Street. *Ullysses* 505 N. Baughman (M02, Tan); 123 Missouri (M02, Gray). *Wakeeney* U.S. 283 North (Rural Area).

Kentucky

Alexandria 16 Thatcher Court (M02); *Edgewood* (Cincinatti area); 69 Edgewood Road (M02, Yellow, S1206); 17 Lyndale Road. *Frankfort* 956 Collins Lane (M02, Gray, S1399). *Fort Wright* 1607 Henry Clay Aveneue. *Guthrie* Park Avenue @ Locust (M02, Tan). *Henderson* S. Green Street; 821 S. Green Street (M02, Blue, 1½); 125 N. Ingram (M02, Blue); 933 N. Main Street (M03, Re-sided, Garage & BW). *Louisville* 121 Cambridge Drive (M02, Gray); 2523 Clarendon (M02, Blue-green); 547 Dover Road (M02, Blue-green); 2827 Eleanor Avenue (M02, Blue-green); 1911 Gladstone (M02, Blue-green, 2 car); 325 N. Hubbards Lane (M02-M03, Gray, 2 car); ... Old Forest Road (M02); 7238 Southside Drive (M02, Tan); 1005 S. Western Parkway (M02, MODEL, Razed); 1920 Winston (M02, Gray); 1922 Winston (M02, Tan); 523 Fifth (M02, Gray [Re-sided]). *Middlesboro* 2409 W. Cumberland; 2432 W. Cumberland. *Newman* 10359 West Highway 60 (M02, Tan). *Owenton* 113 E. Adair (M02, Blue); 109 Perry Street (M02, Gray); U.S. 127 South (M02, Gray); U.S. 127 & 227 (M03, Gray). *Reed* 20854 Hyw 811 (M02, Blue). *South Williamston* 214 Virginia Avenue (M02, Gray, S1074).

Louisiana

New Orleans Bluebird Street; 128 Central Park Place (M02, Blue-green, S918); 3700 Cherry Street (M02, Blue-green); 3704 Cherry Street (M02, Tan); 3623 Livingston Street (M02, Gray); 3629 Livingston Street (M02, Yellow); 3635 Livingston Street (M02, Blue-green); 57 W. Park Place (M02, Re-sided); 4940 St. Roch Avenue (M02, Blue-green); 4969 St. Roch Avenue (M02, Razed); 41 Wren Street (M02, Blue-green).

Maryland

Annapolis Bay Ridge Road (M02, Re-sided); Old Annapolis Boulevard (M02, Gray); 64 Farragut Road (M02, Blue, MODEL). *College Park* 4811 Harvard Road (M02). *Forest Heights* 15618 Woodland Drive (M02).

Massachusetts

Arlington 507 Appleton Street (M02, Gray); ... Appleton Street; 42 Golden Avenue (M02, Yellow, S2328). *Boston* 22 Payson *Framingham* Brigham Road (M02, Yellow, S1542, Basement). *Greenfield* 4 North Street (M02, Gray, S1490). *Hyannis Port* 370 Iyanough (M02, Blue-green). *Pittsfield* East Street (M02, Yellow); S. Mountain Road (M02, Gray, MODEL); East New Lenox Road (M02, Basement); Rhode Island Avenue (M023); West Street. *Plymouth* 62 State Road (Route 3A South) (M02, Tan, S870 [Re-sided]). *West Roxbury (Boston)* 59 Chellum Road (M02, Blue, 2 car); 80 Lyall Street @ VFW Parkway (M02, Tan). *Williamstown* 34 Luce Road (M02, Gray, 1 car).

Michigan

Ann Arbor 1121 Bydding;1125 Bydding;1129 Bydding;1208 Bydding (Bricked siding); 1711 Chandler;3060 Lakewood;605 Linda Vista;1910 Longshore (Burned in 1990s); ... Pontiac Trail; 800 Starwick; 1200 S. Seventh. *Battle Creek* 147 Chestnut (M02, 2 car). *Detroit* 654 Ashland (M02); 11399 Minnock (M02, Blue, MODEL, S5). *Dickinson* 100 Truckey. *Fremont* 328 Pine Street (M02, Tan, S855). *Grand Rapids* 2554 Breton, S.E. (M02, Tan); 2474 College, N.E. (M02, Gray, S1090); 2262 Lake Drive (M02, Blue [Re-sided]); 2524 Martin, N.E. (M02, Blue); 2764 Oakwood, N.E. (M02, Gray); 1849 Philadelphia, S.E. (M02, Yellow). *Granville (Grand Rapids)* 3660 Wilson (M02, Re-sided, S778). *Jackson* 8342 Cooper Road (M02, Tan). *Kalamazoo* 3032 Broadway (M02); 1009 Clover (M02); 2922 Ferdon (M02); 2022 Lakeway Street (M02, Gray); 1228 Miles (M02); ... Olmstead (M02); 1002 Westfall (M02); Oak Park (Detroit); ... Oneida Street; ... Oneida Street; ... Oneida Street. *Paw Paw* 910 E. Michigan Avenue (M02, Blue-green). *St. Joseph* 1125 Hillcrest (M02, Blue); 1127 Hill-

crest (M02, Tan); Sturgis; 615 Cherry Avenue; ... E. Chicago Road; 1209 S. Lakeview.

Minnesota

Harmony Route 2, Box 14A (M02, Blue-green, S1315). *Minneapolis* 4900 Cedar Ave, S. (M02, Blue, S15, MODEL); 4916 Cedar Ave, S. (M02, Tan, 1 car); 2436 Mount View Drive (Gray, S1049; 5009 Nicollet Ave, S. (M02, Blue-green); 5015 Nicollet Ave, S. (M02, Gray, S174, 2 car); 5021 Nicollet Ave, S. (M02, Yellow, S1318); 5027 Nicollet Ave, S. (M02, Gray [Re-sided], 2 car); 5047 Nicollet Ave, S. (M02, Blue-green, 2 car); 5055 Nicollet Ave, S. (M02, Gray); 2820 Roosevelt St, N.E. (M02, Gray [Re-sided], S1070); 5217 S. 31st Avenue (M02, Tan). *Rochester* 733 13th Avenue, N.E. (M02, Blue). *Wadena* 111 Dayton Avenue, S.W. (M02, Blue); 312 Second Street, S.W. (M02, Gray). *Winona* 718 Mankato Drive (Yellow).

Mississippi

Clarksdale Cherry @ Anderson Boulevard. *Jackson* 144 McDowell Road.

Missouri

Beverly Hills (St. Louis) 6900 Woodrow (M02, Blue-green); 6906 Woodrow (M02, Tan). *Boonville* 102 Ashley (M02, Tan, S2123); 407 Spring (M02, Tan, 1 car). *Brentwood (St. Louis)* 2401 Annalee (M02, Gray); 1100 S. Brentwood Boulevard (M02, Blue, Razed); 604 Fairoaks (M02, Yellow [Wood siding]); 8500 Genevieve (M02, Blue-green); 8505 Henrietta (M02, Yellow); 8520 Joseph (M02, Tan); 8914 Litzsinger (M02, Gray [White siding]); 8918 Litzsinger (M02, Gray, S2371); 8920 Litzsinger (M02, Yellow [painted white]); 8924 Litzsinger (M02, Yellow [White siding]); 8928 Litzsinger (M02, Gray); 8934 Litzsinger (M02, Blue-green); 8938 Litzsinger (M02, Yellow); 2529 Louis Avenue (M02, Gray, S1067 [Re-sided]); 441 Maple (M02, Blue-green,

S2070); 2001 Urban Drive (M03, Gray); Bridgeton (St. Louis); 11984 Old St. Charles Rock Road (M02, Tan). *Cameron* ... Third Street. *Columbia* 1006 West Boulevard North (M02, Gray, S2054). *Crestwood (St. Louis)* 856 Liggett (M02, Gray). *Crystal City* 149 Ozark Drive (M02, Yellow); 104 Ward Terrace (M02, Blue [Painted Yellow]). *Dellwood (St. Louis)* 25 S. Dellwood (M02, Tan). *Des Peres (St. Louis)* 1108 Bopp Road (M02, Gray); 1126 Vanetta Drive (M02, Wood siding); 1140 Vanetta Drive (M02, Yellow); 1143 Vanetta Drive (M02, Wood siding). *Ellisville (St. Louis)* Manchester @ Kiefer Creek Road [Moved to Raymond, IL]. *Fulton* Route HH Calloway County (M02, Tan, S2502). *Hermann* 6th Street (M023, Gray, Newport, S2442). *Kansas City* 6637 S. Benton Street (M02, Yellow); ... Cliff Drive; ... Cliff Drive; 830 Jarboe Street; 8432 Jarboe Street; 8436 Jarboe Street; 4621 Lloyd Street (M02, Tan); 2813 E. Meyor Boulevard (M02, Gray); 2 E. 88th Street (Porte Cimi Pass) (M02, Tan); 8 E. 88th Street (Porte Cimi Pass) (M02, Blue); 14 E. 88th Street (Porte Cimi Pass) (M02, Gray); 7218 State Street (M02, Gray); 8306 Summit Street (M02, Tan); ... Swope Parkway; 3840 E. 68th Street (M023); Kirkwood (St. Louis); 2043 Westview (M02, Gray, Basement). *Maplewood (St. Louis)* 3035 Coleman Avenue (M02, Blue-green); 7632 Flora (M02, Tan). *Marlboro (St. Louis)* 1166 Pembroke Drive (M02, Tan, S829, Garage). *Marshall* 1060 Redman (M02, Gray); 1270 Salt Pond (M02, Gray); 1271 Salt Pond (M02, Tan). *Mexico* 610 Boulevard (M02, Gray); 1115 S. Clark (M02, Gray, S1743); 1117 S. Clark (M02, Tan); 918 Jackson (M02, Gray); 515 Woodlawn (M02, Blue-green); 826 Woodlawn (M02, Blue-green, 1 car). *New Haven* 205 Maupin Street (M02, 2 car). *Oakland (St. Louis)* 921 Berry Road (M02, Yellow, Razed). *O'Fallon* 115 W. Pittman (M02, Gray). *Rockport* 310 W. Third Street (M02, Yellow, S1526). *St. Charles* 1104 Pike Street (M02, Yellow, S709); 1157 Tompkins (M02, Gray); 403 S. Sixth Street (M02, Gray). *St. Louis* 6352 Bradley (M023, Tan, Newport); 4848 Germania (M03, Blue-green); 6848 Glades (M02, Gray); 6531 Marquette (M02, Yellow); 6541 Marquette (M02, Gray, S1863);

4122 McDonald (M02, Yellow); 4123 McDonald (M02, Gray); 8836 Moritz (M02, Re-sided); 7003 Stanley (M02, Tan); 1840 Switzer (M02, Re-sided); 4743 Theiss Road (M02, Gray [White siding]). *St. Louis County* Manchester @ Barret Station Road (Razed). *Sappington (St. Louis)* 9407 Gates Manor (M02, Gray [Bricked]). *Shelbina* RFD (M03, Gray); RFD (M03, Gray). *Webster Groves (St. Louis)* 232 Baker Avenue (M02, Tan, S652); 237 Baker Avenue (M02, Gray, S1442); 109 Eldridge Street (M02, Tan); 121 Eldridge Street (M023, Blue); 124 Eldridge Street (M023, Gray); 125 Eldridge Street (M02, Gray); 657 Elmwood (M02, Blue, S1710, Razed 1995); 44 Hart (M02, Gray); 324 Hazel Avenue (M02, Blue-green, S1349, 1 car, BW); 330 Hazel Avenue (M02, Gray); 675 Madison Street (M023, Green Paint); 203 W. Old Watson Road (M02, Re-sided, S967); 676 Plateau Avenue (M023, Brown); 505 Ridge (M02, Blue-green); 540 Ridge (M02); 224 Simmons (M02, Blue-green); 226 Simmons (M02, Yellow); 228 Simmons (M02, Blue-green); 241 Simmons (M02, Gray); 308 Simmons (M02, Gray, S1451, Razed 1995); Summitt @ Twin Oaks.

Nebraska

Crete 707 Boswell (M02, Tan); *Hastings* 912 N. Baltimore (M02, Tan); *Lincoln* Near Bryan Memorial Hospital (Razed); *McCook* 1305 Norris Avenue (M02, Blue, S976); *Omaha* Burdette @ Saddle Creek (M02, Gray); *Wood River* 212 West 12th Street (M03, Gray).

New Jersey

Alpine, Bergen County 19 DuBois Avenue (M02, Yellow); *Beach Haven* Mississippi & Atlantic; *Cliffside Park (Fort Lee)* Pallisades Amusement Park (M02, Yellow); *Clinton* 25 Union (M02, Tan); *Closter* 421 Durie Avenue (M02, Yellow, BWGarage); 22 Division Street (M02, Yellow, Razed 1998); *Newark* Bamberger's Store (M02, MODEL); *Seabright* 1246 Ocean Avenue (M02, MODEL); *Wildwood* 1907 Atlantic Avenue (M02, S928); 419 14th Street (M02, Blue); *Woodbury* 246 Queen Street (M02).

New Mexico

Los Alamos 4102 Fairway Drive (M03, Blue); 4112 Fairway Drive (M02, Blue); 4206 Fairway Drive (M03, Blue).

New York

Albany 249 Hackett Boulevard (M02, Tan [Redwood siding]); 1 Jermain Street (M02, Yellow); 2 Jermain Street (M02, Razed); 3 Jermain Street (M02, Blue-green); 4 Jermain Street (M02, Razed); 5 Jermain Street (M02, Gray); 6 Jermain Street (M02, Razed); 7 Jermain Street (M02, Yellow); 8 Jermain Street (M02, Tan); 355 S. Main Street (M02, Tan, 1 car); ... Pinehurst Street (M02, Gray); *Amsterdam (Albany)* 110 Evelyn Avenue (M02, Blue-green); 23 Dartmouth (M03, Gray, S1884, 2 car); 20 Henrietta Boulevard (M02, Tan); Northampton Road (M03, Gray); *Ballston Spa* 62 Church Avenue (M02, Tan); Route 50; *Binghamton* Hinds Street @ Chenando (M02, Blue [Re-sided]); N. Morningside Drive (M02, Blue, S1348); Sunrise Terrace; *Canojoharie* Ridge Road (M02); *Chatauqua* Hurst @ Pratt (Chatauqua Institution) (M02, Blue); *Colonie (Albany)* Bought Corners @ Route 9 (M02, Tan); *East Greenbush (Albany)* Hampton Manor (M02, Blue); *Fredonia* 10 Holmes Place (M02, Gray, S1998); *Glen Cove, Long Island* 25 McGrady Street (M02, Blue [Re-sided]); 27 McGrady Street (M02, Yellow [Re-sided], MODEL); 29 McGrady Street (Blue [Re-sided]); *Ithaca* 102 Homestead Road (M02, Gray); 1315 E. State Street; Cornell University (M02, Gray); Cornell University (M02, Gray); *Jamestown* 557 Falconer Street (M02, Blue-green, Basement); 226 Hall Avenue (M02, Blue-green, MODEL); *Lewistown* 47 Water Street (M02, Gray); *Liberty* 72 Winslow Place (M02, Yellow, S2001, Basement); Loudonville (Albany); 1 Charming Lane; 7 Clover Lane (M03, Yellow, 1 car); 10 Clover Lane (M02, Gray, 1 car); 11 Clover Lane (M02); 12 Clover Lane (M02, Yellow, 1 car);

14 Clover Lane (M03, Yellow); 264 Osborne Road; 266 Osborne Road (Tan); 270 Osborne Road (White siding); *New York City* Avenue of the Americas & 52nd Street (M02, Blue #1); *Niagara Falls (Cayuga Island)* Devoe & Rozelle (M02, Blue-green); 9100 Hennepin Avenue (M02, Gray, 2 car); 89 Meadowbrook Road (M02, Blue-green); Pine Avenue & 66th (M02, Blue-green); 8621 Rivershore Drive (M03, Tan, Garage); 278 South Avenue (M02, Blue-green); *Olean* 1912 W. State Street (Blue-green [Painted white]); *Plattsburg* ... Sanborn Ave; ... Sanborn Ave; ... Sanborn Ave; *Rexford (Schenectady)* ... Blue Barns Road @ Rt 146 (M02); ... Blue Barns Road @ Rt 146 (M02); 14 Blue Barns Road (M02, Gray); *Saranac Lake* 50 Petrova Avenue (M02, Tan, MODEL); *Scotia* 520 Beacon Street (M02, Blue); 4 Droma Road Extension; *Syracuse* 455 Buckingham Avenue (M02); *Tonawanda* 269 Creekside Drive (M02, Blue-green); Vestal (Binghamton); Vestal Parkway (M02, Blue) ;Vestal Parkway (Yellow, Newport[?]); *Westfield* Elm & Bliss Streets; 125 Elm Street (Garage).

North Carolina

Chapel Hill 5 Mt. Bolus Road (M02, Gray, Rebuilt); 7 Mt. Bolus Road (M02); 109 Stephens Street (M02); *Durham* 2421 Perkins Street (M03, Gray, S1974); *Greensboro* 2103 Dellwood Drive (M02, Gray); 2302 Lawndale Drive (M02, Blue); 617 Myers Lane (M02, Gray, Razed 2000); *Greenville* 1300 E. Fourth Street (M03, Gray, S1732, 1 car); *New Bern* 1415 Rhem Avenue (M02, Tan, S704); 1716 Trent Boulevard (M02, Blue-green, S2417); *Pinehurst* 175 Page Road (M02, Yellow); *Pittsboro* U.S. 64 West (Half Mile from Courthouse) (M02, Gray); *Rocky Mount* ... Sunset Avenue.

North Dakota

Devils Lake 1122 Third Street (M03, Yellow); 1021 Fifth Street (M02, Blue-green); 1036 Fifth Street (M03, Gray); *Egeland* 7437 Hwy 66 (M02, Blue); *Fargo*

1501 Fifth Street, S. (M02, Gray); 1613 Sixth Street, S. (M02, Blue-green); 1621 Sixth Street, S. (M02, Tan); 1622 Sixth Street, S. (M02, Brown Siding); 1248 Ninth Street, N. (M02, Gray, Destroyed in 1957 Tornado); 1334 Ninth Street, N. (M02, Blue-green); 1434 Ninth Street, N. (M02, Blue-green, Damaged in 1957); 1638 Ninth Street, N. (M02, Yellow, S1993); *Finley* Third Street, W. (M02, Gray, S1476, Basement); Highway 200, E. (M03, Gray, S1839); *Grand Forks* 401 Park Avenue (Rebuilt); 602 Lincoln Drive (M03, Gray); *Harvey* 209 Tenth Street, S.W. (M02, Tan, S1145); *Hillsboro* 208 First Avenue, S.E. (M02, Gray, S1569); *Langdon* 424 12th Avenue (M03, Yellow, 1 car); *Rugby* Highway 3, South (Blue-green).

Ohio

Alliance 1001 Overlook (M02, Gray, S1012); *Bedford (Cleveland)* 52 Southwick Drive (M02, Tan); 64 Southwick Drive (M02, Tan); *Beverly* 310 Third Street (M02, Tan, S607); 400 Third Street (M02, Blue); 310 Park Street (M02, Gray); *Bexley (Columbus)* 60 S. Broadleigh (Razed); *Brewster* Fourth Street; *Brookfield* 5828 Stewart-Sharon Road (M02, Gray); *Bryan* 202 Elbar Drive (M02, Blue); *Canton* 4135 Lincoln, E. (32-unit Motel, Top of the Mark); 4645 Lindford Avenue, N.E. (M02); 4908 13th Street, S.W. (M02, Gray, S2448); *Centerville* 142 W. Franklin (M02, Yellow, 1½); 144 W. Franklin (M02, Razed ca. 1976); *Chillicothe* 616 Commanche (M02, Blue-green); *Cincinnati* ... Madison; 4705 Sycamore Road (M02, Tan); *Circleville* 141 Dunmore Street (M02, Tan); *Cleveland* ... Kleber Court (M02, Yellow); ... Merl Drive (M02, Re-sided); *Columbus* 45 N. Ashburton Road (MX, Gray, Garage from House Parts); 185 Arden (M02, Wood Siding); 214 Arden (M02, Gray); 34 S. Broadleigh (M02, Tan [Painted Blue], 1 car); 868 Broadleigh (M02, Gray); 618 Brookside (M02, Gray); 300 S. Gould (M02, Blue-green, S484, 2 car); 27 E. Kanawha (M02, Blue-green, S1655); 47 Kelner Road (M02, Blue, MODEL, S11); 71 Kelner Road (M02, Gray); 2452 Lockbourne (M023, Gray, SD2333

Newport); 1818 E. Long (M02, Yellow); 272
E. Weisheimer (M02, Green, S1015); *Crest-line* 405 N. Thomas Street (M02, Tan);
Cuyahoga Falls 2906 Hudson Drive (M02,
Blue-green); *Dayton* 92 Carson (M02, Yel-low); 3007 Cornell Drive (M02, Yellow);
2810 Earlham (M02, Painted); 2820 Earlham
(M02, Yellow, S2474); 66 Fer Don (M02,
Tan); 8200 Inwood Avenue (M02, Yellow);
1523 Newton (M03, Gray, S2377, 1 car);
2900 Newton (M02, Gray); 2905 Newton
(M02, Yellow); 160 Norman (M02, Yellow);
1647 Parkhill (M02, Blue); 1734 Tennyson
(M02, Yellow, 2 car); *Defiance* 875 Summit
(M02, Yellow, S722, 2 car); *Dover* 13th
Street near Dover Avenue; 1538 Chestnut;
East Liverpool 1611 Pennsylvania Avenue
(M03, Gray); *Eaton* 322 Hill Crest Drive
(M02, Blue, MODEL); 408 E. Israel Street
(M02, Gray); 411 E. Israel Street (M02, Yel-low); *Fairfield* 314 Symmes Road (M02,
Yellow, S2299, Garage); *Findlay* 720 Beech
Avenue (M02, Yellow); 349 Fairlawn Place
(M02, Gray); 130 Woodley Avenue (M02,
Yellow); *Gahanna (Columbus)* 79 N. Hamil-ton (M03, Gray, Razed); 89 S. Hamilton
(M03, Tan); *Girard* 1932 N. State;
Granville (Newark) 188 Welsh Hills Road
(M02, Gray, Basement); *Grove City (Colum-bus)* 1957 Harrisburg Pike (Blue-green);
3359 Kingston Avenue (M02, Gray);
Hamilton 314 Symmes Road (See Fairfield);
Hillsboro North U.S. Highway 62; *Huron*
412 Miami Place (M02, Yellow); 503 Oneida
View (Tan); 220 Shawnee place (M02,
Gray); 306 Tecumseh (M02, Yellow, S1225);
Hudson Elm Street (M02, Blue-green);
Kent Norwood Street (M03, Painted dark
blue); *Kenton* 704 W. Franklin (M02, Blue-green); *Lancaster* 710 N. Rutter Avenue
(M02, Blue-green); 213 Talmadge (M02,
Tan); *Lebanon* 317 Park Avenue (Re-sided);
Madison 5977 Shore Drive (Pink); *Mans-field* Sunset Boulevard @ Lexington;
Marion 63 Olney (M02, Yellow); Olney @
Bellefontane (M02, Blue-green); *Marietta*
204 Dale Street (M02, Bricked Exterior);
Marysville 740 W. Sixth Street (M02,
Yellow); *Massillon* 413 17th St, NE; 3483
Wales, N.W. (M03); *McComb* 104 Shady
Acres Lane (M02, Yellow); *McConnellsville*
670 E. Bell Avenue (M02, Gray); *Medinah*
142 W. Park Boulevard (M02, Tan, S1178);

403 W. Park Boulevard (M02, Gray
[Re-sided], S819); *Mentor* 8015 Dartmoor
Road (M02, Gray, S558); *Middletown* State
Route 42; 925 14th Avenue (M02, Blue-green); *Minerva* 804 E. Lincoln Way
(M02, Tan); *Mount Vernon* 401 Harcourt
Road (M02, Yellow [Painted White]); 6
Lamartine (M02, Yellow, S2527); *Napoleon*
744 Welsted (M02, Tan); *Newark* 247
Stare Road (M02, Yellow); 168 N. 30th
Street (M02, Gray); *New Bremen* 102 N.
Walnut Street (M02, Blue-green); *Northfield
Center* 9361 Brandywine Road (Razed);
North Olmstead (Cleveland) ... Mastick Road
(M02, Blue); *N. Royalton (Cleveland)* 8051
Ridge Road (M02, Gray); 9163 State Road
(M02, Gray, S1168); *Norwalk* Cline Street
@ Milan; *Parma* 1614 Keystone (M02,
Gray); 3309 Tuxedo Avenue (M02, Gray);
Pataskala 7491 S. Black Road; *Perrysburg*
519 W Indiana Avenue (M02, Gray); *Rey-noldsburg (Columbus)* 7658 E. Main Street
(M03, Blue, 2 car); 2396 Main Street;
Roseville 162 N. Main Street (M02, Tan,
S8—); 490 Zanesville Road (M02, Gray,
S811, 2 car); *Salem* Brooklyn Avenue (M02,
Tan); 1380 Ridgewood Drive (M02, Yellow);
1390 Ridgewood Drive (M02, Yellow); *San-dusky* 2082 East Cleveland Street (M02,
Gray); *Somerset* 106 Columbus Street (M02,
Tan, Basement); *Spencerville* E. State
Route 117; *Springfield* 265 N. Broadmoor
Boulevard (M02, Yellow, S1599); 1818 Ken-wood Avenue; 210 E. McCreigh (M02, Yel-low); 1333 Seminole Avenue (M02, Gray,
S1051); *Toledo* 2712 Copland (Yellow); 4219
Douglas (M02, Gray); 4938 Fair Oaks (M03,
Yellow, 2 car, BW); Farnham @ Greenway
(M02, Yellow); 540 Gramercy (M02, Yel-low); 4337 Harvest (M02, Yellow); 3244
Heatherdowns (M02, Gray); 1848 Manhat-tan (M02, Yellow); 2003 Marwood (M02,
Gray); 46 Pasadena (M02, Blue); 44 Poin-settia (M02, Tan); 1649 Riverview (M02,
Blue); 2348 Sherwood Road; 2942 Starr
(M02, Yellow); 110 Sunset (M02, Gray);
3851 Watson (M02, Gray); 742 Waybridge
(M02, Gray); 1862 Wildwood (M02, Blue);
4601 Willys Parkway (M02, Blue-green,
S922); *Troy* 119 Jackson Street (Tan);
Urbana 849 Scioto Street (M02, Yellow);
Vandalia 9070 Peters Pike (M02, Gray);
Van Wert State Route 118; State Route 118;

Warren 420 Perkinswood Boulevard, N.E.; *Westerville* 3584 Westerville Road (M03, Dark Gray [Strandlund's Cottage]); *Westlake* 30555 Center Ridge Road; *Wilmington* 99 Ruby Avenue (M02, Yellow); *Xenia* Old Springfield Drive; Old Springfield Drive; *Yellow Springs (Dayton)* 821 S. High Street (M03, Gray); *Youngstown* Bears Den Road (M02, Gray); 30 Stanton Avenue (M02, Gray).

Oklahoma

Bartlesville 5619 Commanche (M02); 1514 Rogers Avenue (M02); *Nowata* 4 Sunset Drive (M02, Gray); 1012 W. Davis Drive (Same house at same location, but address changed); *Stillwater* 2119 W. Sherwood (M02, Gray, Garage); 915 W. Eighth Street (M02, Gray).

Pennsylvania

Allentown 2205 Washington (M02, Gray, S2370); *Ambridge* Park Road @ 5th Street (M02, Blue); *Bradford* 26 Brook Street (M02, Yellow); 322 Interstate Parkway (M02, Gray, S1362); 326 Interstate Parkway (M02, Tan, S1156); 26 Parkway Lane (M02, Yellow, S1596); 176 Williams Street (M02, Gray); *Clarks Summit* 230 Fairview Road (M02, Tan); 902 Fairview Road (M02, Gray, S2048); 116 Glenburn Road (M02, Blue-green, S974); 901 Layton Road; *Erie* 1315 Chelsea (M02, Bricked Veneer); 2912 Court Avenue (M02, Blue); 716 W. Grandview Boulevard (M02, Yellow); 3322 Greengarden Avenue (M02, Yellow, S693); 8190 Grubb Road (M02, Yellow [Re-sided]); 3907 Iroquois (M02, Gray); 916 Kahkwa Boulevard (M03, Tan); 4010 E. Lake Road (M02, Re-sided); 309 Marshall Drive (M02, painted); 735 Napier (M02, Re-sided); 138 Norman Way (M02, Blue); 1303 Oakmont (M02, Re-sided); 156 Parkway Drive (M03, Blue, S2279); 4237 Pine Avenue (M02, Yellow); 1190 Townhall Road (M02, Blue); 1930 W. 11th Street (M02, Gray [Re-sided], S514); 1961 W. 11th Street (M02, Gray [Re-sided], Relocated); 3428 W. 11th Street (M02, Blue, S1661); *Farrell* 1623 Farrell Terrace (M02, Painted Brown); 1650 Farrell Terrace (M02, Gray); *Girard* 602 Lake Street (M02, Blue, MODEL); *Harrisburg* 1901 Herr Street (M02, Blue, MODEL); 1905 Herr Street (M02, Tan); 3105 N. Fifth Street (M02, Blue-green, S1317); 1217 N. 17th Street (M02, Gray, S2425); *Hermitage* 2970 Moorefield Road (M02, Tan); *Indiana* N. Third Street @ Chestnut; 247 Locust Street (M02, Gray); *Lebanon* 344 S. First Avenue (M02); 402 East Chestnut Street; *McKean (Erie)* 8190 Grubb Road (Blue-green); *Northeast* 1104 S. Shore Avenue (M02, Yellow [painted], S713); *North Warren* Route 62 toward Russell; *Philadelphia* 11000 Bustletown Avenue (M02, Blue-green); 9534 Roosevelt Boulevard (M02, Gray, S1942); *Quakertown* Pail Town Road @ Old Bethlehem Pike; *Sewickley* 432 Logan Street (M02, Re-sided); *Sharon* 1138 Bonair Avenue (M02, Painted Brown); *Sharpsville* 369 Fourth Street (M03, Gray); 480 Fourth Street (M02, Gray); 493 Fourth Street (M02, Wood Siding); *Union City* 107 N. Main Street (M02, Blue); *Warren* 1819 Market Street (M02, Blue).

South Dakota

Huron 669 Dakota N. (M02, Gray); 1305 McDonald Drive (M03, Yellow, S1829, 2 car, BW); 1278 Utah, S.E. (M02, Tan); *Miller* 315 E. Third Avenue (M02, Gray); 320 E. Fifth Street (M03, Gray); *Pierre* 1117 East Capitol Drive (M02, Tan); 1123 East Capitol Drive (M02); *Rapid City* 4121 Canyon Lake Drive (Yellow, Newport); 101 East Quincy (M03, Gray, 2 car); 1909 Ninth Street (M02, Tan, 1½ car); *Redfield* 204 E. Second Street (M02, Gray, S1375); *Sioux Falls* 1509 S. Glendale Avenue (M02, Gray, S1500, 1½); 1809 S. Grange Avenue (M03, Tan); 800 S. Hawthorne Avenue (M02, Blue); 1505 S. West Avenue (M02, Gray); 1725 S. Menlo Avenue (M02, Blue-Green); *Wakonda* 410 Idaho Street.

Tennessee

Knoxville 1106 Bearden Drive (?); 1043 Cedar Hill Road (Blue-green); Chapman

Avenue; 222 Chamberlain (Gray); Emoriland Boulevard (1 block east of Broadway) (?); 1846 Fairmount (Stucco); 3510 Glenhurst Road (Blue-green); 1106 Northshore Drive (?); N. Papermill Road (?); *Memphis* 4723 Barfield (M02, Gray, Razed 1988); 3608 Charleswood (M02, Tan); 2399 Eastwood Place (M02, Blue-green); ... Strathmore (M02); ... Bluebird Street; *South Memphis* 977 Bluebird Lane (M02, Gray, S1766); *Surgoinsville* Old State Route 1 (M02, Gray).

Texas

Dallas 5006 W. Amhurst (M02, Yellow, MODEL); Fort Worth; 4701 Marks Place (M02, Blue-green).

Virginia

Abingdon Bradley Street; Highway 11; *Alexandria* 2104 Scroggins Road; ... Summit Avenue at Daymen (Razed 2000); *Arlington* 4831 N. 24th Road (M02, Green , Razed 5-1996); *Bassett* Ridgewood @ Bassett Heights (M02, Gray); *Marion* South Sheffey Street; *Martinsville* 700 block Auburn Place (M02, Gray); 800 block Indian Trail (M02, Yellow); *Norfolk* 6101 Hampton Boulevard (M02, Yellow); 6105 Hampton Boulevard (M02, Re-sided); *Quantico Marine Base* 2730 McCard Street (M02, Gray); 2731 McCard Street (M02, Green); 2732 McCard Street (M03, Pink); 2733 McCard Street (M02, Gray); 2734 McCard Street (M03, Green); 2735 McCard Street (M02, Pink); 2736 McCard Street (M02, Gray); 2737 McCard Street (M02, Green); 2738 McCard Street (M03, Pink); 2739 McCard Street (M02, Gray); 2740 McCard Street (M02, Green); 2741 McCard Street (M03, Pink); 2742 McCard Street (M03, Gray); 2743 McCard Street (M02, Green); 2744 McCard Street (M02, Pink); 2745 McCard Street (M03, Gray); 2746 McCard Street (M02, Green); 2747 McCard Street (M03, Pink); 2748 McCard Street (M02, Gray); 2749 McCard Street (M03, Green); 2750 McCard Street (M03, Pink); 2751 McCard Street (M03, Gray); 2752 McCard Street (M03, Green); 2753 McCard Street (M03, Gray); 2754 McCard Street (M03, Pink); 2755 McCard Street (M03, Green); 2756 McCard Street (M02, Pink); 2757 McCard Street (M02, Gray); 2758 McCard Street (M02, Green); 2759 McCard Street (M02, Pink); 2760 McCard Street (M02, Gray); 2761 McCard Street (M02, Green); 2762 McCard Street (M03, Pink); 2763 McCard Street (M03, Gray); 2764 McCard Street (M03, Green); *S. Arlington* 1112 S. Forest (M02, Blue); 1117 S. Forest (M02, Gray); 1124 S. Frederick (M02, Gray); 1818 N. Randolph Street (M02, Gray); 4647 S. Third Street (M02, Blue); 2915 S. Seventh Street (M02, Gray); 5200 S. 12th Street (M02, Blue); 5201 S. 12th Street (M02, Gray); 3500 N. 13th Street (M02, Yellow); 2812 N. 23rd Street (M02, Blue); 4831 N. 24th Street (M02, Gray).

West Virginia

Beckley 121 Mankin Avenue (Gray). 206 Vine Street (Gray). *Bridgeport* 231 Cherry Street (M02, Wood Siding). 520 Johnson Avenue (M02, Tan). 416 Orchard Street (M02, Blue-green). *Chester* 1004 Phoenix Avenue (M02, Tan). *Clarksburg* 203 Green Avenue (M02, Blue-green). 731 E. Main Street (M02, Blue-green). 115 Mandan Road (M02, Tan, 1 car). 160 Seneca Drive (M02, Blue-green, 1 car). 1100 Van Buren (M02, Blue-green). *Elkins* Findley Street. *Huntington* 300 Green Oak Drive (M02). 1839 McCoy Street (M03, Blue-green, S1850). *Morgantown* 645 Callen Avenue (M02, Gray [Re-sided]). 395 Laurel Street (M02, Tan, 2 car). 356 Oakland Street (M02, Blue). 484 Rotary Street (M02, Tan, Razed). 334 Watts Street (M02, Gray). *Westover (Morgantown)* 43 Highland (M02 Yellow [Tan Paint], S1240, Basement). 45 Highland (M02, Gray, S2084). 47 Highland (M02, Bluegreen [White Paint], MODEL). *Wheeling* Allendale Road53 Clifton Avenue (M02, Tan, Basement). 100 Edgewood Street (M02, Tan, 1 car). 127 Edgewood Street (M02, Painted Brown). 2 Edgelawn Avenue (M02, Tan, 1 car). 4 Edgelawn Avenue (M02, Blue). 6 Edgelawn Avenue (M02, Yellow). 54 Elm Lane (M02, Gray, 2 car, BW). 102

Garvins Lane (M02, Tan, S2271). 120 Mclain (M02, Gray-brown). 121 Mclain (M02, Tan, Basement). 601 Mt Olivet Road (M02, Brown). 8 Pallister Road (M02, Gray, Basement). 15 Pallister Road (M02, Tan). 188 Ridgecrest Road (M02, Blue-green, Basement). 190 Ridgecrest Road (Blue). 4 Romney Road (M02, Painted Light Green). 120 N. Eighth (M02, Re-sided, 1 car). *Williamson* 635 Mulberry Street. *Williamstown* 111 West Eighth Street (M02, Blue [Painted Yellow], 1 car). 122 West Eighth Street (M02, Yellow [Painted White]).

Wisconsin

Appleton 6 Johnson Court; 14 Johnson Court; 1909 N. Union Street. *Beaver Dam* 91 W. Water Street; 93 W. Water Street. *Beloit* 1718 Arlington (M02, Blue-green, S1623). *Buffalo City* 575 S. River Road (M02, Yellow, S731). *Burlington* 418 McHenry Street (M02, Blue). 356 Perkins Street (M02, Yellow, S728). 457 Randolph Street (M02, Blue, S920). 340 Reynolds Avenue (M02, Blue, S1337). *Cuba City* N.W. cor. Jackson & Parker; 115 W. Bryan; 621 N. Madison (garage). *Darlington* Galena Street south of Hill Valley Road; Galena Street south of Hill Valley Road. *Eau Claire* 1813 Badger; 1700 Fairway (M02, S668). 1819 Lyndale Avenue (M02, Yellow, S747, 1 car). RR6 at Hillcrest Golf Club. *Fond du Lac* 341 Boyd Street; Division Street. *Fontana* 450 Mill Street (M02, Yellow). 3B Shabonna Drive, Unit 1, Lot 14 (M03, Yellow). *Green Bay* 998 Ninth Street (M02, Yellow). 717 Porlier Street (M02, Gray). 919 Reed Street (M02, Blue). 1219 S. Webster. *Hillsboro* Hillsboro Avenue. *Horricon* 205 W. Walnut. *Janesville* 825 N. Washington (M02, Blue). *Kenosha* 7502 21st Avenue (M02, Yellow). 5540 37th Avenue (M02, Tan, S1138). 2032 74th Place (M02, Yellow). 3901 W. Taft Street (M02, Gray, S765). *La Crosse* 1211 Bluff Street; 4514 Mormon Coulee Road; 2011 Park Ave.; 2215 State Road; 751 N. 22nd Street (M02, Gray, S1752). *Lake Geneva* 1005 Grant Street (M02, Blue). 1309 Madison (M02, Wood siding). 308 Maxwell (M02, Yellow). *Lancaster* 1020 W. Maple Street. *Madison*

432 Blackhawk (M02, Blue-green). 556 Chatham Terrace (M02, Yellow). 418 Critchell Terrace (M02, Gray). 5750 Elder Place (M02, Gray). 820 Emerson (M02, Tan). 4325 Felton Place (M03, Gray, S1900). 537 Gately Terrace (M02, Yellow). 534 Glenway (M02, Yellow). 3553 Heather Crest (M03, Yellow). 314 N. Hillside Terrace (M02, Yellow, 2 car). 334 N. Hillside Terrace (M02, Blue-green). 513 N. Owen (M02, Tan). 505 S. Owen (M02, Blue-green). 548 S. Owen (M02, Gray, S2001). 3810 St. Clair (M02, Tan, S1926). *Marshfield* 908 North Avenue. *Menasha* Oak Street. *Middleton (Madison)* 7120 North Street (M02, Yellow, S1287). *Milwaukee* 3802 W. Capitol Drive (M02, Blue, S2). 3825 W. Marion Street (M02, Blue-green). 55th & Phillip Place (M02). 4433 N. Sherman; 4956 N. 27th Street (M02, Tan). 4964 N. 27th Street (M02, Yellow). 4276 N. 36th Street (M02, Yellow). 2746 N. 81st Street (M02, Blue-green, S934). 2777 N. 82nd Street (M02, Blue-green). 3205 N. 82nd Street (M02, Blue-green). 3014 N. 83rd Street (M02, Blue-green). 2971 N. 91st Street (M02, Tan). 3474 N. 93rd Street (M02, Tan). *Monona (Madison)* 404 Lamboley (M02, Gray); 703 Pinchot (M02, Blue). 208 Starry (M02, Tan, 2 car). 5112 Tonyawatha Trail (M03, Tan, S2089). 2410 Waunona Way (Re-sided). 1304 Wyldhaven (M02, Tan). *Monroe* 1715 20th Street (Blue-green). 1717 21st Street (Yellow). 1626 25th Street (Blue-green). *Mosinee* 733 Western. *Montello* 51 Stevens Avenue. *Mount Horeb* 207 S. Center Avenue (M02, Gray, S759). *New Glarus* N.E. Cor 4th Street & 11th Avenue (M02, Gray). 5th Street & 8th Avenue (M02, Yellow). *Oregon* 677 N. Oak (M02, Re-sided, 1½). *Oshkosh* 1020 Baldwin; 915 W. Fourth (M02). *Plattville* 545 Lutheran Street. *Portage* 1125 Wisconsin Avenue; Seier Road T10 R11 (north of State Highway 16). *Racine* 2322 Webster (M02, Yellow, S1531). *Reedsburg* 749 N. Walnut Street. *Schullsburg* Scales Mound Road. *Sturgeon Bay* 116 N. Ninth Avenue. *Verona* 205 Franklin (M02, Tan). 203 Westlawn (M02, Tan, 1½). *Waterford* 110 S. Jefferson (M02, Blue, S1653). 105 N. Jefferson (M02, Yellow, S1266). *Wausau* 311 Ethel Street. *Williams Bay* 539 Highland Road.

Notes

1. Peterson, Charles E. "Prefabs in the California Gold Rush, 1849," *Journal of the Society of Architectural Historians* 24.4 (December, 1965), 318–324.

2. E. W. Ingram, Sr. "All This from a 5-Cent Hamburger: The Story of the White Castle System," *The Newcomen Society in North America* (1970), 19.

3. Guy L. Irwin. "Porcelain Enamel Will Make the All-Steel House Practical," *Better Enameling* (March, 1931), 4–9.

4. *Ibid.*, 2.

5. Dorothy Raley, ed. *A Century of Progress in Homes and Furnishings* (Chicago: M. A. Ring Co., 1934), pp. 17–18, 111–112.

6. "A New Type of Construction for Porcelain Enameled Buildings," *Better Enameling* (August, 1932), 4–6, 36, 40.

7. Hugh W. Wright. "A Frameless Steel House with Porcelain Enameled Exterior," *Better Enameling* (September, 1932), 7–9; "Frameless Porcelain-Enameled House Dedicated," *Better Enameling* (November, 1932), 21. This porcelain-enameled house was built by Ferro Enamel Corporation in South Euclid, Ohio. The "Ferro House" had a steel frame, special "ferro-clad" wallboards of enameled steel over insulation board, and porcelain-enameled steel shingles. The interior used porcelain enamel on the baseboards, wall tile, lighting fixtures, switch plates and flooring.

8. "Lustron" was registered as a trademark by the Porcelain Products Company for "Building Materials in the Nature of Structural and Architectural Sheets or Shapes for Use as Exterior or Interior Facing for Walls, Floors or Ceilings, for Partitions, Doors, Counters, Shelves, Signs, Cabinets, Compartments, Chutes, or Other Architectural, Industrial or Commercial Products in Which Flat or Curved Surfaces Are an Essential Element." The U.S. Patent Office gave Lustron trademark number 353,109. (Official Gazette of the United States Patent Office [December 28, 1937], 793.) Strandlund acquired this logo when he purchased the rights to the Lustron Homes some ten years later.

9. "Strandlund Becomes Vice President and General Manager of Chicago Vit," *Better Enameling* (September, 1943), 17.

10. "Carl Strandlund Honored," *Better Enameling* (May, 1944).

11. Carl G Strandlund. "Potentialities of Porcelain Enamel," *Better Enameling* (January, 1946), 10–11.

12. Personel letter from Carl Rolen to Robert Reiss, *Columbus Dispatch* (August 1, 1976), files of Lustron Research.

13. "Lustron Homes," *Better Enameling* (November, 1946), 10–13.

14. "RFC Approves Loan on Lustron Homes," *New York Times* (January 31, 1947).

15. Telegram, Strandlund to Senator Ferguson (November 22, 1946), Lustron file, Ohio Historical Society (OHS).

16. "Chicago Vit Sells Lustron House Interests," *Better Enameling* (December, 1945) 35.

17. "Lustron Home Exhibit in New York," *Prefabrication* (March-April, 1948).

18. Personal Interview, Tom Fetters and Betty Wallach, Lustron 2001 Convention, Columbus, Ohio (May 29, 2001).

19. Lustron "Newsletter," Vol.1, No. 18 (May 21, 1948), Files of Lustron Research.

20. Lustron "Newsletter," Vol. 1, No. 19 (May 28, 1948), Files of Lustron Research.

21. Lustron "Newsletter," Vol. 1, No. 23 (June 25, 1948), Files of Lustron Research.

22. Lustron "Newsletter," Vol. 1, No. 26 (July 23, 1948), Files of Lustron Research.

23. Lustron "Newsletter," Vol. 1, No. 27 (July 30, 1948), Files of Lustron Research

24. Lustron "Newsletter," Vol. 1, No. 28 (August 6, 1948), Files of Lustron Research.

25. Lustron "Newsletter," Vol. 1, No. 29 (August 13, 1948), Files of Lustron Research.

26. Lustron "Newsletter," Vol. 2, No. 4 (February 18, 1949), Files of Lustron Research.

27. Lustron "Newsletter," Vol. 1, No. 50 (January 7, 1949), Files of Lustron Research.

28. Personal Letter, Rolen to Reiss, *op. cit.* (August 1, 1976), Files of Lustron Research.

29. Lustron "Newsletter," Vol. 1, No. 17 (May 14, 1948), Files of Lustron Research.

30. Personal Interview, Tom Fetters and Dick Reedy, Lustron 2000 Convention, Columbus, Ohio (June 25, 2000).

31. Lustron "Newsletter," Vol. 1, No. 46 (December 10, 1948), Files of Lustron Research.

32. Personal Letter, R. Harold Denton to Hugh Cameron (July 4, 1988), Files of Lustron Research.

33. "Porcelain Skin Protects Prefab," *Popular Science* (June, 1948) 114.

34. Four page Camera Tour Brochure, Lustron Corporation (1948), Files of Lustron Research.

35. "Lustron Homes Rising in NY-Conn Centers," *New York Times* (May 22, 1949).

36. "Lustron House to Go on Display," *New York Times* (May 26, 1949).

37. Strategic Air Command Agreement (1949), Lustron File, OHS.

38. "The Factory Built House Is Here, But Not the Answer to the $33 Million Question: How to Get It to Market?" *Architectural Forum* (May, 1949), 107–114.

39. Telephone interview, Vince Kohler with Leon Lipshutz (June 24, 1988).

40. "Lustron Expected to Seek $3,000,000," *New York Times* (June 24, 1949).

41. "Lustron Ships 24 Hours a Day," *New York Times* (July 8, 1949).

42. "Tropical Settings in New Model Home," *New York Times* (July 20, 1949).

43. "Lustron Gets RFC Loans," *New York Times* (July 22, 1949).

44. "To Study Lustron Loans," *New York Times* (July 28, 1949).

45. "Strandlund Defends RFC Aid to Lustron," *New York Times* (July 29, 1949).

46. "Lustron Shipment 42-House Record," *Ohio State Journal* (August 1, 1949).

47. "Lustron's Losses Put at $14,754,000," *New York Times* (August 5, 1949).

48. "Lustron Gets Order," *New York Times* (August 17, 1949).

49. "Cornell Gets Two 'Pre-Fab' Dwellings to Study Space Needs of Farm Houses," *New York Times* (October 2, 1949).

50. "Lustron Closes Big Sale," *New York Times* (November 12, 1949).

51. "Military Housing Opens Wide Field of Building Work," *New York Times* (November 13, 1949).

52. "That Lustron Affair," *Fortune* (November 1949), 92–94.

53. "Wonderland Revisited," *Forbes* (November 15, 1949).

54. "Loan for Lustron Is Laid to Truman," *New York Times* (December 16, 1949).

55. "Lustron Warned on Debt Owed RFC," *New York Times* (December 30, 1949).

56. "Hot Spot for Lustron," *Newsweek* (January 23, 1950), 60.

57. "$37,500,000 Fizzle": #1 "The Lustron Corporation Story: Its Huge RFC Debt and Colorful Career of Promoter Strandlund," *St. Louis Post-Dispatch* (StLP-D) (February 4, 1950), 1, 2; #2 "U.S. Put Up Millions for Houses When All He Sought to Build Was Oil Stations, Lustron Head Says," StLP-D (February 6, 1950), 1, 4; #3 "Lustron Head Criticizes RFC, Blames It in Part for Failure to Mass Produce Dream House," StLP-D (February 7, 1950), 1, 6; #4 "Lustron Head, Seeking More RFC Cash, Still Insists He Can 'Revolutionize' Housing," StLP-D (February 8, 1950), 1, 13.

58. "U.S. To Study Using Big Lustron Plant," *New York Times* (February 16, 1950).

59. "Receiver Is Appointed for Lustron Corp. for Operation of Plant Another 30 Days," *New York Times* (March 7, 1950).

60. "Lustron Officials Relieved of Posts," *New York Times* (March 9, 1950).

61. "Lustron Gets Extension," *New York Times* (April 4, 1950).

62. "Sale of Lustron Plant Ordered by U.S. Court," *New York Times* (May 6, 1950).

63. "RFC Bids $6,000,000 for the Lustron Plant," *New York Times* (June 7, 1950).

64. Twenty three associated pages. Schedule L-22 Dealers' Credit Balances; Dealers' Deposits; Real Estate Schedule B-1 (Sale of 3802 W. Capitol Drive, Milwaukee, WI, House for $9126 by Clyde M Foraker, Receiver); Patents, Copyrights and Trademarks with "No Book Value"; Schedule L-8 Accounts Receivable: Statement of Affairs—Bankruptcy. List of Creditors signed by Carl Strandlund, June 15, 1950, Files of Lustron Research.

65. "Lustron Loss Put at $500,000 in Deal," *New York Times* (June 27, 1950).

66. "Hise, Ousted RFC Head, Blames Congress for Loans to Lustron," *New York Times* (August 18, 1950).

67. "A Close Call for Fruehauf," *Business Week* (April 17, 1951), 70, 72, 76.

68. "Auctioneer Knocks Down Remnants of Lustron Dream," *New York Times* (July 21, 1951), 23.

69. "Claims On Which First and Final Dividend of 25% to be Paid" (3 pages) Case 50-B447. Files of Lustron Research.

70. Petition—File 50 B 447 (February 16, 1960), Files of Lustron Research.

71. "Lustron Housing Corp. Extension of Remarks of Hon. Pat Sutton of Tennessee in the House of Representatives, Thursday, February 8, 1951," *Congressional Record—Appendix P* A690–692.

72. Carl Koch, *At Home with Tomorrow*, 1958. Chapter 6, "Lustron," 110–125.

73. Personal letter. Dennis E. Robertson to Tom Fetters (April 24, 1992), the details on the Monona, WI, house reconstruction, Files of Lustron Research.

Bibliography

Air Force Times (January 21, 1985). "Lustron for Life," by Pat Dalton, 4 pages.

Ann Arbor (MI) *Observer* (March 1989). "Ann Arbor's Steel Houses," by Grace Shackman, p. 142.

APT Bulletin (December 1991) "What Ever Happened to Lustron Homes?" by Robert A. Mitchell, AIA, pp. 44–53.

The Architectural Forum (June 1947). "The Industrialized House," pp. 105–110.

The Architectural Forum (May 1948). "Big Capital."

The Architectural Forum (August 1948). "The Winner," p. 14.

Architectural Plans, Model 02 Home, The Lustron Corporation, Columbus, OH.

Architectural Plans, Model 03 Home, The Lustron Corporation, Columbus, OH.

Barwig, Floyd E. A paper prepared at the University of California. "Lustron Homes."

"Bathtub Blues" *Time* 54.1 (July 4, 1949), p. 55.

Bender, Richard. "A Crack in the Rear View Mirror." New York: Van Nostrand Reinhold Company, 1973, p. 28.

Berkshire (MA) *Courier* (November 10, 1949). "All-Steel Lustron House Was Built 50 Years Ago," by Bernard Drew.

Better Enameling (February 1950). "Porcelain Enamel in Home Construction," pp. 13–14.

Better Homes & Gardens (September 1969). "Whatever Happened to the New Building Ideas of a Few Years Back?" pp. 62–63.

Brodt, Phil. Research paper on Lustron Homes (Spring 1992) [unpublished].

The Capital (Annapolis, MD) (February 25, 1995). "This Place Is a Real Steel," by Frances Jacques.

Carter, Thomas, and Herman, Bernard L. *Perspectives in Vernacular Architecture, III.* Columbia, Missouri: University of Missouri Press, 1989, pp. 51–61.

Cedar Rapids Gazette (July 12, 1992). "Lustron, Unusual Homes Are Built of Metal," by Mike Kilen [Information on Tom Fetters search for Lustron Houses], pp. 1C–2C.

Ceramic Industry (August 1948). "First in New Ceramic Era—Lustron's $13 Million Plant," pp. 56–59.

Ceramic Industry (March 1949). "Thinking Out Styling," p. 79.

Chapel Hill (NC) *Newspaper* (June 14, 1992). "This House Is a Real 'Steel'" by J. J. Warlick.

Chesterton (IN) *News* (September 10, 1992). "Tour Focus on Post-War Homes."

Chicago Herald-American (November 20, 1946). "First Lustron House Finished," p. 26.

Chicago Sun-Times (March 11–12, 1983). "Lustrons: The 'White Castles' of the Housing Trade," by Robert Greene, p. 14.

Chicago Sun-Times (March 22, 1985). "Relentless Lake Threatens to Erode Homes of History," by Celeste Busk.

Chicago Tribune (March 1992). "Lustron Homes: A Financial Failure, but Still Standing," by staff.

Chicago Tribune (March 21, 1993). "Steel Housing: An Old Idea That's New," by Rich Davis of Evansville, IN (AP).

Chicago Tribune (March 27, 1994). "Early Steel Homes Still Reside in Chicago," by John Handley. Refers to Tom Fetters book manuscript on Lustrons.

Collier's (November 5, 1949). "Lustron—The House That Lots of Jack Built," pp. 15–18.

Columbus Citizen-Journal (November 3, 1981). "Home Made of Metal Is Fireproof, Repair-Free," p. 32.

The Columbus Dispatch (November 25, 1984). "Nails Don't Work on Metal Houses," by David Lore, p. 2B.

The Columbus Dispatch (January 2, 1994). "Little Houses," by Joe Blundo.

The Columbus Dispatch (March 19, 2000). "Postwar House of Steel Attracts Some Folks Like a Magnet," by Kathy Lynn Gray. Details on Tom Fetters search for Lustron houses.

The Columbus Dispatch (June 26, 2000). "Luster Still Isn't Off Life in All-Steel House," by Suzanne Hoholik.

Council Bluffs, Iowa, newspaper (November 20, 1988). "Lustron Homes Still 'Modern,'" by Winnie Wilmarth.

Dallas (TX) *Morning News* (March 13, 1989). "Everything-Proof House: It Has No Wood," by David Dillon.

Decatur (IL) *Herald & Review* (August 2, 1992). "No Termites," by Lisa Morrison, pp. E1 and E2.

Des Moines Sunday Register (December 7, 1980). "Houses Built to Relieve Shortage," p. 12E.

Des Moines Register (October 18, 1988). "In Search of Lustron Steel Houses," by Jim Pollock [Tom Fetters search is detailed].

Des Moines Register (September 29, 1990). "Two Small Homes Make One Big One," by Carol McGarvey.

Des Moines Register (June 11, 1993). "Long Live the Lustron," by Linda Mason Hunter.

Durham (NC) *Herald* (February 1989). "Living with Lustron," by Emily Crump.

(Elgin, IL) *Courier News* (1995). "Shiny, Steel Paneled House Reflects Bit of Americana," by Mick Zawislak.

Engineering News-Record (November 25, 1948). "Lustron's $14,000,000 Gamble," pp. 61–63.

Engineering News-Record (February 23, 1950). "RFC Cuts Off Aid, Forecloses on Lustron."

The Evansville (IN) *Courier* (February 14, 1993). "Life with Lustron," by Rich Davis, pp. D1 and D5.

Fine Homebuilding (August-September 1984). "Lustron: A Prefabricated Ranch House of Porcelainized Steel," by Tim Snyder, pp. 26–30.

Fiftieth Anniversary Celebration Y2K Lustron Home (June 25, 2000). Alex James, Celebration Chairman. Monaco's Palace, Columbus, Ohio.

Folklife Center News (Spring 1992). "Architecture and Personal Expression in Southern West Virginia."

"Footsteps from the Past: 50th Anniversary of the Lustron Home" February, 2000. Host: Jean Connor with Special Guest Lustron Expert: Tom Fetters. A Video Production produced by The Village of Lombard.

Giles, Drs. Carl and Barbara. *Steel Homes*. Tab Books, 1984.

Greensboro News & Record (July 22, 1989). "A Steel of a House," by Hayes Clement.

Hartford (CT) *Courant* (January 9, 1982). "'Home of Future' Now a Rusty Relic," by G. A. Richter.

Hartford (CT) *Courant* (1988). "1949 Recalls Blonde TV and Prefab Lustron Home," by G. A. Richter.

The Hawkeye (Burlington, IA) (February 25, 2001). "Home Steel Home," by Randy Miller.

HGTV (Home & Garden TV–Cable). Episode 305, "Steel House." Video story on Chesterton, IN, Lustron museum.

Highway Traffic (April 1960). "Biographical Sketch of Lt. Governor Wilson Wyatt," p. 5.

Historic Illinois (October, 1993; Vol. 16, No. 3). "The Lustron Home," by Cynthia Fuener. Interior photo by Tom Fetters.

Historic Preservation (January-February 1995) "Showing Its Metal," by Kim Keister. Detailed story on the Chesterton Lustron museum, pp. 37–43, and 93, 96.

Homewood (IL) *Historical Society Newsletter* (July 1986). "Lustron Living," by Adelaide Wasserman.

Homewood (IL) *Star* (March 1993). "All-Metal Lustron Dwelling Requires Little Maintenance," by Suzanne P. Law.

Hutchinson, Kansas, Herald News (1964). "Steel Pre-Fab Holds Age Well."

The Indiana Preservationist (January 1987). "Magnets Handy in Metal Landmarks," by Lizbeth Henning.

The Indiana Preservationist (July-August 1994). "'Machine for Living' Gears Up for Tours," by Tina Connor. Story on Chesterton Lustron museum.

Indianapolis Star (August 7, 1988). "Homes with Magnetic Personalities," by Sally Falk, pp. 1–2.

Inland Architect (March-April 1987). "Prefab's Recurring Promise," by Ruth Knack, pp. 13–15.

Iowa Historian (December 1988). "Join the Hunt for Lustron Steel Houses," by Steven Blaski [Mentions Tom Fetters search for Lustrons].

Iowa Historian (February 1989). "Lustrons Located; Now Help Us Find Another Missing Link." Features a map of Iowa with Lustron locations marked.

The Iron Age (April 14, 1949). "Porcelain Enameling at Lustron," pp. 72–75.

Kansas Preservation (September-October 1995). "In Search of the Kansas Lustron," by Larry Jochims.

Koch, Carl. *At Home with Tomorrow.* New York: Rinehart & Company, 1958. Chapter 6, "Lustron," pp. 110–125.

KSUI-WSUI Public Radio (The University of Iowa) (January 1989). Feature story on Tom Fetters search for Lustron Houses.

McHenry County Historical Society. *Tracer* (Winter, 1995). "Looking for Lustron Homes," by Nancy J. Fike.

Middlesex (CT) *News* (October 10, 1993). "The Lustron Home," by Gene Cassidy.

Minneapolis Tribune (September 12, 1982). "Widow Recalls How Strandlund's Dream Became a Nightmare," p. 9E.

Money (April 1999). "Absolutely Prefabulous," by Paul Lukas.

The Morning Call (Allentown, PA) (October 25, 1992). "Visionary Homes of Past Never Caught On," by Gary Mayk.

National Housing Agency News, Office of Housing Expediter. #675 (October 30, 1946). The Newsletter affirming that the Dodge-Chrysler Chicago Plant would go to Lustron Corporation.

New York Times (August 22, 1991). "Failed Dreams That Paved the Way," by Eve M. Kahn, pp. C5–8.

The News-Gazette (Champaign, IL) (January 26, 1989). "For the Brave, These Post-War WWII Homes Were a Steal," by Kirby Pringle.

Ohio Magazine (1995). "House-in-a-Can," by James A Bauman, pp. 68–73 and 119.

Ohio Historical Society (June-July 2000, Vol. 39, No. 3). "Prefabricated Houses Fulfill Postwar Dreams," by Lee Jansen.

Old House Journal (July-August 1992). "Prefabs of the Future" [Photograph provided by Lustron Research].

The Plain Dealer (Cleveland, OH) (November 7, 1992). "Ranch-style House Constructed of Steel," by Angela D. Chatman, p. 5.

Post Tribune (May 17, 1994). "All-Steel House Becomes Historical Site," by Tim Zorn. Mentions Chesterton, IN, Lustron museum opening.

Prefabrication (March-April, 1948). "Lustron Home Exhibited in New York," p. 18.

Rockford (IL) *Register Star* (2000). "Steel and Porcelain Lustron Homes Quickly Became a Piece of the Past," by Brian Leaf.

St. Louis Post Dispatch (December 19, 1982). "A Porcelain-Steel Dream House That Americans Wouldn't Buy," by Frank Peters, p. 5E.

State Historical Society of Wisconsin (September 1992). "The Lustron Home," by Tricia Canaday, pp. 7–10.

The State Journal-Register (Springfield, IL). (December 18, 1993). "Lustron Shines On," by Julie Cellini.

Steel (February 14, 1949). "Lustron Steps Up Output," p. 67.

The (Dallas, TX) *Times Herald* (1993). "Manse of Steel," by Mary Barrineau, p. F4.

The (New Orleans, LA) *Times Picayune* (March 11, 2000). "Mailbag," "Steel Homes Cherished by Some," by David W. Myers.

The (Elkhart, IN) *Truth* (March 7, 1993). "Four Lustron Houses Still Stand in City with a Heart," by Matt Stokely, p. E5.

The Tuscaloosa (AL) *News* (March 14, 1993). "Lustron Met the Test of Quality," by Gene Ford.

The Washington Post (January 20, 1950). "RFC Is Weighing Its Lustron Stake," p. 4M.

The Washington Post (February 1, 1986). "Shaping the City," by Roger K. Lewis.

The Washington Post (June 30, 1988). "Little Metal Houses from the '40s Suburbs Maintain Their Mettle," by Sara Koncius, pp. 19–26.

Welding Innovation Quarterly (Vol. 9, No. 2, 1992). "The Failure of Lustron."

Western Express (Pittsfield, MA) (January 4, 1994). "Lustron Homes Approaching Half Century," by Tom Coulson.

Wilmington (NC) *Morning Star* (March 10, 1992). "House of Steel's Price a Steal," by Andrea Shaw, pp. 1A and 4A.

Wilmington (NC) *Morning Star* (March 17, 1992). "Wilmington Sculptor Likes the Feel of House of Steel," by Andrea Shaw.

Wisconsin State Journal (April 23, 1989). "Firm Died but Lustron Homes Survive," by Chris Martell, p. 3H.

Index